TONY PALMER
THE TRIALS of OZ

Typeset by Jonathan Downes,
Cover and Layout by SPiderKaT for CFZ Communications
Using Microsoft Word 2000, Microsoft , Publisher 2000, Adobe Photoshop CS.
First published in the U.K. in this edition by Gonzo Multimedia

Gonzo Distribution Ltd
6th floor, New Baltic House
65 Fenchurch Street
London EC3M 4BE

© Isolde Films MMXI

All rights reserved. Without limiting the rights under copyright reserved above, no part of this publication may be reproduced, stored in or introduced into a retrieval system, or transmitted, in any form of by any means (electronic, mechanical, photocopying, recording or otherwise), without the prior written permission of both the copyright owners and the publishers of this book.

ISBN 978-1-908728-43-2

For Angelo, Apollonia, and Gabriele
and all children
likely to be depraved and corrupted

CONTENTS

p.7 — Introduction by Richard Neville

p.9 — Introduction to the 2011 Edition by Tony Palmer

p.13 — Introduction to the original 1971 Edition by Tony Palmer

p.17 — **CHAPTER ONE:** The Trial begins – in Australia; at the Magistrates Court in West London & finally at The Old Bailey. Who were the defendants, and what was obscenity?

p.39 — **CHAPTER TWO:** The Schoolkids themselves and Issue No.28

p.59 — **CHAPTER THREE:** The case for the prosecution by Detective-Inspector Luff & Brian Leary QC. Vivian Berger, one of the schoolkids, for the defence.

p.77 — **CHAPTER FOUR:** The Old Bailey & Judge Michael Argyle QC, MC; the evidence of Richard Neville. George Melly and 'cunni-linktus'. Anthony Smith and the evidence of Jim Anderson & Felix Dennis.

p.127 — **CHAPTER FIVE:** The experts – Caroline Coon; Dr Haward; Michael Schofield; Dr Josephine Klein; Michael Segal; Edward de Bono; Dr Eysenck; Dr Linken; Mrs Berg; Michael Duane – and the age of Rupert Bear.

p.175 — **CHAPTER SIX:** Yet more experts – John Peel; Marty Feldman; Professor Dworkin; Feliks Topolski; Mervyn Jones; Grace Berger; Professor Wollheim and the idea of a 'liberal society'.

p.201 — **CHAPTER SEVEN:** Closing speech from Brian Leary QC for the prosecution.

p.213 — **CHAPTER EIGHT:** Closing speech from John Mortimer QC for the defence.

p.231 — **CHAPTER NINE:** Closing speeches from Keith McHale on behalf of Oz Publications Ltd., and Richard Neville on his own behalf

p.249 — **CHAPTER TEN:** The summary by Judge Michael Argyle, QC

p.277 **CHAPTER ELEVEN:** The Jury decides; the defendants react to the verdicts; the reaction in Fleet Street; the sentences.

p.289 **POSTSCRIPT:** What happened next...... by Tony Palmer & Felix Dennis

p.299 **LIFE AFTER THE TRIAL** by Jim Anderson

p.303 **I WAS AN OZ SCHOOLKID** by Charles Shaar Murray

p.307 **LAST THOUGHTS** by Brian Leary QC

p.309 **CODA** by the daughters of Michael Argyle QC, MC.

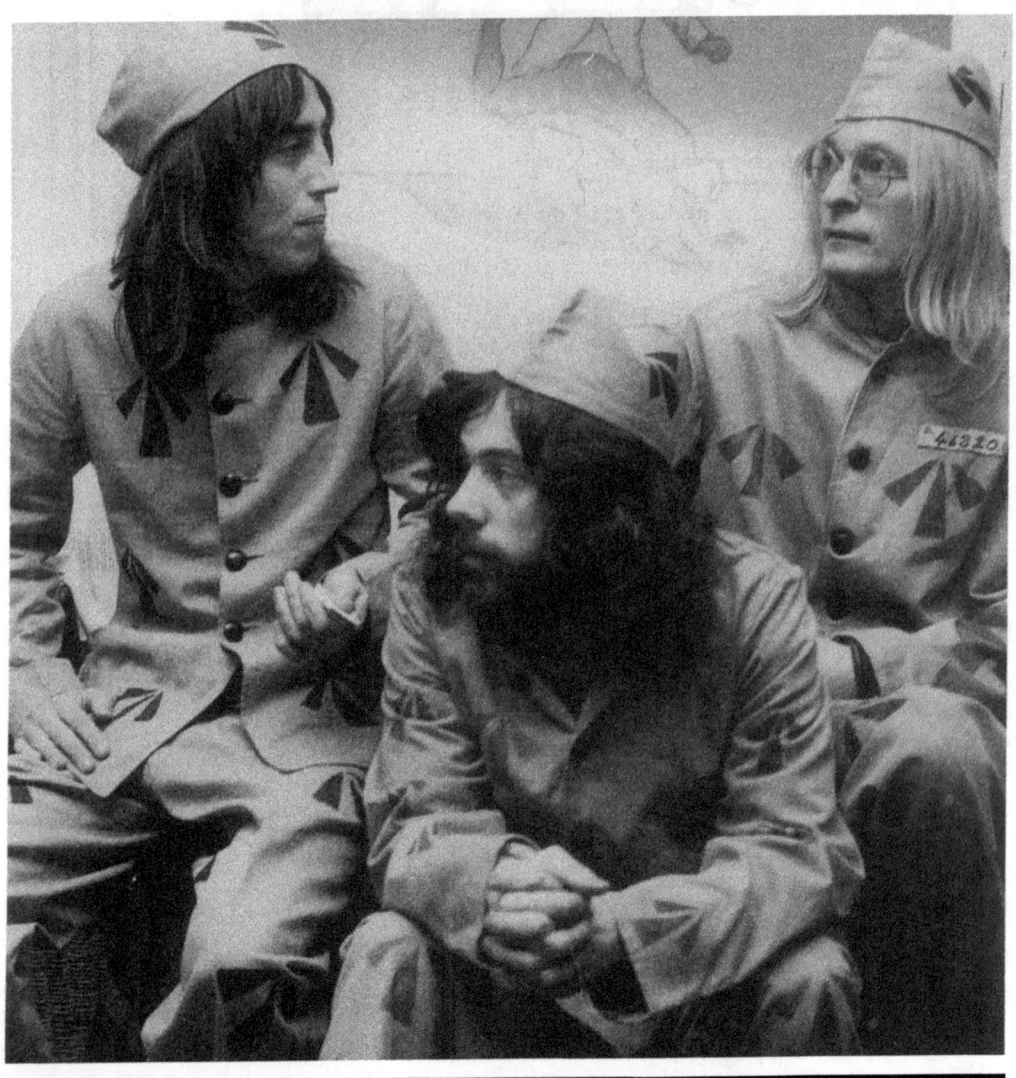

ACKNOWLEDGEMENTS

My thanks are due to Richard Neville, Jim Anderson and Felix Dennis for their tolerance of me during the trial itself, and their active help in preparing this new edition of my book; true friends, then as now. To Richard also for giving his permission to reproduce from the original OZ magazine No. 28 "whatever I needed"; to Jim for sharing with me his personal struggles since the trial; and to Felix for opening his archive and allowing me to use such as I thought necessary.

Thanks also to Tom Stoddart for permission to use his poignant photograph of Brian Leary, the prosecuting Counsel, and to Brian himself for his frequent transatlantic phone calls from Mexico City which brought back many memories. Ever the gentleman, his courtesy has shown no signs of diminishing even in his retirement. And to Charles Shaar Murray, one of the original 'schoolkids', for writing so clearly about the many concerns we all shared at the time of the trial. And to Edward FitzGerald QC who first brought to my attention the book by Geoffrey Robertson called *The Justice Game*, although the opinions stated herein about that book are entirely my own. To Rob Ayling, my redoubtable business partner whose idea it was that my book might have some merit and was worth reprinting, and to his old friend Jonathan Downes who had the thankless task of re-type-setting the whole text for the simple reason that the original was so dense as to be almost unreadable. The present edition, I can confidently say, is a damn sight easier to read, and had Anthony Blond and Desmond Briggs still been alive (they were the original publishers), I have no doubt they would agree.

And finally to Gabrielle Spray, the daughter of Judge Michael Argyle, the Judge at that infamous trial of OZ in 1971. I have always worried that we had done him an injustice (if that's not too obvious a pun) in the original book, not least because subsequently he was relentlessly pilloried by the scum of Fleet Street who should have known better, but rarely do. Gabrielle's eloquent coda, written with her two sisters, I hope goes some way to giving a fairer picture of a man whose long career in the Law, quite apart from his heroic service in the Second World War, cannot have prepared him for what he was confronted with in those days at the Old Bailey, long long ago now, but still seeming like yesterday.

The publishers of this present edition would also like to thank Corinna Downes, Steve Jones JP, Jessica and Emily Taylor, Richard Freeman, Graham Inglis, Ian Cramer and Oll Lewis who all played their part.

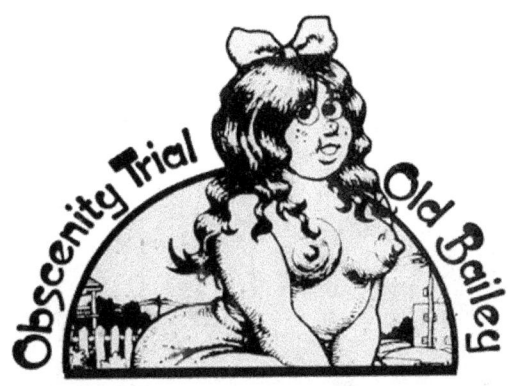

FOREWORD

by Richard Neville

As my 70th birthday looms, details of the *OZ* Trial recede and the much-needed reprint of Tony Palmer's book will perhaps help me remember.

Outside the courtroom it was hot – that I remember. At the end of each day I took the tube to Palace Gardens Terrace and sat on the sunny steps drinking beer. Later, three typewriters clattered in our crowded basement as we typed up strategies for the following day. Week after week the event rolled on, usually with a packed house. The court reporters were vile, shaping their copy to the detriment of the defendants, cosying with the judge and circulating rumours of bomb threats. Apart from his draconian sentencing, the Judge could be accommodating. We were able to insert a friendly Trotskyist into the court to liase with our legal team and pass us vital notes, and to parade a gallant stream of experts into the witness box, day after day. When the founder of 'Release', Caroline Coon, presented evidence in hotpants, the Judge blushed all the way up from his bib to his wig.

Little did we know the trial was a set-up. The cops who pursued us had long been bribed to ignore the wares of Soho pornographers, so the hounding of the alternative press was a decoy – a true life attempt to corrupt public morals. A year after the *OZ* Trial, senior officers were jailed and hundreds of cops were prosecuted. Despite this, and the courtroom humbug, the tribulations of the trial did not leave me embittered, not even when cops hurled me downstairs and into a cell like a bag of potatoes. As Felix once said, "We're no angels".

The point is, we were riding a wave of change and loving it. People laughed when I called the Sixties a 'youth quake' – a term picked up from Vogue Australia in 1963, of all places, but that's what it felt like. Sex, rock, drugs, anti war marches, tripping, feminism, environmentalism ... a long strange adventure indeed, and not yet entirely erased. This year the UN has been highlighting the role young people have played in toppling dictators, describing the events as 'youth quakes' which "reveal the power of aspirations for human rights and fundamental freedoms." May it ever be so.

Back in the Old Bailey Sixties, Tony Palmer, a mere chicken himself, followed the trial every inch of the way, and his book was widely read and informative and remains so. This account of what went on, required reading at the time, has been out-of-print far too long, so I wish him well with this eagerly anticipated 40th Anniversary re-print.

THE SUNDAY TIMES magazine

JUNE 9, 1991

Twenty years ago these men were star turns in the showpiece trial of the alternative society. Did OZ matter?

DEPRAVITY

INTRODUCTION TO THE 2011 EDITION

With the 40th anniversary of the trial approaching, I was asked to consider a re-print of my 1971 account of the events during and surrounding those few weeks in June, July and August of that year at the Central Criminal Court in London known as The Old Bailey, which I had christened 'The Trials of OZ.'

I had and have no particular wish to look back, and I had and have no particular wish to re-visit a book which I wrote in a white heat, in just three weeks, some 40 years ago. But then my attention was drawn to an exceedingly pompous and badly written tome called *The Justice Game*, published some 28 years later by one Geoffrey Robertson QC who is, he tells us, "counsel in many landmark cases in constitutional, criminal and media law in the courts of Britain and the commonwealth." "I knew all about the law," he wrote, "but nothing about justice." That may be so, but his account of the OZ trial in that book might lead one to think that he, and he alone, stood between the eternal damnation surely awaiting the three defendants, Richard Neville, Jim Anderson and Felix Dennis, and the rule of law. This was not so. His own play produced by the BBC in 1992 continued this impression, even asking if he could play himself. "The producer and director smiled and let me down politely," he wrote, adding: "both were in their nappies in 1971."

Neville in his own description of those events in his book *Hippie Hippie Shake* says that Robertson, "who rowed for Oxford before breakfast and played championship tennis after lunch...working at break-neck speed... demonstrated both legal prowess and a gritty determination to win." Thus, he was a pivotal reason that, in the end, the trial ended in triumph for the defendants. My memory is somewhat different. John Mortimer, the principal defence QC, consistently opposed calling ever more 'expert witnesses', as advocated by Robertson, feeling that such people

would not only antagonise the Judge but confuse the Jury. Mortimer was right, because in my view that is precisely what happened. Even Brian Leary, the prosecuting Counsel, at the final Appeal before the Lord Chief Justice, Lord Widgery, admitted "expert witnesses as a race are apt to be... confusing."

And upon re-reading my text, whatever its faults, I kept being reminded of my favourite book by Dickens, *Bleak House*, in which we read of *Jarndyce and Jarndyce*: "The one great principle of the English law is, to make business for itself." "Woe unto you, lawyers! for ye have taken away the key of knowledge." Luke Chapter 11, verse 52. Or John Mortimer himself in his play *A Voyage Round My Father*, which opened even while the OZ trial was proceeding: "No brilliance is needed in the law. Nothing but common sense, and relatively clean finger nails."

I doubt if I had any of these principles in the forefront of my mind when I first wrote *The Trials of OZ*. But nor was it in the minds of the several others who have traded subsequently in a spew of books, BAFTA nominated plays, theatrical events and cinema films based in part on my text without the slightest acknowledgement. For the chief players in this drama, the trial was a matter of passionate concern not a preening demonstration of cleverness for its own sake. My old book shows this all too clearly I believe, hence my agreeing to having it re-published.

At the end of the original introduction I wrote that I saluted the dignity with which the three defendants had faced "the unthinking cruelty of the law." Nothing that has happened since, or been written since, has caused me to change that view.

Tony Palmer,
Nanjizal,
1st August, 2011

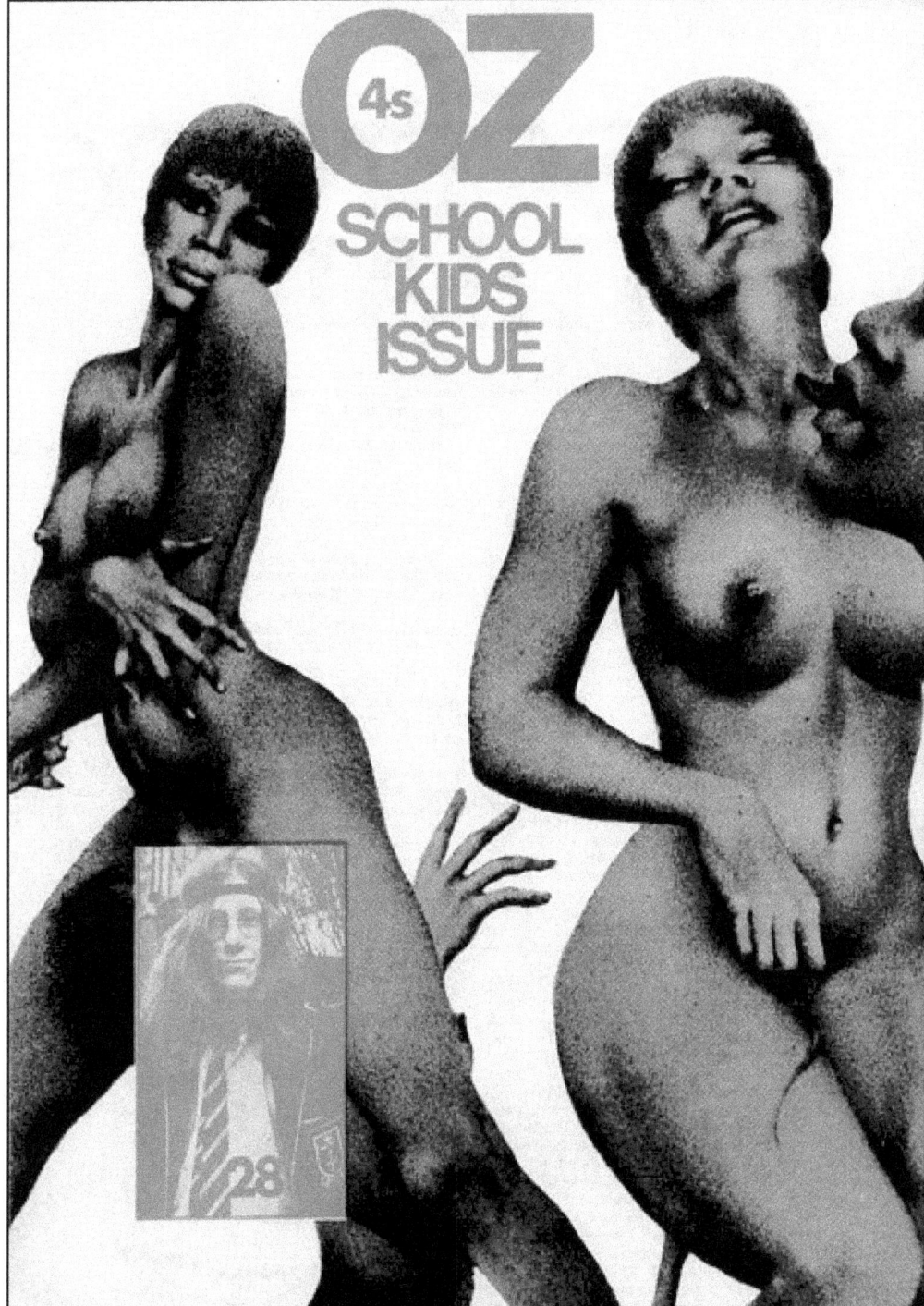

OZ OBSCENITY TRIAL

The OZ Obscenity Show begins at the Old Bailey on or about June 22nd. The editors, Jim Anderson, Felix Dennis and Richard Neville face charges of publishing an obscene magazine (max penalty 3 years), sending indecent publications through the post (max penalty one year) and the absurd, archaic and rarely used count of "conspiring... to produce a Magazine containing divers, lewd indecent and sexually perverted articles, cartoons, drawings and illustrations with intent thereby to debauch and corrupt the morals of young children and young persons within the Realm and to arouse and implant in their minds lustful and perverted desires..." This flattering assessment of the ability of OZ to affect the way people think or behave carries a maximum penalty which is entirely at the discretion of the judge.

But while it is OZ on trial at the Old Bailey, it is in fact an entire community which is being prosecuted. If you care about your freedom to think, communicate and experiment, if you care about freedom of the press, freedom to live the life you wish, then you also are in the dock.

Up until recently we had greeted the harassment of OZ with only sporadic bursts of seriousness, as had many of our friends. It was instinctively assumed that we could ultimately establish in a court that OZ did not deprave and corrupt — even if it meant redefining the whole concept of obscenity. Notwithstanding the perpetual ransacking of our offices, we were aware that in less enlightened communities we would have been automatically goaled. But it has finally dawned upon us that the authorities in this country take our publishing venture more seriously than we do. We discovered that the police had been watching our houses for some time and they virtually admitted to tapping our phones and keeping dossiers on trivial little known facts of our personal lives. So while the fearful significance of the OZ persecution has become belatedly apparent to ourselves, many people are still more amused than amazed. The pickaxing of this magazine is nothing less than political censorship. OZ has relentlessly promoted some elements of the new culture — dope, rock 'n' roll and fucking in the streets; it is the only magazine in this country to consistently and constructively analyse the tension between the freak/dropout community and the militant left and to struggle to develop a theory from such antagonism. We see fun, flippancy, guiltless sex and the permanent strike of dropping out as part of an emerging new community, but painfully acknowledge the limitations of leeching on the present society and becoming stooges of its consumer junkyism. We appreciate that OZ antics are often adventuristic, escapist, dilettantish, narcissistic and juvenile; but we are congenitally incapable of facing a solemn fun free future, cutting cane beneath some spartan banner of liberation; we want only to play with our toys, not own them, and we are fumbling towards a solution of living and working collectively — not for profit — which there ain't — but because we love what we do and believe naively in a joyful tomorrow of spiritual, emotional and intellectual coitus non interruptus.

But still we are afraid. An endless avalanche of support is necessary for us to win the court case. Not just the urgent money (make cheques payable to the OZ Obscenity Fund) but moral encouragement as well. Write letters to newspapers, to your MP, do everything to make the public aware of the importance of the issues involved. Help whiplash the backlash. For while religiously executed, it is politically motivated.

Approximately 30 people have already agreed to give evidence on OZ's behalf. This means the case will probably play for at least a giddy three weeks. Any other willing expert witnesses, such as school teachers, authors, psychiatrists, educationists, child welfare officers etc who have not yet been cast for a part in the OZ drama, please contact our solicitor, David Offenbach at 01-629 1191.

We have been cheered by the opening of an OZ Obscenity Centre at 39A Pottery Lane, Holland Park. The organisers plan to provide news and information relating to the trial, as well as co-ordinate protests, rallies demonstrations and other events which are being planned to coincide with the trial.

The eunuch prime minister and his repressed harem of cabinet ministers have created a climate which is stifling every new expression of sexual freedom. Help OZ win at the Old Bailey or you may never wank in peace again.

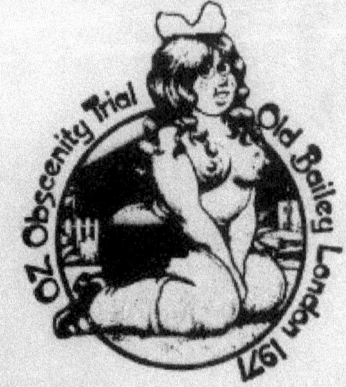

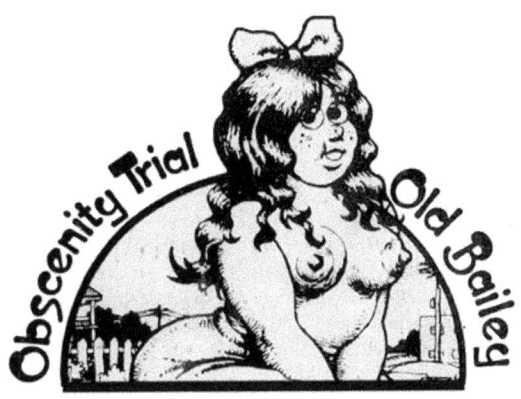

INTRODUCTION

This was the longest obscenity trial in history. It was also one of the worst reported. With minor exceptions, the Press chose to rewrite what had occurred, presumably to fit in with what seemed to them the acceptable prejudices of the times. Perhaps this was inevitable. The proceedings dragged on for nearly six weeks in the hot summer of 1971 when there were, no doubt, a great many other events more worthy of attention. Against the background of murder in Ulster, for example, the *OZ* affair probably fades into its proper insignificance. Even so, after the trial, when some newspapers realised that maybe something important had happened, it became more and more apparent that what was essential was for anyone who wished to be able to read what had actually been said. For example, in spite of the fact that the three editors were acquitted on their most serious charge - that of conspiring to corrupt the morals of young children - *The Times* wrote an editorial chastising the trio as if what they had done was to have corrupted the morals of young children. Trial and judgment by a badly informed press became the order of the day. Therefore, more of the book than I had originally intended is devoted to the words spoken, rather than to my own comments. But in all, its primary purpose remains one of information.

Until the beginning of this trial, I had never been to the Law Courts for anything other than the briefest of visits. It came as a shock, therefore, to realise also, with increasing fascination, the difference between what actually happened and what one had always been led to believe happened in such places. Maybe this trial was the exception; certainly, when I went subsequently to the Court of Criminal Appeal to hear an application on behalf of the accused for bail, there seemed to exist an altogether more civilised atmosphere in that Higher Court. But it was in the Lower Courts that *OZ* met its fate, as do most of us when we come into conflict with the Law; so it is there that we must confine our attention.

The libel problems in writing this account have been immense since no-one, and in particular the Judiciary, likes to be criticised. If I have, therefore, accidentally and according to the technical sense of the word, libelled anyone, then I declare unreservedly that this was not my intention. I was, and still am, only interested in the truth of the matter. One solicitor whom we consulted warned me that "the Establishment was obviously gunning for magazines like *OZ* " and all that surrounds such publications. That may or may not be true, but it was an interesting admission.

THE TRIALS OF OZ

Although I knew the three accused before the trial began, and although I have used in the text material that was available to them and their colleagues in the underground press, notably its weekly, *Ink*, I must emphasise that I hold no brief for their magazine, *OZ*. Like many others, I had not even seen the 'School Kids Issue' until after the prosecution by the police had begun. So this is not, in any sense, an official *OZ* book although (I'm told) one is on its way*. Admittedly, I have had free use of a complete transcript of the trial provided for me, as well as the fullest cooperation from Richard Neville, Felix Dennis and Jim Anderson. However, once again, I must emphasise that I do not claim to speak for them. Indeed, so eloquent were they in their different ways that I feel they are not in need of spokesmen or apologists. My task was altogether more simple; to make available, as soon as was possible, an account of those 26 days in Court so that the general public should no longer be as misinformed as they have been and so that commentators and columnists everywhere should no longer be able to put around their half-truths and lies about the magazine, *OZ* 28, either its contents or its examination at the Old Bailey.

Again, my task in this has been made easier than might seem at first. Clive Goodwin, a freelance film producer, was given permission to tape the entire proceedings - which he did, except for the Judge's summing up. This he refused, without giving any reason, to allow to be recorded. As a result there exists a more or less complete sound record of what happened, and if anyone wishes to challenge what I have written, it will be a straightforward matter to ascertain the truth. Apart from some minor adjustments made to translate the spoken into the written word, and occasional shortenings for clarity of some of the cross-examinations, what appears in the following pages is exactly what was said.

For this unique possibility, I am grateful to Mr. Goodwin and his two recordists who laboured, patiently, throughout. Also to Bill Bailey and his indefatigable team who transcribed the 130 half-hour tapes, and finally to Jaqi Williamson, my secretary, who typed it all up from my illegible handwriting. Desmond Briggs and Anthony Blond spurred me on when my hand was lagging and their passionate and oft expressed belief that, somehow, down at the Old Bailey, injustice was being done, was of immense encouragement. Hopefully, it has all been worthwhile. I hope so, mostly for Richard and Felix and Jim's sake.

Because, in the last resort, whatever they may or may not have done, I salute their courage, and the dignity with which they faced the unthinking cruelty of the Law.

Tony Palmer
1.8.71

OZ 28 May 1970
OZ is published by OZ Publications Ink Ltd.,
52, Princedale Road, London, W.11.
01—229 7541

Advertising: contact Felix Dennis/ Liz Watson at 01—727 8456

Printed by OZ Publications Ink Ltd.

Distribution:

U.K./ Moore-Harness Ltd,, 11, Lever Street, London E.C.1.
01—253 4882

Artists, cartoonists and illustrators should submit their masterpieces to Jim Anderson c/o OZ offices.

This issue of OZ appears with the help of Jim Anderson, Gary Brayley, Felix Dennis, Bridget Murphy, Richard Neville, Liz Watson and David Wills.

OZ is a member of UPS (Underground Press Syndicate) and a subscriber to LNS (Liberation News Service).

The contents of OZ are not copyright. They may be reproduced in any manner, either in whole or in part, in any publication whatsoever — whether or not a member of UPS — without permission from the publishers. (An acknowledgement would be appreciated). No rights reserved.

Stone Deaf
(drawn for the "Boy's Own Paper" by T. Bivirsy.)

CHAPTER ONE

Mr. Mortimer rose at 2.55 p.m. on Wednesday, June 23 in Court Number 2 of the Central Criminal Courts at the Old Bailey in the City of London.

"Ladies and gentlemen of the Jury," he began.

Pointing to two cardboard boxes containing 400 copies of the satirical, underground magazine, *OZ* No. 28 - School Kids Issue, he went on:

> "I am sure you are all very curious to discover what it is that has led us all here, people from various parts of London and various walks of life, to consider how dangerous or explosive may be those bits of paper over there in those little sugar baskets. In my view, this is a very, very important case. Because it is this case, and cases such as these, which stand at the crossroads of our liberty, at the boundaries of our freedom to think and say and draw and write what we please.
>
> Members of the Jury, this is a case about dissent. It is a case about dissenters; a case about those who are critical of the established values of our society, who ask us to reconsider what they believe to be complacent values, and are anxious, on that basis, to build what they think (and what we may not think) is a better world. Members of the Jury, we are all of us, totally entitled to disagree with their views; but this is a case about whether or not they are also entitled to disagree with us."

The Jury, nine men and three women, shuffled about nervously, some looking away from Mr. Mortimer's persistent gaze with apparent embarrassment. The Court Room was noticeably draughty and cold. The actual temperature was 62°F. Mr. Mortimer rubbed his not under-endowed paunch, pushed his horn-rimmed spectacles back up his nose, and continued:

> "When you hear the word dissenter, you may think of those who, in past times, used to thunder their denunciations in dark clothes and rolling phrases

from the pulpits of small chapels. Now, the dissenters wear long hair and colourful clothes and dream their dreams of another world in small bed-sitting rooms in Notting Hill Gate. In place of sermons with their lurid phrases about damnation, we have magazines reflecting a totally different society from that in which we live.

You will probably hear a lot about sex in this case and you may hear something about drugs. We would also like you to hear something about the basic beliefs which the people who edited that magazine share, basic beliefs with which few of us would quarrel. A genuine, and generally held, belief that peace is preferable to war, for example. A genuine and generally held belief that racial tolerance is preferable to intolerance. That love between people is preferable to hatred. That freedom of expression is at all times preferable to censorship. An impatience, which may at times have been expressed childishly, with what they regard as the hypocrisies of conventional attitudes. The right to speak freely, without inhibition, about whatever matters there are that deeply concern them and their lives. A refusal to recognize that there should be taboos which would prevent our free debate about every single matter which concerns us as human beings. And it is in pursuit of those beliefs that this prosecution and this trial originate."

The crowded public gallery, into which were squeezed a veritable assortment of London's hippie community, grinned at one another with obvious satisfaction. Mr. Mortimer may not look much like it, but, in truth, he was one of them. The public gallery in Court No. 2 has one distinct characteristic. It is so constructed that from it the spectator finds it almost impossible to hear or see anything that is going on in the Court Room below.

"The indictment accuses the defendants of, among other things, corrupting the morals of children and young persons." Mr. Mortimer concluded: "Members of the Jury, those of you familiar with history may have heard of the Greek philosopher Socrates. Socrates also stood trial and his trial resulted in his death. And the charge on his indictment was that he had corrupted the morals of young persons. And the reason he was so charged, was his unfortunate habit of continually asking why?

And we who defend in this case believe that we do so in the interests of everyone, whatever age or sex or class or education, to question and to ask, why?"

I first became interested in this trial after I had attended the West London Magistrates' Court the previous December where Richard Neville, one of the three accused persons now before us, had appeared on a drugs charge. He and his girl friend, Louise Ferrier, had been arraigned for the possession of cannabis, detained overnight and brought before the Magistrate at 10.30 a.m.

At least, it should have been 10.30, but as they had been put down as No. 45 on the list to be heard that morning, I found myself sitting through the cases of 44 others.

If you have never attended a local magistrates' court and you cherish the illusion that British justice when administered by the police is a fair and impartial thing, I suggest that a visit would quickly dispel those illusions. Those up in court before Neville included an Irish alcoholic, clearly unwell, clearly inarticulate, clearly desperately in need of help.

"Speak up, I can't hear what you're saying," shouted the magistrate. It seemed to me that he harangued the defendant loudly when it suited him and then mumbled inaudibly when it

suited him; I was sitting five yards from the magistrate, for example, and most of the time even I had difficulty in hearing a word he was saying. The Irishman in the dock had difficulty in offering a coherent, verbal explanation of his conduct so the magistrate ignored him, addressed his remarks to the police, who sniggered, and sent the man to jail for Christmas. It didn't seem to occur to anyone that the police themselves, when presenting their version of any story, also mumbled, fumbled, droned away in clichés and read their statements like naughty schoolboys summonsed before the headmaster. They gossiped noisily while other evidence was being read and ordered witnesses around like imbeciles. They couldn't even get the law right - one constable thought that the annual road tax was £24 and had based his particular arrest partially on this assumption.

Another defendant, a dilapidated middle-aged Scotsman suffering from a virulent and contagious form of TB, was on trial for having stolen or misplaced four letters addressed to his landlady.

> "Well," said the magistrate, "your action may have caused great anxiety. You're obviously a public health danger. I shall send you to prison if you come here again."

Whereupon the man, who had difficulty in breathing properly, began to offer his explanation only to be shouted down by the magistrate and manhandled out of the dock by a police sergeant. The priceless jewel of articulation, the way with words, which most of us take for granted, had not been his to command. The magistrate must have known this, and so had used his own verbal, linguistic and educational advantage, mercilessly.

Another defendant, who had been out of work for months and had stolen a small amount of lead presumably to buy his family something for Christmas, was fined £15 and told to pay within 21 days. It was obvious that the only way he would be able to raise the money was to steal some more lead.

Another was fined £40 for masturbating 'in a public urinal'.

> "If you've got a kink this way, you'd better go and see a doctor," advised the magistrate.

Two policemen laughed loudly. Two local pressmen by my side scribbled away furiously, busily underlining the sexual details.

Eight members of the Hare Krishna Temple appeared next, accused of "willfully obstructing the free-passage of a highway". These are members of a religious sect who dance and sing up and down Oxford Street (among other places), giving a little local amusement and offending no-one. "I don't know why you were there," said the magistrate to himself, not bothering to find out.

The police sergeant who had arrested them could hardly contain his sarcasm when he described their address as "a place of worship".

And then came Richard Neville, No. 45 on the list, looking tired and despondent. The facts were brief; that Neville, while released on bail pending this present trial for obscenity, was alleged to have been in the possession of drugs at his flat in Notting Hill. The police had raided the offices of OZ with the intention of taking away evidence to use in the obscenity trial. Apparently, they had rushed in, locked the doors, taken the phones off the hook, intimidated the occupants and "seized", among other things, advertising data and accounts' ledgers.

Surprisingly for such work, they had turned up with two hash hounds. They also failed to caution one secretary until they had asked her all the relevant questions. Then, they rushed round to Neville's flat and arrested him and his lady, Louise Ferrier. Every one of the 44 defendants before Neville had been asked if they had anything to say. Neville was not. Every one of the 44 defendants before Neville who had requested bail, had been granted it.

Neville was not. Prepared to stand bail - to a total of a quarter of a million pounds - were, among others, Kenneth Tynan, Colin MacInnes, George Melly, Ed Victor from Jonathan Cape Ltd, Michael White and Clive Goodwin. Neville's solicitor, David Offenbach, was not allowed to make full application for bail. He was shouted down. Members of the public rose to protest. They were forcibly evicted by the police. Abuse was hurled. Application for bail would have to be made to a judge in chambers, said the magistrate. That was almost impossible, said Mr. Offenbach, as Christmas was upon us. It was indeed, replied the magistrate.

Neville asked permission to make a statement. One policeman applauded mockingly while others hurled themselves at Neville, pulling him from the Court. He had wanted to make a prepared statement which he had scribbled in the back of a book with a borrowed pen. Police had refused him a pencil and paper. Here are extracts:

> "This is primarily a political occasion. In a broad sense, most cannabis charges are political to the extent that they represent a repression of a new culture by the old. I am in this dock this morning not because of any criminal activity ... but because I am involved in publishing *OZ* magazine, one of the most articulate, informed and crazy-passionate voices of our generation. Because this voice is being heard and understood by growing numbers in our community, people such as Detective Inspector Luff (the arresting officer) are determined to silence it by whatever means they can. (His) opposition to bail is utterly uncalled for. There is no question of my not turning up; there is no evidence to suggest that I might not do so. I look forward to the case even more than Mr. Luff because it will enable me to establish that there is a real conspiracy to stifle dissent in this country, that the freedom of the press - the freedom of our press - is being forcibly stifled by policemen who have taken it upon themselves to enforce, not the law, but their own dismal and hypocritical standards of morality."

Mr. Neville was forcibly removed before he could make this statement. The Law and its embodiment, the police, had triumphed - for the moment.

The statement might seem a little naïve, a little paranoid, even a little exaggerated. But it was certainly not worthy of suppression. Above all, both the statement itself and the police behaviour in the magistrates' court that morning suggested that there might be something more to the arrest of Richard Neville than at first had seemed apparent. Could there, for example, be said to be any validity in the claim that the Press, by which Neville meant the underground press, was being stifled? Was there, moreover, evidence to suggest that it had been stifled before, in any other place? Indeed, did the content of the underground press warrant its suppression anyway? In what sense were these magazines and newspapers 'underground'? Did their increasing emergence in ever greater numbers indicate anything particularly noteworthy, and if so what? And how was it, for example, that in the context of a declining overground newspaper industry, these journals had managed to appear at all?

It had been rumoured in some quarters, for example, that the future of *The Times* newspaper itself might be in question. In the first three months of 1971, it had lost nearly a quarter of a million pounds and even the Thomson pockets were not thought to be bottomless. The prospect of a nationalised Court Circular in order to preserve some

supposed and probably mythical journalistic dignity could not be dismissed, although that wouldn't be doing much for the image of the Free Press. Union problems, the postal strike and falling advertising revenue had doubtless contributed to what was a general malaise, although the turgid, some would say unreadable, prose style which afflicted some of its columnists, probably hadn't helped either. Nonetheless, the *Daily Sketch* had already gone up the spout and might well be followed in that direction by several more. Whether this would be a real loss except in terms of journalists keeping each other mutually employed, was another question. *The Times* and the *Guardian* then announced, yet again, that their prices would have to be increased "before long". Mr. Lawrence Scott, the *Guardian's* chairman, thought that there would be few newspapers which could avoid such increases, necessitated as they were by the bogey of rising costs. Mr. Henry Stevens, company secretary of the *Daily Telegraph*, had gone so far as to suggest that almost no national newspaper was making a profit and, in one case at least, a very substantial loss was being incurred.

It must have been a surprise to such people, therefore, to learn that the underground press was, at the same time, on the edge of a vast boom. Among magazines such as *Friends*, *Time Out*, and *OZ*, circulation was growing at a pace which the various organizations could hardly contain. Increasingly, these publications were being designed, not just to appeal to young people, but to steal away some of the readership of already existing overground magazines. This curious phenomenon had occurred, moreover, without any of the traditional trappings of success - very little advertising, no tit and bum content, no proper distribution and very little fuss. It was obviously fulfilling a need being experienced by those who were dissatisfied or frustrated with or just left out by the accepted organs of communication. The underground press existed because it believed that proper newspapers either ignored what was really happening or else distorted it. Certainly, the sustained and polemical brilliance of the 'colour supplement' and 'footnotes' sections of the magazine *Private Eye* indicated that there was much to be told that somehow, mystery upon mysteries, never reached the daylight of print.

Unfortunately, the Eye's accuracy was not always what it should have been and its gossip not always free from malice. But its challenge to other newspapers was simply that, frequently, it was better informed than they were.

And whereas previously the subject matter of the underground press had often been concerned with the pop milieu, its interest was now extending to political involvement, social discussion, the other arts and even sport. Far from being amateur, moreover, either in spirit or in organisation, a determined new professionalism had crept into the hearts of those responsible. This commercial explosion had first begun five years ago with the success of Jann Wenner, a 27 year old Californian, who saw that none of the media understood or were prepared to take cognisance of, the hurriedly expanding pop-orientated culture. Even today, BBC television, for example, devotes not one single second to this subject. One of the only programmes to make some attempt in this direction, *How it is*, the BBC took off in spite of an audience larger than the average for *Omnibus*, its accepted and acceptable arts slot. Curiously, one of the regular contributors to *How it is* had been Richard Neville. Wenner knew that the snobbish and scandal-seeking attitude with which the Press then talked about popular music & rock 'n' roll, was alienating a potentially huge audience. Since pop was reckoned to be one of the more eloquent voices of young people, it was at least worth taking seriously, however childish and misguided that voice might sometimes be. His newspaper, *Rolling Stone*, supplied that seriousness. It wrote about pop and all that pop involved in a non-didactic, non-patronising way. The result was often over-seriousness and a feebly edited concentration on trivia; but the circulation grew to nearly a quarter of a million and the 36-page fortnightly was now distributed internationally.

A host of others prospered in its shadow. Some, like *OZ*, experimented typographically, hoping to change completely newspaper design. Illegibility was achieved more often than might have been desired, but its success was often stunning. The layouts devised for *OZ* by Australian Jon Goodchild were in part responsible for the huge growth of posters and interest in poster design. Another publication, *Time Out*, begun in 1968 as a single sheet alternative to the almost archaic (some would say unreadable) *What's On*, had developed into a 100-page weekly magazine, partly review but mostly information, which many London hotels now recommend to foreign visitors in preference to *What's On*.

Newspapers, such as *Black Dwarf* or *Red Mole* were generally propagandist in intention, although they had frequently given access to information of much wider public interest. The Bertrand Russell/Ralph Schoenman Memorandum* was only one notable example. It still seems to me astonishing that such a document, whose existence was known by many journalists, should have been left for publication to a sneered-at underground journal.

The need for such newspapers was neatly summarised in the aims and ambitions of two new weeklies which were in preparation in the summer of 1970. The first, called *The Alternative*, hawked around a brochure and a dummy. "There is a large and increasing number of radical and intelligent young people," the brochure told us, "who are not satisfied with what the national papers have to offer." The fault, it said, was that most established publications were too big, having to satisfy both the old and the reactionary as well as the young and the radical, Unfortunately, *The Alternative* couldn't even raise the money necessary to pay for its brochure and it collapsed.

The second, called *Ink*, said it wanted to demonstrate that youth and radicalism were an attitude of mind and not an age-bracket. It wanted to provide space for the kinds of story that journalists were frequently aware of but afraid to publish because of particular editorial restrictions. It intended to be non-profit making and not dependent for its existence on advertising.

Its activities were to include the publication of pamphlets and eventually books. It said it was to be non-political and non-propagandist. Its editorial staff and correspondents were to be properly paid, and it was said that many well-known journalists had offered their services; one distinguished publishing editor did the same. The newspaper intended to achieve an immediate circulation of 50,000 and it said it had revolutionary plans for distribution to keep to this intention. It would certainly be youth-orientated but without being in any way exclusive. Its title, like its ambition, was simple and fundamental. The body needed blood, it said. Newspapers needed Ink. Its editor was to be Richard Neville, and it must have been ironic to him that in the very week he was in the process of launching his new newspaper, *Ink*, his old newspaper, *OZ* (which he also edited) was being seized for obscenity. As it happened, ironically, the charge of obscenity was one with which he was thoroughly familiar.

OZ, as its title suggests, had begun in Australia. In 1963, Neville, then at New South Wales University, together with Richard Walsh, had put together a 16-page, black and white, letterpress, "a gutsy mixture of satire, graffiti and radical features" (Neville's own description).

* Ralph Schoenman (born 1935) is an American left-wing activist who, for a time, was secretary to Bertrand Russell, the pacifist philosopher (1872-1970). For a time he was general secretary of the Bertrand Russell Peace Foundation, but in 1969 Russell publicly repudiated his relationship with Schoenman for a number of reasons, most notably because Schoenman's extraordinary lack of tact had jeopardised the Foundation's relationships with Communist China, the Israeli Government, and others. The last straw was when one of its directors resigned feeling that "Ralph Schoenman has captured the Foundation and turned it into a monolithic expression of his own limited interests and abilities." Bertrand Russell wrote a long memorandum describing the aetiology of his relationship with Schoenman and pinned to it a note stating "this is my memorandum. I told my wife what I wished her to type and she has typed it. I have read it over to myself twice carefully and she had read it aloud to me once. I entirely endorse it as being mine and what I wish to say."

However, it didn't get beyond Issue No. 6 before it was prosecuted - for obscenity - and Neville's long battles with the Law had begun. The magistrate's summing up in that particular case is worthy of quote:

> "In my opinion, this publication would deprave young people or unhealthy-minded adults so injudicious as to fancy it as literature, and so misguided as to cultivate the habit of reading it. Upon consideration of the whole of the evidence, the following specific findings are made:
>
> - That the magazine is obscene in that it unduly emphasizes matters of sex, crimes of violence - that is, rapes and assaults - and horror; and I am satisfied that the publication was not justified in the circumstances.
> - That the magazine is obscene according to the ordinary meaning of that term, and I am further satisfied that the publication was not justified in the circumstances. In reaching these conclusions, I am satisfied beyond reasonable doubt of the guilt of each defendant, and each defendant is convicted.
>
> On the question of penalty, the observation I would make is this: that much has been said and written from time to time of the need to curb obscenity and pornography appearing in the guise of literature. It is a remarkable fact that, in recent years, when the flow has increased noticeably, prosecutions are rare. It is indeed a serious thing, to corrupt or pollute the minds of the young, and it is high time that the publication of this stuff was stopped and stopped in such a manner as will indicate to other persons offending in a like manner the view of the Court, and show the Law's determination to vindicate itself in regard to those who would seek to set themselves above it.
>
> Those of us who have worked in these Courts, as I have done for more than 30 years, know only too well the tragic effect the wrong treatment of matters of sex has on the minds of immature and weak-minded adults. In all, I am satisfied that salutary penalties are called for and I propose to inflict such penalties.
>
> The defendant Walsh and the defendant Neville are each sentenced to six months' imprisonment - the sentence to date from the date and time of their apprehension. The corporation is fined £100."

Neville recounted later how "students and lecturers all over the country organised demonstrations and mass meetings in protest against the sentence", while Sydney's top radio commentator expressed the Establishment view:

> "And I was very pleased indeed to see - and I don't care whether these people who talk about liberties and so forth jump in the lake - I was very pleased to see that (they) were gaoled on charges of publishing an obscene publication, *OZ* magazine. Well, that's a good thing - to wipe *OZ* out will be one of the best things for the country. A dirty little rag with filth in it!"

£100 bail was granted, pending appeal.

Surprisingly, as it seemed at the time, the Appeal Court reversed the magistrate's decision. Again, Judge Levine's summing up is worthy of quote, if only because it bears directly upon the case at the Old Bailey we were about to hear.

"The publication charged as obscene is the 1964 February edition of a magazine known as OZ, a magazine of satire, dealing for the most part with current topics. The evidence of the literary experts called in these appeals clearly established that the magazine as a whole has literary merit, which varies in degree from the success achieved in some articles, which are effective, to failure in others, where the satire has misfired.

In these appeals much emphasis has been placed upon the importance, purpose and function of satire as a literary form. Satire is an important part of the literature of protest dating back to ancient Rome and Greece and before, and satirical magazines such as OZ have no doubt been published wherever protest was thought necessary. And whilst it may be a necessary part of satire to be critical of human behaviour by using a wide variety of weapons, including shock, invective and even crudity, and techniques (such as) ridicule, lampooning and caricature, nevertheless, I cannot make it too clear that obscenity may not be used as a weapon. Indeed, the appellants do not contend otherwise than that the best piece of successful satire may at the same time be obscene. I am not unmindful that there can be a large element of cant and hypocrisy in attempts to justify an obscene publication on the basis of literary merit and social necessity.

However, I am satisfied that the article is a successful satire, that it does not glorify or condone, but on the contrary would create in ordinary people feelings of revulsion, abhorrence and censure against such behaviour (as it depicts).

There remains the question of whether there are other people in the community of a class or age group whom this article is likely to deprave. I should record that it is not suggested that the magazine contains what the Americans call 'hard-core pornography', nor in my opinion does the magazine as a whole or in part resort to pornography.

The submission is that the article would affect young girls and persons with weakened personality structure. As to the former, I must find that I am not satisfied that this magazine nor the article in particular would have any real tendency to deprave or corrupt them.

As to the class of persons with weakened personality structures, I accept the evidence deposed, that the behaviour of persons in this class is principally affected by what happens to them, or in their presence, rather than what they read of happening to other people. Generally, the reading of literature does not affect their behaviour unless the literature is of an erotic, pornographic nature. This magazine is not of that nature and I find that this class of person would not be depraved or corrupted by it.

Accordingly, in my view, the Crown has not discharged the onus it bears to establish that the magazine, or any part of it, is obscene. Consequently, I would uphold these appeals and quash the convictions."

Neville had been born in Sydney in 1941, the son of a Colonel. Raised in conventional middle-class circumstances and dispatched, he says, to Knox Grammar School in grey flannel suit coat, khaki shorts and boater, he had matriculated to a job in a department store where

he gained what he later jestingly described as valuable experience in publishing, by delivering newspapers every day to department heads.

He enrolled at the University of New South Wales in 1961 as an Arts student and the following year became editor of the student paper, *Tharunka* (aborigine for message stick). In his final university year, he had co-launched *OZ* magazine which, as we have seen, immediately aroused great attention, especially from the Sydney police.

He graduated from university in 1963 and continued to co-edit *OZ*. He became film critic for the *Sydney Morning Herald* and advertising copywriter for Qantas, Clearasil and Consulate, "the cool clear Virginia menthol cigarette".

In 1966, he had left Australia to explore the Far East, lost his way, and arrived at Dover six months later. Reading in the *Evening Standard* Londoner's Diary that he was about to launch a London edition of *OZ*, he did just that. It immediately attracted attention..

"Evocative reading for your pop fan daughter . . . Don't help spread this MUCK . . ." wrote *The People*. "The most disgusting publication I have come across in my entire life . . ." noted Mr. Bernard Brook-Partridge (Conservative candidate, Nottingham Central). "Crude, nasty, erotic . . . and debasing. . ." *Sunday Express*. "Obscene and dirty . . . with do-it-yourself formulas for LSD . . ." observed the *News of the World*.

Others were less hostile.

"The most successful of the underground publications. . ." wrote *The Times*. "A phenomenon you can no longer afford to ignore," noticed *Harpers Bazaar*. "*OZ* . . . the No. 1 underground magazine . . . a masterpiece of production . . ." affirmed New York's *Village Voice*. "What happens in *OZ* (now) happens five years later in *Playboy* . . ." commented the *London Evening Standard*. "More than any other publication, *OZ* represents the spirit of our generation . . ." acclaimed *Mermaid*, a university magazine. *Private Eye*, on the other hand, thought *OZ* "the worst magazine in the history of the world . . ." Neville has since contributed to several TV programmes and in 1970 published his first book *Play Power* (Jonathan Cape/Random House) to a stormy reception. Despite numerous visits from police over the past few years, Neville had not actually been charged with any offence before the present indictment against School Kids *OZ*.

He had been assisted in the research for *Play Power* by one Jim Anderson, who had subsequently become increasingly involved in Neville's affairs and in particular in the editorship of *OZ*. Born in Suffolk in 1937 of solid rural stock, as he described it, Anderson had also spent his formative years in Australia, where he had been plunged into the hard and unsympathetic atmosphere of the Australian outback, He had completed his primary education at various country schools and later moved to Sydney to study law at Sydney University, After graduation, he had been admitted to the Bar, and became a legal officer inside the New South Wales Department of Justice. His special field was criminal law but he also gained experience in probate and conveyancing. He found law unrewarding spiritually, if not financially.

According to his own testimony, he found of special annoyance the wide disparity between what was expected of him in public and what he wished to do in private. He was investigated by his own department, for example, with special attention being to his choice of friends who were classified as 'sub-cultural'.

Disillusioned, he resigned in order to leave Australia. He then spent several years travelling in Afghanistan, Libya and Morocco and completed a number of unpublishable novels. Eventually arriving in London, he worked as a schoolteacher, male nanny, children's book-

packer and soda-fountain attendant in Fortnum and Masons, before drifting into *OZ* in 1969.

The third defendant now sitting in the dock was Felix Dennis. Born in Kingston-upon-Thames in 1947, he had been educated in a State primary school where he passed the 11+ and moved on to a grammar school in Surbiton, Surrey. Expelled, he then went to private school. Expelled again, he tried St. Nicholas' Grammar School in Middlesex. Expelled again, he spent a term at the Harrow Art College. Expelled finally, he began playing in rock'n'roll bands as a drummer and singer. He was then 14.

He left home at $16\frac{1}{2}$ and moved to London early in 1967. He had to sell his drums to pay for his girlfriend's abortion, and had to sell his tape recorder to pay the rent, although not before he had sent Richard Neville a tape containing criticisms of the then newly launched magazine *OZ*. Neville persuaded him to sell *OZ* in the King's Road, and he soon graduated, he says, to being *OZ's* champion street seller. He had joined *OZ* full time late in 1968 as its advertising manager, having survived a variety of other ernployments - park attendant for Harrow County Council, a grass mower for Eastcote Council and a grave digger for Pinner County Council. He became business manager and a director of *OZ* in 1969 and says that, being Geminean with schizophrenic tendencies, his time has since been equally divided between the business and aspects of the magazine, and the design and editorial.

Watching them in the dock that first day - Dennis, in a white suit, large silver-rimmed spectacles, well-cut beard; Neville, dark-haired in a green and brown suede jacket and yellow T-Shirt emblazoned with the word *OZ*; and Anderson, blond, also in a yellow vest, with a fringed suede jacket and red trousers, all three defendants longhaired in the currently hirsute manner - it was hard to believe they were capable of organising a teddy bears' picnic, let alone a conspiracy to corrupt and deprave the youth of the land.

Neville had chosen to defend himself, a decision which he was later to explain in his opening address to the Jury; Anderson and Dennis were defended by Mr. John Mortimer QC. Mr. Keith McHale appeared for the Company, OZ Publications Ink Ltd, Brian Leary for the prosecution. Before Judge Michael Argyle QC, Neville, Dennis and Anderson pleaded not guilty to each of five charges, that:

- They had "conspired with certain other young persons to produce a magazine which would corrupt the morals of young children and other young persons" and had intended to "arouse and implant in the minds of these young people lustful and perverted desires";
- That "between May 1, 1970 and June 8, 1970, they had published an obscene article, *OZ* No. 28, known as the School Kids Issue";
- That "between the same dates, they had sent a postal packet containing a number of indecent or obscene articles in *OZ* No. 28";
- That on June 8, 1970, they had possessed "obscene articles, 252 copies of *OZ* No. 28, for publication for gain";
- and that, on June 11, they had possessed 220 copies of *OZ* No. 28, also for publication for gain".

The precise definition of 'obscene' was to receive much attention during the course of the trial. For the moment, therefore, a brief review of the main legal weapons against 'obscene' publications might be instructive.

THE TRIALS OF OZ

- **The Obscene Publications Act 1959** which deems an article obscene "if its effect . . . is, if taken as a whole, such as to tend to deprave and corrupt persons who are likely having regard to all relevant circumstances, to read it." The maximum sentence is imprisonment for three years. There is a defence to the charge if the publication can be proved to be "in the public interest", but this is illusory, as few juries would ever hold that a publication with a proven tendency to deprave and corrupt could ever be in the public interest.
- **Conspiracy to corrupt public morals** - this controversial charge is usually expressed in words befitting its archaic origin.

Thus the *OZ* editors were charged with:

> "Conspiring ... to produce a magazine containing divers lewd indecent and sexually perverted articles, cartoons, drawings and illustrations with intent thereby to debauch and corrupt the morals of young children and young persons within the Realm and to arouse and implant in their minds lustful and perverted desires."

In a penetrating analysis by one 'Geoff' Robertson of the current situation *vis-à-vis* the obscenity laws, published on May 26 by the Oxford University newspaper, *Cherwell* entitled 'The Politics of Obscenity', Robertson concludes, sharply, that "they don't write laws like that any more". "Nor should they," he continues. Robertson, who was later to play a more direct role in defending *OZ*, then quotes Mr. Justice Scarman, chairman of the Law Reform Commission. "The whole concept of 'obscenity' should be abolished", he said.

> "H. L. A. Hart has been another consistent critic of the existence of this 'crime',"

...says *Cherwell*.

> "A particularly unpleasant aspect of the charge is that the penalty is indeterminate - life imprisonment could be ordered, or, in the case of the two Australian *OZ* editors, deportation".

Cherwell 's report goes on to ask how closely these laws,

> "...predicated as they are upon the notion that words and pictures can effect severe changes upon a reader's thoughts and behaviour, square with current psychiatric thinking? The Arts Council report on the obscenity laws quoted with approval the evidence of Dr. Anthony Storr, a leading psychiatrist:
>
> '..as regards the extent to which people can be said to be depraved or corrupted. When people use these terms, they are very often referring to the idea that persons could, by reading literature, for instance, be encouraged to engage in sexual perversions which they have never thought of. In my view, disturbances of sexuality of this kind have their origin in early childhood and are the result of the family environment to which the individual

was exposed during his first five or six years. It is, therefore, highly unlikely that a book will have the effect of making someone perverse who is not so already.

My own view is that people who are afflicted with sexual perversions go out and find the literature which fits in with their own particular predilection. In other words, literature is secondary to the pressure of perversion and does not induce or cause it.' (cf. *The Obscenity Laws*. André Deutsch, 1969, p. 83).'"

If this report is correct, concludes *Cherwell*, and certainly it constitutes the best evidence at present available,

"...our obscenity laws are based on fantasy and our obscenity trials are meaningless rituals which juggle with unreal concepts. But as Lord Longford has discovered, condemning commercial pornographers is a highly popular political pastime. Even Harold Soref, MP, a director of Soref Brothers, a South African shipping company, and one of the few public supporters of the principles of apartheid, last week presumed to inveigh against 'moral pollution', by which he meant pornography, not racialism.

Scotland Yard has, of course, been enforcing the obscenity laws for some time now - but not against the purveyors of commercial pornography. *The Perversions of Aphrodite* and *Spanker's Monthly* are still on open sale. *IT, OZ* and *The Little Red School Book* have become the victims of the Vice Squad's vigilance. The apostles of radical change and not the pedlars of sexual fantasies are indicted as the depravers and corrupters of British youth."

Indeed, according to *Cherwell*,

"...police action in this area seems more concerned with proponents of an 'alternative society'. *IT* for example, has already been convicted of 'conspiracy to corrupt public morals' and hit with swingeing £3000 fines."

The publisher of *The Little Red School Book*, Mr. Richard Handyside, was found guilty by a Lambeth magistrate, Mr. J. D. Purcell, of possessing obscene material and was fined a total of £50 with 110 guineas costs.

And *OZ 28*, which, at the invitation of Neville, Dennis and Anderson, had been edited by a collection of 18 school kids now stood charged with both offences - being a conspiracy to corrupt public morals and being obscene.

Yet, according to *Cherwell*, both *OZ 28* and *The Little Red School Book* are overwhelmingly concerned with breaking down the authoritarian structure of our schools - one is written and illustrated by school kids, the other is a compendium by two Danish schoolteachers of radical suggestions about learning, teacher-pupil relations, exams, etc., with some advice of sex and drugs.

THE TRIALS OF OZ

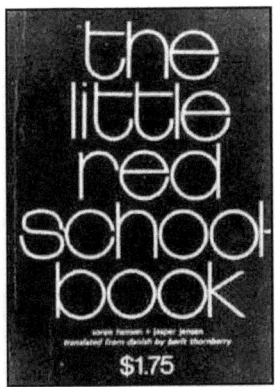

Both are in *this* sense 'political', advocating basic change in the education system, and only incidentally concerned with matters of sex. Indeed, following his conviction, Handyside affirmed that his was "a political prosecution from the day the police began raiding our warehouses.

We shall be fighting this all the way," he concluded; "this issue is one of denial of liberty."

Yet, as *Cherwell* points out, what sex shop would bother to stock *The Little Red School Book*?

"There seems to be, literally, a world of difference between the commercial pornographer and the proponent of radical change.

The smut pedlar is largely concerned with titillating his readers, but 'underground press' sexual references have neither this motive nor effect.

Of what interest would attacks on the authoritarianism of the school system or dispassionate discussions of the 'counter culture' be to the pornographers' clientele?

The current rash of 'obscenity' prosecutions, then, marks a significant extension of the concept of obscenity to embrace the articulation of a life-style at odds with conventional mores. Obscenity laws have been used with some success in the US to persecute 'underground' magazines, and it will be interesting to see how similar prosecutions fare in this country.

Will the discredited concept of 'obscenity' be extended to cover encouragement given to political conduct and life-style inimical to conventional notions of - for example - disobeying teachers and 'dropping-out'. It may well do so, with very little criticism, if the current furore over commercial pornography is allowed to blur the true political significance of the forthcoming trial of *OZ*."

On the day, however, the high-flown ideals of *Cherwell*, articulate and persuasive though they may be, seemed at first to be far distant.

Outside the Court Room, for example, a procession arranged by an organisation calling itself 'The Friends of *OZ*' marched from Lincoln's Inn Fields, through Fleet Street, past the Old Bailey and into Smithfield, London's meat market. Well, almost. Had not the police intervened, as they were numerically equipped to do, the banner-waving, flag-flying, balloon-carrying 200 would have carried their cause, which they obviously believed to be just, right into the meat, all red and glistening as it was.

An elephant, originally scheduled to head the procession, failed to materialise and a lorry surmounted with a large and largely naked plastic nude called Honeybunch Kaminski, twenty feet tall and made out of papier-maché, was told it could proceed only if it kept pace with the other traffic. The driver, not wishing to be arrested, drove off rather suddenly and was not seen again.

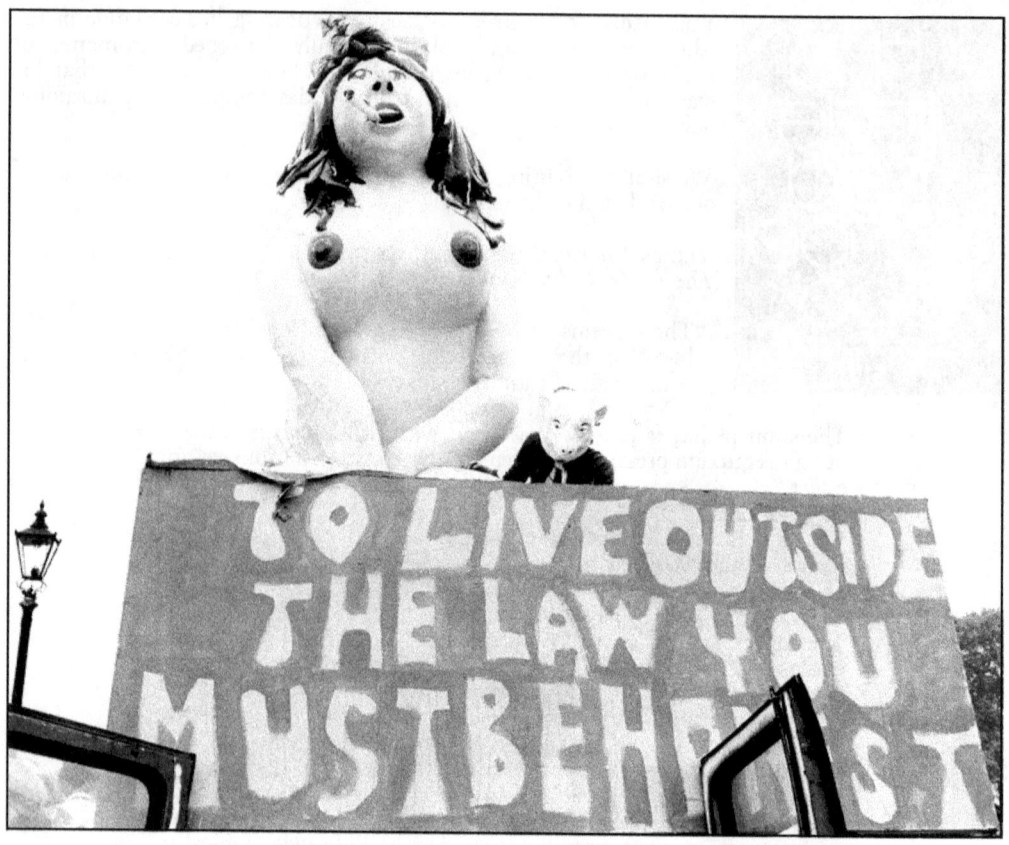

Honeybunch Kaminski and Rupert Bear (Felix Dennis Collection)

One placard in the procession read:

> "Limited in sex, they dare
> To push fake morals, insult and stare.
> While money doesn't talk, it swears
> Obscenity, Who really cares?" *

With 'baldilocks' Longford hopping about in search of filth, it seemed a pertinent enough jibe. But judging from the grunts of indifference coming from the Smithfield porters and the sniggers from the professional newsmen (one of whom kept shouting "get 'em off"), 'The Friends of *OZ*' looked to have set themselves an uphill task. Certainly their efforts before the trial had been prodigious. A nifty press kit, as it was described, had been distributed 'internationally', an organiser told me, to - among others - the *New York Times*, the *Herald Tribune*, *Le Monde* and *Der Spiegel*. The kit contained selected snaps of the defendants in festive pose, attired variously as schoolboys, which they are not, policemen, which they are

* From *It's alright Ma (I'm only Bleeding)* a song on *Bringing it all Back Home* by Bob Dylan (1965)

THE TRIALS OF OZ

not, and nude (courtesy of David Bailey) which at the trial they were not. It exhorted us to join the carnival spirit of the operation.
It begins:

> "See . . . the Drama of the Courts, with revelations of conspiracy and debauchery never made public.
>
> This novel event, the first of its kind in the country and staged largely at State expense, is designed to provide maximum entertainment for Her Majesty's subjects. The cost is expected to be not less than £100,000 and visitors can expect to witness a grand spectacle ... with a divers range of personalities, life-styles and modes of dress displayed and dissected before their very eyes. Unfortunately, requests for the trial to be held in the Tower of London have been refused."

This enterprising display of modish propaganda also spilled over into other, more predictable, areas. The predictable John Lennon, for example, had written a song, we were told, called *God Save Us* and another *Do the OZ* which were both to be released in the States coincidentally with the start of the trial.

Tony Garnett, clutching the loosest of scripts by Adrian Mitchell, was preparing to film the whole event - a trial scene always makes for a good movie - although what he was doing about the interiors had not been disclosed.

Five different designs of T-shirt had been manufactured and an appeal fund, which thus far had raised around £6,000, had been launched. An Independence Day Carnival, subtitled 'A Celebration of People's Rights', was planned for July 4 in Hyde Park at which there would be a "Smoke-in Picnic" accompanied by the "Massed Choirs of the Underground" to protest against the "growing climate of government repression". All of which may or may not have been a fun thing to have got involved in, but from the point of view of those who saw themselves as either the upholders or the interpreters of the Law - in this case Detective-Inspector Frederick Luff who had originally seized the offending magazine, *OZ* 28, and Judge Argyle who would have to sit through all the buffoonery and reach some (hopefully) balanced conclusions - it must all have seemed somewhat childish. Which indeed it was, because the progenitors of this particular method of protest argued that this was the most effective, if not the only, course left open to them. Felix Dennis, for example, had last been seen publicly squirting a water-pistol at David Frost on the famous 'Jerry-Rubin-calls Frostie-a-pig' television show the previous November (*pictured right*).

But Rubin and Hoffman appeared organised and purposeful in a way that 'The Friends of *OZ*' seemed not to be, if their tatty procession complete with hired clowns (literally) was anything to go by. What is more, the events surrounding the Democratic Convention in Chicago did seem to

have embodied a genuine confrontation between opposed and opposing cultures. And it was becoming hard to believe that the 48-page School Kids *OZ* represented any comparably universal issues in anything more than the most feeble way.

Still, the atmosphere inside the Old Bailey did seem more conducive to a grand debate. Bewigged and begowned counsel scurried back and forth as if in search of a cause.

The telephone kiosks surrounding the Old Bailey were scrawled with predictable graffiti.

"Sex; Public Schoolboy - pretty face, bollocks even prettier", read one. Another said: "Arse for sale. Tel . . . Ask for Nikki." A third: "Cunt for sale. Freehold." The canteen in the basement is dominated by a sign which says: "Prisoners' lunches must be ordered before 12." Since no Court rises before 1.00pm, one can only presume that the prisoners' lunches will, by that time, be cold. When I first visited the canteen, the two Junior Counsel sitting there were both reading the *Morning Star*. Court Room No. 2 was similarly austere. It soon became clear that jokes were not allowed unless cracked by the Judge who thrice warned that the Court would have to be cleared unless the humour subsided. Sundry barristers giggled at the back, however, and one read *Private Eye*. The bench was littered with the Judge's equipment which included a sheaf of pencils which he rattled from time to time, an *A to Z of London* streets and a large Sherlock Holmes magnifying glass.

Apart from the 'Friends of *OZ*' procession, there had been one other pre-trial incident worth recalling. John Mortimer was the third QC to have been approached to defend Dennis and Anderson. As long ago as April 20, the case had been set down for hearing at the Old Bailey to begin on June 22. After lengthy consideration, the defendants briefed Tom Williams, an MP and QC who - in the subsequent two months - had three meetings with the defendants' solicitor. On Friday June 11, eleven days before the trial was due to begin, Williams suddenly returned the brief, stating that he was involved in "another matter" and, therefore, would not be able handle the *OZ* case. The defendants immediately applied for an adjournment of three weeks, to give them more time to brief another QC. The following Wednesday, Judge Argyle agreed to hear the application. Jonah Walker-Smith, a Junior Counsel for defence, related the Williams story; but even before the prosecutor had time to oppose the application, Judge Argyle turned it down.

Later, now only five days before the trial was to open, the defendants had a long conference with Basil Wigoder QC (who had been involved in cases such as the Rudi Dutschke[*] affair, the Cambridge demo case and Jonathan Aitken's brush with the Official Secrets Act[**]). He seemed enthusiastic and another conference was arranged for the following Sunday. But then, an hour later, Wigoder unexpectedly withdrew, saying that he was concerned lest the

[*] Rudi Dutschke (1940 - 1979) was the most prominent spokesperson for the German Student Movement of the 1960s. In 1968 he was shot in the head by Josef Bachmann who later told the judge that he had done it "out of hate", calling Dutschke a "dirty communist pig". After the attempted assassination, Dutschke and his family went to the UK to recuperate, and in 1969 he was accepted at Cambridge to finish his degree. Two years later, the Conservative Government expelled him describing him as an "undesirable alien" who had engaged in "subversive activity".

[**] Jonathan Aitken, a former Conservative MP was convicted of perjury in 1999 after questionable dealings with Saudi Arabian businessmen. However, his earlier brush with the law in 1970 was as a result of more idealistic activities. He was acquitted at the Old Bailey for breaching Section2 of the Official Secrets Act 1911 when he photocopied a report about the British Government's supply of arms to Nigeria during the Nigerian Civil War, and sent a copy to the *Sunday Telegraph* and to Hugh Fraser, a pro-Biafran Tory MP. As the famous novelist Frederick Forsyth wrote in his non-fiction book on the Biafran War, there was an unspoken but strong prejudice in British Government in favour of the Muslim Hausa people of northern Nigeria, and against the non-Muslim Ibo and Yoruba people.

defendants should treat the trial as a circus. He was assured that this would not happen and agreed to reconsider, but 15 minutes later he determined to withdraw. So, four days before the trial was due to begin, the defendants made another application to Judge Argyle to postpone the case. As they entered the Old Bailey, Judge Argyle called to a policeman: "Take those men into custody - they seem to be carrying briefcases."

A policeman immediately searched Anderson, Neville and Dennis, and confiscated Jim Anderson's nose-drops. The three were then put in the dock. Once again, Walker-Smith (Mortimer's junior) explained to Judge Argyle that another QC had dropped out of the case, and asked for an adjournment. At this point, Judge Argyle broke in and said: "I will not be judging this case when it comes up, therefore I can make this remark. There is evidence before me that this case is not being taken in due seriousness."

Walker-Smith objected to this, asking the Judge what he meant by "evidence". Judge Argyle refused to say exactly what "evidence" it was that he had or to allow the adjournment application. Neville said at the time: "This has thrown the defence strategy into absolute chaos."

Suffice it to say that when Neville got up to begin his defence, that chaos seemed to be no longer present.

> "Firstly, ladies and gentlemen of the Jury," Neville began in his opening address, "you may be wondering why one of us is defending himself. This is because I have no wish to hide behind the gowns and wigs of the legal profession. I believe I should try and talk to you direct and tell you myself how and why we all publish *OZ* magazine, and what we hope to achieve."

A fat, German reporter from *Die Tagespiel* was asleep in the Press benches, snoring quietly. Neville, speaking from the dock, seemed nervous, stumbling over words and phrases, but looking determined. Reading from a pile of speech-cards, he continued.

> "Some of our most basic freedoms are being whittled away bit by bit. The right to strike is in jeopardy, for example. With the Industrial Relations Bill, such accepted practices as the blacking of goods and sympathy strikes will become illegal.
>
> With the new Immigration Bill, black citizens will actually be required to carry passes, to be produced on demand. Members of the Jury, none of these threats to freedom may yet apply to you personally. But those of us in the dock are aware of them all the time. The Misuse of Drugs Bill, for example, has given the police even more power to search and interfere with the activities of young people like us.
>
> Underground magazines and newspapers have been persistently harassed by authorities. Three days ago police raided yet again the offices of our friendly rival, *International Times*. Thus, it comes as no surprise to us that the National Council of Civil Liberties should have accused the police of political censorship in their efforts to suppress magazines like ours. We should be on guard against those who seek to close down political discussion under the guise of its so-called 'obscenity'."

The Judge, in his half-moon, rimless glasses, stared at the ceiling, fiddling with his wig. He seemed not to be listening.

"Every day," Neville went on, "there are new examples of erosions of our liberties. Erosions which are all connected with the current economic, moral and political climate. Some of them are minor, others are more significant. Last weekend, for example, a pacifist lawyer of many years standing, the American David Dellinger, was refused entry into this country. This man is well known for his gentle demeanour and intense hatred of violence in all its forms, which is why he has provided great inspiration to those who oppose the wars in Vietnam, Laos and Cambodia. He wished to come to this country to visit his teenage daughter - and was refused permission to enter. Such is the price of being a pacifist today.

OZ is a magazine which is not committed to being rigidly or destructively anti-society; it does not only mirror the prejudices of its editors, but has become the sounding board for people with new things to say and nowhere else to say them. So, for example, there has been a Homosexual *OZ* - edited by homosexuals for the usual *OZ* readership. There has been a Women's Liberation *OZ*, edited by Germaine Greer, a women's liberationist, and distributed to the usual *OZ* readership. There has been a Flying Saucer *OZ* - edited not by men from Mars, but by people who believe in such things, and the issue was sold to the usual *OZ* readership. Perhaps when this trial is over, we can ask you all to edit a Jurors' *OZ*... which, like all the others, will be distributed to the usual *OZ* readership?"

Mr. Leary, the prosecuting Counsel, scribbled away furiously at his notebook; as did the Court shorthand writer, a diminutive balding gentleman; as did Mr. Mortimer; as did Mr. McHale. Even the Judge made the occasional note in his notebook. The workings of the English legal system are sufficiently archaic as not to allow the proceedings to be recorded either in sound or video; thus, it is entirely possible that all live scribblers wrote down a different version of what Mr. Neville said.

"But all of these issues of *OZ*," Neville went on, "should not be seen in isolation from other magazines and newspapers published in this country such as *International Times, Friends, Ink, Mole, Express, Styng, Press Ups* and do*z*ens of others, known generally, if misleadingly, as 'the underground press', papers which offer a platform to the socially impotent, and which mirror the changing way of life in our community. And because this 'underground' or 'alternative' press is a worldwide phenomenon and because it represents a voice of progress and change in our society, then it is not really only us who are on trial today... but all of you... and the right of all of you to freely discuss the issues which concern you.

There are many groups today who are making demands for freedom. These demands, of course, frighten the established order and I believe that the charges against us result partly from such fear. This is not surprising. Many people were frightened by the call to abolish slavery and they put forward all sorts of arguments as to why such abolition would lead to the decline and fall of our civilisation. And many people are saying similar things about the current demands for children's rights. Just as many people hotly opposed the idea of women ever having the vote.

During this case, we shall hear much more about the increasing agitation of children and the relevance and importance of their demands for all of us. If their demands strike you as impudence, remember that children do not even have the most basic freedoms. They do not have freedom of dress or appearance.

They do not have freedom to participate significantly in deciding what they should learn. They do not have freedom of expression - this incident reported last week is typical: a schoolboy claimed in his school magazine that the meals were unhygienic. Instead of answering the allegations, the headmaster merely confiscated all the copies of the magazine and tore off the front page which contained the offending story. That example may seem rather trivial, but how would you like to be treated like that? What if you published a letter in your local paper attacking the council and the mayor came along and ripped the offending pages out of every copy? There was also recently the case of the young teacher in Stepney - evidently very popular - who had to borrow money in order to publish his pupils' poems. He then got sacked for his pains.

Now, one of the reasons we invited children - or at least adolescents, which is what we're really talking about - one of the reasons we invited adolescents to edit this special issue of *OZ* was to combat this tendency for everyone to try and shut them up. We were interested in what they had to say. But we didn't want to be like the headmasters who censor everything they I don't happen to agree with."

Neville leaned forward, getting as close to the Members of the Jury as was physically possible. The Jury looked intrigued.

"So we advertised in Issue 26 for any schoolchildren between the ages of 14 and 18 to come and edit *OZ*. We offered them freedom from editorial interference, and we kept our promise. There was no coercion of any kind and our assistance and advice was confined almost exclusively to technical matters. They would not be caned or sent to Coventry if we didn't like what they wrote or drew. *OZ* 28 is the result of this experiment. 'School Kids Issue' it says on the cover – which means, of course, the issue edited by schoolchildren, not aimed by others at them.

Remember, if you convict us at the end of this trial, you are in reality convicting schoolchildren. And if you convict schoolchildren, then you yourselves must accept some responsibility for their guilt. So far from debauching and corrupting the morals of children and young persons within the Realm, our evidence will show that *OZ* is part of a communications network which intends the very opposite. It sets out to enlighten and to elevate public morals."

It was a direct challenge to the public prosecutor, Mr. Leary who smiled. In truth, since he was prosecuting in an obscenity trial, one was tempted to think that never was a man so appropriately and unfortunately named.

Neville concluded,

"On the charge of publishing an obscene magazine, this Court will benefit from a great deal of new evidence which has come to light in recent years. On September 30th 1970, for example, the most comprehensive report on obscenity and pornography ever undertaken, recommended to the US Congress that 'all federal, state and local legislation prohibiting the sale, exhibition and distribution of sexual material to consenting adults' should be repealed. A possible distinction between sexual offenders and other people with regard to explicit sexual materials, said the report, is that sex offenders have seen markedly less of such material while maturing. This

Report includes a thorough breakdown of Danish statistics which reveals beyond any doubt that sex crimes in Denmark have dropped since the abolition of obscenity laws.

Two of the Commissioners make a special point about children. 'There is no substantial evidence that exposure to juveniles is necessarily harmful', they write. 'There may even be beneficial effects if for no other reason than the encouragement of open discussions about sex between parents and children relatively early in young lives.' School Kids *OZ* was a step in the direction of closing that gap."

Afterwards, in the street, Vivian Berger, one of the school kids who had been involved in the preparation of *OZ* 28, said to Neville: "It was an incredible speech - I just hope the Jury was able to understand it."

It was a shrewd observation, because it was becoming increasingly apparent that, as far as one could tell, the Jury and the defendants inhabited totally different worlds; to some extent, they even spoke quite different languages. Nonetheless, Mr. Mortimer had also underlined the same point about the relative freedoms of schoolchildren.

"There is no doubt, is there Members of the Jury," he had said, "those schoolchildren today, by common consent, do have very special problems; problems which all of us spend a lot of time thinking about.

Are the selections [*sic*] methods for admittance to the various schools they go to, satisfactory? Is the examination system which harries them perpetually and keeps their noses to the grindstone of facts, rather than perhaps allowing them to develop their own idiosyncrasies and talents, the best thing we can produce? Is the system which sends them into universities the most satisfactory? Should schools be more self-governing institutions, with the children having more say in their control? How should they deal with the questions of drugs? How should they deal with the questions of sex? All of these are problems which are not only very important to schoolchildren, but terribly important to us; because we are all of us, most of us, parents of children. And the future of this country we live in, depends on the sanity and sense of our children."

From the careful and deliberate way in which John Mortimer spoke these words, you could tell that, for him, these were the essentials of the debate. Looking now directly at Neville, he said:

"And so it was thought of interest that there should be a schoolchildren's edition of *OZ*. You may think that children shouldn't be allowed to have their heads; that it is bad for them. But there are schools in this country where people who do think that children should be allowed such freedom may send their children. These are called free-expression schools. And there are other schools which take quite a contrary view. But do the people who run these schools where children are allowed to say and do what they like (because this is thought that is the correct way of bringing them up), find themselves charged with a conspiracy to corrupt the morale of young persons?

When you come to read this particular issue of *OZ*, Members of the Jury, we think you will find it a most interesting insight into the true state of mind of teenagers living in a big city, going to state schools, grammar

schools and comprehensives. Are we going to say, subsequently, well, that's true; that's what kids think; that's what they think and that's how they feel, don't for goodness sake let's ever let it be known? Let's shut our minds to it; let's go on as if all the boys thought of nothing but cricket bats and all the girls thought of nothing but knitting patterns. Is that really how we want to view life?

You will have to consider, Members of the Jury, whether it is not essential that we should know what these kids say and feel when they are being treated without inhibitions, when they are not in the classrooms of schoolmasters who may punish them if they are too voluble. And it may be for the public good of all as parents, as teachers, and as human beings, to know how our children really feel and really behave."

CHAPTER TWO

So could it be said, as the defence maintained, that *OZ* 28 really depicted how "our children really feel and really behave?" Before we proceed, it would be sensible, therefore, to describe and quote from *OZ* 28 in order that subsequent argument may be considered in the light of actual textual evidence. The Members of the Jury were not allowed to see the magazine, however, until after they had heard the opening remarks of both the defence and prosecution.

Then, such are the peculiarities of the English legal system; they were only permitted to read their individual copies within the confines of the Jury Room. Thus, they began reading soon after lunch on the second day but were not allowed to take the magazine home to finish reading it overnight. They had to finish their task the following morning, adjourn for lunch, and continue on into the third afternoon - in all, four and a half hours. Meanwhile, the entire business of the Court was at a standstill.

Some Junior Counsel played scrabble, witnesses hung about under the dome of the Old Bailey looking disconsolate, journalists adjourned to the pubs opposite and Mr. Mortimer regaled his friends with spicy anecdotes from theatrical life. Alec Guinness, the actor, had attended the Court on the second morning to study form for his forthcoming leading judicial role in Mr. Mortimer's newest play, *A Voyage Round My Father.**

* Today, Mortimer, who died in 2009, is best known as the author of the long-running *Rumpole of the Bailey* series of books and the TV series of the same name which aired between 1975-1992. It appears that he never forgot his sojourn as defender of the *Oz* faith, and in one of his last books *Rumpole Rests His Case. P.46/47* Chapter Two. *(*Penguin, 2002) there was a story called *Rumpole and the Remembrance of Things Past.*

It includes the following poignant passage:

> 'Was it cool for you,' I wondered, 'being an articled clerk in a solicitors' office?'
> 'I wrote a column for an underground magazine. It was called "Kill All Lawyers". I showed it round the Aquarius so I kept my credibility.'
> 'What did your law firm think about that?'
> 'It was printed in green ink on green paper, so it was more or less illegible. Anyway, I don't think the partners subscribed to *Peeping Tom.*'

OZ 28 has 48 pages, all two-tone in colour. It is typographically ingenious, with the usual tendency thereby towards illegibility.

Apart from the front and back cover, it has 31 pages of text, eleven pages of advertisements and four pages of photos. In all, these contain some 35 different photos, 30 cartoons and 20 separate articles, not including an editorial and the various biographies of the contributors and editors. Since the edition was edited by school kids, (it is labelled 'School Kids Issue') there is an inevitable preoccupation with school and school problems, although the subject matter also includes sex, drugs, rock music, the 'underground' and revolution. The intention of the magazine is expressed in its editorial, written by Jim Anderson, one of the three defendants.

> 'This *OZ* has been put together with the help and inspiration of about 20 people, all 18 or under, mostly still at school, who came from various parts of London and England in answer to our appeals for injections of youthful vigour in our ageing veins.
>
> We were half expecting a crowd of revolutionary high school bomb throwers, United States style, but England is England, and although we got one 100% hippie complete with blue satin, beads and bells and a job at the Roundhouse, some of them actually liked school, and others were cagey about using their real names or upsetting their dear old school too much. Get those A levels kiddies! However we all had a fantastic month doing it, milling around weekend after weekend in true communal style, gradually getting all the copy together, the drawings, the photographs, the freak-outs. *OZ* was hit with its biggest dose of creative energy for a long time.
>
> More freedom was everybody's cry - get rid of the primitive examination system (Xmam [sic] Blues); get rid of teachers who can't see beyond their own prejudices (Headmaster of the Year); give us the freedom to smoke, to dress, to have sex, to run school affairs . . . *OZ* itself suffered a heavy critical assault (*OZ* Sucks . . .) but on the whole everyone who worked on the issue enjoyed the chaotic anarchistic anti-authoritarian way in which the issue was put together, and we hope it reminded them of the sort of fun school can be and only too rarely is.
> Now read on . . ."

Beneath the editorial and on the opposite page are the briefest of flip biographies, presumably written by the school kids about each other, among which are:

"**Viv Kylastron**, 16, Aries. Smoked at 9, tripped at 11. Owes this to the Roundhouse and Bradford.

An anarchist, trying to dissolve it and replace it with a living school. Came to *OZ* to meet Richard Neville and others; also interested in the workings of *OZ*. Interested in mysticism."

"Rob. January 16, Scorpio, from Highgate; at present undergoing comprehensive education. Doesn't read much at the moment because of lack of time. Listens to Hendrix, *Quintessence*, *Soft Machine* and thinks Zappa 'plays incredible wah-wah'. Would like to see Enoch Powell get a divorce and marry a very black woman. Has many obscene ideas but can't put them down 'cos can't draw. . . Enjoys working for *OZ* (Slurp, Slurp) even though he does 'fuck-all'. Dislikes school 'cos of skinheads and headmaster. However, wants to become eminent chemist someday."

"**Anne Townsend**, 16, Farnborough.

Says she is a bitch. Claims to like de blo*oz*e. Hang-ups about blokes. Hates her parents, turns on regularly, reads *OZ*, *IT* and *Petticoat*.

'I want all the freedom I can get', but will conform to anything as long as she gets something out of it."

"**Charles Shaar Murray**, 18, Reading.

He's a Jewish Pantheist.

Doesn't turn on because he has weak lungs; Says he is a clumsy lover. 'I have all the sex appeal of a mouldy sock. Believes in the brotherhood of man and the dawning of the age of Aquarius. Starts a journalism course in the autumn."

"**T. I. Bradford** - a Leo with Gemini (?) rising. His first names are The Incredible. He is known by practically everyone in the infamous 'underground' as a generous anarchist. After being expelled (for being human), he left Bradford Grammar School and Bradford and came to London, where he worked at the Roundhouse, started his own bookstall, helped the Electric Cinema, lived at Drury Lane Arts Lab and did everything else (perhaps he'll write a book). He is a vegetarian and does not eat sugar or artificial foods. Disillusioned by the 'underground' or rather lack of it (like us all) but tries to live in harmony and is very trusting. The most modest member (sic) of our *OZ* community."

The idea of school and all that that entails comes in - not unexpectedly - for some heavy beating. Under a headline, 'School Atrocities', Vivian Berger (Viv Kylastron above) writes about his experiences. Berger was later to be called as a witness for the prosecution.

> "I go to school in Islington, Owens. It is a very 'nice school'. Our headmaster told us so. Once a week we go rowing. Mr. Copping, who takes us rowing, likes us to do as we are told. He says we mustn't ever ask why or he'll send us to the headmaster. (I'm afraid of the headmaster.) Once, he took us out when it was snowing and we couldn't row because the Thames was too rough. Instead, he said, we must go on a run. So we changed to our shorts and shirts and set off through the snow, which stung our faces. It was very cold. We ran through the streets and mud, and over bridges for a long time. We got colder and colder. But it was all right. Only one boy got chilblains and only eight of us were absent the next day.
>
> We have another clever teacher - Mr. Butler, who likes the old way of running schools. He canes people. Once he caned me. I had to bend over and put my hands on a low chair so that the muscles of my arse would be tense and it would hurt more. I gritted my teeth, because it did hurt and left red marks and bruises. Was Mr. Butler smiling? These incidents are true but written by a brainwashed pupil. There are thousands of pupils similarly brainwashed. They accept everything, and until they can be shown their stupidity, there will be no change."
>
> <div align="right">Vivian Berger.</div>

Another piece is unsigned and printed alongside a violent but skillfully drawn cartoon depicting an evil, pipe-smoking schoolmaster. The schoolmaster is masturbating while sticking his fingers up the anus of a schoolboy, who is vomiting. The article reads:

> "Like - the ageing master who used to walk around the juniors' showers 'cleaning his glasses' as he looked at the kids' balls, saying sometimes, 'I don't think I've seen you before?'
>
> Like - the cat with three As at A level who disagreed with his headmaster. The Director of Studies at the University at which he finally got a place told him: 'You have the worst reference I have seen in 25 years of teaching.'
>
> Like - the master who would make boys stand upright in a hot room until (in one case) they fainted.
>
> Like - the junior school master who made a kid of 10 hold two tennis balls at arms' length for 15 minutes (try it sometime), hitting the kid with a ruler when he let his arms waver.
>
> Like - the master whose 'record' was 150 detentions a week and who kept trying to improve it.
>
> Like - the entire school system."

Other articles are more balanced, and more perceptive. One is an understandable, and for anyone who has suffered from this particular system, totally real examination of examinations. This author is one Alan Clayson, about whom no information is supplied.*

> "About the third week in August, I received the same unfeeling piece of paper I have received with monotonous regularity on two other occasions for the past three years - the dreaded results! As usual, they were not brilliant. They caused the same emotional distress for both me and those round me. 'Friends' and other enemies asked with a smirk about my results and unhappily I had to be truthful as nobody can escape the merciless table of results that the local press prints smugly every Friday as they reach the colleges. For some parents, there is nothing more soul-destroying than the public exposure of their child's bad exam results.
>
> Let us 'examine' this peculiar system of selection that has prevailed and is blindly passed on, occasionally questioned but hardly, hardly ever changed, for decades. ·
>
> Examinations are a primitive method of recording a tiny, often irrelevant, section of the behaviour of an individual under bizarre conditions. Those who evaluate the behaviour are untrained as it is relatively easy for anyone to get a holiday job checking examination papers. As for the actual examiner, the marker of the paper, he — being more or less human — is incapable of consistently good and fair judgment as he has to rush through 12 hours per day, often reading the same information thousands of times.
>
> He is inclined to become irritable; it's not good for an old man or old woman (that's what they are, usually) to do so much concentrated work for such a long period. The work becomes tedious and the last few hundred papers he marks reflect this. There was a case of some poor old examiner, having so little time, that he marked papers on the way to work on a crowded tube train. Despite everything, I pity examiners — theirs is a hard lot, with almost unbelievable mental pressure.
>
> If examination results predict future performance, it is a poor way of doing so as hardly any potential employer takes any notice of grades and many (school kids) even obtain jobs before results are announced. Employers are inclined to take more notice of personal reports and references (also subject to influence) than the work of a collection of old men and students working for the holidays, marking and checking an exam set by a vague 'Board' for an entity which is geographically uncertain. Also, a person with 'good' exam results may be unable to adapt to the stone cold realities of working life.

* Alan Clayson later became quite well known as a music journalist and author as well as the singer with a band called *Clayson and the Argonauts* who - in the opinion of this editor - were really very good and deserved considerably more success than they actually got.

Examination results only apply to actually gaining a job for a probationary period. The rest depends upon ability at the job. Only in a few cases can initial incompetence be considered. These are those in which human life is involved, e.g. the medical profession and to a certain extent industrial work (safety measures, the nine types of industrial pollution, etc.)

Encouragement and incentive to work does not come from knowledge of exam grades, because most of them come at the end of a training course when it is too late.

Having an examination system in colleges and schools gives the HIGHER AUTHORITIES (whoever they may be) a false air of respectability. However, exams, taken at their basic level, stink of the Inquisition and are a kind of unconsciously synthetic Third Degree of the intellect and emotion.

There is a more palatable way used in many establishments whereby clearly defined topics are set to be completed in the not-too-distant future. Unfortunately, these are only secondary to exams although they are a far better usage of a person's ability.

This year, I was subjected to A level, and it rejected me. I feel no conscience about it. I really knew the stuff (I did, really!) and I still remember most of it. I treat it as a battle between me and the examiner's state of mind at the time he marked my paper. I questioned one result by letter to the Board asking them to check the paper, but I don't think they did. I received a letter from them saying they were sorry and all that, but I'll have to try harder next time blah blah blah. . .

This piece of literature may give the impression of someone so bound up in himself that it hardly seems worth telling the world about even the most trivial things. Maybe it is, but the education system in general and the examination boards in particular have given me a bad time, especially these past few years and I dare say I've given them a few laughs. Seriously, many lives have been ruined and many parents' dreams have been crushed because they have been made to suit the balance instead of what they really want to do.

I don't forgive them for that."

<p style="text-align:right">Alan Clayson.</p>

After the trial, a *London Evening Standard* editorial noted:

"By any standard of common sense, *OZ* 28 was a pretty filthy example of smut."

Among this 'smut' is a critical look at the School Corps System, entitled 'Babes in Arms', printed (for obvious reasons) unsigned. It is typical, however, of the magazine's general balance that opposite is reproduced a contrary opinion, entitled 'British Hitler Jugens' and signed by Alex Darcy, who was 17 and came from Reading.

'Babes in Arms' reads:

> "We go to the City of London School in Blackfrairs. It's a public school, and like many public schools in this country it houses a 'Combined Cadet Force', an organisation designed to induce school children to take a career in one of the armed forces. We hate it.
>
> Between the third and sixth years, it's virtually compulsory for pupils to join the CCF. In other words, for three years of our lives, several hours a week and much of our free time, we have to play soldiers. We have to carry rifles (2nd World War .303s), we have to parade in front of local factory workers who jeer and laugh at us, we have to march, polish buttons on our uniforms, mirror-shine our steel—shod 'bovva' boots, study elementary battle tactics, salute our superior officers (often sixth-formers who have gained 'promotion') and generally lick arse and 'do-as-we-are-told'.
>
> Once a term we are required to go to two-day camps based at military establishments away from the school. Here we learn how to kill more efficiently. Last camp, one of our friends had his head shaved closer than a skinhead. (Most of us stuff our hair up into our caps to avoid detection, but this isn't always effective. The required length of hair is on a line level with the middle of our ears, and it must never touch the collar.) The food at these camps is absolutely dreadful. Mostly it's dehydrated crap, rationed in strict portions.
>
> Opposition to joining the CCF at our school is systematically crushed. Once you have joined, your name and particulars are filed at the Ministry of Defence, whose permission has to be obtained before you can leave. Only a minute proportion of fellow pupils known to us in the CCF would stay if they had the choice. Gradually, though, it's dawning on us that we are being trained merely to provide cannon fodder for the next generation of mindless generals. It's interesting to note that the only form of warfare in which we have never been instructed is guerrilla fighting. Perhaps we will have to learn that for ourselves."

Not all articles are anti-school. Many are constructive and sensible. One such also appears under the headline 'School Atrocities' and is written by Robb Douglas. He describes himself as being 18, from Hornsey, London, and of a working class background. He now works with physically handicapped people and likes making people happy.

> "I actually enjoyed school. To me, school was a second home. Somewhere safe and relaxing, which is strange for a place which is geared to training people for the rigours of the rat race. My school was comprehensive for my last two years, but this didn't affect the social scale in any way, and a happy medium was struck. I came initially from a secondary school which joined with another secondary one, the pupils of which had always seemed to us more intelligent, but afterwards it was clear that we were of equal intelligence.

> My school was enjoyable because I was allowed to wear my hair halfway down my back, and then, because it was long, I was treated like a harmless freak and allowed to do virtually as I wished. As nearly everyone wore a uniform, and I wore jumpers, jeans and bumper boots, I stood out in the morning assemblies. I eventually refused to attend these assemblies on the grounds that I was an agnostic and should not be pumped with Christianity every day.
>
> My last year involved only art, which I did all day long instead of studying metalwork, maths, English and technical drawing, which were the subjects I was supposed to be doing. I started at 10.30am instead of 9.00am and finished at 5.00pm instead of 4.00pm Officially I was absent for six months because no one marked me present.
>
> This freedom of choice is what all sixth forms should be allowed. The school should know that they will study because they have stayed on. What is wrong with continuous lessons and pupils entering or leaving when they want to? My school days were as varied as I wanted them to be. I did light shows, posters, models. This form of teaching expands your mind to the limit of what you can take in and understand. Remember that no school likes expelling pupils and would preferably reach a compromise, so just back down a little sometimes. A hand hold is better than no hold; with a helping hand you can always lift yourself higher."
>
> <div style="text-align: right">Robb Douglas.</div>

Sex, and its treatment in the magazine, was to prove the big bogeyman for the prosecution. At one time, it seemed that sexual innuendo lurked in every comma and in every stroke of the cartoonist's pen. Much psychological evidence was to be called to demonstrate that the open and uninhibited way in which sex is depicted within the magazine, although shocking and even distasteful to a more adult generation, would in no manner be harmful (and what became clear, was not intended to be so) to any young child who might come into contact with it - for one obvious reason. The child already knew what was being described anyway.

For example, an article under the headline 'Teacher loves to run his fingers through my hair . . .', [and] printed next to a cartoon of a big-breasted Medusa out of whose head is sprouting 23 penises, reads:

> "We first became aware of sex during one biology lesson at the age of 11 or 12. From then on we were all dying to see a prick but we all swore that we would keep our virginity until we got married (some have, others not!) One after another we all started our menstruation and in our little minds we believed that we were women. A few of us had started going out with boys and everyone wallowed in excitement on Monday morning as we sat and told our friends everything that had happened on our date. To begin with, we all worried like mad about the petting sessions, but things sorted themselves out.
>
> I shall never forget the look of horror on people's faces when one girl lost her virginity at the age of 13, under a tree in the

park. For a while everyone respected her until the next lost hers and the novelty wore off. One girl became very worried because she believed she was becoming a nymphomaniac (if you are interested I can let you have her phone number).

Then came the inevitable discussions on what it was like and why the remainder of us should remain virgins. Some decided to wait for the right man while others spent weekends fucking in convenient places. To many it seems impossible to go out with someone for more than six months and not have sex. A few became pregnant and managed to deal with it without parents or teachers being aware of it.

Discussions hardly ever take place as we get older, and the matter is left entirely to the two individuals involved.

SMILE — if you had sex last night."

Another article is a strong plea for more sexual freedom; not free sex or free love, as the prosecution wanted it, but sexual freedom.

Written by 'Anne' who, according to her printed biography, says she is 16, comes from Farnborough and hates her parents. "I want all the freedom I can get," she says, but adds that she will conform to anything as long as she gets something out of it. Her article reads:

"This society, although labelled permissive (by society itself), is not free enough to permit man to revert to his natural instincts in public. This ruling does not extend as far as animals.

Freedom of sexual expression in public has many tight restrictions. One may kiss in certain places but only fuck in a few places at certain times. Surely this idea is as pretentious and puritanical as the old forms of censorship? Its purpose is to prevent corruption and protect the individual from disturbing or immoral sights. This is ironical in itself and only made to satisfy the so-called moral conscience of society. Everyone knows what copulation is. Animals perform the act every day in public, so why not let humans have the same freedom if they wish it? Surely we should have the right to make the choice?

If the act disturbs some, they do not have to watch, and if they want to, why not?

The act of making love is beautiful and natural and should be admired.

The Danish Sex Fair was the first step on the way to sexual freedom although some saw this as just an excuse for open pornography. If pornography is limited to sexual behaviour, then I think there should be no censorship of it at all. Why so many restrictions on natural behaviour?

Were you born to be free? Free from the system, free from tradition. If you were, you are one of the minority and you are bloody

lucky; but the rest of you, what about you? This society is closing in on you and taking you over. It is a safe bet that you obey someone who is your equal but holds a higher position than you. Why not start a freedom campaign in your area now and just do as you wish? Whenever you feel like pissing in the street, then do it: if you feel like dancing at a funeral, then go ahead and do it. Live for the moment and not the future. Be free and tread on anyone who stands in your way. Your true identity is sure to come to the surface. Don't become Mr. and Mrs. Average. Live a little before it's too late."

<div style="text-align: right">Anne.</div>

Drugs was to prove another bogeyman. No-one could deny, or did deny, that it was a subject occasionally dealt with in the magazine. References in the text to 'turning on' only added to the assumed air of debauchery in which *OZ* 28 had been produced.

And the lack of any specific admonishment was thought to be indicative of a moral laxity and disregard for the Law that was thoroughly reprehensible. The editors of *OZ*, in other words, had failed in their duty to warn young people of the dangers involved.

Again, much evidence was to be brought to show that a censorious attitude would have been far more damaging, if only because it was far less effective, to young people. Adolescents had a mind to find out for themselves rather than be told from on high; far better, therefore, to offer advice rather than instruction. This pragmatic approach is caught perfectly in an article headed 'Drugs and the Public Schools' and signed by 'Andrew Clarke - Old Melburian'. It was never discovered whether Melbury was or was not a fictitious school.*

The article read:

> "Recently the public schools have been hitting the headlines under the heading 'BOYS EXPELLED FOR POSSESSING CANNABIS'. Quite naturally this worries those with boys at these establishments, but, of all the drugs that float around public schools, cannabis (whether in the form of grass or hash) is about the rarest. In my own experience, the number of boys who smoke is remarkably small compared to the number who indulge in much worse forms of self-prescription.
>
> One of these things is the taking of cough mixtures such as Fensil in great quantities. These potions are drunk a bottle at a time for the sake of the small buzz they give the users who, for the most part, do not know how much harm they are doing to themselves.
>
> They do this perhaps because they see that it is now becoming more fashionable than ever to be a drug user and because their opportunities for obtaining hash are incredibly few and far between for them in their sheltered positions. When I returned to my old school on a visit, within one hour at least five people approached me attempting to score and, on being disappointed, asked for

* The present publishers tried, but could not find it. The only Melbury School we were able to find was a State primary school in Nottingham.

transport to a distant chemists with the intention of buying cough mixture and caffeine tablets.

In this way, potentially harmful and lethal drugs are being used as substitutes for the comparatively harmless hash. Surely this is what the authorities should be fighting against with a lot more determination and force - these so-called legal drugs that are so much more dangerous than the illegal soft ones? How long will it be till someone gets hooked or worse? Are they waiting until someone actually kills themselves before realizing that they are getting hysterical about drugs that are well-publicised, while overlooking common everyday things that are easily and legally obtainable? It is time hysteria was overcome and the situation viewed in the correct perspective.

I am not attempting to advocate the use or legalisation of cannabis, but rather trying to make people realise what is going on behind the newspaper headlines. So that if you know someone at a school who smokes hash, be thankful that it is nothing worse, however illegal it may be."

The same careful expediency is expressed on a page headed 'Dear Dr. Hippocrates'. This, it transpired, is a syndicated column originating in America. In taking the same, non-didactic, non-authoritarian stance, it was to be argued, it had proven to be of far more use than any self-appointed or self-righteous approach. He was the Marjorie Proops of the Underground* to be trusted because he or she seemed to understand the problems involved.

It was later discovered that Dr. Hippocrates is a pseudonym for Dr. Eugene Schofield, a much respected Californian doctor.

One question and answer reprinted here, reads:

"**Dear Dr. Hippocrates:**

On an acid trip I took recently, my left hand and arm went totally dead on me. This happened twice before on very heavy acid trips. I have taken acid about 60 times in the last three years if that's any more help to the problem. Anyway, like I said, my left arm went dead. I couldn't move it very well and I could barely make a list of my fingers. In about three hours my left hand and arm were back to normal use but I was worried by the incident. Oh, by the way, it has always been my left hand and arm that have gone dead.

Is this a normal occurrence or is something wrong? I haven't taken any acid trips lately nor do I plan to until I find out about this."

Answer: "All 'LSD' available on the black market today is illegally produced by chemists who, of necessity, run makeshift laboratories. Compounds produced in these laboratories contain impurities

* Marjorie Proops, born Rebecca Marjorie Israel, was a journalist who joined *The Daily Mirror* in 1939, soon becoming the Advice Columnist, a post which she held until her death in 1996. For nearly half a century she was arguably the best known 'Agony Aunt' in the UK.

which may be more dangerous than the pure drugs. 'LSD' is related to ergot, a substance which causes constriction of blood vessels including those in the brain. Ergot is a fungus which grows on rye and other grains. During the Middle Ages, epidemics of ergot poisoning occurred in which the characteristic symptoms were gangrene of the feet, legs, hands and arms. If I were you I would have a thorough physical examination. You live near a Free Clinic where you can speak frankly to a physician about these experiences".

Music, by which, alas, one automatically assumed rock music, is treated in a way that could serve as instruction for a good many other magazines and quality Sunday newspapers.

The approach is thoughtful and clearly unaffected by the need to please either the publicity agent or the group themselves. Quite apart from a sharp and hostile review of my own book about pop, *Born Under a Bad Sign*, the magazine contains one scintillating analysis of the dilemmas of underground music. I find it hard to believe that anyone could find such a piece titillating, offensive or in any way worthy of suppression. Written by Charles Shaar Murray, it begins:

"It was, at least for me and most of the people I know, the music that first aroused interest in things Underground, and the music is still the most mature and developed manifestation of the culture of the Underground. Underground visual arts draw their most effective imagery and inspiration from the music: the outstanding examples of this are Martin Sharp's Dylan and Hendrix posters and the 1967 Hapshash output. In fact, an amazing amount of the most adventurous designs are album sleeves: '*Sgt. Pepper*', *Disraeli Gears, Ogden's Flake, Ars Longa Vita Brevis, Tommy, I Stand Alone, Ceremony, King Crimson, Quintessence.* Underground literature is virtually non-existent: Burroughs, Ginsberg and the late Jack Kerouac are all of the Beat Generation. Maybe in ten years' time we may develop their equal; we certainly haven't got one now. So it's back to the music.

It's precisely because the music is such a vital, integral part of our movement, that what's happening to it at the moment augurs so badly for the whole underground community. The whole point about the early underground music scene was that it was an honest, experimental, no-bullshit service provided by and for artists and consumers whose tastes were ignored by the media. Alternative press, alternative music, alternative styles. The fifth-rate bubblegum and Mumsy pop music was discarded in favour of genuinely creative musical endeavours, based on all known styles and a few unknown ones. Carnaby Street's cardboard fashions were ignored by a community who if they wanted to wear red satin trousers and their mothers' hats, just went out and did it, whatever 'they' said we were all wearing this year. Honest people played honest music independently of *Top of the Pops*, the *NME* and Peter Murray. Some of it sold to the Dumb Majority and that was beautiful. Do them good to have some honest music in the house.

Frankie Vaughan, on the other hand, leapt into print to tell the mothers of Albion that a 'Love-in' was just 'an excuse for a great big orgy'. The media found that the underground music scene had

beaten Tactic One - 'Ignore it and it'll go away' - so it tried Tactic Two - 'Take it over, package it, sell it back to itself '. This worked admirably - they're still doing it now. We haven't infiltrated them - they've infiltrated us. Once the only part of the pop scene concerned with honest music and real people, there's now more hype, bullshit and bustling on the so-called progressive scene than anywhere else. The straight/commercial pop scene is simple and honest: put it on the radio and people hear it and if they like it, they buy it. That's all, that's how they sold a million *Love Grows* and five million of *Sugar, Sugar*. The music is crap, but the people are honest. With us, half the music is good, but half the people are dishonest.

In the teenybopper scene a few years ago, singers were sold on faces, clothes and 'image'. Now this kind of irrelevant hyping is almost the exclusive property of the Underground. Music is again secondary. The MM 'Musicians Wanted' classified ads carry gems such as 'Guitarist wanted for semi-pro progressive band. Long hair essential'. Any group who looks sufficiently hairy and make the right New-Left political noises can develop a hearing even if their music is derivative and uninspired.

So now the revolution is a groovy way to sell things. Someone cleaned up from selling thousands of Ché posters, and 20th Century Fox advanced Omar Sharif's career nicely. Capitalism is alive and well - thanks to us. Those of us pledged to 'da revolution' - I'm not - would do better to withdraw their services from the media; what can you do with your street fighting ideals if the very people you want to fight against can package street-fighting, put it into posters, records and books, and sell it back to you at enormous profits? So hair and trite revolutionary lyrics can sell us inferior music. Aren't you proud?

The best music is generally produced by people who are either regarded as pop stars - Auger, Driscoll, *Who*, Hendrix, *Beatles*, Beck (the trendies never forgave him for *Love is Blue* and *Silver Lining*), 'Fleetwoods', 'Floyd', 'Jethro' (Townshend and Anderson couldn't sell out if they tried) - or those who are ignored by the Underground because of insufficient hyping – *The Soft Machine* and *Renaissance* are outstanding.

I'd love to meet a chick who could fuck like *Led Zeppelin One,* but she'd wear me out in a week. At least it's non-political.

The other source of good music is from the folk side - Jansch, Mike Cooper, Mike Chapman, Stewart, Harper. The hypers have kept out of folk music which is probably why it's doing so badly, due to lack of skilful local promotion.

I have no idea of the solution, except to hope for a return to the basic attitude of yesterday's Underground and today's teenies: (that sounds incredibly condescending from a bloke of 18): listen to as much music as possible and pick up on what you like. Don't worry if it got bad reviews in *IT* or if your trendy friends sneer; if you like

it, buy it. That's where we ought to be, where we should have been all the time. Honest people, honest people. No more bullshit. Shalom."

Charles Shaar Murray.

Of course, no amount of quotation can adequately summarise either the content of *OZ* or its impact. Inevitably, my selection is only a selection, although I hope not intended to prove any particular point other than that beneath all the typographical wizardry, there is some good and coherent thinking struggling to get out.

The cartoons are more explicit; they range from the surrealist image of armadillos being squeezed out of a tube like toothpaste, to the deliberately shocking juxtaposition of Rupert Bear, a familiar and lovable childhood image, with the sight of him and his erect penis charging a reclining, elderly woman. The issue also contains some material which was clearly not contributed by schoolchildren, such as Dr. Hippocrates' column, advertisements for records, and a brash and silly parody of hard-sell techniques recommending its readers to buy back-numbers of *OZ*.

> "Once again, *OZ* offers you the chance of a life-time. Yes, this is the EVENT you've all been waiting for - THE ANNUAL BACK ISSUE BONANZA!! A gigantic throwaway of all available back numbers! Don't miss this exciting opportunity to cash-in on these scarce gilt-edged collectors' items.
> But hurry! Stocks are dwindling fast - black market prices are already a City scandal. *OZ* and only *OZ* can make this sensational sacrifice because of surplus returns from Commonwealth distributors and unprecedented release of impounded copies by New Scotland Yard. This offer may never be repeated! ORDER NOW!!"

Among the particular issues being promoted are:

> "*OZ* 23. HOMOSEXUAL *OZ*. Hounded by Scotland Yard for being obscene. Suck for Peace. Scoop preview from still unobtainable Homosexual Handbook. Miles on the Moon along with several bags of piss. Pirate TV - Rohan O'Railly's plans for Caroline. Phil Ochs meets Mick Farren. Max Emst portfolio, *OZ* answer to *The Forsyte Saga* - the life and loves of Leonard Cohen. Multi-racial male kisses. Only 25 left of most controversial OZ ever. Selling in Earls Court for £3 each. Save £2.5s. Rush your 15s now."

> "*OZ* 27. The mindbending ACID *OZ*. Packed with facts, information and the real dope (suck the corner of page 46 !) on that short cut to Heaven and Hell. You've probably already got it (with this issue our circulation soared to 40,000 plus), but isn't there a friend who really NEEDS it? Do them a favour and drop us 3/6."

Again, it's hard to believe that anyone, unless predisposed to do so, could take these ads in anything other than the jesting spirit in which they are written.

A double page of small-ads is more sad than provocative, and evidence was to be brought showing that since such advertisements were primarily of interest to those in search of such information, they were hardly likely to corrupt or deprave those who were not. But, for the record, these included:

"HI THERE SEXY. Contact New Sexciting Adult Friends. S.A.E. for FREE DETAILS Where BCM/WWW, London W.C.1."

"SWEDISH PORNOGRAPHY. PHOTOS FILMS SLIDES MAGS Uncensored, unretouched nudes. Males and females. ALL VARIATIONS. Send 10/- (or 9 I.R.C.'s) for profusely illustrated full colour catalogues. Adults only. SEND TO: TRENDEC-O, Fack 6105, Malmo 6, Sweden."

"BISEXUAL YOUNG MAN, 23, OF CENTRAL LONDON SEEKS MATURE FEMALE WITH SIMILAR TENDENCIES. Box No. 4 (28)"

"Submissive Male with guilt complex seeks Dominant Female, Box No. 6 (2')"

"Guy requires turned on chick for temporary marriage. BEL 5873."

"VOYEURS . . . HOMOSEXUALS Lesbians, Heterosexuals, all Erotic Minorities . . . Join
Contact Club International. Ulrikagatan 2, Stockholm, Sweden. Membership £2 only. 100% Confidential. Free Fucking, Sucking, Hardcore Pornzines of your choice! Excellent for masturbation and Fuckstimulation!!"

"Exclusive private male 'Gaye' guest house. Privacy guaranteed. Send for brochure for immediate particulars. Ring 28348 Hastings after 6 pm"

Finally, there is a two-page feature headed

"The *OZ* MULTI-PURPOSE ANTI-FORM FROM THE INTERNATIONAL SOCIETY FOR THE ABOLITION OF DATA PROCESSING MACHINES. USE IT TO ANSWER ALL OFFICIAL REQUESTS FOR INFORMATION, E.G.: TAX RETURNS, LICENCES, CREDIT REQUESTS, SOCIAL SECURITY ETC."

It includes such pertinent and topical questions as:

7. WILL INFORMATION BE FED INTO A COMPUTER?
Yes No

8. IF YES, NAME, MAKE AND MODEL NUMBER

9. WHO WILL HAVE ACCESS TO INFORMATION?

(Agencies, Government and or Private, and individuals; please list all names. If unknown, please state.)*

Lastly, there is a page of puzzles. Anderson was to testify that this page was little more than a collage designed to brighten the end of the magazine. Apart from an exhortation to "keep your blood clean" and advice to mothers about not whipping their children for wetting the bed ("They can't help it. It's a disease, a dangerous one !"), the page contains one poem of dubious virtue:

* The International Society for the Abolition of Data Processing Machines is an interesting footnote to the social history of the 1960s. It was founded by Harvey Matusow (1926 -2002) and American communist who protected himself in the McCarthy witch-hunts by providing evidence against his former left-wing colleagues. In 1955 he admitted his falsehoods in a book False Witness in which he disclosed that he was an FBI agent and was paid to lie about members of the American Communist Party including folk singer Pete Seeger. As a result of this, Matusow was found guilty of perjury and was jailed alongside Wilhelm Reich. Upon his release, Matusow moved to England where he re-invented himself as a minor figure of the Underground and started the International Society for the Abolition of Data Processing Machines, stating that "The computer has a healthy and conservative function in mathematics and other sciences", but "when the uses involve business or government, and the individual is tyrannized, then we make our stand".

> "There were days I spent
> In an aggrovated [sic] haze,
> And weeks of endless bover,
> But now I dig the Spinach craze
> And Incest with my mother!"

Curiously, although again perhaps not so surprisingly, it is the Underground itself which comes in for the most criticism. In the letter column, for example, Steve Francis leads off with a tirade which removes in one any feeling that OZ, or what OZ has come to represent, is any way the whole or even partial solution for which young people crave. It reads:

> "Dear OZ,
>
> The underground press is failing to live up to its name; in fact it could hardly be more overground if it tried. *IT* seems to have degenerated to chasing itself round in circles; soon, with any luck to disappear up its own arse: *Rolling Stone* never was and never will be, and even *OZ* overburdens us with pseudo-intellectual crap about idealistic revolutions and utopias just around the corner which would be more at home in the heavy weeklies. All the same, *OZ* is at present our only chance, mainly because they do at least experiment with design and lay-out of the magazine; the Magic Theatre edition for instance was a great idea, treating the concept of magazines as an art form in the most imaginative and inventive way so far.
>
> But *OZ* is still severely lacking in many other respects. Too many of the articles seem to be nothing more than reprints from American and Continental magazines, and so many of these are so pedantic and tangled up in words as to be of little interest to any but a tiny minority. Not only this but they lack the punch and vitality which is essential in such articles. They aim gentle body-blows at Society, which are ignored or laughed off, instead of delivering an almighty kick in crutch as often as possible. *OZ* will sidle up to you, put its hand in your pocket, and start frigging you, when what it should do is fuck you from head to toe, body, mind, heart and soul, fuck your brain clean of the stench and slime of Society, leaving you ready to accept revolutionary and anarchistic ideals and doctrines. This totality of involvement is missing at the time when we need it most.
>
> For too long we, the readers, have sat back and had shit shoved into our brains. WE should decide what we want to read, not just accept what is given to us. WE should write the fucking magazine, it should be a medium through which our ideas, our creativity, can be communicated to people who think the same and to break through the mental apathy of those who couldn't care. How can new ideas, new ways of thinking be born and become something like established if they cannot be put across to the maximum number of people possible? We should be concerned with the now, and the future using the past only as a form of reference and a means of

avoiding the more obvious pitfalls. Too much of the bullshit that appears in *OZ* is anachronistic as soon as it is written.

Compare them with articles in the *New Society* or the *Spectator*. Are they really different, apart from words like shit and fuck which occur more frequently? Are they inciting us to riot, to rebel, to burn the cities down? Where is the petrol these words should be pouring on the embers of our seemingly defunct anarchism? Perhaps everyone's scared of burning their own hands, of seeing accusing fingers pointing at them. Perhaps beneath their easy talk about revolution there is an under-current of reactionary thought, a process that will devolve them into the same grey mass they pretend to reject. How long before the wife-and-kids-and-mortgage syndrome gets the better of them and they sink into an even more vacuous existence then before? . . . The pages of *OZ* should be packed with the fuel of revolution, which should burst into flames as it is read, flames that dance mesmerisingly before the eyes, flames that spread into the mind and rekindle the fires of rebellion that seem to be dying. Nothing whole-hearted or committed is happening NOW, nothing is there to incite us NOW, just vague promises about tomorrow. Tomorrow must become today. Kick out the jams NOW."

<div style="text-align: right;">Steve Francis</div>

A little overwritten, perhaps, but hardly the stuff of complacency. And the same could be said of a furious letter printed opposite:

"Dear Ed,

I've followed OZ since its first appearance and I wish I had them here as a reference. I'm sure happy that it exists. I'm aware of all your problems, printers, suing etc. but for Fucks sake! You are on what year now? Third? First I could not read it at all but I figured that part you would learn. You did. The full blown pictures are extinguishable. Congratulations! After three years: pathetic!

The whole world is packed to the brim of talent. Poets, writers, music, art, LIFE. And where are you now? Tired, you say. Your plea for aid from schoolchildren in the last issue. Put it on the cover baby. You need it. Not in the smalls.

OZ being the only anywhere near organised 'Underground' mag in Europe, well for HEAVENS SAKE. SPREAD IT!

You have a lot of responsibility. Not towards saving your own literary Public Image baby, but in spreading the TRUTH! COMMUNICATION! That's what I work for. Enlightenment. Spreading a mag. does not only mean finding stores other than Smith's. Remember 100 per cent of your readers have more than once in their lifetime been exposed to a sexual organ,

and, would you believe, all 100 per cent have actually made use of it too?!! Incredible as it may sound. .

One does not need it shoved in one's mind from every corner of the universe, and particularly not from the pages of *OZ* which has a hell of a lot more to say. You've got *Suck* and others for that. That's their bag, baby, let them do it. Stick to your own. *OZ* is important. We need you!

At least 90 per cent of what's written and painted today is unpublished. Well. Do something about it. Don't people submit any of their work to you? You do a LOT, but you could do more and back again to the cocks and cunts. I'm fucking convinced that it does more bad than good. Think about that."

<div style="text-align:right">
B. Bjerke

Lista de Correos

Ibiza,

Balearic Isles, Spain.
</div>

And a third letter, printed under the misleading headline 'And now I'd like to fuck you miss', continues in the same vein:

"Dear Editor,

OZ always seems to me too flippant in its approach and presentation to be seriously for or against anything, with the superimposition of words on pictures suggesting that neither is up to much; but if the two are thrown out together maybe it'll look interesting. As long as *OZ* remains principally a consumer good, I don't see it as being genuinely revolutionary or anti-Establishment. Not that there's a publication in Britain that does seem to be a genuine, informed yet still emotional yet still well written, response to important and unfashionable events.

That piece on Scunthorpe epitomised all I resent in *OZ*, the Underground taking a snotty look at the provinces; if OZ was real, it would attract pieces from kids who've lived in Scunthorpe and really knew it - you'd have written to the English teacher at a local comprehensive school and had him commission his hippest kids to do something for you.

As it is, I'd be as embarrassed to be in *OZ* as I would be if I were in *Radio Times*.

I wish *OZ* would open up, become more wide-eyed in what it covers and more accessible in how it presents its material. It seems to me to be no kind of achievement that most of the kids I teach (16 to 19 years old, at one of the most progressive colleges of SE London), working class to upper class, can't relate *OZ* to themselves, although they are the personnel who would be staff in any revolution - if such a thing had any kind of reality, which (you will have gathered) I don't think it has, in Britain.

The lines you apparently see between the Establishment and you get blurred and rubbed out every time you, and anybody connected with you, goes on TV, every time you accept a CBS ad...

I don't believe in revolution, but I do look for a diffusion of responsibility; in general, the Underground seems more rather than less passive, vulnerable, gullible, and less rather than more likely to achieve change (although it may be more willing to accept changes initiated by somebody else). Basically, the Underground depresses me; from the unintelligible guitar solos to the unintelligible writing, it seems to celebrate masturbation. And that's unproductive.

So 'till things are different, I'll suck the tits of the Establishment in preference to joining the wanker's circle. Thanks."

C. G.

Perhaps the most balanced viewpoint, and, from the point of view of the Jury, probably the most sensible, is expressed in a fourth and final letter. It speaks for itself.

"Dear *OZ*,

When I first heard of the magazine *OZ*, I was curious to know what underground magazines contained to make them frowned upon by society in general. My first impressions (as I stared at a distracted nude) was one of repulsion. I decided that it was a load of pornographic crap.

A small group of girls sat in the corner of the classroom hovering like a load of vultures and sniggering over advertisements for contraceptives and pictures of nude bodies. They knew about such things (the majority were not virgins), and yet they still had not passed the giggling stage. Their embarrassing titters infuriated me.

I voiced my opinion on the magazine and was informed I ought to really read it and not make snappy decisions. After reading a number of back copies, I realised a number of the articles were rather interesting and enlightening. Eventually I grudgingly admitted being wrong."

HILARY.

William Kirk, [the] Chairman of the Mental Health Council, later said that Neville, Anderson and Dennis would get their just deserts. After sentence had been pronounced, Mr. Kirk said:

"From Mr. Justice Argyle, the wizards of OZ have got what they deserved. He is giving notice that it is no longer a paying proposition to peddle filth to the young for profit."

CHAPTER THREE

The case for the prosecution was in the hands of Mr. Brian Leary, an apparently gentle man of infinite charm, with swept back greying hair and well clipped sideburns. Called to the Bar in 1953, he had been a Harmsworth Scholar at the Middle Temple. He had also a pronounced tendency to nod and wink at the witnesses as if trying to comfort them, although these affectionate gestures may have been no more than nervous twitches. Now one of the senior prosecuting Treasury Counsel at the Old Bailey he had a reputation for a worldly, although scrupulous, fairness. He had prosecuted in the notorious 'Queer Bashers' Case', for example, in which it was proved that a group of skinheads had, with no provocation, maliciously beaten up and seriously injured some passing homosexuals. More recently, he had assisted the Attorney General in obtaining the conviction of the Hosein brothers for the murder of Mrs. Muriel McKay, wife of the Deputy Chairman of the *News of the World*.*

Aged 42, a product of King's School, Canterbury and Wadham College, Oxford, Mr. Leary now lived in Kent where, at weekends, he nursed his herb garden. It was rumoured that, with his wife and 12 year-old son, he spent his holidays in Acapulco.

Altogether, he seemed much too friendly a man to be seen hounding such as *OZ*. His opening speech, moreover, was a model of courtesy and tact, introducing the different counsel to the Members of the Jury with a great deal of "My learned this" and "My learned that". It was not until he moved on to a description and discussion of the business which had actually brought us all here, that he showed any signs of being particularly interested in anything other than the effect of his own politeness.

* This was a particularly nasty *cause célèbre* in the late 1960s, although it is largely forgotten today. Arthur and Nazamodeen Hosein were from Trinidad, which was a British Crown Colony in 1955 when the Hosein brothers emigrated to England. Arthur borrowed heavily to buy an old farm house on the Hertfordshire/Essex border. One night the brothers were watching media magnet Rupert Murdoch and his wife Anna on television when they had an idea for a potentially very lucrative crime. However, on 29th December 1969 they kidnapped the wrong woman, as the wife of Murdoch's deputy Alick McKay was using the Murdoch's Rolls-royce whilst the Murdochs were on holiday. Several hours later McKay received a telephone call demanding £1 million for the return of his wife. She was never seen again and it is widely believed that her body was fed to pigs on Hosein's farm. In 1970 the Hosein brothers were found guilty and jailed for life. Arthur is now dead, whereas his younger brother has - allegedly at least - returned to Trinidad.

"In an earlier edition of *OZ* magazine," he began, "the publishers invited persons under 18 to come along and to help edit the April *OZ* ... the edition, of course, which came to be known as *OZ* No. 28, School Kids Issue. In *OZ* No. 26, there appeared a little advertisement; it read like this:

> 'Some of us at *OZ* are feeling old and boring. So we invite any of our readers who are under 18 to come and edit the April issue. Apply at the *OZ* office in Princedale Road, W.11, any time from 10.00am to 7.00pm on Friday, March 13. We will choose one person, several, or accept collective applications from a group of friends. You will receive no money, except expenses, and you will enjoy almost complete editorial freedom'.

Leary went on to say that one Vivian Berger had: "contacted the offices of *OZ* at No. 52 Princedale Road at Notting Hill and subsequently, as he will tell you, attended a number of editorial meetings. On either April 6 or 7, he went to Richard Neville's basement flat at 38A Palace Gardens Terrace - again in Notting Hill - where there were a group of about 25 young boys and girls, all of them - apparently - under the age of 18. And, according to Vivian Berger, the three accused made it clear to him, and to the rest of the group of young persons there assembled, that they should decide which articles and illustrations should be published in the future edition of this magazine *OZ*. On the three following weekends, Vivian Berger says that the same group - or most of the same group - attended Anderson's flat which was on the first floor at 38 Palace Gardens Terrace, and selected every single article and cartoon which was eventually published in the magazine. Upon publication of the School Kids Issue No. 28, he was given three free copies of the magazine. He kept one at home and he passed the other two copies to his class-mates in the fourth year at the school he was then attending. Now, when you come to listen to that young man giving his evidence, Members of the Jury, treat what he has to say with care. He is, what we would call, an accomplice."

The sinister connotations of that word echoed round the Court Room. You knew, immediately, that dirty work had been afoot. Mr. Leary winked, knowingly perhaps, at Mr. Neville, who remained impassive. Leary went on to explain how this sinister document, *OZ* 28, had been distributed throughout the land; evidence was to be brought from newsagents in Banstead (Surrey), Leeds, Doncaster and Basingstoke to the effect that, yes, they had actually had in their possession this allegedly obscene document. One wondered what kind of police 'persuasion' had gone on to extract these 'confessions', or maybe one was getting over-sensitive and the police were just doing their job. Leary gave a little cough, nodding to the Judge who nodded back, and then began to recount, in a hushed whisper, the original police raid on the offices of *OZ* in the said Princedale Road.

> "If a complaint is levelled by any member of the public," he began, "about an allegedly objectionable book or film, Members of the Jury, it's referred to the Obscene Publications Department in Scotland Yard. Thus, in this case, officers of that department carried out an investigation of complaints received about this magazine and interviewed each of the three accused as to his individual responsibility for the publication. Members of the Jury, let me tell you what each of them said when they were seen by police officers of that department on June 8.
>
> At about half past three, officers from the department went to visit Princedale Road and there saw the secretary, a young lady called Marsha Rowe.

She dialled a number and spoke on the telephone to somebody - who turned out to be 'Jimmy' Anderson. He was told that the officers were there and would wait for a few minutes until such time as he came along. Later, he was asked if he'd been involved in the production of *OZ* No. 28, and he said:

'Yes, it's terrific, don't you think?' And some three minutes later, Mr. Dennis, another of the accused, turned up with a young girl companion and was asked what his position was with OZ. He said, 'You already know, I'm a director'. Anderson was then asked who was responsible for the publication. He said 'Felix' (meaning Felix Dennis), 'Richard Neville and myself . . . I am mainly responsible.' And turning to Mr. Dennis, the officer said: 'Is that right? Are there three of you responsible for publication of OZ?' And Mr. Dennis said: 'Yes, you bloody well know.' Later Mr. Dennis said: 'My God, I can sense you're hostile to this publication.' And they were then cautioned that they weren't obliged to say anything, and that anything they did say would be taken down in writing and given in evidence. And Mr. Dennis, amused to the last, said: 'Shouldn't you have done this earlier?' Finally, they were asked how many numbers of No.28 were produced. Mr. Anderson said: 'About 40,000. It's good don't you think?' And Mr. Dennis said: 'Don't say anything. If they've done their homework, they'll know that anyway.'

Mr. Dennis added later: 'Look, we're a reasonably happy bunch of guys, just a bunch of long-hairs trying to bring out a magazine. I think it both necessary and desirable, but clearly you think otherwise; what do you say to that?' And the officer then passed a comment that has no place in, uh, this case."

There was laughter, not surprisingly; the Judge looked cross. Mr. Leary winked at him and he smiled, wanly.

"Mr. Anderson then said: 'The point is, the children produced it themselves not under our guidance' And Mr. Dennis added: 'Look, you've only got to go down to the cafés in the Earls Court Road and places like that and see what happens to the repressed children. See the drug addicts and the alcoholics - the dropouts of your society.' Mr. Anderson said: 'We believe in what we're doing. I think it's terrific the kids did this. We were all impressed with their ability.' Mr. Dennis agreed: 'I'm proud of it. It gave us an injection of youth; you can quote me on that.' And with that parting shot, the officers left, no doubt with the magazines under their arms."

It was already 4 o'clock so the Court rose for the day. It was becoming apparent that one reason for the slowness of English justice is the leisureliness of the Courts. Thus, at the Old Bailey for instance, sittings almost never begin before 10.30am and usually end for the morning by about 12.50pm. Often there is a fifteen minute adjournment mid-morning which is called at the discretion of the Judge usually for the benefit of the shorthand writer who might otherwise - as Mr. Argyle frequently remarked - "get tired".

The afternoon session begins around 2.10pm and can end as early as 3.45 p.m., again at the discretion of the Judge and presumably depending on his 'other commitments'. On the second Friday afternoon, for example, Judge Argyle could be seen studying a road map of England throughout the proceedings. An unkind soul suggested that Argyle was planning his weekend in the country. In all, on this reckoning, the most that can be expected from the Courts is a 4-hour day, or 20-hour week. For this, a High Court Judge is paid in excess of £10,000 a year.

His Honour, Judge Argyle, whose hobby is boxing, has three teenage daughters. At the beginning of the trial, he had told the defendants that since it had been he who had refused their application for an adjournment, he would now stand down if they preferred. He had not realised at the time that he would be judging their case and did not want them to think that he was in any way prejudiced. Neville thanked his Lordship for this courtesy but agreed for him to continue. The Judge made another, and perhaps more revealing, admission to the Jury. Referring to a great sheaf of documents which had been handed to them, he said:

> "Don't worry at the moment if you don't understand them all. Nor do I. But as the case proceeds, particularly a specialist case like this, I've no doubt we'll get a grip on it by the end."

Mr. Leary, meantime, coughed his way into the second day. Referring to the same bundle of papers, he began:

> "The word obscenity, where it arises in this particular act, is defined by Section 1 of the Obscene Publications Act of 1949, and it's been thought helpful to you to set out the relevant section. If you look under the heading of Test of Obscenity, you will find these words: 'An article should be deemed to be obscene, if its effect, if taken as a whole, is such as to tend to deprave and corrupt persons who are likely, given regard to all relevant circumstances, to read, see, or hear the matter contained or embodied in it.' And Section 2 makes it an offence to publish something which is obscene within the definition given by Section 1. Look also at the words set out under the heading 'Defence of Public Good': 'A person shall not be convicted of an offence under Section 2 of this Act, if it is proved that publication of the article in question is justified as being for the public good on the grounds that it is of interest to science, literature, art or learning or other objects of general concern.' As to deprave and corrupt: deprave means, as you'll note, to make morally bad, to pervert or corrupt morally. And to corrupt, in its turn, means to render morally unsound, rotten; to destroy the moral purity or chastity, to pervert and ruin, to debase and defile. . . and I'm just taking, at random, various dictionary definitions. In other words, that you are, by your actions, directing somebody towards unlawful behaviour, or anti-social behaviour, or immoral behaviour, morality being something which is considered essential to the well-being and healthy life of a community. And anybody, who by writing or by publishing somebody else's obscene writings, corrupts that fundamental sense of morality and the Law says he is guilty of a criminal offence. Further, it's not a question of whether he or she has corrupted anyone; or whether he or she must corrupt anyone, or whether he or she will corrupt anybody . . . but whether, what he or she has published, will tend to."

By this time, the Members of the Jury (who had not yet been allowed to see the offending magazine) were having their tongues so thoroughly whetted, that a copy of *The Beano* might have seemed to them obscene. Or, at the very least, tended to. In all, 26 jurors had been objected to on the first day by the defence; although it is not incumbent on the defence to state any reason for their various challenges, it had been clear that they hoped to get as sympathetic a collection of jurors as possible. The chosen few, however, certainly looked a mixed bunch. A tubby, 45 year-old, red-faced gentleman; a dyed blonde with bright blue spectacles, and a six-months pregnant housewife whose daughter, we were to learn, was about to give birth herself. You could imagine the sweat breaking out on their foreheads as Mr. Leary at last moved into the attack. Dangling a copy of the offending *OZ* 28 within their sight but beyond their reach, he winked at Neville and began:

> "Let us examine what this magazine deals with. It deals with homosexuality; it deals with lesbianism - on the front cover! I don't know whether you can see the front cover of the magazine from where you are seated, but you will. It deals with sadism; it deals with perverted sexual practices; and, finally, it deals with drug taking. You will - having read the magazine through - ask yourself: 'Does such a magazine in fact tend to corrupt and deprave persons in whom those sort of practices are latent?' And I mean, Members of the Jury, those persons - and there are a lot of them about - who are anxious to experiment with drugs: children, teenagers, youngsters, call them whatever you will, into whose hands this magazine was clearly likely to fall.
>
> Some things, of course, may be indecent without being necessarily obscene. Let me give you an example: if a man strips off on a crowded beach and lies there naked for all to see, you might reach the conclusion, no doubt, that that was indecent. If that same man lying there started to masturbate himself, Members of the Jury, you must reach the conclusion that that was obscene.
>
> Lastly, remember: you do not sit there as judges of taste. You do not sit there to say whether you like or approve of the sort of things you'll find published in *OZ* No. 28. And you're not sitting, in any sense, as a board of censors deciding what should and should not be published."

So why *were* they sitting there? It was a question Mr. Leary left unanswered. Instead, he proposed to call his witnesses for the prosecution, the 'conspirator', Vivian Berger, and Detective-Inspector Luff. It did not occur to anyone at the time, least of all Mr. Leary, that in spite of all his tending to deprave and corrupt, neither he nor the police had managed to find a single child who had, in any sense, been depraved or corrupted (or even who had tended to be depraved or corrupted) by *OZ* 28 - School Kids Issue.

The good Detective-Inspector bustled into the dock, all blue-suited and Brylcreemed. A nice man, he personified with his little blue eyes and snub nose, the American slang description of all policemen. Married, with three girls aged six, eight and ten and a little boy aged four (had they been corrupted?) he had joined the Metropolitan Police when 21. A police constable for the first 11 years, he had found his vocation, some thought, when he had joined the Obscene Publications Squad in June, 1969.

Alas, his career had been short-lived. Fourteen months later he was moved on - into 'training'. No-one in Scotland Yard was prepared to admit what or whom Detective-Inspector Luff was training. Luff began his evidence with a painfully slow account of how he had gone to the offices of OZ in Princedale Road and seized the sinister material contained therein. He did, however, make one admission which caused a flutter.

> "I cautioned the defendants, Mr. Dennis and Mr. Anderson, and informed them that the facts would be reported to the Director of Public Prosecutions, firstly in relation to obscene material and secondly in relation to offences in the Post Office Act. Mr. Dennis said: 'Wow! Be sure you get that right. Okay, so you'll get us under the Post Office Act, not the other one.' Then he added, 'Right on!'"

At this, the Judge asked: "Did you understand him to mean 'write on'?"

And Luff replied: "Well not write on - W.R.I.T.E. - but a revolutionary expression, 'Right On'; this is what I understand the remark to mean."

The Judge said: "I see," and Mr. Leary winked.

Richard Neville then began his cross-examination of the good Inspector. The prospect of the two principal contestants face to face at last promised much.

> "Detective-Inspector," he began. "I've lost track of the number of times you've seized various publications from the authors of OZ, and I was wondering if you could tell me on how many occasions you have raided our offices?"

Luff smiled at the Jury and with the confidence of one long accustomed to the rigours of the witness box and answered:

> "I'd have to do some research to answer you absolutely."

> "You could tell me, roughly, how many times, could you not?" replied Neville.

Luff paused. "I would think half a dozen times", he said.

> "And what were the articles taken by you or by the Obscene Publications Squad?" asked Neville.

Luff grinned again, his puffy cheeks looking puffier.

> "Well," he stumbled, "I understand there was some previous issues of OZ which were taken and submitted to the Director of Public Prosecutions. These were subsequently returned to you or your other defendants. Apart from that, I think only the articles we have before us in Court today and a number of others which comprise those publications, packages which were about to be posted."

Neville interrupted: "What about such things as advertising files and artwork and personal letters?" he inquired. It then became apparent that Luff had taken away private documents, pictures hanging on the wall, a filing cabinet and more-or-less anything he could lay his hands on.

> "Would it be fair to say, Inspector," Neville concluded, "that you removed so much material, not because you were particularly interested in getting evidence against OZ 28, but because you had decided to close down the whole operation of OZ magazine?"

Luff puffed. He looked at the Judge who was momentarily consulting his A-Z of London streets. Mortimer polished glasses, slowly, and we waited. Eventually, Luff said:

> "It would not be correct to say that. I took such documents and such magazines as I considered would be material and relevant to any proceedings which might be brought at that time."

But he was not to be let off the hook so lightly. Neville hustled in and asked: "At one stage, did you actually say to one of the defendants, Mr. Dennis, that you believed that OZ ought to be closed down?"

Luff paused. "I don't think I used those words," he said and paused again; "...but I certainly made it clear that I didn't like OZ publications."

Neville asked: "Do you think that the underground press in this country has a legitimate right to survive, to exist?"

Luff seemed confused.

> "Well, as a whole," he began, "I can't comment because, obviously, there are some publications that are in a different category to this magazine; but one is forced to use one's own thoughts when they attack society and try to change it in that direction, yes."

After a further pause, he added:

> "I was asked whether the magazine as a whole tended to deprave and corrupt me; as an individual, it is difficult to say. When one considers the magazine as a whole, perhaps there is a general dirtying of the mind."

Luff fingered the edge of the witness box, looking nervously around for support.

John Mortimer now rose to the attack.

> "Inspector, just let me ask you this. You're the officer in charge of this case, I expect, aren't you?"

> "Yes, I am, sir."

> MORTIMER: And as far as my clients, Mr. Anderson and Mr. Dennis, are concerned, are they two gentlemen of perfectly good character?
>
> LUFF: Yes, they are, sir.
>
> MORTIMER: Does that also apply to Mr. Richard Neville?
>
> LUFF: Yes, it does.
>
> MORTIMER: Has he ever been in any trouble in the Courts of this country before?
>
> LUFF: No, he has not.
>
> MORTIMER: And yet you told Mr. Richard Neville that either you, or members of your squad, had previously made about half a dozen visits to the premises of *OZ* magazine.
>
> LUFF: Yes, sir.
>
> MORTIMER: Have you in the course of your investigations, Mr. Luff, made any inquiries as to the sort of people among whom this magazine is circulated?
>
> LUFF: We've confined it to the area produced in Court . . .

This somewhat mysterious answer did not, however, prevent Mr. Mortimer from reading a list which Luff had seized but somehow overlooked.

"It starts with Mr. Richard Ingrams of *Private Eye*," Mortimer began.

> LUFF: Yes.
>
> MORTIMER: You are familiar with the magazine *Private Eye*? And you weren't supposing that anyone working on that magazine might be liable to

be corrupted by anything that might appear in *OZ*? Have you heard the name of Mr. Kenneth Tynan at all?"

LUFF: Yes, I have.

MORTIMER: Would you . . . no, I'm not going to ask that question. Is he a very well known journalist and writer?

LUFF: Yes, I suppose so.

MORTIMER: And then Mr. John Gordon of the *Sunday Express*?

LUFF: Yes, sir.

MORTIMER: Not exactly a pillar of the permissive society?"

The humour of the situation did not appeal to the Judge.

"This is a trial of criminal charges of some gravity," he complained. "There's been a lot of laughter in Court. I have deliberately said and done nothing about it; but this is not a theatre for public performance. I think it will be a great deal better if people in Court and in the gallery did any laughing they wanted to do outside this Court. I'll say no more for the moment, but if it goes on, this Court has more than adequate powers to deal with any situation that arises. Yes Mr. Mortimer?"

Mr. Mortimer proceeded to flick through the mailing list.

"Miss Caroline Coon, the co-founder and inspiration of *Release*, the drugs organisation; the National Council for Civil Liberties; Manfred Mann, the pop singer; Jeff Nuttall, the author of *Bomb Culture*; Jonathan Aitken, the journalist; Alan Aldridge, the painter; William Burroughs; Ray Connolly, the columnist; Geoffrey Cannon, editor of the *Radio Times*; Michael Bateman, of the Atticus column of the *Sunday Times*; the news editor of the *Daily Mirror*, Clive Goodwin; Mr. Richard Crossman, the editor of the *New Statesman*, a former Cabinet Minister; the Defence of Literature and Arts Society; Christopher Logue, the poet; Charles Marowitz, the theatre director; Gerald Scarfe, the cartoonist; Derek Hill of the New Cinema Club; Mr. John Lennon, a well-known singer; the publicity manager of Messrs. Faber and Faber..."

It was an impressive list. At least, for the first time, the Jury looked momentarily impressed. Mr. Mortimer prepared his *coup de théâtre*. Shoving his spectacles up his nose and beckoning to Detective-Inspector Luff, he began:

"When you answered the questions which Mr. Neville put to you about wanting *OZ* to be closed down, you said that you might wish that to happen, because in your view it attacked society, did you not?"

Luff drew himself up to his full, authoritative height, and replied: "Only I didn't use those words; but I since you put it, in my opinion, (of course, my opinion is not worth much), but the School Kids Issue . . ."

* Kenneth Tynan (1927-1980) was another one of those people who, at the time of the first edition, was a household name, but is now - four decades on - largely faded from memory. He was a theatre critic, a playwright, most notorious for having presented a revue called *Oh! Calcutta!* a show which included segments written by Samuel Beckett and John Lennon and featured frequent nudity. He was also the first person to say the word 'fuck' on British television. Amusingly, *Private Eye* always maintained that Tynan's stammer made it the first thirteen syllable four-letter word.

Mr. Mortimer got cross and interrupted: "Now, just listen to me; first of all, just answer the question. Did you not say, in answer to Mr. Neville when he asked you about OZ closing down, that it was your view that OZ attacks society; didn't you use that phrase?"

Luff adjusted his tie and brushed his suit nervously. Eventually he replied: "Yes, I did."

And Mortimer, now pointing the finger, said: "Isn't that the real basis for police hostility to this magazine?"

Luff flapped around and bleated:

> "Sir, you asked the question as to why I used the word hostility. But the basis for police action in these proceedings came about as a result of members of the public contacting us, as police officers..."

His voice trailed away as Mr. Mortimer had already sat down, ignoring the good Detective Inspector. The point had been made. McHale followed. As defence Counsel for the publishing company, *OZ Publications Ink Ltd*, he had one noticeable advantage over his fellow advocates. He was sometimes completely inaudible at least to the gallery; and even in his rare moments of audibility, he seemed to pin his oratory on words such as 'ratiocination'. A mild, moustachioed, middle-aged man, he carried with him the most beautiful of Juniors, a black gentleman. What with the nods and winks from Mr. Leary, the whole place began to feel at times like a sophisticated tic-tac school rather than a Court of Law. Luff admitted to McHale that he had heard the phrase 'Alternative Society' somewhere or other but wasn't quite sure what it meant. And that was that. For the present, there was no further mileage to be got from Mr. Luff.

After an adjournment, statements were read out from the various newsagents declaring that yes, they had had the offending magazine and that yes, they had sold it for money and yes, they had been interviewed by the police and yes, they admitted to being naughty and yes, this was the truth, the whole truth and probably nothing but. Neville spoke his speech as did Mr. Mortimer and, at last, into the witness box stepped a real live member of the criminal classes, the 'conspirator', Vivian Berger, or Viv Kylastron, as he had described himself in *OZ*.

Diminutive and dressed in a brown, tasselled, suede jacket, he began by saying that he could not take the oath as he did not believe in God. Mr. Luff looked shocked and the Judge looked pained. However, Vivian Lawrence Berger 'affirmed' which, in Law (the Judge told him), was just as binding as taking the oath. He proceeded to tell of how, in reply to an advertisement in *OZ 26*, he had written to the editors offering his services for the School Kids Issue. Subsequently, he had attended a number of editorial discussions at the first of which he was still only 14 and a pupil at Alice Owens' Grammar School in Islington. He explained how Neville, Anderson and Dennis had offered advice as to the technical requirements of the magazine but had never interfered with the content. Berger himself had been responsible for a cartoon in which Rupert Bear rapes Gipsy Granny. Actually, he had made a collage of an American cartoon (Gipsy Granny) on to which he had stuck Rupert Bear's head and added Rupert Bear captions to make up a scurrilous, although he maintained, humorous, little fable. Thus, beneath the caption, 'Rupert Finds Gipsy Granny', Rupert is seen staring up the vagina of the reclining lady. The limerick reads:

> "It looks just like a ball to me.
> Open it and see."

Picture 2 is headed 'Rupert's way Barred', and the story continues:

> "Then Rupert starts to push and peep.
> But finds the hole is much too deep."

Berger confessed to Mr. Leary that he had also contributed three of the articles, one of which he had signed with the apparently mysterious pseudonym of 'Viv'. Mr. Leary looked impressed with his wisdom. No, replied Berger, he hadn't been paid and, as he lived in Hampstead, he hadn't been paid any expenses. But they had all been into Mr. Neville's garden and had their photographs taken, although they were fully clothed at the time.*

Yes, he had seen "at least 100 copies" of the magazine circulating in his school although how they had come to be there, he couldn't actually say. "Someone must have smuggled them in - at night."

> "The message behind the magazine," he added: "was that the people who were involved in the writing of it, considered that a change in the educational system was necessary. That was the message as far as I was concerned."

Mr. Neville, in his cross-examination of the young Vivian Berger, made a more substantial point. Having established that Berger had never been allowed to say what he wanted to say

* During production of this present edition, the author noted that – at the time – Richard Neville lived in a flat which – to the best of the author's memory – had no garden. The pictures were quite possibly taken in the author's garden instead. Claims in various monthly music magazines during the year prior to publication of this new edition that the pictures were taken in the garden of John Lennon's mansion, Tittenhurst Park, near Ascot in Berkshire, are completely wrong.

in the various school magazines available to him and that he felt his experiences with *OZ* had in no way rendered him 'morally unsound', Neville asked him if he had met Detective-Inspector Luff before. Yes, replied Berger, he had taken his statement from him. And since that time? Berger paused and then said:

> "About a month later, I was stopped in the street approximately two or three times a week and searched and even occasionally taken down to the station and searched again. I was always let free later to carry on with what I was doing, but as this all happened about two or three times a week, it became rather a hindrance. Wherever I was, I felt I had to look out for policemen. One day, for example, I went down to the end of the road to buy some cigarettes. As I came out of the shop, I was stopped by two plain-clothes policemen. They searched me, and asked my name and address, which I gave them. When I got to my house, I found two more plainclothes policemen standing by the door. They searched me again and asked me my address. I went into the house and stayed there for about half an hour. Then I came back downstairs and went out of the house again; but the same two policemen were still there and they searched me again, saying that I had probably been into the house to collect some drugs. They didn't find anything on me, so I then went back into the house to tell my mother who rang the solicitor. About two hours later they came around to the house again and searched me once more. Later, I went out to see a film but when I came back, they were still outside the door and I got searched again before I was allowed in."

The Judge asked if Berger could recall the date. Berger replied:

> "I'm not sure of the date . . . sometime in the earlier part of June, I think; I'm really not sure. It's very confusing. There were so many incidents. The only one I can be certain of was round about the 23rd of December when I was searched on the way to a school play. Because I refused to go to the station, I was beaten up in their car."

"Beaten up?" asked Neville.

"In their car: by the policemen," replied Berger.

Neville asked "Have you had similar experiences with the police before you were involved with School Kids *OZ*?"

Berger thought for a moment and then said: "I think I'd been searched once, before the OZ trial was known about."

Mr. Neville sat down. If ever he could escape the clutches of the Underground, one of the Court ushers remarked later, Neville might make a reputable barrister.

The police cannot have realised that the young man for whom they had developed a predilection for searching was Chairman of the School Council at Hampstead Comprehensive, was a poet whose work had been published in various anthologies, a scholar of sorts whose English essay had been adjudged the best in the school, and an actor who recently had had a successful audition with the National Youth Theatre. Not the kind of inarticulate yobbo who could be beaten up and not bother to answer back - always assuming, of course, that Berger *had* been beaten up.

Asked by Mr. Mortimer why he had contributed the Rupert Bear cartoon, he replied:

> "I think that, looking back on it, I subconsciously wanted to shock your generation: to portray us as a group of people who were different from you in moralistic attitudes. Also, it seemed to me just very funny, and like anything else that makes fun of sex."

Mortimer asked: "You say you did it to shock an older generation? What relevance did Rupert have as a figure or as a symbol?" Berger replied: "Well, Rupert would probably be known to many generations as the innocent young character who figures in magic fairy tales. Whereas here, he's just doing what every normal human being does."

Mortimer tried to clarify this.

> "Was it part of your intention," he suggested, "to show that there was a more down-to-earth side of childhood than some grown-up people are prepared to think?"

> "Oh yes," Berger responded cheerfully. "This is the kind of drawing that goes around every classroom, every day, in every school."

The Judge looked wounded. "Do you really mean that?" he asked, somewhat hurt.

> "Yes, I do mean it," Berger replied immediately. "Maybe I was portraying obscenity, but I don't think I was being obscene myself."

Mr. Leary then elucidated from Mr. Berger that he lived with his mother and his two sisters, aged 10 and 12. Yes, he had often bought *OZ* magazine and yes he had usually left it around the house. His mother had known about his involvement in the School Kids Issue and had actually encouraged the lad to contribute. No, she did not think it had depraved or corrupted him. I say elucidate, although from the pedantic, almost geriatric way in which Mr. Leary proceeded, it was easy enough for the attention to wander. Headaches and slumber, rather than spice and excitement, became the order of the day. Perry Mason was never like this; if he had been, the other Mr. Berger would have won every time. Moving with the stealth of one who suspected that time was limitless, Mr. Leary lurched to the meat of the matter, as he described it.

> "You were asked by Mr. Mortimer," he nodded, "about your contribution to the magazine. Do you remember saying: 'I thought I was portraying obscenity, but not being obscene myself'?"

> "Yes, I do remember saying that," Berger replied, somewhat hesitantly.

Quick as a flash Leary enquired: "And what did you mean by that?"

Berger was not to be cajoled.

> "Well," he replied, "If the news covers a war or shows a picture of war, then, for me, they are portraying obscenity - the obscenity of war. But they are not themselves creating that obscenity, because it is the people who are fighting the war that are creating that obscenity. The obscenity is in the action, not in the reporting of it. For example, I consider that the act of corporal punishment is an obscenity. I do not consider that the act of reporting or the writing about corporal punishment is obscene."

Thus, the word 'obscene' slipped in and out of the discussion without apparent definition.

It was a definition which was to prove crucial to both the defence and the prosecution.

Berger went on to explain how previous issues of *OZ* had circulated quite openly at his school, without complaint from the headmaster, and his cross-examination trailed away into insignificance. Was this the drama we had been led to expect? Outside the Court Room, however, tempers were still high. 'The Friends of *OZ*' issued a manifesto to demonstrate solidarity and to re-advertise an 'Independence Day Rally' on July 4.

> "Up until recently," it began, "we had greeted the harassment of *OZ* with only sporadic bursts of seriousness, as had many of our friends. It was instinctively assumed that we could ultimately establish in a court that *OZ* did not deprave and corrupt - even if it meant re-defining the whole concept of obscenity. Notwithstanding the perpetual ransacking of our offices, we were aware that, in less enlightened communities, we would have been automatically jailed. But it has finally dawned upon us that the authorities in this country take our publishing venture more seriously than we do. We discovered that the police had been watching our houses for some time and they virtually admitted to tapping our phones and keeping dossiers on trivial, little-known facts of our personal lives.
>
> So while the fearful significance of the OZ persecution has become belatedly apparent to ourselves, many people are still more amused than amazed. The pickaxing of this magazine is nothing less than political censorship. *OZ* has relentlessly promoted some elements of the new culture - dope, rock 'n' roll and fucking in the streets; it is the only magazine in this country to consistently and constructively analyse the tension between the freak/drop-out community and the militant left, and to struggle to develop a theory from such antagonism. We see fun, flippancy, guiltless sex and the permanent strike of dropping out as part of an emerging new community, but painfully acknowledge the limitations of leeching on the present society and becoming stooges of its consumer junkeyism.
>
> We appreciate that OZ antics are often adventuristic, escapist, dilettantish, narcissistic and juvenile; but we are congenitally incapable of facing a solemn fun-free future, cutting cane beneath some spartan banner of liberation; we want only to play with our toys, not own them, and we are fumbling towards a solution of living and working collectively - not for profit - which there ain't - but because we love what we do and believe naively in a joyful tomorrow of spiritual, emotional and intellectual *coitus interruptus*. Help whiplash the back lash. For while religiously executed, it is politically motivated. The eunuch Prime Minister and his repressed harem of Cabinet Ministers have created a climate which is stifling every new expression of sexual, political and cultural freedom."

All of which was quite jokey stuff when compared with the apparent solemnity of the Court. Anyone would think that such was the righteousness of the cause, witnesses would be falling over themselves to get into the witness box to speak up for the defence. In fact, at this stage of the trial, some declined to testify on behalf of the magazine because they didn't think the case sufficiently important. At least 20 witnesses were reluctant, including the philosopher A. J. Ayer, Anthony Storr, the psychologist; and Ralph Steadman, the cartoonist, who told me he thought the whole thing obscene, although again refused to define what he meant by 'obscene'.

Later on, witnesses were almost queueing up to testify and many were offended because they were not called. In the chaos of the early days, some suspected that Neville and his friends had engineered the whole affair either in mild imitation of the Chicago Conspiracy Trial (from which, it was claimed, all seven defendants had made money), or out of some naive belief in martyrdom from which Neville hoped to gain lasting, albeit local, adulation. Others thought that the non-appearance of some well-known professional witnesses squashed the popular heresy that the liberal establishment, whoever they may be, felt the need to stand up and be counted once every ten years. 1961, *Lady Chatterley;* 1971, *OZ.* To be liberal these days, apparently, you had to go to Court to say so.

But across the river, less than a mile from the Old Bailey, another and more obviously pathetic little drama was being played out at the Lambeth Magistrates' Court. While Mr. Leary had been examining Mr. Berger, Mr. Mortimer had been temporarily absent defending yet another publication which had fallen under the ever watchful eye of the Obscene Publications Squad, *The Little Red School Book.* Various satirical writers were not slow to see the innate absurdity of the situation in Lambeth, nor its relevance - both immediate and long-term - to the strange goings-on at the Bailey.

> "To be sure," one satirist wrote in the *Spectator*, "I find it hard to relate to you, dear reader, just how depraved and corrupt this pornographic little tome is. If ever there was a case for the suppression of revolutionary muck, this is it. For example, in a section labelled 'Sex', we read:
>
>> 'People go to bed with one another for many reasons. They may lack security and seek it through sex. They may use sex as a way of exploring their own identity. They may have deep feelings for each other and perhaps want to have children. Sex may or may not involve strong feelings. Strong feelings may or may not involve sex. People who warn you against both strong feelings and sex are as a rule afraid of both. They haven't dared to do very much themselves, so they don't know enough about it. Or their own experiences of sex may have been bad. Judge for yourself, from your experiences.'
>
> Now I want you to be quite clear that the garbage that you have just been reading has been adjudged fit only for dirty old men in long mackintoshes. And strictly speaking, what you have actually been doing is commit an illegal act since these words and others like them have been banned by the magistrate, Mr. J. D. Purcell of Clerkenwell, and their publisher, Richard Handyside fined £50 and told to pay £110 costs. Quite right too. In fact, if I'd had my way, he would have been sent to prison for at least 50 years so that he could be prevented from spreading such salacious sewage ever again. And the hairy young man (a hippy, I wouldn't doubt) who shouted at the magistrate 'You obscene old man!' after the magistrate had pronounced sentence, should be flogged. Handyside got his training at that school of cultural debauchery, Cambridge University. He has said that the decision will make him bankrupt. Well, that will be no loss; and as for the Secretary of the National Council for Civil Liberties, Tony Smythe, who said that the verdict was an 'absolutely sickening decision. This is one of the gravest blows to freedom in Britain

which has been experienced for a very long time.' I don't think I need tell you what Mrs. Whitehouse, the well-known and seasoned campaigner for moral purity, could do for him.

Now there are some who maintain that Mrs. Mary Whitehouse is an evil woman. This suggests, of course, that there was a time when she was not an evil woman - a proposition which some others might find difficulty in denying. Her evil influence, it is maintained, lies in the probability that, through her example, more timid souls have taken up the bludgeon of censorship with renewed vigour. Baldilocks Longford and his merry men are merely the public (or maybe it should be pubic) tip of an iceberg whiter than the purest snow. I have never met the good lady (although I've heard tell that she's tried to sue me twice for obscenity), so I hold no brief as to the rightness or wrongness of such criticism; nor am I absolutely certain of her ability to fulfill the demands of being a, sorry, *the* 20th century witch. I'm sure that, deep down, she has a winning smile and a heart of gold although where the gold came from is, perhaps, another matter. However, her presence in the Lambeth Magistrates' Court must have added a considerable amount of fuel to the devilish fires of those who take such uncharitable views of this gay young thing from the Midlands. Just how she came to be there, or who had asked her (if anyone), we must quickly pass over. Someone said that she had attended at her own initiative hoping to be called as a witness for the prosecution. As she sat resolutely at the front of the public benches, it was easy enough to believe such a jibe.

And when you remember that her attendance just happened to coincide with the trial and successful prosecution (so far) of that filthy and degenerate *Little Red School Book*, then you will realise that where the cause is just, Mary (known as Whitier Than Thou to some) is sure to be. At the risk of tempting you further along the paths of unrighteousness, let me quote for you another section of this forbidden document. You will readily see, I know, how such immorality should not be, and will never be, as long as Britain remains great, allowed. You will also note that the subject matter is - once more - sex.

> 'There are many other forms of family life apart from marriage between one man and one woman. People can have group marriages or live together in a group as a commune. But in law our society still only recognises one kind of family - marriage between one man and one woman. People use the word 'abnormal' to mean many things. They may mean something which doesn't fit in with their particular standards; they may simply mean something of which they themselves are afraid. 'Abnormal' is a very dangerous word. It's often used as an excuse for the prosecution and repression of some people by others. It's particularly misused in the sexual context.'

This obvious reference to Mrs. Whitehouse is so insulting and so ungracious that, if I were her, I would sue immediately. Are there no manners left? And when that sneering, leering, defence QC, John Mortimer, made his closing speech at the trial, slobbering as he did over every sexual innuendo in the pathetic and transparent and pathetically transparent disguise of a plea for some sort of wishy-washy liberalism, you could tell where he was at: it wasn't somewhere you or I or Mrs. Whitehouse would care to be.

"Most legal cases deal with hard facts," he began. "This case differs from them in that it deals not with facts, but with opinions' (a likely story). 'No one (in this case)-will ever be able to establish a danger of corruption or depravity. *The Little Red School Book* cannot in any common usage of the word be described as pornography. No one could possibly be titillated by it for purposes of erotic enjoyment.

It is part of a continuing argument between those who think children should judge for themselves, and the Prosecution which says that children are best not told the truth when the truth might be 'dangerous'. Sex, they say, should have a sense of guilt, and then people will be discouraged from unwise experimentation. The defence witnesses" (and a real old rag-bag of do-gooders they were) "put forward an opposing theory: they say that feelings of guilt give rise to obsession, which gives rise to exaggerated interest in sex. They say that to deal with sex in a practical, matter-of-fact way, may help young people find sex less obsessive. It is significant, in a way, that the prosecution has chosen to single out 23 pages from a total of 218. It is characteristic of those seeking censorship to concentrate on sex. Men may do more harm by being wicked politically than ever they will do sexually. Hitler did far more harm that Casanova ever achieved. The attention of the prosecution zones in on 23 pages dealing with sex;" (quite right too); "our exaggerated interest in that, is a symptom of the mystery and clouds that have hung over this matter for years. The book is preaching honesty, concern and judging from one's own experience. Surely this is the opposite effect from 'depraving and corrupting'. This Court will reduce itself to absurdity if it accedes to the prosecution's request.

But, thank God, it did and the book was banned. It was rumoured that John Mortimer was so discouraged by the verdict that he was considering giving up the Bar. And good riddance. We could do with fewer meddling lawyers like him. Surely we have had enough of books like this which question authority. Sex education has got to stop if we are ever going to get into the Common Market. If trash like *The Little Red School Book* (note the Communist overtones) and that other depraved journal, *OZ*, are allowed to get away with it, the Obscene Publications Squad will go out of business. And we've got enough unemployment as it is."

Mr. Mortimer returned to the Old Bailey, a saddened man. For the first time, the defendants looked worried. Before his departure for Lambeth, Mr. Mortimer had argued that since the

prosecution had brought no evidence of conspiracy between Messrs. Neville, Anderson and Dennis and the schoolchildren, this particular indictment should be dropped.

"My submission to your Lordship is this," he began, "that there must be proved an agreement, and, at the time of the agreement, an intent, to corrupt and debauch the morals of children and young persons, and arouse in their minds lustful and perverted desires. Now, m'Lord, the evidence which has been called by the prosecution all points in the opposite direction. Mr. Berger's evidence suggests that, far from there being any agreement, the issue was handed over to the school kids who then produced their own entirely independent work. Inspector Luff's evidence recounted how Mr. Anderson said to him that the children produced it themselves, not under anybody's guidance. Later, Mr. Neville really summed up their state of mind when he said: 'As with all issues of *OZ*, I am involved with publishing it, not because it makes money, which it doesn't, but because I believe it raises relevant and important issues for the understanding of our society.'

That is the real evidence of their intent, which was that he thought it was a socially valid and important document. And there's no evidence at all that there was an agreement to debauch and corrupt young persons. It is not enough for the prosecution to prove an agreement to produce this magazine; they must prove that the agreement was entered into with the intent of corrupting morals. When Parliament last had to consider the question of obscenity, and charges which could be made with regard to obscene articles. they did so in the Theatres Act of 1968. Then, they specifically abolished (with regard to theatres) the offence, the common offence, of trying to corrupt public morals. Thus, we are in an extremely illogical position. If what had happened in this case was that all the school kids had been assembled together at the Roundhouse, for example, in order to produce a play (with the agreement of Mr. Neville and Mr. Anderson and Mr. Dennis) and this was later thought to have been obscene, it would have been impossible to have brought a charge against that performance, let alone an allegation of a conspiracy to corrupt the public morals. In our submission, therefore, it's important to see that this particular charge of conspiracy is not laid against the defendants in these most dubious of circumstances."

Mr. McHale bumbled away along the same lines and Mr. Neville likewise entered a plea that the charge of conspiracy be abandoned. Judge Argyle polished his glasses. Luff looked seedily around. A troupe of Conservative Garden Party ladies rustled in and settled on the visitors' benches, noisily. Constable 395, on 'duty' in Court Room 2, read *Reveille*.

Eventually, the Judge said: "Conspiracy is simply this: a criminal agreement between at least two people to commit a crime; that's the basic definition of it. That's what you're charged with. I have carefully considered the submissions made and also those made by Mr. Neville on his own behalf adopting the arguments by learned legal counsel and by Mr. McHale, but I reject the submissions that were made."

Terse and to the point, you might say. One of the regular crime reporters did, and added mysteriously: "Things certainly don't look too good. Like a drink?"

CHAPTER FOUR

In the Middle Ages, criminal trials in London were usually held within the precincts of Newgate Prison, known universally as the Heynhouse, or 'hateful gaol'. The prison took its name, not surprisingly, from New Gate, which was Roman in origin and twice rebuilt by them. The risk of catching 'gaol fever', or typhus as it probably was, eventually forced the King's Justices and City dignitaries to pass a resolution in Common Council providing for the first building designed specifically as a Hall of Justice for the City to be constructed.

> "It ys nowe agreed for the comfort of all this Cytye that a convenyent place be made for that purpose holsomly to be orderyd and preprared upon the common grownde of this Cytye yn the old bayly of London."

It cost little more than £6,000 and was completed in 1539. But its design seems to have been much criticised. The railed enclosure into which the prisoners awaiting trial were herded, had no roof, and one end of the court was open to the weather, bringing a great deal of discomfort to the jurors. Accordingly, a new court was commissioned (the immediate predecessor of the present Central Criminal Court) and, such was the speed and breathtaking efficiency of the Law in England, it finally opened in 1774. It had only one court but, by the time it became the Central Criminal Court by Act of Parliament in 1834, a further court room had been added and a third was soon needed.

By the start of the present century, Newgate Prison could no longer contain the excesses of Victorian England, and it was demolished. Both the 800 year-old prison, notorious for its filth and corruption throughout literature, and the adjoining 400 year-old Sessions House, passed away with the 82 year-old Queen.

The west view of Newgate Prison, 19th Century

It seemed a fitting end for all concerned. The present building was opened on February 27, 1907, by King Edward VII, accompanied by Queen Alexandra, and cost £395,000. The then Recorder, Sir Forrest Fulton, KC, in his speech to the King, said:

> "We trust this building, whilst well adapted for the transaction of legal business, also possesses architectural features at once dignified and beautiful which will make it an ornament to the Metropolis of your Empire and a fitting home for the first criminal court of justice in Your Majesty's dominions."

The inside of the dome, for example, is sufficiently absurd that if it were built as part of a film set for a Hollywood epic, the designer would be chastised for having allowed his imagination to overrule his better judgment. Unluckily, the bomb which dropped on the north-west corner of the Old Bailey on the night of May 10-11 in 1941, failed to demolish the dome, although it did destroy Court No. 2 in which the *OZ* trial was now taking place. From the point of view of the defendants, it must have seemed regrettable that the court was speedily rebuilt - this time it only took nine years, but at a cost of a mere half million pounds.

By 1966, however, it had become clear that even the Old Bailey was not big enough to keep pace with twentieth century crime, so a newer and much larger building was thought necessary to accommodate all the newer and larger lawyers. A suggestion to build a completely new Central Criminal Court by the River Thames, about half a mile away, was rejected. Thus, by the end of this year (1971), the Bailey will have acquired a peculiarly ugly extension which will increase its number of courts to 18; the expense will be around the seven million mark, or roughly one thousand times that of the original building. Such is the cost of the Law. The dome, 195ft to the ball, will remain, as will 'The Lady' (beloved by every hack film director and American tourist) who surmounts it. The product of Mr. Frederick William Pomeroy, a Royal Academician, she is 12ft high and cast in bronze. Happily, she is covered with gold leaf which is renewed every five years at a cost of upwards of £500. The sword she holds is 3ft 3in long and the span of her arms is 8ft. She is cleaned every August when the Courts are not in session. Contrary to the popular rumour, again beloved of hack film directors and American tourists, the good lady is not blindfolded. Pomeroy's later became Rumpole's favourite eaterie and winery opposite the Old Bailey.

The Court should sit at 10.30 a.m. in the morning. It was late on all but one of the 26 days of the *OZ* trial. Three sharp knocks on the door of the Judge's dais as he enters, is the signal for the black robed usher to open the Court with the proclamation:

> "All persons who have anything to do before My Lords the Queen's Justices of Oyer and Terminer and General Gaol Delivery for the jurisdiction of the Central Criminal Court, draw near and give your attendance."

Each morning and afternoon the Judges in the four original Courts are escorted to the bench by an alderman, a sheriff and the under-sheriff. On the morning that Richard Neville began his evidence, Judge Argyle entered clutching a posy of wildflowers. In 1750, the Lord Mayor, two judges, an alderman, an under-sheriff and about 50 other people died as a result of the gaol fever which some unfortunate prisoners are supposed to have brought into Court. Two years later another Lord Mayor contracted the fever in similar circumstances and died. The remedy adopted was to disguise the smell of the unwashed bodies of the prisoners.

So the judges all carried little posies of garden flowers and the floor of the dais and the ledge of the dock were strewn with strong-smelling herbs. The custom has been continued ever since; consequently, not a single person has died from gaol fever in any of the courts since the present building was opened. The posies are now carried on two days each month between

May and September. Richard Neville, Felix Dennis and Jim Anderson were lucky enough to see this happy custom enacted before them.

His Honour Judge Argyle, is one of the resident Judges at the Old Bailey. Formerly the Recorder of Birmingham, Major Michael Victor Arygle, MC (1945) and QC (1961) is 56. A product of Westminster School and Trinity College, Cambridge, he had stood as a prospective parliamentary candidate in the General Elections of 1950 and 1955. It came as a surprise to no-one to discover that he had fought, and lost, as a candidate for the Conservative Party[*]. In the 1950 General Election, he had opposed the then Mr. George Brown[**].

Bedecked in his black robes and little white wig, he seemed a formidable figure. The notion of impartiality in English justice rests, in part, on the supposition that the Judge in his summing up and advice to the Jury at the end of trial, as well as in his general conduct and questioning throughout the proceedings, will epitomise this impartiality. We should see.

The wig he wore was introduced into the Courts in the reign of Charles II, having come from the court of France in about 1660. Until then, judges generally had worn a skull cap and a coif which fitted the head somewhat like a helmet and is said by some historians to have been derived from the cloth head-dress worn by Knights Templars under their helmets. In the middle of the 16th century, it is recorded that some judges wore a limp black cloth over their skull caps. The belief, held by some, that the hole in the wig of a judge is a reminder of the tonsure and the days when the Church held more sway in the Courts, is erroneous. The modern wig, as worn by judges at the Old Bailey, has no side curls but one vertical curl at the back with two short queues which hang down behind.

The modern neck-wear of a starched wing-collar and two plain white bands hanging down in front, evolved from about the middle of the 17th century. The origin of the bands as part of legal dress has never been definitely established but most theories [advanced] favour the probability that they passed into the legal profession from the Church. And there was certainly nothing clerical about Judge Argyle.

Richard Neville began his evidence in clear, confident voice.

> "I, Richard Clive Neville, do solemnly, sincerely and truly declare and affirm that the evidence I shall give shall be the truth, the whole truth and nothing but the truth. As I am in the unusual position of cross-examining myself,"

...he went on,

> "I shall start by asking myself to tell myself about myself."

And he did; the facts of which we have already discussed.

His speech, which had preceded his self-examination, had been quietly effective in its restrained,

[*] Argyle seemed to attract myth, especially in the tabloids where it was reported that he lived in a house called 'Truncheons'. He didn't. The house was called 'The Red House'. 'Truncheons' was in fact the home of Mr Justice Christmas Humphreys.

[**] George Brown was deputy leader of the Labour Party throughout the 1960s, and was ennobled as Lord George-Brown in 1970. He was a legendary heavy drinker, and on one occasion he is said to have embarrassed the nation whilst in South America. At a diplomatic reception he went over to a tall person dressed in red and asked for a dance. He received the following answer: "I will not dance with you for three reasons. The first is that you are drunk. The second is that the band is not playing a waltz, but the Peruvian national anthem. The final reason is that I am the Cardinal Archbishop of Lima". This story is, sadly, probably apocryphal.

almost apologetic, tone. At least none of the Jury went to sleep, as one was to do later in the proceedings. Neville had taken the precaution of printing 20 copies of his speech for immediate distribution to the Press. The lessons of Chicago* had been well learned.

Mr. Mortimer had also provided a moment of amusement when outlining the general course which the defence proposed to take. Referring to a precedent called the 'Agency Chewing Gum Case (1968)' (actually it was the 'A and BC Chewing Gum'), he suggested to his Lordship that the Court followed a similar line - whatever that was.

Judge Argyle confessed he'd never heard of the case and declared that he would have to look it up. But that didn't prove to be quite so easy as he discovered that someone had stolen his legal text books from the bench, or, as he more elegantly put it: "Somebody has inconsiderately removed the 'Statutes and Authorities' which I had assembled." Those in search of irony took note. Mr. Neville, however, maintained a more sombre pose.

> "It had been very exciting," Neville now said, "to meet the children who came forward to contribute to OZ 28; I remember some of the contributions when they first came in and being excited as an editor, professionally excited, with the quality of some of the drawings. But over the weeks that this issue evolved, I became less and less involved with the actual production of the magazine on purpose; I felt that to be there every minute of the day and constantly worrying like a hen about its exact content would, even unconsciously, influence the decisions made by the schoolchildren. And this would be precisely the opposite of what we had intended. Yet, I'd just like to say that I accept full responsibility for both the magazine and for the way in which it was distributed."

"Was there any plan or agreement between you and Mr. Anderson or Mr. Dennis," asked Mr. Mortimer, "of doing anything with the intention of corrupting the morals of children and young persons?"

"Absolutely not," replied Neville.

Indeed, it would have been surprising had he answered anything else.

* The Chicago Seven were seven defendants - Abbie Hoffman, Jerry Rubin, David Dellinger, Tom Hayden, Rennie Davis, John Froines, and Lee Weiner - charged with conspiracy, inciting to riot, and other charges related to protests that took place in Chicago, Illinois on the occasion of the 1968 Democratic National Convention. The defendants, particularly Yippies Hoffman and Rubin, mocked courtroom decorum as the widely publicized trial itself became a focal point for a growing legion of protesters. One day, defendants Hoffman and Rubin appeared in court dressed in judicial robes. When the judge ordered them to remove the robes, they complied, to reveal that they were wearing Chicago police uniforms underneath. Hoffman blew kisses at the jury.

The trial extended for months, with many celebrated figures from the American left and counterculture called to testify, including folk singers Phil Ochs, Judy Collins and Arlo Guthrie, writer Norman Mailer, LSD advocate Timothy Leary and Reverend Jesse Jackson. Ochs, who was involved in planning for the demonstrations, told the court how he had acquired a pig to nominate as a presidential candidate. Rubin attempted to deliver the acceptance speech for the pig, named Pigasus, but before he could finish, police arrested him and Ochs under a livestock ordinance, a charge later changed to disorderly conduct. On February 18, 1970, all seven defendants were found not guilty of conspiracy. Two (Froines and Weiner) were acquitted completely, while the remaining five were convicted of crossing state lines with the intent to incite a riot, a crime instituted by the anti-riot provisions of the Civil Rights Act of 1968. By deftly manipulating the media, the trial was turned into a nationally-publicized platform for putting the Vietnam War on trial.

"I rather hoped," he went on, "that it would have a beneficial effect on the community as a whole and on any young people who might read it in particular."

Mr. Leary winked into action. He couldn't have sounded more polite.

"Mr. Neville," he began, "do I understand that when you took a degree in Australia, you majored in English and Philosophy?"

"That's correct," replied Neville.

"I wonder if you'd kindly define for us, therefore, the word 'editing'," nodded Leary.

Neville smiled. "You're going to catch me out," he said.

Leary smiled.

"I hope not," he chuckled.

Neville paused and then said, "It implies the selection of material and the presentation of that material for publication."

Leary smiled again and added, lugubriously: "Ye-es."
Anyone would think he'd just won Wimbledon.

> "I understand," he went on, "that you, and your co-accused in this case, take collective responsibility for the editing of this particular magazine, OZ No. 28?"

> "Well, I don't want to seem evasive," Neville replied, "but it's already been established in Court that the editing of this particular issue involved a large number of people."

"Of course," wheedled Leary.

> "And the selection of materials was, therefore, a spontaneous affair," continued Neville.

Leary interrupted.

> "But you haven't answered my question," he said. "Broadly speaking, am I right that you and your fellow accused accept responsibility for the editing of School Kids OZ?"

> "We accept full responsibility for what appeared," offered Neville; "but it would be vanity to take full responsibility for editing this particular issue."

> "Well," coughed Leary, "I gather you've told us you don't want, in this case, to hide behind the barrister's gown."

> "That's correct," said Neville.

Leary smiled and said: "Also, you don't wish to hide behind the children..."

> "Not at all," said Neville.

> "So I want you to say frankly and firmly to the Court," said Leary, "...that I myself, and those with me in the dock, are responsible for the production which turned out to be OZ No. 28."

> "That's correct," agreed Neville.

> "Put that in the affirmative," said Leary, a little louder.

> "Yes," admitted Neville.

Maybe Leary was not as simple as he seemed.

> "Because let me try and dispose of something about which you were telling us," he said. "You agreed (I think you did), that you entered into an agreement to publish whatever the children decided for better or for worse. Well, that's strictly not true, is it?"

Neville looked unsettled.

"I gather that you tell us," continued Leary, "that you have wide experience in the publishing field?"

"Yes," agreed Neville.

"Because you know, in your experience of publishing," smiled Leary, "that you don't have to print what other people suggest might go into print, do you?"

"Not at all," agreed Neville.

"I mean, one must, as a responsible publisher, if one is going to put something into print and have it circulated amongst the reading public," continued Leary, "one must be careful, in treating inflammatory issues, to present a balanced picture?"

It was a curious battle of wits that we were observing - one might even say a battle of intelligences. Yet it would be wrong to assume, thereby, that Mr. Leary - or any other prosecuting Counsel - was being vindictively destructive. It would be equally wrong, in my view, to assume that the Law or its administration in this trial was quite as simple-minded as it often seemed. The problem was more complex.

Since the process of examination and cross-examination was to some extent a formalised and ritualistic game, it was clearly important to play that game, not only according to the rules, but also to one's advantage. Otherwise, one might emerge with somewhat less than the semblance of credibility. Thus, those who - like Mr. Leary - were trained in the skills of this particular game, had an advantage over those who - like Mr. Neville - were not. So it was possible, for example, to ask an apparently simple yes or no question but cloak that question in moral assumptions which render it almost impossible to answer directly. Thus the witness always seems to be evasive.

Take, for example, Mr. Leary's last question. 'Of course a responsible publisher would wish to present inflammatory issues in a balanced light'.

The answer was obviously 'yes'. To have answered 'no', would have doomed one anyway. So one had to answer 'yes'. But to do so, was to assume that morally loaded words like 'responsible', 'inflammatory' and 'balanced' were clearly understood, which they were clearly not. Left undefined, Counsel could then say that you agreed with his proposition. Thus, he could proceed to define what you meant - without consulting you. So, the only honest way to answer such a question was to ask what, exactly, was meant by 'responsible', 'inflammatory' or 'balanced' But to do that was to risk the scorn of any Judge who might reasonably assert that an apparently simple question had a correspondingly simple and monosyllabic answer. And in a case like this one which hinged on moral assumptions and accepted or acceptable patterns of behaviour about which it was ludicrous to make categorical assertions, this disadvantage might prove disastrous.

As, indeed, it did. Mr Leary continued:

"The cover of the magazine portrays, does it not, a series of lesbian poses?"

Mr. Neville looked at the magazine now stretched out before him.

"Yes, there are depicted three or four girls enjoying themselves."

"Well, if that's how you wish to phrase it," said Leary looking at the gallery.

"I dislike the word 'lesbian', that's all Mr. Leary," replied Neville honestly.

"Oh really. Why is that?" asked Leary.

"Because it has moral overtones," replied Neville. In my experience, girls do enjoy a certain amount of physical pleasure from each other; but I would not depict these girls as lesbian. Most human beings are more or less bisexual."

THE TRIALS OF OZ

Mr. Leary then directed our attention to a male phallus which, he said, seemed to be "strapped on" to the thighs of one of the girls.

"I think it's called a dill-doll," he quipped.

Neville said he wouldn't call it anything of the kind so the Judge said we'd better call it an "imitation male penis", to which Neville replied that he didn't know of a penis that was not male. And so they bantered on, Mr. Leary insisting on his lesbian orgy and the unfortunate display of 'private parts' in the magazine. Indeed, it was all so good humoured that almost without noticing, Neville made what seemed at the time two damaging and ultimately fatal admissions: first, that the cover, although aesthetically pleasing, was in part designed for essentially commercial purposes and had nothing whatsoever to do with any high-minded stuff about school reform that might or might not be contained within the magazine. And second, that, yes, the cover was erotically stimulating. Leary then proceeded to plod through the entire issue, line by line, almost syllable by syllable, reading out the juicy bits just in case any of those in Court had missed them.

> "Dope sheet - how to drop acid," ...he read. "Hells Angels menace Arts Lab in drug orgy rape gang bang loot shock. Two exclamation marks!! So violent the printer destroyed 6,000 copies."

The excitement was well-nigh unbearable and totally improbable. It was, of course, a highly selective process omitting any passages which might actually have shed some light on Neville's general contention that the purpose of the magazine had been to provide a forum for discussion about many of the topics which attracted and involved young people. It was also the second of Leary's devious, although in his terms justifiable, techniques: grind the witness down by making him or her examine every last detail of the magazine until they couldn't see the wood for the trees, let alone the general landscape. Without exception, all the defence witnesses succumbed to this microscopic and boring analysis; they succumbed in that they eventually seemed to be saying anything to shut Mr. Leary up.

The drawing on our front and back covers by R. Bertrand was lifted without prior permission or consent from his brilliant Desseins Erotiques, edited by Eric Losfeld 14-16 Rue de Verneuil, Paris 7eme, France (Le Terrain Vague 1969).

The last issue of OZ sold in excess of 40,000 copies, making it the largest Underground publication outside the United States.

> LEARY: [reading from the magazine]: ". . . Multiracial male kisses Only 25 left of most controversial *OZ* ever. Selling in Earls Court for £3 each. Save £2.5s. Rush your 15s. now." The suggestion there being that it was at a premium in the Earls Court area. That's right, isn't it?
>
> NEVILLE: Yes, that is the suggestion.
>
> LEARY: The Earls Court area being famous - or infamous, whichever way you like to put it - for male perverts.
>
> NEVILLE: It's famous for Australians.
>
> LEARY: Yes, but it wasn't the Australians that were rushing to buy the Homosexual *OZ* because they were Australians, was it?

NEVILLE: I always thought that homosexuals were mainly centred around Piccadilly. But if you insist on Earls Court, then I'll settle for Earls Court.

LEARY: Isn't it Piccadilly for drugs? Earls Court for queers?

NEVILLE: Well you've been in London longer than I have, Mr. Leary, so I'm sure you know what you're saying. I'll accept that, although I thought it was Piccadilly for both.

During an adjournment, a police officer on duty in the Court asked Neville to autograph a copy of *OZ* for his 14 year old son. Other police officers wore *OZ* badges on the undersides of their jacket lapels. Leary, meanwhile, chuntered on.

He maintained that by putting the caption 'School Kids Issue' on the front cover, you were bound to attract schoolchildren. Neville thought that if that had been their intention, it would have been much better to have printed a picture of the World Cup football team. No, *OZ* was not interested in cheap sensations although it did employ them from time to time as part of the weaponry of satire.

Couldn't Mr. Leary understand that much of what he was reading out, such as 'Leper Rapes Virgin - gives birth to Monster Baby', was an obvious parody of the techniques of over-sell much favoured by the overground press? No, probably he couldn't. Yes, it was true that *OZ* had had many different printers during its short life.

"There was one printer, I think it may have been in Peterborough," said Neville, "who the police from that area visited while *OZ* was actually on the press and ordered the printers to stop the machine running. The police had had no power to make such an order. But the printer became scared and, of course, refused to continue printing for us."

Mr. Leary then developed what seemed to be a predilection for the word 'kinky' which he kept throwing up like a tennis ball for Mr. Neville to knock about the Court. Neville offered alternative words but Mr. Leary persisted with 'kinky'. It would be dirty old men in Mackintoshes before long.

Leary now moved to his master stroke. Referring to the centre spread of the magazine which contained this 'Back Issue Bonanza' advertisement, he noticed a hard-sell blurb for Issue No. 27. "'The Mindbending Acid *OZ*, packed with facts" he read.

"'The facts about acid' - LSD?" he enquired.

NEVILLE: That's correct.

LEARY: And 'information' - about the same drug?

NEVILLE: Yes.

LEARY: "And the real dope; suck the corner of page 46." Just tell us, what was the point of putting that in this issue?

NEVILLE: You mean, suck page 46?

LEARY: Yes.

NEVILLE: Suck page 46. Well; ever since acid first became popular in this country, there have been many rumours floating around that paper can be impregnated with acid; so, you would merely have to suck a postage stamp or even suck an envelope and you might possibly get a high.

THE TRIALS OF OZ

LEARY: - Yes -

NEVILLE: - from acid. This "suck the corner of page 46" was just a throwaway acknowledgement of those sort of rumours. In fact, page 46 was not impregnated with acid.

LEARY: No. But it was a good selling line, wasn't it?

NEVILLE: But highly unbelievable.

LEARY: What?

NEVILLE: It was an unbelievable line.

LEARY: What age did you leave school?

NEVILLE: 18.

LEARY: I gather you've got no children of your own.

NEVILLE: I have no children of my own, no.

LEARY: But you see, this is a magazine which we know passed into the hands of a number of schoolchildren. And here we see advertised *OZ* 27, the Mind-bending Acid *OZ*, packed with facts, information and the real dope on that short cut to Heaven and Hell.

The persons reading this advertisement, moreover, are invited to suck the corner of a particular page.

Did it ever occur to you that some child might think there was perhaps something in it?

NEVILLE: It didn't occur to me at the time this advertisement was presented.

LEARY: Does it now?

NEVILLE: No; because I think that, in this context, it is absolutely a throwaway jokey line. And, furthermore, if they did suck page 46, all they would get is some ink on their lips.

LEARY: It's not everybody that understands these little jokes, is it?

It was better than the Marx Brothers.

THE TRIALS OF OZ

Mr. Leary now turned to the sexual content of the magazine.

"Am I right that you advocate every kind of sexual experience for children?" he asked.

"To elevate and enlighten their morals and assist them to grow up naturally?"

Neville replied that it was the general intention of *OZ* to aim at an abolition of sexual guilt among people who feel sexually precocious or experimental.

"Yes," nodded Leary.

"If they feel precocious or experimental, they should be encouraged to experiment, is that right?"

Neville shrugged his shoulders.

"May I read, therefore, a section from page 28?" continued Leary.

> "'I can open my throat pretty well if a guy has a really long cock.
>
> Actually, I prefer one that's not too long - six inches is plenty - but I love the fat ones that fill up my mouth. If the guy is really groovy, he's stroking my neck and shoulders and breasts' . . . and so on.

What was that put into the magazine for?"

"Well, to start with," replied Neville, "that is part of a whole page of advertisements."

(It was, it transpired, an extract from an ad for the newspaper *Suck*).

"But this had nothing to do with the schoolchildren who produced this particular magazine, had it?" shouted Leary.

Neville paused. "No," he said. "It was not."

"Because what that little extract you've chosen from the magazine *Suck* does," added Leary triumphantly, "is to glorify the act of fellatio."

to do it, but I can open my throat pretty well if a guy has a really long cock.
Actually, I prefer one that's not too long - six inches is plenty - but I love the fat ones that fill up my mouth. If the guy is really groovy, he's stroking my neck and shoulders and breasts while I'm sucking him - and now he can say those words, because now is when they're real. I love to hear a guy tell me that my mouth is wonderful and to tell me how he wants me to do it, whether he wants it harder or softer or faster or slower. And I love it when he cups my face in his hands for those last few strokes. By that time, he's pumping and it's so great to be looking straight at his pelvis and seeing it drive his prick into me. And I love the taste - that sharp, salty taste with a bit of clorox in it. Well, it's just beautiful, that's all - and, like I said, I dig fucking, too, but I never want to give up sucking.

I'll give you one physical variation, that you might not know of, for your files - how's this. The girl gets an ice cube and a glass of hot water - or a cup of hot tea or coffee. When she's got the guy nice and hot by sucking him in whatever style she prefers, she puts the ice cube in her mouth and keeps sucking him - you know rubbing the cube up and down his prick, inside her mouth. This usually has a wild effect on the guy - Carol will definitely dig it. Then when you think he's really flipping, you spit out the ice cube, take a mouthful of the hot water or tea or coffee and go back down on his cock again with your mouth full of the hot liquid.

And by printing that sort of extract, it must have the effect of encouraging people to do that sort of way-out sexual thing.

Now if you're dealing with children who, you agree, are apt to enjoy experiments, and a particular experiment is written up in a passionate and attractive sounding way, the chances are, by printing such an advertisement, it's going to encourage that type of behaviour, isn't it?"

Neville paused for a long time.

"Yes," he said. "I would say that.

But what I'm also saying is that people should not feel guilty about enjoying sex, and that paragraph is certainly not harmful; it coincides with *OZ*'s general approach towards sex, which is one of openness and honesty and not trying to sweep it all under the carpet."

"May I add the words 'and encouraging'?" asked Leary.

"Well," replied Neville, "we're getting on to the whole question of how people learn . . ."

"I wondered if you'd avoid it, Mr. Neville," interrupted Leary.

"If I what?" asked Neville politely.

"If you would avoid it," harangued Leary as he banged the bench. Which was a pity that we avoided it, that is, because it was one of the first indications anyone had given that something more was at stake than what one later witness was to describe as "merely a schoolboy prank".

It was becoming clear that the trial was proceeding on three different levels.

First, there was the prosecution which seemed concerned only to prove that *OZ* 28 was nasty and obscene and liable to corrupt the morals of young persons within the Realm; second, there was the defence, in the person of Mr. John Mortimer, which was aware that wider considerations were involved, possibly even the important considerations of censorship and pornography that no amount of legal verbiage should be allowed to cloud over; and third, there was the apparently mystical and messianic approach of Mr. Neville who seemed to feel that, to some extent, he had actually staged the whole event as the scenario for the (as yet) unwritten film to be called *The Children's Crusade, or how I learned to stop worrying and recognise that I had rights.*

"There are many groups in this country that are involved in attempts to reform education," he went on. "And however distasteful it might seem to some people to want to abolish the discipline and authority of schools, this is a view that an increasing number of people hold."

Including Mr. Neville, one presumed.

Again, it was a subject which was to be more fully discussed later on, although not by the Judge who directed his questions to more pertinent matters.

"What about the illustration at the top of page 8, Mr. Neville; how does that add to the article printed there?" he asked. "The boy there has got a meat hook in his right hand, hasn't he?"

NEVILLE: Yes, that's what it looks like.

JUDGE: And in his left hand, a rolled copy of your magazine, *OZ*?

NEVILLE: That's right.

JUDGE: In the same position as an erect penis would be if that was his penis?

NEVILLE: Quite honestly, Your Lordship, until you've just pointed it out, I had not noticed it.

JUDGE: Oh really?

NEVILLE: Absolutely, I had never thought of comparing holding the magazine with an erection.

JUDGE: Hadn't you?

NEVILLE: No, I hadn't.

JUDGE: I see. Very well.

Meanwhile, Mr. Leary had obviously decided that, at all costs, Neville must be kept away from the psychological and social aspects of the magazine. Those were not concepts which came within the rigid workings of the Law. Quite simply, the Law could not cope with anything as devious as the creative imagination and its world of possibilities. The Law understood good and bad as being exclusively a matter of right and wrong, as prescribed by statute. Morality was defined as that which was permitted by law; and what was permitted had always had very little to do with morality. Mr. Leary, as far as one could see, was unperturbed by such considerations, and flicked through the pages of *OZ* for what he called "the dirty pictures".

"And there isn't a word of editorial comment condemning the use of drugs is there?" he asked in passing.

"No, of course not," replied Neville.

Mr. Leary then came as near to losing his temper as it was possible to do while at the same time remaining a complete gentleman. Reading from one of the articles in the magazine, he pounced on certain of its phrases:

> "Although we are living in a so-called permissive society, there are many things natural to human instinct that are prohibited in public. Signs in many places proclaim 'Petting Prohibited'; byelaws to parks and woodlands say that people caught fucking will be prosecuted. University and college authorities rule that you cannot visit the opposite sex after 10.30pm in the belief that thus fucking

cannot happen between the magical hours of 10.30pm and 8.00 a.m. and that nobody fucks at any other time.

People may not even piss in any place vaguely public without fear of being arrested for exposing themselves and being labelled as sex-fiends...

The annoying thing about this is that this ruling does not extend to domestic animals, who may fuck when and where they want to without anyone saying fuck all... Why can't this sexual freedom be extended to us, after all we're only animals!"

"The platform of those contributions, would you agree," he asked Neville, "is sexual permissiveness?"

NEVILLE: Sexual freedom, yes.

LEARY: Contributions from schoolchildren?

NEVILLE: Yes.

LEARY: Schoolchildren are sometimes inclined to be awfully selfish, don't you think? ·

NEVILLE: Yes, I think that's a characteristic of all of us, Mr. Leary.

LEARY: Yes. Some of us perhaps more than others.

NEVILLE: Certainly.

LEARY: But selfishness isn't to be encouraged in children, is it? Do you think?

NEVILLE: No. Not to be encouraged in anyone, Mr. Leary.

LEARY: Because what's being suggested here is that people should couple in the streets if they feel like it; is that right?

NEVILLE: Yes.

LEARY: And why can't this sexual freedom be extended to us? After all, we're only animals.

NEVILLE: Yes.

LEARY: And the editorial standpoint? A good thing?

NEVILLE: I don't ever ...

LEARY: ... enlightening?

NEVILLE: Well, I think . . .

LEARY: Copulation in public, worthy or unworthy?

NEVILLE: Copulation in the street is, I think, a very . . .

LEARY [shouting]: Would you deal with its worthiness or otherwise?

NEVILLE: Its worthiness?

LEARY: Something to be encouraged or condemned? You follow me, don't you?

NEVILLE: I think it's made very, very clear throughout . . .

LEARY: Are you for it or against it?

NEVILLE: For or against what, Mr. Leary?

LEARY: Public intercourse.

NEVILLE: I have already made it clear myself that . . .

And so on. Neville was being slowly demolished and demoralised by the persistent Mr. Leary. You had to admire Leary's stamina and courage, especially when he moved in to consider Rupert Bear and Gipsy Granny.

> "There's something dropping down between the parted cheeks of the anus of the woman. What's that?" he asked. "He's attempting intercourse; is that right? Hardly elevating or enlightening is it? That particular drawing? There's very little left to the imagination, is there? In these drawings? And there's some red substance coming out of Gipsy Granny's vagina. Because she was a virgin, I suppose? Would you accept that there might be people who didn't see the joke in it? I mean, what they'd see is a representation of a well loved childhood figure having intercourse with an old woman. After all, it's a little difficult to see how a grandmother can still be a virgin."

Mr. Leary smiled round the Court Room, confident.

> "Now just consider with me, Mr. Neville will you," he droned on, "the child's mind, not properly formed but open to all these influences. Do you not see the danger in advancing these adult, completely formed ideas and presenting them to a child in a packaged magazine?"

Neville replied that his knowledge of child psychology had led him to believe that the sexual proclivities of children were formed at a very early age. They were not formed when they were teenagers, and were certainly not formed by posters or by magazines.

> "Are you saying that they cannot be influenced thereafter by their elders?" inquired Mr. Leary. Leary went on before Neville could reply. He invited all to look at the front cover - for the 53rd time. "See anything wrong with that?" he asked, smiling at the Jury.

By this time, we'd also learned to stop worrying and really love the cover - all those naked women embracing one another. It hadn't occurred to anyone at this stage that it could be, in fact, one woman depicted eight times in different poses and thus be more fantasy then reality.

No, replied Neville, he saw nothing wrong with it.

> After all, he said, "there are much more realistic photographs on the covers of *Penthouse*, *Playboy*, *Mayfair* or *Curious* - all on sale at W. H. Smith's, and much more likely to catch the eye of young people primarily interested in sex".

> "Have you ever seen a *Penthouse* cover or a *Playboy* cover with a girl with a rat up her vagina?" asked Leary, demurely. "Or a girl wearing an artificial male penis?"

As opposed to a female penis, I suppose he meant.

Drugs loomed up next, but this time Neville held his ground, steadily maintaining that *OZ*, although it worked on the assumption that the taking of drugs was almost universal amongst the young, was quick to point out the dangers of drug addiction.

But when Leary turned to the two pages of small ads, the bottom fell out of Neville's bold defence. He looked scared.

"No. 2 under the small ads gives a box number in Sweden," Leary began.

"That's directed at homosexuals?"

NEVILLE: Yes.

LEARY: For £3, your magazine tells them that they may obtain an uncensored magazine from Sweden showing scenes never published before and covering every angle of love.

NEVILLE: That's what the advertisement says, yes.

LEARY: And this is the sort of thing which we've heard came into the hands of schoolchildren? Further down: 'The Adult ReVu' [sic].

> 'No box numbers. No forwarding fees. This little BLUE BOOK is a must for all Way Out Adult gear.'

Do you see?

NEVILLE: Yes, I see.

LEARY: Kinky?

NEVILLE: Well, I'm not partial to the use of the word myself.

LEARY: Well then, use your own.

The Judge interrupted; "What's the problem now?" he asked.

LEARY: Kinky is another word which the witness doesn't like.

JUDGE: Which one were you looking at now?

LEARY: My Lord, the one that starts: "The Adult ReVu".

JUDGE: Oh, so sorry. I was looking at Voyeurs, Homosexuals, Lesbians.

LEARY: My Lord, sorry. Rubber gear, men dressed as maids, leather gear, all perversions.

NEVILLE: All aspects of human sexual behaviour which are rather sad, yes.

LEARY: The very fact that it's referred to as 'Adult ReVu and Adult gear' * imports, I suppose, indicates it's not meant for children?

NEVILLE: Yes, there is that connotation.

LEARY: Because they're pandering to the diseased mind, aren't they?

NEVILLE: They're pandering, if you like, to people who are an unfortunate and often victimised minority.

LEARY: Yes. But what's the point of having an advertisement of that nature in School Kids *OZ*?

NEVILLE: Do you think that *The Times* endorses all the advertisements that *The Times* prints? I think you're reading *Fanny Hill* into a two line advertisement.

LEARY: On the next column, you see the two white boxes, the lower one of which is headed 'Voyeurs . . . Homosexuals'.

NEVILLE: Yes.

LEARY: There's your hated word: 'Lesbians, Heterosexuals, all Erotic Minorities. Join Contact Club International in Sweden, membership £2 only, 100% confidential. Free Fucking, Sucking, Hardcore Pornzines of your choice, excellent for masturbation and fuckstimulation.' Not a particularly pleasant choice of words is it?

NEVILLE: I don't find it particularly pleasant or unpleasant, it's just . . .

LEARY: Hardly elevating?

NEVILLE: It's not particularly elevating, no.

LEARY: Or enlightening.

NEVILLE: Only in as much as it abolishes the guilty, repressed attitude towards sex.

LEARY: Excellent for masturbation and fuckstimulation. The poor people, who haven't the chance at a happy marriage and so look for their own sexual satisfaction either to themselves, masturbation, or objects like your inflatable rubber woman and massagers advertised on this page, fuck-stimulation; see what I mean?

Mr. Neville may not have done, but the Jury certainly did. Later, Mr. Leary told me he'd grown rather fond of Richard Neville. But, like anyone else, he had a job to do. So had Mr. Neville which was to sum himself up. Since he was defending himself, he was able to rebuff some of Mr. Leary's accusations. A legal nicety perhaps, but worth the rub. "Isn't it much better to try and educate and inform the whole of society about the dangers of drug taking," he concluded, "than to just give it another sermon. There are plenty of people around giving sermons." Seeking to avoid this, Neville then called as his first witness the critic and singer George Melly, hoping that Melly's good humour and spontaneous bonhomie were precisely the tonic that the Court needed. Unfortunately, it didn't quite work out like that.

* EDITOR'S NOTE: The magazine doesn't actually say that, although it does say 'strictly adults only' later in the advert.

Alan George Melly, born August 17, 1926.

Able Seaman extraordinary, professional jazz singer for 12 years, author of *Flook* in the *Daily Mail*, the *Observer's* film critic, sometime contributor to *The Listener*, the *Sunday Times*, the *New York Times*, elected Critic of the Year 1970, author, broadcaster and wit.

Neville had brought him along as a character witness and all-purpose expert.

Yes, Melly had known Neville for just over two years. Yes, he liked him. Yes, he trusted him. Yes, if he had a daughter, he would allow her to marry him. Melly went on to define what he thought the underground and popular culture had to contribute to society as a whole.

"Each pop generation has its moment of revolt," he said, "when it sees society, probably from a rather adolescent point of view, as totally fallible, totally wrong. It is at this point that, in the past, those who choose to make money out of pop culture, move in and package and exploit whatever this particular moment in pop history has thrown up, and turn it into merchandise.

Thus, I called my book on the subject *Revolt into Style*, because each pop movement seems to me to start with a moment of revolt which is then packaged and turned into style. But it seems to me that in the last year or two, the pop "generation which is now in revolt has started to learn just how they've previously been turned into shares, money and merchandise and are sticking their heels in a bit harder to resist it, are learning ways round it, are sticking to their guns.

This has given rise to the Underground, although that, in some ways, has become meaningless because it's become so overground. I suppose the term 'alternative society', although it's more pompous, is more accurate. The alternative society is one that tries to invent or evolve its own life-style which is usually in opposition to the official life-style. It has its own press, and *OZ* is an organ which seeks to probe and to see what society is about.

At 45, it's for me not the authoritative newspaper in the world, but I find it very interesting and I learn from it, particularly about what people younger than myself are thinking. So I think it has a definite social function. For example, I find it extremely useful in discussing things with my 16 year old son because it is there; it's something concrete. One can read it and we can discuss whether we agree or disagree about the contents. If I had to start a discussion on some broad moral front with him, I would find it much harder without *OZ* because *OZ* raises these questions in a way that is intelligible to both parent and child."

About the sexual content of the magazine, he again stated the obvious.

"Most children go through a period when, as adolescents, they are naturally very interested in the changes they notice in their own bodies. They react to it in various ways. They have fantasies about sex, and at the same time they find

it incredibly funny. I think dirty jokes about sex are a form of defence; because sex is something that's very deep in us and we laugh at it to relieve ourselves. One loses one's guilt; one has a good laugh about the subject, and it's cleared. In talking to people of my son's generation, what's more, it seems to me that they are less guilty, less uncertain, less miserable, less tormented about sex than my generation was. I had a comparatively liberal upbringing, but I still had a lot of guilt. I still hated schoolmasters who told me if I masturbated, I'd go blind and my backbone would fall to bits, or forbade me to use phrases like fellatio or cunnilingus, as if these acts were 'dirty' and 'perverted'. So much misery in this world has been caused by guilt about sexuality, that anything that can be done to alleviate it, is to the good. Of course, there is the other view which people put forward that it's only by remaining guilty that we remain aware that we are mortal, sinful creatures; but I believe it's our duty to make life as happy and as guilt-free and as pleasure filled as we conceivably can."

"Forgive me," said Argyll. Could you help members of the Jury with the word 'cunnilinktus'? (he mispronounced it). They may not have done Latin."

"I'm glad you asked me that," replied Melly. "Sucking or blowing, my Lord. Or 'going down'; or in my naval days 'gobbing'. Actually, in my naval days we had another phrase, 'yodelling in the canyon'".

The Court erupted in laughter - except for Judge Argyll. "This is a courtroom," he said sternly. "Not a theatre."

Really?

Melly then spoke briefly about the surrealist quality of some of the images used in the magazine, particularly noting one drawing which depicted armadillos being squeezed out of a large tube, an idea which he said was worth storing in his image bank, whatever that was. He added, as further evidence for his contention that *OZ* was most useful as a bridge across the generation gaps, that he was often invited to lecture to probation officers and police federation meetings; *OZ* was the one topic that was guaranteed to come up in the conversations. It seemed to be a red rag to authority. And yet, it focused people's concern for youth and its problems; as such, it was necessary.

"What brings you here today?" Mr. Leary broke in, somewhat abruptly.

"My belief," replied Melly, "that something which I think is valuable is up for judgement, and I felt it necessary to stand up and be counted."

Leary wheeled away. Could Mr. Melly find any note of caution in the magazine about the taking of drugs? Did Mr. Melly approve of drug taking? Did he disapprove? Did he disapprove of anything? What? Why? For whom? Was Mr. Melly aware, asked the Judge, that there were many people in the Court Room far more acquainted with the drug problem than he was? What experience did he really have of children and adolescents? Was there not something regrettable in the deliberate impoverishment of a vocabulary that employed words like cunt and bollocks?

"Do you swear in front of your children?" asked Leary.

"Certainly," replied Melly by now totally confused.

"But you don't unless there's some reason for it, do you?" smiled Leary.

"Don't use what, sir?" enquired Melly.

"FOUL LANGUAGE," shouted Leary.

"You define foul language as four letter words, do you?" asked Melly.

"Words like 'cunt' and 'bollocks', yes," replied Leary, now the essence of politeness.

"In their place, they're perfectly acceptable words," agreed Melly.

"Mr. Melly," said Mr. Leary, full of stunned indignation. "I'll give you a chance to think about that."

"I don't need it," replied Melly. "Yes, I would use these words."

Leary looked speechless.

"In front of your . . . would you call your eight or ten year old daughter a little cunt, would you?"

"I don't think she is one," said Melly. "But I might easily refer to a politician as one."

"But in front of her?" asked Leary.

"I'm afraid so," said Melly.

"You know lots of people do that sort of thing. You can look absolutely amazed by it if you like, but I assure you quite a number of people use four letter words without shame and without guilt."

"You're giving us your opinion," said Leary.

"Well, that's what I'm here for," replied Melly.

"You have a point of view," he went on, "and I have; and I'm expressing mine and you are casting doubt upon it. That is your advantage in this situation in relation to what I am saying. I can't do the same towards you, or not much. But we are expressing opinions; we are expressing interpretations of very vague ideas. Aren't we? If the Members of the Jury's parents were sitting there, they would find certain things obscene that the Members of the Jury undoubtedly would not find obscene, because each age changes its interpretation about what is obscene. Doesn't it?"

Mr. Leary looked pained, as did the Judge. Mr. Mortimer had his head in his hands. Maybe he was just tired. Mr. Leary pressed home his advantage.

"In this particular issue, No. 28, Mr. Richard Neville doesn't give advice, does he?" he asked.

Melly replied "Well, that, I think - I think we've said it enough - is because the issue is not edited by Richard Neville; he's handed over the magazine."

> LEARY: Mr. Melly, forgive me, the answer is no. Whatever reason, the answer is no, is it not?
>
> MELLY: Well, yes, the answer is no. But I mean we haven't been into the reason, and I think it is relevant surely.
>
> LEARY: If you want to bring in the reason, do, but please try and answer my questions.
>
> MELLY: Can I ask one thing now?
>
> LEARY: No, sir.
>
> MELLY: Oh.
>
> LEARY: Mr Melly, would you think it offensive if I suggest the sort of thing which goes on at your home every night . . .
>
> MELLY: What do you mean by that?
>
> LEARY: Well, smutty jokes and bad language, and in front of the children. Is that unfair?
>
> MELLY: I think it is unfair. I live what I believe to be a decent life...
>
> LEARY: Yes . . .
>
> MELLY: I love my children and my wife. I'm extremely happy and the fact that I sometimes exchange rude jokes, that is not unique, I believe.
>
> LEARY: ...of course not . . .
>
> MELLY: We all enjoy rude jokes . . .
>
> LEARY: You're a man whose family is open to all sorts of progressive thoughts which come into the home and are freely discussed. That's right, isn't it? And you would be content, would you, to leave this magazine lying around, not only in your own home, as we know you do, but having it lying around anybody's home?
>
> MELLY: You're trying to make me out as the monster of NW1!

But as far as the Jury was concerned, Mr. Leary had no need for further comment.

Mr. Melly's blustering had done it for him.

In reply to re-examination by Mr. Neville, Mr. Melly rallied momentarily.

> "This case is being prosecuted not because of the sexual element involved, but because of the anti-authoritarian attitudes which are expressed," he said.

> "It seems to me that there are so many straight pornographic publications that are available. You can see them even in ordinary newsagents. Therefore, this is really a trial about a certain attitude towards life which doesn't please the Law. I know several fairly lukewarm, liberal figures who are rather worried at the moment by this sort of prosecution because they believe that it may threaten their own form of expression later."

But the damage was done. It was a grim moment. If the Law was a game, then you just had to play it according to the rules; and since the Judge could, to some extent, interpret these rules at his own discretion, the witness was left with little choice except to do as he or she was told; or else be seen to be apparently breaking these rules. Thus, at times, it seemed that the Law was not so much an ass as a bigoted and pompous idiot, blind to the merits of questions not susceptible to a yes or no answer. 'Maybe', or, 'it depends what you mean by', were ideas totally foreign to its intelligence. Three weeks later, Mr. Melly's house in Gloucester Terrace, N.W.1. was visited by members of the local police. The arm of the Law was indeed long, although it was later asserted that the police were merely investigating a complaint about a noisy party. There was no party at Mr. Melly's house. Maybe everyone was just getting a little paranoid.

The 'Monster of BBC Television (W.12)' sneaked in next, hot foot from a BBC row with ex-Prime Minister Wilson over the political documentary, *Yesterday's Men*.* **Anthony Smith**, the editor of the current affairs programme *24 Hours*, was the original morning-after-the-night-before television producer, with his bright, beaky face peeping out between slightly oversized spectacles topped by some fashionably greying hair.

Yes, he had known Richard Neville since the midsummer of 1967. Yes, he had once run a programme called *The Eleventh Hour* in which Neville had frequently participated, expressing views which later became identified with those of the Underground. He affirmed that the Underground had become an increasingly significant phenomenon which journalists of all colours had been compelled to take cognisance of. No, Richard Neville was not the kind of person who would be likely to corrupt or debauch. It was all predictable stuff - after all, no defendant was going to call a personal reference witness who would then stand up in court and say he was a schmuck. Not even in this trial. Yes, if Mr. Smith had a daughter, he would happily let her marry Mr. Neville.

And that was that. Mr. Leary desisted from attack; indeed, he had no need, and Mr. Smith shuffled out of the Court Room, soon forgotten.

* Another *cause célèbre* which is largely forgotten, this information is culled from the BBC's own `BBC History` website. The BBC enraged Harold Wilson and his outgoing government after they lost the 1970 General Election. They were effectively tricked into taking part in a programme that would ridicule them.

Had Wilson and his front-benchers known, for example, that the programme would take as its title a soundbite from their own campaign against the Conservatives (they called the Tories 'yesterday's men'), they would not have agreed to take part. The icing on the cake was a disrespectful song specially commissioned from pop group *The Scaffold*, featuring Mike McGear, the brother of Beatle Paul McCartney, and *Yesterday's Men* was in stark contrast to a serious and conventional 'balancing' documentary that had been made about the Conservative government a year after the election.

Anthony Smith, CBE, later became President of Magdalen College, Oxford University.

The following day, one of the members of the Jury - the pregnant lady - failed to turn up. Judge Argyle was all for discharging the absent lady and proceeding. Protests were made by the defence on the grounds that her absence would unbalance a carefully selected Jury. After all, 26 jurors had been objected to, said Mr. Walker-Smith, in order to acquire a jury of peers. And this case was not a whodunnit; opinion, from as broad a cross-section of the community as possible, was of the essence. So we waited - for one and a half hours. Eventually, the luckless Mrs. Bathurst arrived. She'd been collecting her daughter from the hospital where she had just given birth. She had telephoned to say she was on her way, but as to who was on what way or why was never established. The Judge was at his most sympathetic. Who was at home to look after the daughter and child, he asked? The domestic complications which followed evoked from Mr. Argyle the suspicion of a smile. He recommended the lady be discharged; after all, she was pregnant herself. It was all most unfortunate.

Smith, then, had been a disappointment - not quite as unfortunate as George Melly, but neither seemed to command the emotional or intellectual resilience to counter-balance the devious Mr. Leary. The defence now lurched off into an apparently endless succession of witnesses called to give their expert evidence as to the likely effect of the magazine on the minds of the young.

Anderson and Dennis, the other defendants, were not called until later in the trial. The theory behind this divide and rule technique remained obscure to me and many others; so, for the purposes of clarity, I propose to review their evidence alongside that of Richard Neville, and then go on later to consider the bulk of the defence not immediately relevant to the three accused.

Anderson, the second defendant, was called to the witness box first. He cut a sad figure. He just seemed too nice to have been involved in any nasty or dirty conspiracies. Flaxen-haired, in a yellow T-shirt, thin, bespectacled, he gave his evidence quietly and nervously. Throughout his time at law school in Australia, he had been employed by the department of the Attorney General of New South Wales. "I became very disillusioned by the processes of law," he said. "I was upset at the way witnesses were often browbeaten; and the hypocrisy of judges led me to believe that truth was not something which the Courts valued very highly." Mr. Leary grinned and scribbled away - obviously, for him, a useful piece of information. Now 33, he lived in the flat above that of Richard Neville in Palace Gardens Terrace. Unlike Neville, who had affirmed, Anderson nonetheless swore on *The Bible* that he really would attempt to speak the truth, although what constituted that strange commodity was becoming increasingly in doubt. He had first become interested in *OZ* because it seemed to him that it was critical of society in an honest and intelligent way with which he felt he could identify. The most he had ever earned from working on the magazine was £20 per week; more often, he only got £10. Sometimes less.

For him, *OZ* had no dogmatic editorial policy as such; it preferred to reflect rather than preach. He recounted the familiar story of how *OZ* 26 had advertised for school kids to come and edit a future issue, and added that, when only about 30 children responded, he was a little downhearted.

> "It was not as good as I thought it might be," he said. "But we were overwhelmed by the number of things they had to say and the views they wanted to put forward," he added. "There was a feeling of creative energy and excitement produced by the children."

And it would have been wrong, he felt, to have censored, in any way, their contributions. The most that he and the others had offered was technical advice. Editorial decisions - whether to include or omit (and much had been omitted) - were collective.

The detailed examination of the contents which followed merely confirmed that, according to the accused, apart from the nine pages of advertisements, all the material contained in *OZ* 28 had either been chosen, or directly written, by the schoolchildren. The tedium of this line by line inspection might have seemed necessary to some; but the effect was one of redundant verbiage, alleviated only by the occasional sneeze or cough. Laughter, as we have observed, was forbidden, except when it was the Judge who made the joke

> "I found it very much like an ideal classroom situation," continued Anderson, referring to the conditions under which the magazine had been created, "with everybody teachers and everybody pupils."

It was like a school project, with everybody enjoying what they were doing and having a great deal of fun while being totally involved. It was what a school should be all the time. What was unfortunate, he added somewhat sadly, was that, as an issue, it hadn't sold particularly well - until, that is, the police came along, and with them, Mr. Leary.

> "Did I understand you to tell us that you were very interested in truth and justice?" he asked.

> "Yes," replied Anderson.

> "Do you accept the principle that justice holds the balance, so as to achieve, ultimately, the truth?" said Leary.

It wasn't really a question so much as a statement with which Anderson had no choice but to agree.

> "And when you left the legal profession," continued Leary, "and took a hand in the production of this magazine, you say that that was in an attempt to improve society?

> "Yes, it was."

Anderson seemed very confident.

> "You appreciate, do you not, that publicity can have an effect upon firstly, society, and secondly, the course of justice?" asked Leary, somewhat mysteriously.

> "Yes," said Anderson.

> "Have you seen the shirt which Richard Neville is wearing this morning?"

So that was it.

> "I haven't noticed it as yet, Mr. Leary," answered Anderson.

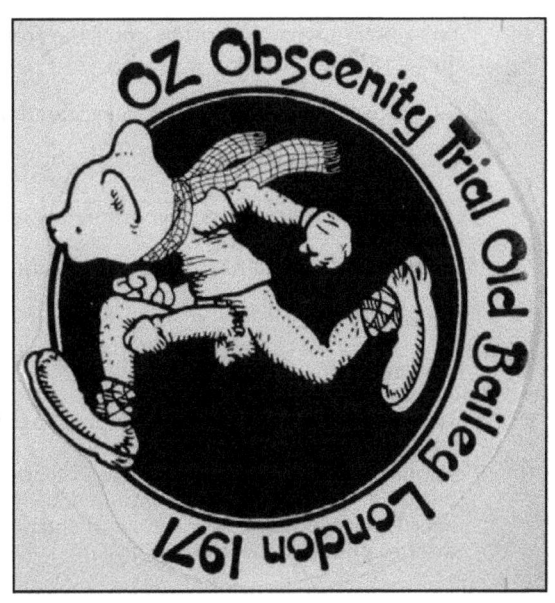

A collective of T-shirts for perverts

"You observe what is written upon the front, printed upon the front of that shirt, yes?" said Leary.

"'*OZ* Obscenity Trial, Old Bailey, London 1971'".

"Yes," said Anderson.

"Have a lot of those shirts been printed?" asked Leary.

"Several hundred I think," said Anderson.

"For sale?"

"How much?"

Did it matter? Did it really matter? Obviously Mr Leary thought so.

"It appears that if you are convicted of offences and the Court deems it apt to impose a fine upon you," continued Leary, "then that fine will be met from the sale to members of the public of shirts which have been specially printed in order to publicise this trial?"

"I think the more important reason for the shirts," replied Anderson, "is to make everybody aware that this trial is happening. I think it's a matter of great public concern and public importance, and the shirts are one way of advertising and telling everybody that such a trial is taking place.

"Well, of course, it's of concern to *you*, sir," said Leary.

"Well, I think it's of concern to a great many people," said Anderson. "I think some very important issues are on trial in this Court and I think it involves the liberty of us all."

"Yes," said Leary, looking at his nails.

"Our freedom to speak", continued Anderson.

"Yes," said Leary, looking at the roof.

"And that that freedom to speak, to express ourselves, be preserved."

Leary seemed to be no longer listening.

"How was revenue for the magazine increased?" he asked.

"By advertising," said Anderson.

"Some of the advertisements in this magazine are for sexual perverts," said Leary.

"Would you agree or not?"

"Well, I wouldn't agree with the word 'pervert', Mr. Leary," said Anderson.

"Oh. Why?"

Leary looked astonished.

"Well, I prefer the words erotic minorities; sexual minorities," replied Anderson.

"Abnormal?" asked Leary.

"It depends on your definition," replied Anderson. "I prefer to use variations; it's a much kinder word."

Leary grinned.

"Well, what's unkind about 'abnormal'?" he said, and grinned again.

"Our small ads," Anderson went on, "...which are a regular feature of OZ, provide a valuable social service to lonely...."

"A social service for lonely people?" inquired Leary. "It's not every child which is completely normal, is it?" he said.

"That's true," agreed Anderson.

"And unhappily, to take but one example," continued Leary, "some little boys do lead on homosexual men provoking them into acts of buggery; you know that?"

"I've heard it," said Anderson.

"You can't tell, can you, by looking at a little boy whether he's normal, whether he's been previously corrupted by some older man or whether he has..." (Leary paused) "...inclinations?"

"Yes, but I don't think something like this would influence them one way or the other," said Anderson. "And from my experience with children, this is one of the most boring pages they could possibly imagine."

"One of the most boring?" shouted Leary. "Are you suggesting that the subject of sex is boring?"

Leary was running away with it, again.

> "The small ads were merely lying around, and they just happened to be seen by the schoolchildren? And there they were - giggling - I think your evidence said?" he asked.
>
> "One or two of them did, I think," replied Anderson.
>
> "Yes," smiled Leary, pausing; "...about these sad people who form sexual minorities?"
>
> "Yes," said Anderson.
>
> "That's your attitude?" inquired Leary quickly.
>
> "Yes," replied Anderson.
>
> "They are very common and they're in every newsagent's window. Other papers like the *New Statesman*..."
>
> "Every newsagent's window, did you say?" asked Leary, looking at the Judge, who was looking at the roof.
>
> "Oh I'm sorry," said Anderson. "I didn't mean *every*; in many newsagent's windows."
>
> "Have you taken the oath?" asked Leary. "That's right, isn't it?"

There was silence. Anderson looked amazed, as well he might. The Judge polished his nails. Having established that Anderson had written the Editorial reminding readers of the purpose and achievement of this particular issue, Leary asked him to consider whether his description of Vivian Berger's Rupert Bear cartoon accurately reflected his opinion now.

> "Youthful genius?" asked Leary.
>
>> ANDERSON: Yes, I think it was an extremely clever and funny idea.
>>
>> LEARY: Did it amount to youthful genius?
>>
>> ANDERSON: Well, maybe I was a little bit generous in my praise, but...
>>
>> LEARY: The youthful genius set to work by snipping out of the Rupert Annual, the head of the bear. That's right?
>>
>> ANDERSON: Yes, I suppose that's what he did.
>>
>> LEARY: And then, if we were keen to watch a genius at work, we would see him sticking it on the cartoon.
>>
>> ANDERSON: Yes.
>>
>> LEARY: Already drawn for him.
>>
>> ANDERSON: Yes..
>>
>> LEARY: Where lies the genius?
>>
>> ANDERSON: I think it's in the juxtaposition of the two ideas, the childhood symbol of innocence...

LEARY: Making Rupert Bear fuck?
ANDERSON: Yes.
LEARY: Is that what you consider youthful genius?
ANDERSON: Yes. I thought it was extraordinary, even brilliant.
LEARY: Extraordinary it may be, but whatever it is, it's not genius is it?
ANDERSON: Well in my opinion Mr. Leary . . .
LEARY: Do you see where the artist has put the drops of blood? Genius?
ANDERSON: Well it's just an artistic addition . . .
LEARY: A what!?
ANDERSON: An artistic addition to the . . .
LEARY: To show a bleeding virgin is an artistic addition?

It was unanswerable and the tragedy, by now inevitable, was that Anderson felt impelled to answer at all. Leary dangled the spectre of youthful genius around like some bloodied rag.

"Look at the picture of the schoolteacher masturbating himself," he said, "and touching up the schoolboy who's vomiting. Youthful genius?"

Did it horrify Mr. Anderson, asked Leary, to think that a child of 11 had experimented with acid, as Viv Kylastron admitted in his printed biography that he had done?

"No, it doesn't horrify me," replied Anderson. "But I hope that if he did really take acid, which I don't believe, he did it with proper supervision."

"Are you suggesting that this kind of experiment with a child of 11, could ever be properly supervised?" asked Leary.

"Well, I think it could be," replied Anderson honestly.

The Judge looked at the roof again.

"Mr. Anderson," began Leary. "I give you the opportunity to reflect upon the answer you've just given to this Court."

Anderson paused; looked lost; looked frightened.

"What do you want me to say?" he stuttered. It just didn't matter any more.

"I gather you've some experience of teaching children?" Leary continued.

"Yes," replied Anderson.

"Especially those children who couldn't read..." said Leary.

"Yes," said Anderson.

"Nothing they like more than looking at the pictures? That's right?" asked Leary.

THE TRIALS OF OZ

Les Mademoiselles de Oz:
L-R: Neville, Anderson and Dennis

"Yes, they love looking at pictures," agreed Anderson.

"And quite a high percentage aren't going to read all the articles with the painstaking attention which we have paid to them, are they?

They're going to thumb through the dirty pictures inside. That's right, isn't it?"

Leary smiled, politely.

"They're going to be attracted by the lesbians on the cover," Leary continued, "thinking that, perhaps, there's something for school kids within. And what they find is the youthful genius which draws a school master masturbating whilst touching the anus of a small schoolboy."

Leary should have ended there. He had said enough.

Leary instructed us to look once more at the cover.

"You see the girl on the extreme left, wearing a male penis. A penis strapped to her?" he asked.

ANDERSON: Yes.
LEARY: Nice?
ANDERSON: That's just a dildo.
LEARY: Of course it is; but is it nice?

ANDERSON: Well, it's beautifully drawn . . .

LEARY: Do you find the erect male organ nice? Would you agree it's clearly indecent?

ANDERSON: No, not indecent in the least.

LEARY: What?

ANDERSON: I don't find it indecent in the least.

LEARY: Do you find anything indecent?

ANDERSON: Yes, I find lots of things indecent.

LEARY: Just name one . . . you said many things, just name one.

ANDERSON: Well, there's nothing here to help . . . I think if somebody urinated in front of me perhaps I might find it indecent, but . . .

LEARY: Would you find it indecent for somebody to pass water in the Court Room?

ANDERSON: I think I would yes.

LEARY: The best example you can give of indecency?

ANDERSON: I'm sure I could think of . . .

It was to prove a disastrous admission. Poor Jim Anderson; frightened as he was, tired, anxious, he just couldn't cope with Mr. Leary's hectoring.

He was, Leary told us again, merely doing his job. In the name of the Law, after all, and Mr. Anderson knew about the Law didn't he? Anderson was by now getting thoroughly confused.

"You're not married, are you?" * asked Leary.

"No, I'm not" replied Anderson.

"You haven't got any children of your own?"

"No, I haven't."

"But you wouldn't think it a good thing that parents should masturbate in front of their children, would you?" Leary paused...

"Well, I don't. It depends on the family circumstances," stuttered Anderson.

"The WHAT?" Leary banged his desk furiously, looking around for support. "I'm sorry," he said. "May we have that reply again?"

* Jim Anderson was, and is, gay. After the trial he told his mother, but he never did tell his father. In 2011 an article in the Australian *Star Online* described his latest art exhibitions as "Queer Troublemaker's Life on Show". He is quoted: "I think, as a homosexual the most important thing you can do is be out all the time. That way mainstream society can realise there's nothing to be scared of". Although Anderson was not 'out' officially at the time, it is hard not to believe that the police investigation would have shown his sexual orientation - after all it was only four years after homosexuality had become legal in the UK. Leary would, therefore, presumably have known, and by 20th Century standards one would suspect that if a prosecuting counsel browbeat a gay witness in this manner today, they would be immediately found in contempt of court for homophobic behaviour.

THE TRIALS OF OZ

The prospect of the monster of NW1 masturbating away like fury in front of his assembled family no doubt occurred to some, most probably to the 40,000 'children' who had rushed to buy the magazine.

> "You said to Inspector Luff, did you not," asked Leary, "that 'the point is the children produced it themselves, not under our guidance; clearly, they need it.' And the sort of guidance which they got from your magazine was all the wrong way, was it not?
>
> "Oh, I think it was absolutely the opposite, Mr. Leary," replied Anderson. Leary ignored him.
>
> "Because they're encouraged within the covers of this magazine to indulge in sexual perversions," Leary said after a pause.
>
> "Well, I think they're encouraged to express themselves in a very open-minded and honest way, Mr. Leary," interrupted Anderson. Leary still ignored him.
>
> "To conduct experiments in drug taking and incest," he continued.
>
> "Not at all," pleaded Anderson.
>
> "Because there is placed at their disposal, under various box numbers, persons whose sexual activities are graphically set out..."

Leary sat down, and no amount of re-examination by Mortimer's junior, Walker-Smith, could restore the credibility of the crumpled Mr. Anderson. His fears about the workings of the Law had been justified after all.

Lastly, there was Mr. Dennis, an altogether tougher, less sensitive and, some thought, less intelligent* individual. Throughout the proceedings, he had boasted to his friends that when in the witness box he was going to 'get' Mr. Leary. We should see.

Mr. Dennis affirmed - he was an atheist, he told the Judge.

> "Yes, yes," said Argyle, wearily.

A director of OZ Publications Ink Ltd, for almost two years, his annual income from the magazine had averaged £850.

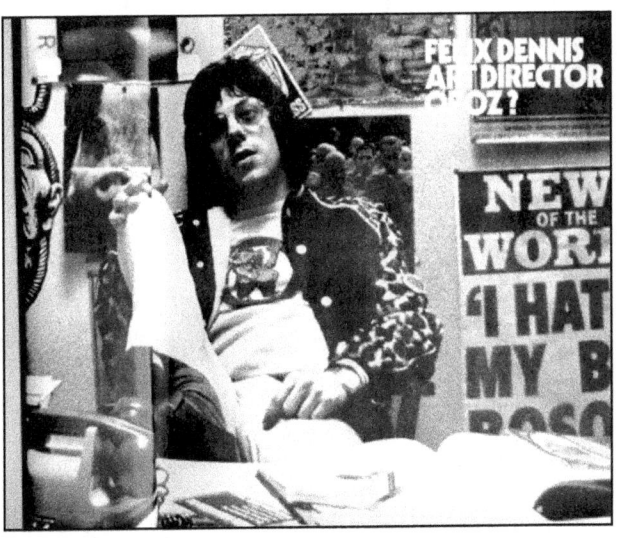

* It was Judge Argyle himself who, at the end of the trial, described Dennis as having "lower intelligence".

His function in that Company, asked John Mortimer for the defence?

"Basically," Dennis replied, "I worry about money."

Dressed in his dark blue dungarees inscribed with the motto 'University of Wishful Thinking' and his bright yellow *OZ* T-shirt, his insistence about money was not difficult to believe.

> "£850 a year," he continued, "works out at about a bob an hour; Mr. Neville takes less – about £700 a year, and that includes all his expenses. That's the absolute top whack."

Mortimer then asked Dennis to look through a great bundle of documents which included a list of receipts for the distribution of the magazine. Like the subscription list from which Mr. Mortimer had read earlier, it was curiously impressive.

> "The British Museum, 1970-71, is that right? The Libraries of the Universities of Oxford and Cambridge and the National Library of Scotland? *Life* Magazine, enclosing a cheque for a year's subscription? and then Swedish Radio?
>
> The University of Zambia? The Department of Anthropology and Sociology, University of British Columbia, Vancouver? The *Evening Herald*, Dublin? CBS – Columbia Broadcasting Company Records? The Institute of Pathology at Middlesex Hospital? *Braden's Week* from the BBC? The University of Birmingham? a back order issue from the University of Pennsylvania?"

...and so on.

Dennis went over the now familiar story of how *OZ* 28 had come to be edited; he did not disagree with or dispute any of the evidence offered by Neville or Anderson. Yes, they had previously produced a number of special issues for the normal *OZ* readership.

> "I remember the first meeting with the school kids being a very confused situation," he said.
>
> "I remember being asked dozens and dozens of questions about what sort of magazine they were going to produce. I even remember a lady from the *Daily Telegraph* wandering around interviewing the kids. Some of them were running around with things they had produced, asking other people whether they were good enough to go in.
>
> A lot of the kids came along just to have fun; they didn't realize that, in fact, they were actually going to have to produce something.
>
> We suggested to them that we wanted everything in the magazine, apart from the advertisements, either done by them or selected by them. By the time of the second meeting, they even wanted to change the look of *OZ* as well as some of its contents."

Mr. Dennis was so direct and straightforward that, despite his shaggy hair and beard, his simple honesty seemed to be impressing the Jury.

> "If only he were dressed like a human being," a court usher said to me.

Dennis went on to explain that the physical job of pasting up the material in order to make it intelligible to the printer, was done by him and Anderson. The technical complications involved in preparing the magazine for the presses were beyond the skills of the schoolchildren.

It was impossible to remember in detail exactly which article or advertisement or photograph had been chosen by whom or when or why; but, yes, all the material had been selected by the schoolchildren whether actually written by them or not.

"I didn't want to interfere," added Dennis. "I just gave them advice where I could."

"Can you help us about the meaning of the word 'gimpy'?" asked the Judge suddenly.

"Indeed, my Lord," replied Dennis.

"'Gimpy' is an expression which is, or was, very fashionable amongst skinheads. I don't know if you know anything about skinheads at all, but it's an expression used by them to describe long haired people."

"Thank you, Mr. Dennis," replied the Judge. "It's been worrying me."

Some of the material, for example, had been taken from *The Boy's Own Annual*, Mr. Dennis went on to explain, or from the thousands of underground magazines from all over the world which littered Mr. Anderson's flat.

The four photographs which represented the school kids' tribute to the murdered four students from Kent State University, were from *The Times*. The quotation which was there superimposed –

"These bums . . . you know, blowing up the campuses"

...was from Richard Nixon. Parts of the magazine's design offended him, Dennis, as an artist; some of it was difficult to read, much of the artwork had become blurred, even obscured. As to the small ads,

"...we run them not because of the money we make on them," said Dennis.

"By the time you've collected all the information, kept all the box numbers, helped people get all the right letters posted to the right box numbers, you haven't really made any money at all.

We do it as a service. And many of the larger advertisements are carried in many of the glossy magazines, like *Mayfair*, *King* and *Penthouse*."

"These actual advertisements?" asked the Judge.

"Yes," replied Dennis. "Or, at least, advertisements very similar to these."

Mr. Mortimer asked Dennis if he could tell them anything about the guest house in Hastings which had advertised "exclusive private male 'gaye' facilities".

"Yes, I have made enquiries about this," replied Dennis. "I had some difficulty first of all contacting the guest house, because it had moved."

To Neville, now cross-examining, Dennis explained the true meaning of the expression 'fucking in the streets'.

THE TRIALS OF OZ

"'Fucking in the streets' does not mean copulating in the highways and byways of the metropolis," said Dennis. "It is not, perhaps, a very nice expression for people older than myself. But it is an expression which has its roots in politics, in the freedom of sexuality if you like. It's a political slogan which has emerged from groups such as Women's Liberation and Gay Liberation. It's just a battle cry. Just so, the expression 'Right On'. That is an expression used by American revolutionaries in general and the Black Panther Party in particular. It is a show of solidarity if somebody's in trouble. If somebody has just made a speech with which most people agree, instead of saying, as you would in England, 'hear, hear', the person would raise his right hand and say 'Right On'."

So Mr. Luff had been Right On after all.

Dennis then outlined the difficulties of getting the magazine printed at all. Being particularly interested in developing a new form and style of typography, had led them into all manner of difficulties.

"Our print costs are, in fact, very high," he said, "because we have to print on out-dated machinery. On the one occasion that we have used up-to-date equipment, we were told after some months by the printers that they no longer wished to continue producing our magazine. The reasons we were given included the fact that *OZ* had received publicity in the *News of the World,* and that the managing director of the company, Mr. Woodrow Wyatt, who's a politician, couldn't afford to have his name associated in any way with a publication such as *OZ.*

There have been many other instances where printers have not felt able to print *OZ*; the reason given was not always to do with its content. When I first went round looking for printers, for example, I wasn't dressed as I am now. I had very long hair; I had come from a culture different from theirs; I had a small magazine with an un-established credit rating; and no printer's going to print a magazine that has colour and has a weird name like *OZ* with a freaky, long-haired guy in front of him saying 'Don't worry, we'll pay you'.

And it was only after I began wearing suits and carrying a very heavy brief case and waving a cheque book, that we ever found printers at all. There was one occasion, however, when a printer, without ever having seen an issue of *OZ,* said that it would be impossible for him to print the magazine. So, I said: 'Well, you haven't even seen an issue yet; how do you know you've even got the technical capability to print it?'

And he said: 'No, I don't think it would be possible for us to print *OZ* because, you see, we're far too near the Palace'".

The Judge looked - well, I was going to say pained, but he's been that so many times already.

"Now, wait a minute, wait a minute," he said. "Can we keep the Royal Family out of this, do you think? We haven't succeeded in keeping many people out of it, yet."

All this, of course, was not to mention the inconvenience of having the *OZ* files in New Scotland Yard for a year, nor the continual visits of the force in the past. One policeman, said Dennis, had actually warned them of their impending doom.

THE TRIALS OF OZ

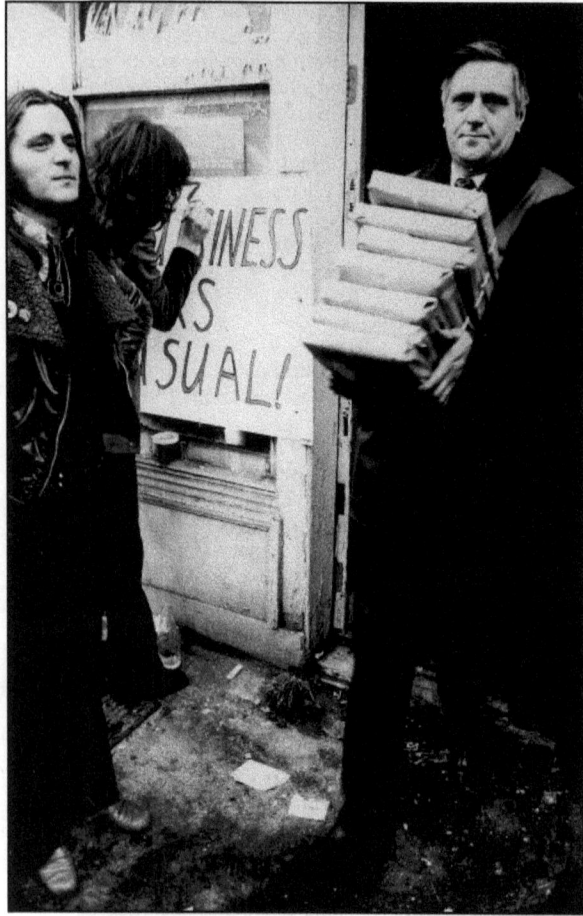

A raid on the *OZ* offices, January 1971

"He said that 'we could push it so far, but no further'. And when I said to him: 'What does that mean, you could push it so far and no further,' he says: 'You know what I mean, son; you're pushing it.'

So I say: 'Well, we're only printing what we believe to be true and what we believe to be right; what do you mean?' And he just said: 'You know what I mean, son, you're pushing it.'"

Mr. McHale asked Dennis whether it would be technically possible to produce a magazine all of whose contributions remained anonymous.

Of course, replied Dennis. True pornography usually is.

And it would be very easy to make a great deal of money this way? But the object of *OZ* had never been to make money.

"Mr. Dennis, help me a little, will you?" began Mr. Leary.

"If I can," replied Dennis.

"You are not suggesting, are you, that it came as a surprise for you to find that *OZ* No. 28 should be prosecuted?"

Leary smiled, bleakly.

"It was indeed a great surprise for me," replied Dennis.

"Was it?" repeated Leary.

"Of course it was," declared Dennis.

"I wonder if you'd look at this letter," began Leary. He read it deliberately, but ferociously:

THE TRIALS OF OZ

"'Dear Dave,

Thank you for your letter about the School Kids Issue, and I'm sorry to read that it depresses you with its ugliness.

OZ was never intended to, and in all probability will never, make profits. The refusal of most printers in this country to print *OZ*, forces us to recourse to small and uneconomical presses thus raising the print bill to an uneconomical figure The issue to which you are referring was produced by schoolchildren almost entirely alone.

If people find OZ filthy I can only say that it is a sad reflection on this society's educational programme. And if children's heads are filled with 'filth', I can only say that my colleagues and I will continue to risk prosecution, and any form of condemnation, to expose it. Personally, *OZ* makes me laugh. We are in it for fun and not the money.

Yours sincerely,

Felix Dennis'"

Leary paused.

"Do you now want to tell us about the policeman putting his hand on your shoulders and saying: 'You know what I mean, son. You're pushing it?'"

"He certainly didn't place his hand on my shoulder or any part of my body," replied Dennis.

"You see," continued Leary, "I was going to suggest to you that you realised perfectly well what Sergeant Warren meant by saying 'you were pushing it', because, if you kept on pushing your luck, sooner or later complaints would deluge to such an extent that the authorities would have to take action."

"Mr. Leary," said Dennis defiantly, "what you're saying has no substance. I've not been provided with any information or evidence whatever that the police were 'deluged'.

It only takes one complaint from one member of the public to initiate proceedings."

Flicking through the 'Back Issue Bonanza', Leary went on:

"'*OZ* 23, Homosexual *OZ*, hounded by Scotland Yard for being obscene'
Do you see?"

How big was the readership of *OZ*, in general terms, asked Leary? Well, replied Dennis, if you reckon that about 15 to 17 people read every copy sold, that would make the total something like half a million. And for *OZ* 28?

"Well", said Leary, "I suppose *OZ* 28 has become rare now."

"*OZ* 28 is becoming extremely rare," affirmed Dennis. "There was a gentleman the other day who offered me £5 for a single copy."

"Well, what did you do?" asked the Judge. "Did you hold out for more?"

The Court laughed. Dennis did not. He said:

"I told the client that if I gave him a copy and accepted his money, I might be in very serious trouble. I'm afraid that this trial has imposed a considerable strain on my two co-defendants and myself. I now believe, for example, that my telephone is tapped and people are asking me questions because they are police officers. I know that sounds ridiculous, but I thought that was quite possible with this person."

"Yes," beamed the Judge.

"If it's any comfort to you," said Leary, "I don't know a thing about it."

"Do you think that children should be encouraged to experiment with drugs?" he asked instead. Dennis was ready for him.

"I think it depends what drugs you're talking about," he replied. "Be specific."

"Amphetamines," said Leary.

"*OZ* is conducting a vigorous campaign against the taking of amphetamines," said Dennis.

"Thank you," said Leary.

"Heroin?"

"To my knowledge," replied Dennis, "*OZ* has published very little about heroin; but we did publish a guide to drugs and their abuse in which we mentioned the dangers of taking heroin. Heroin was something to be absolutely discouraged".

"LSD?" said Leary.

"LSD is a different kettle of fish," said Dennis. "I think that LSD could be an extremely dangerous drug. If it is not administered properly, terrible damage can be done to some people. But I can envisage the circumstances, and there's no point in me disguising it from the Court, in which I would not condemn somebody for taking LSD. I would in no way encourage or condemn them in certain circumstances; that's a moral decision for somebody else to take. It's their own decision."

"Ye-es," said Leary. "Oh well; cannabis?"

"In 1967," said Dennis, "*The Times* carried a full page advertisement which stated that the law against cannabis, or marijuana, was both immoral in principle and unworkable in practice, and I would accept that view."

For the first time, Mr. Leary looked flustered.

"Now, will you turn to page 28," he began: "...you'll see, what my learned friend Mr. Mortimer insists on describing as an 'advertisement' for *Suck*. Help us a little bit. Is that a magazine that you know of?"

DENNIS: It is a magazine with which I am vaguely familiar. It originates from Holland. It's a Dutch paper printed in English, costing 12/6d. It's described I think quite accurately as Europe's first sex paper.

LEARY: Yes. Pornographic sex magazine . . .

DENNIS: In your understanding of the word 'pornographic', I would say that to be true, Mr. Leary. In my understanding of the word 'pornographic', not.

LEARY: Oh . . . I see. You think that nothing of what I mean by a pornographic nature, can affect, or tend to affect, the minds of anyone?

DENNIS: Of course it could affect the minds of someone. I think somebody getting their first issue of *Suck* on their breakfast table would certainly get affected by it.

LEARY: Ye-es. Corrupted by it?

DENNIS: I would think most certainly not.

LEARY: Yes, I see. Or depraved, in any way, by it?

DENNIS: It would depend entirely on the person, on what issue of *Suck* it was, what article they were reading and so on. How can I possibly say? You're asking me to make hypothetical assumptions.

LEARY: Ye-es ; but I was wondering if you agreed that *Suck* was a pornographic magazine.

DENNIS: *The Bible* says that it's easier for a camel to go through an eye of a needle than for a rich man to get to heaven.

LEARY: Yes. Well, that's a useful analogy, if I may say so.

DENNIS: I'm glad it's been of assistance to you.

Mr. Leary was getting as good as he gave. Even the Judge looked amused. Presumably hoping for better material, Leary turned to the small ads.

"What do you understand those 'teenage male models' are wanted for?" he asked.

"I have absolutely no idea, Mr. Leary," replied Dennis; "possibly to model fashion clothes."

"Really?" replied Leary, astonished.

"It means absolutely nothing to me, Mr. Leary," continued Dennis; "...and until I have further information, I wouldn't presume to say. It could be that the person wanted people to model swimwear, or something of that nature; but I did not know."

"Since you put it that way," said Leary, "...the other possibility is that the purposes for which these teenage male models were required, was for the satisfaction of sexual lust?"

"I would have to admit, Mr. Leary, that there is a remote possibility that that is true."

In spite of having been in the witness box for nearly two hours, it was the first thing Dennis had conceded. Leary read on from the small ads:

"'Gay Men invited to send £3 for our New Magazine *Iron Boys*. This uncensored magazine from Sweden shows scenes never published before, covering every angle of love.' What sort of love?" he asked.

"I would say that it's homosexual love, Mr. Leary," replied Dennis.

"Yes," said Leary slowly. "And every angle of love probably includes men and boys, doesn't it?"

"I can say to you, Mr. Leary," answered Dennis, "...that I have in fact seen the magazine *Iron Boys*, although only very briefly."

LEARY: Well, do you agree then that it involves boys?

DENNIS: No, Mr. Leary, to my knowledge it did not involve boys.

LEARY: Showing scenes never published before, covering every angle of love?

DENNIS: I would say that that is a typically exaggerated advertiser's phrase.

LEARY: There to attract the eye of anybody with homosexual tendencies, isn't it?

DENNIS: It is, indeed, Mr. Leary.

LEARY: Nothing to do with any introductory service, but there to pander to the lusts of homosexuals?

DENNIS: Mr. Leary, I find that phrase repulsive. Would you please rephrase your question?

LEARY: No, certainly not.

JUDGE: Certainly not. Just answer it, that's all. You can comment if you wish. What's your answer?

DENNIS: In my opinion it is not pandering to the lusts of homosexuals.

LEARY: How would you put it? [...pause...] Assisting gay men to meet gay boys?

DENNIS: No, it is not doing that.

LEARY: Hmmmmm?

DENNIS: No it is not doing that.

LEARY: Assisting gay men to get a thrill, a sexual thrill, out of thumbing through photographs never published before covering every angle of homosexual sex? I am at pains to point out that this page covered not only the introductory service whereby perverts were introduced one to another, but supplied uncensored magazines from Sweden to homosexuals.

DENNIS: Is that a question, Mr. Leary? If it is I would have to say that I can't accept your phrase 'perverts'.

LEARY: What phrase would you like to use?

DENNIS: If you wish to use the phrase 'homosexuals' I would find it much more to my liking. Your constant insistence that homosexuality is a perversion - is not in my opinion.

LEARY: What about voyeurs?

DENNIS: To be quite honest I've never thought seriously about yoyeurism in my entire life until this present moment.

LEARY *[shouting]*: Well, I'm asking you seriously to consider it NOW!

It was Dennis' turn, at last, to get flustered. Mr. Leary moved in to the attack.

"What about encouraging children to engage in group sex?" he asked. "Do you approve or disapprove?"

DENNIS: Mr. Leary, that's a hypothetical question. Would you please give me other details surrounding that question and I can answer it.

JUDGE: No, Mr. Dennis. You can either give your view or you can say, 'I can't answer the question'.

DENNIS: I can't answer the question, Mr. Leary. Thank you, my Lord.

LEARY: Well, may I suggest there are two answers? You could say, if you thought it right, 'I strongly disapprove of group sex between children.' Do you want to say that or not?

DENNIS: Without the relevant circumstances being explained to me surrounding that decision, I could not possibly just make a wide and generalised statement.

LEARY: Then I take it - sir - that you believe there are circumstances in which young children may participate in group sex with your approval?

THE TRIALS OF OZ

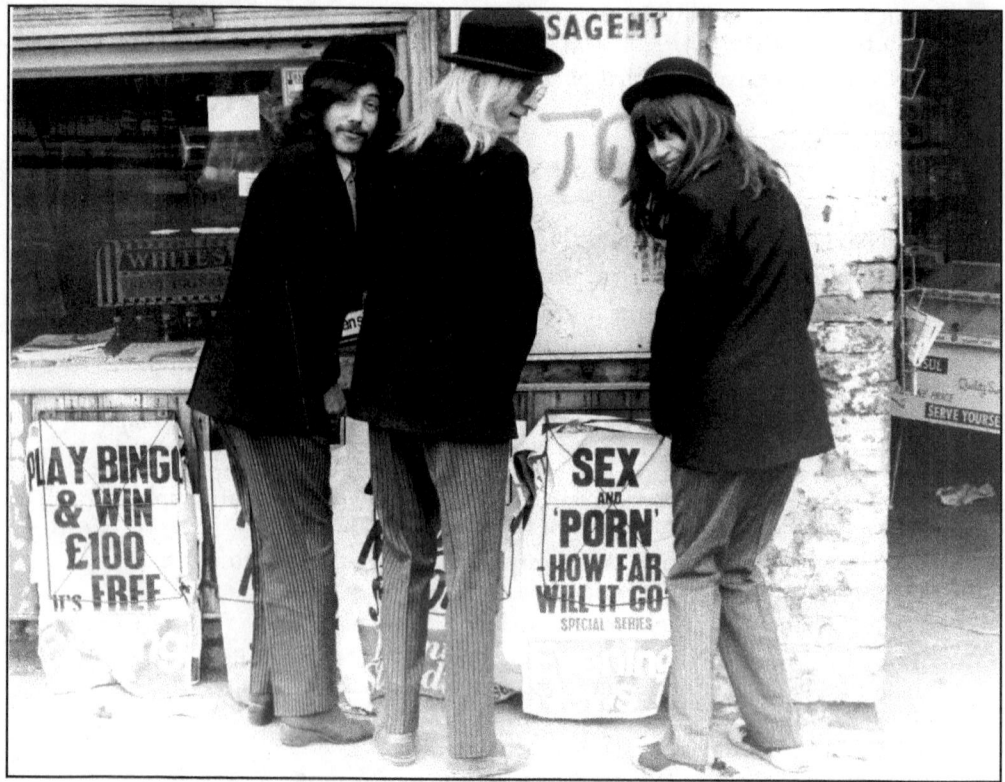

DENNIS: No, not with my approval or disapproval. You may not say that.

LEARY: You have an entirely open mind about it and if children want to do their own thing with each other in groups, you can see no harm in it?

DENNIS: I can see, of course, there could be harm in it, Mr. Leary; there could be harm in almost anything.

LEARY: Yes. But none that you can see, Mr. Dennis.

DENNIS: No, that's not true; you're putting words into my mouth.

Was this *OZ* 28 that they were talking about? It was hard to believe. From the mountains of evidence collected by the police, Mr. Leary then produced a little red book which turned out to be the record of box numbers and relevant addresses. "I've never seen it in my life before," said Dennis. Also a letter sent out by one of the OZ secretaries, Marsha Rowe, stating that *OZ* No. 9, advertised in that 'Back Issue Bonanza', had sold out within a week of its being advertised in *OZ* 28 - proof, according to Leary, that the *OZ* advertising techniques worked.

Leary held up the magazine, displaying its cover once again.

"Those concerned with this publication," he said, "did their best to provide an erotic cover, didn't they?"

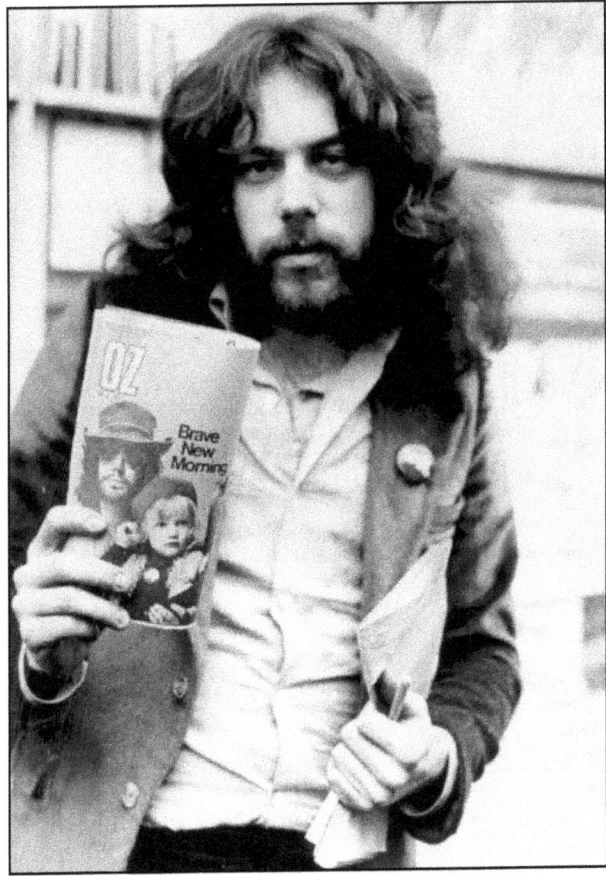

Felix Dennis with a copy of *OZ* magazine - 17th February 1971

"I've seen that cover too many times for me to give you an honest evaluation as to whether it's erotic or not," replied Dennis. "It's become an object of my nightmares."

"Depicting lesbians?" said Leary. "In groups?"

"The cover was chosen by the children themselves," insisted Dennis.

"In fact," he added, "I didn't think it was a very good cover."

"Did *you* suggest the World Cup team?" asked the Judge to everyone's complete puzzlement.

Prompted by Leary, Dennis then recounted a further visit by Detective-Inspector Luff, not mentioned so far.

On this occasion, Luff had been to another *OZ* office. Dennis, somehow forewarned of Luff's impending arrival, had a photographer standing by as well as a Granada TV reporter to record the scene.

"It is a fact," said Dennis, "that newspapers and television and the mass media in this country have become extremely interested in the alleged harassment by the police of certain underground publications. I do not think their interest is in any way illegal or irresponsible, and I consider that to have a photographer and a responsible journalist present at a police raid on a magazine of any kind, is not in any way being irresponsible or in any way obstructing the police in the course of their duties."

Leary switched tack, again.

"After this trial had started," he said, "did you have anything to do with the Independence Day Carnival on Sunday July 4 at Hyde Park, 2 o'clock in the afternoon?"

"I attended that Independence Day Carnival for about half an hour, yes," agreed Dennis.

"Did you speak at it?" said Leary.

"I did indeed speak at it."

"About this trial?" Leary paused, long.

"I pointed out to the crowd that, in the opinion of many people, and not necessarily people connected with an alternative culture or underground newspapers, the government of this country was in fact becoming a repressive government, and that many of the previously understood liberal interpretations of the law were now being disregarded."

Leary then produced the Independence Day Carnival broadsheet which included the phrase about *OZ*

> "...relentlessly promoting some elements of the new culture, dope, rock'n'roll and fucking in the streets".

It was clearly meant to be the *coup de grâce*. The Jury were sent out while Mr. Argyle considered the admissibility of this extra piece of evidence. Dennis denied having anything to do with its production. As far as he knew, it emanated from 'The Friends of *OZ*'.

The Judge took their names and, for the only time during the entire trial, refused the defendants bail over the lunch adjournment.

Leary's chance had passed. After lunch, he asked Dennis the inevitable question:

> "Is it right that *OZ* has relentlessly promoted some elements of the new culture?" he said. "Dope, rock'n'roll and fucking in the streets?"

DENNIS: Is it right in my opinion that this particular issue of *OZ*, or all issues of *OZ*, have relentlessly promoted that, Mr. Leary?

LEARY: You heard what I said. I'll say it again: *OZ* has relentlessly promoted some elements of the new culture: dope, rock'n'roll and fucking in the streets.

DENNIS: No, that is not an opinion with which I would agree.

LEARY: Do you know an organisation called the 'Friends of *OZ*'?

DENNIS: Yes, I do.

LEARY: What connection has the company OZ Publications Ink Ltd with the 'Friends of *OZ*'?

DENNIS: None whatever.

LEARY: And when you came to address this meeting on July 4, you had the opportunity then to disassociate yourself and the Company from any form of public protest.

DENNIS: I'm sorry, I don't quite follow your question . . . I had the chance there to . . .

LEARY: *[Shouting]* When you heard there were some 10,000 in Hyde Park, you had the choice of encouraging or discouraging public protest. Against this trial. The magazine with which you are intimately associated!

DENNIS: Yes, except that that wasn't the point of the Independence Day Carnival at all.

LEARY: Did you, or did you not deal with the idea that *OZ* had relentlessly promoted some elements of the new culture: dope, rock'n'roll, and fucking in the streets?

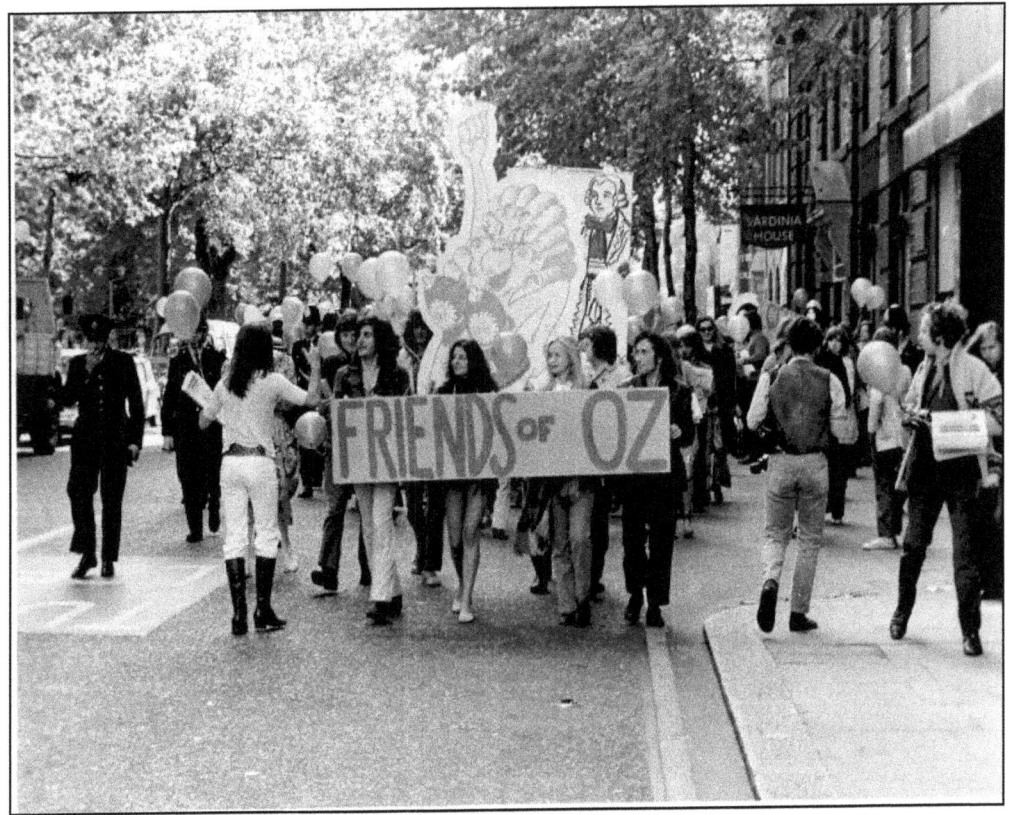

The 'Friends of *OZ*' demonstration processes through London

DENNIS: No, sir, I did not deal with that at all.
LEARY: Because, [...pause...] that's just about the size of it isn't it?
DENNIS: Sorry?
LEARY: Just about the size of it, isn't it?
DENNIS: The size of what, Mr. Leary?

Leary sat down. Astonishingly, Dennis had kept to his word. As near as was conceivable, he had 'got' Mr. Leary. Things began to look a little better.

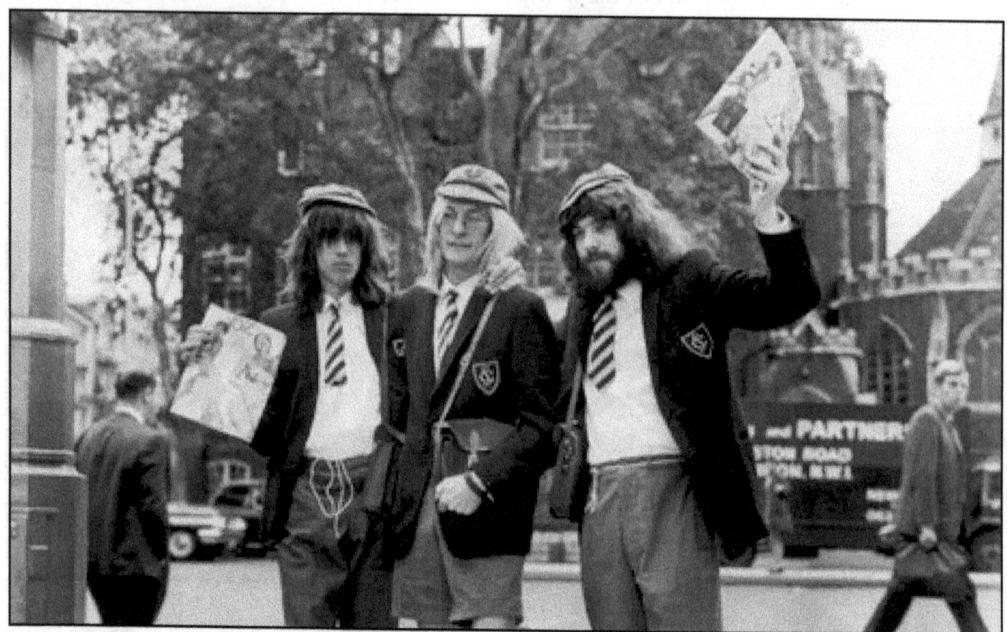

Three lonesome schoolboys who have just got into town...

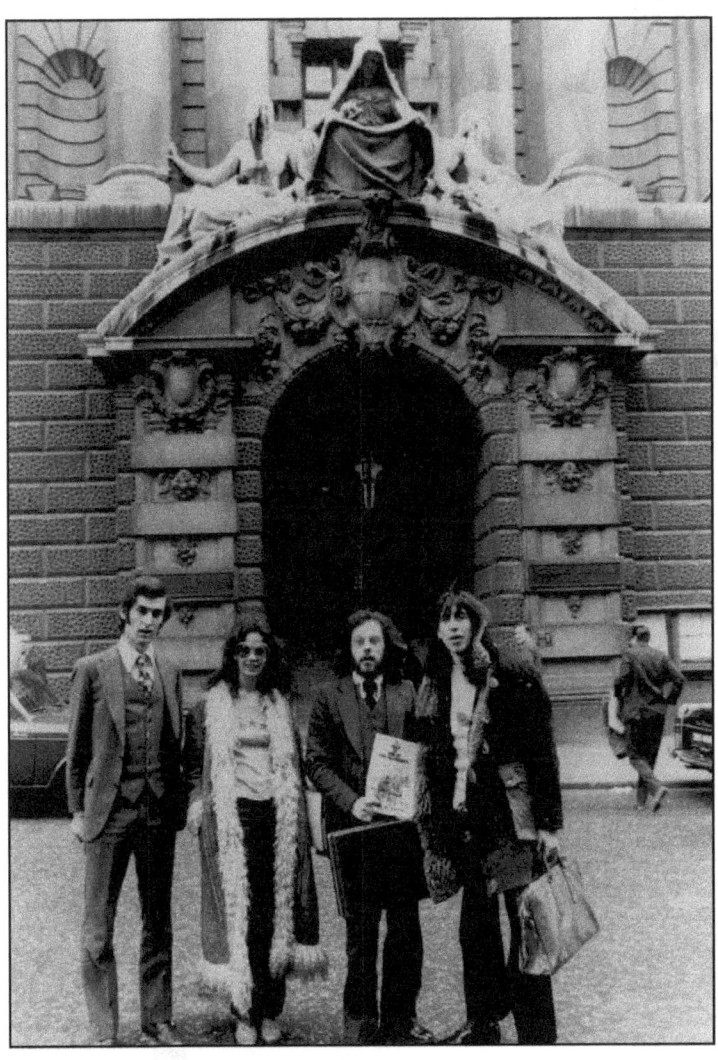

....and found themselves in front of The Old Bailey

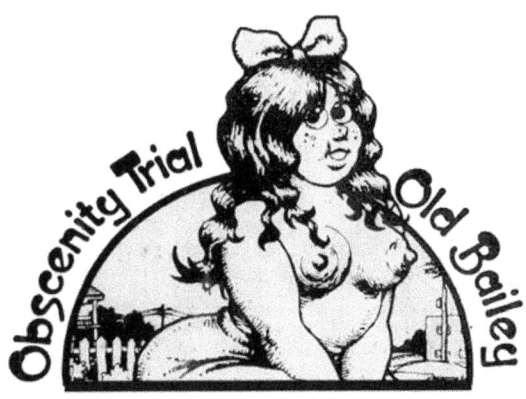

CHAPTER FIVE

By the time the defence had begun to call its expert evidence on the use and misuse of drugs and sex and the likely effect of these on the minds of the young, the trial was already into its third week, and no-one was prepared to guess at the likely, or even probable, end of it all.

Could it really be possible that grown men and women were anxious to devote so much time and energy to the minute examination of a magazine which, until the police had begun their prosecution, had passed by more or less unnoticed? Was this not an absurd misplacement of effort? Obviously, the Judge did not think so.

"The one thing we have plenty of in this case," he kept reminding us, "is time."

To almost every witness he said: "Take as much time as you want."

And so they did, each anxious in their different ways to emerge as stars of the show, each aware of the role they had been asked to play, in what was clearly becoming for some one of the 'great moral debates'. Others took a more humble, perhaps more straightforward view; the first of these was **Miss Caroline Coon**, white hot pants and all.

"I certainly have, as I'm sure most of us have, seen you on television," said the Judge.

Was he looking at the hot pants?

Miss Coon had actually appeared in the Court Room before the exciting Mr. Anthony Smith, but as she was questioned at length by Mr. Leary about drugs, which seemed to me to fall under the category of 'expert evidence', I thought it best to begin this chapter with her and her hot pants.

"We founded 'Release' in 1967," she said, "to help young people who were arrested for drug offences. But since that time, we've expanded the work that we do and are now more of a welfare service to help young people in all sorts of problems that they might have. There is still no other similar organisation run by young people for young people.

We have 15 full-time workers and about 18 volunteers who come and help us in their free time. As well, we have a panel of about 12 solicitors on call in London and a team of psychiatrists and doctors to assist us with what we do. Recently, we have been registered as a charity."

"And how many clients would you say that 'Release' has, on average, per week?" Neville asked.

"Last year we did a survey," said Miss Coon, confident and bubbly. "It was estimated that we saw over 7,000 young people during 1970 and our case load increases all the time."

"Do these young people come to you only for advice about drugs?" asked Neville. "No, they come to us for all sorts of problems," replied Miss Coon. "We have a very complete library with the most up-to-date medical opinion about most social issues."

'Release' had been called upon to give advice to Lady Wootton's committee on LSD and amphetamines, Miss Coon went on.

"And William Deedes[*] asked our organisation to give advice about police powers of search and arrest. I think this was because we are the one organisation which has more experience in dealing with young people in these areas than almost any other in this country."

"Is it true that you were invited, earlier this year, to lecture at the Home Office Police Conference for Drug Squad Officers?" asked Neville.

"Yes, I was," replied Miss Coon. "And you were invited to lecture at Scotland Yard on community relations?"

"Yes, I was."

"And at the Royal Society of Medicine?"

"Yes. The transcript of that talk was published in *The Practitioner*."

Miss Coon looked hushed; Mr. Neville, merely pleased.

OZ, she believed, was a forum for young people in which they could freely express their ideas. Overground newspapers, such as *The Times*, were closed to them in a way that was difficult to explain but real nonetheless. She thought that, generally, *OZ* gave a balanced

[*] William "Bill" Deedes KBE, MC (1913-2007) was a Conservative politician, cabinet minister, and between 1974 and 1986 the editor of the *Daily Telegraph*. He was given a life peerage in 1986. According to many sources he was the model for William Boot, protagonist of Evelyn Waugh's satirical novel *Scoop* (1938), and for *Dear Bill* the recipient in *Private Eye* for a hilarious collectional of fiction letters from Denis, husband of Margaret Thatcher.

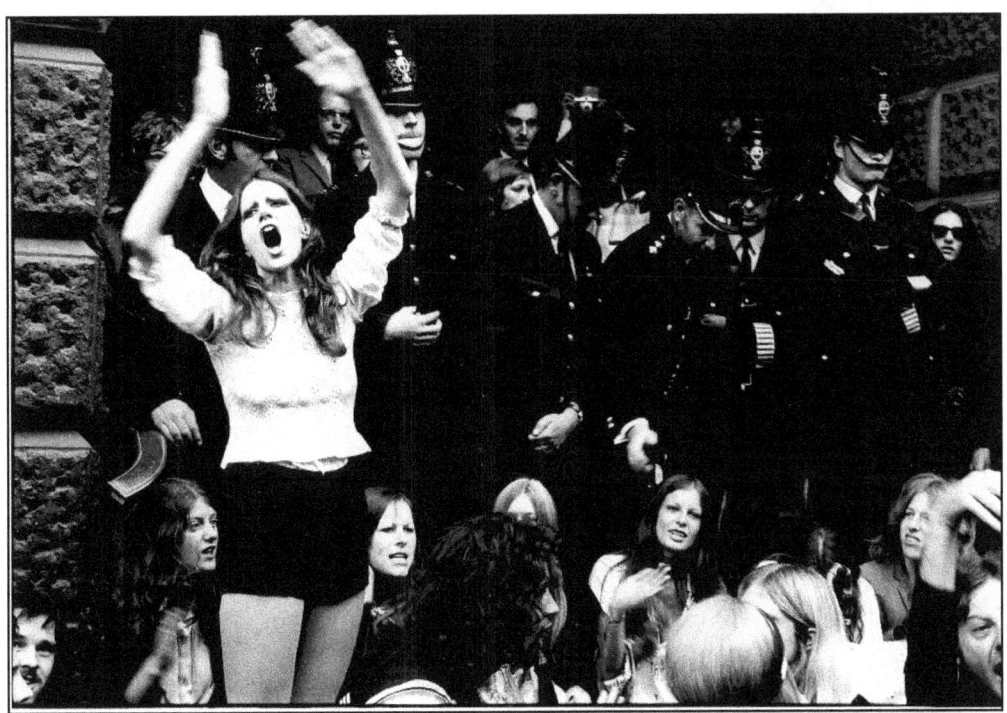

A rampant Coon...

approach to drug taking. If anything, *OZ* had actually prevented the problem from getting worse, simply by refusing to moralise or dogmatise about the various forms of drug addiction. Certainly, it had always implicitly discouraged the use of hard drugs such as heroin or amphetamines.

"You see," she told the Court confidentially, "I think that the trouble with so much of the information available to young people about drugs, is that they're not really given facts. And unless you're specific with young people and really show them what they should and should not do, then they're going to experiment without the advice of their contemporaries. It's because of the myths surrounding drug taking that drugs have become dangerous. You must dispel the myths by giving actual facts. It is always better to be specific."

"Would it be fair to say," asked Neville, "that there's a great shortage of facts and information about acid, for example?"

"Well," she replied, hitching up her pants. "There are a lot of rather expensive books available in libraries which do have lengthy articles about drugs, but not really the sort of books which young people would read. Lengthy and scientific dissertations are not things which young people will be bothered to get their teeth into."

"Do you recall off-hand the acid issue of *OZ*, the acid number?" asked Neville.

"Yes, I do," replied Miss Coon.

"Would you say that helped to make facts and information more accessible to young people?" enquired Mr. Neville.

"Certainly," snapped Miss Coon.

"You don't recall it as being an irresponsible approach to taking LSD, do you?" prompted Neville.

"I think *OZ*'s attitude to drugs is very responsible," retorted Miss Coon.

The Judge interrupted.

"I think this is all excellent advertising matter for 'Release', but what's it got to do with the charges in this case?"

...he asked. I had completely forgotten he was there.

"Well," replied Neville. "I think the relationship between drugs and young people has already been raised in this Court before today, your Lordship, by Mr. Leary."

"Well, carry on Mr. Neville, please do," said the Judge wearily.

"I'll try and be as brief as possible, your Lordship," offered Mr. Neville.

"There's no shortage of time; we have plenty of that," said the Judge. "It's just the relevance, you see."

"I think the issues in this case are very wide, your Lordship," suggested Neville.

It seemed to me the Judge looked cross.

"The evidence has got to be related to something to do with the charges in this case," he said.

Neville continued, turning again to Miss Coon who was batting her eyelids at the Jury.

"Is it true to say," he asked, "that there are members of the medical profession whose attitude to drugs is ill-informed?"

"There are a great many such people in all professions, including lawyers," replied Miss Coon.

"Well, let's not touch on lawyers because I think that area is a little bit too touchy in this Court Room," suggested Neville. Miss Coon swanned on.

"One doctor said to me, he said, 'Caroline, the young people who come here dependent on drugs, are beyond our help!'"

Miss Coon then went on to define what she understood as the distinction between hard and soft drugs.

"It's a very emotional issue," she said, "not helped by the use of emotive words like 'hard' and 'soft'. A hard drug is a drug of dependence which, when you stop taking it, causes withdrawal symptoms. Drugs such as heroin, morphine, biseptone, methedrine and amphetamine. Cannabis, for example, is certainly not a hard drug. You don't get withdrawal symptoms after you stop taking it, although there is some reason to believe that it's psychologically dependent.

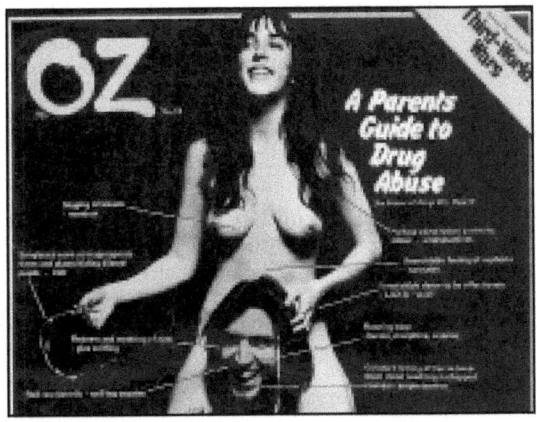

LSD is a much more difficult drug to classify. It's a dangerous drug because you don't know the sort of mental makeup that a young person who takes it has. But there are many young people who take LSD without any disastrous consequences because they are of sound mind.

At the Isle of Wight Pop Festival in 1970, for example, about 20 people came to us for help after taking LSD. We used to take them to our 'trip tent' which had pretty material hanging up and nice lights and we tried to talk them down off the LSD by showing them pretty things and by reassuring them that they were not going through the terrible traumas that they were imagining."

"Is it not true that I have been co-opted as a 'Release' worker on occasions?" asked Neville.

"Yes," replied Miss Coon. "The cooperation between 'Release' and *OZ* had always been professional and productive."

Leary blundered into action against the delectable Miss Coon. For once, he too seemed to have been charmed - by her beauty. He got into a terrible muddle about where exactly the offices of 'Release' were located, coughed, sipped water, nodded, winked and coughed again.

"Are you against the use of any drug?" he asked.

It was a feeble question. Miss Coon was altogether too well versed in the subject to be trapped by such an obvious ploy.

"If a young person comes to me and says 'What do you say about taking cannabis?' I have to say: 'First of all, you do realise that it is against the law, and if you get a conviction against you for drugs, you're probably not going to get a visa to go to America. A lot of jobs will be unavailable to you.' He will say: 'Well, that aside, what sort of physical trouble will I run into?' And then I have to say: 'Well in my opinion, any excessive behaviour is dangerous. He would say: 'Well, I'm not going to take cannabis excessively.'

I'll say: 'Well, I don't think it's a very dangerous drug to take'. Because we are not professionals, I then point to the Government reports issued on the subject in British medical journals. This is why we have a library. If young people are told by schoolteachers, or the authorities, they might dismiss such advice as just stuffy nonsense. The whole point about *OZ* is that it's young people talking to their peers. And you're not so likely to think it just stuffy nonsense if it comes from your own contemporaries?"

Miss Coon hitched up her pants and looked pleased. As well she might. Mr. Leary was flustered. A gentleman in the public benches laughed aloud. There was a shocked and profound silence.

"Would the gentleman who's laughing so loud please leave Court," said the Judge. "I have repeatedly said this is not a public entertainment."

It was not a view universally accepted.

But it confused Mr. Leary even further. It seemed as if he had begun to see drug references in every syllable, every comma and every blank piece of paper. 'Head' - that was a drug reference, wasn't it? 'Lay Off' - that was surely a drug reference. 'Smoked'? - well, that was obvious.

"Miss Coon," Mr. Leary said wearily, "...you and I understand one another, do we not?"

"Do you honestly expect me to say 'yes'?" replied the irrepressible Miss Coon.

"I think," she said, "....that the *News of the World*, for example, is far more hysterically obsessed with drugs than *OZ* magazine. *OZ* just accepts drugs as part of a whole social milieu. I think the allegations of obscenity against Neville, Felix and Jim are totally ludicrous. And I honestly believe that what's on trial today is young people's life-style."

He was being outwitted at his own game, was the unfortunate Mr. Leary.

The Judge intervened; one sensed that he was helping Mr. Leary out. He got involved in a long and totally irrelevant discussion with Miss Coon about the merits of the World Health Organisation and its attitude towards drugs. Only Judges, it appeared, were allowed to be irrelevant. Wasn't it interesting, he said, that Middle Eastern countries imposed the death penalty for 'pushing' cannabis? Yes, agreed Miss Coon. In reply to a question from Mr. Neville, Miss Coon said that the last time she had been in Saudi Arabia, she had watched several thieves having their hands cut off in the market place. Fascinating, wasn't it?

"I spend a great deal of time dealing with crime," Argyle said.

Surprise, surprise.

"Because this is my work."

One knew there was a logical explanation after all.

"So I don't deal greatly with people who have drug problems," he continued.

"This is really only a very small log floating on the river of national affairs in both our cases, isn't it?" he added.

"Thank you very much," he concluded. "You've lightened a dark and very dull afternoon."

Then began what should have been the crucial evidence for the defence - proof, indeed, that such material as had been published in *OZ* 28 could not conceivably have had a detrimental influence on the minds of children. Often, it had had the reverse effect - as Neville and the others maintained - in that it had enlightened and informed in a non-dogmatic and non-patrician way.

But what should have been, was not to be. As the days wore on, and the days lengthened into weeks while still the 'experts' came, the defence seemed to be in danger of defeating its purpose by the simple process of overkill. Quite apart from the defence, solicitors, assistant solicitors, detective-inspectors, tape recordists, police shorthand writers, pressmen, all hopped around, as if firmly convincing themselves and others that they were in at a great event and would go down in history as having played a role, albeit minor, in the ensuing tragedy. Their diligence seemed to lead at this stage more often to confusion than clarification, and their antics annoyed even the more sympathetic of observers.

First of these was **Dr. Lionel Richard Charles Haward,** the Director of Psychological Services for West Sussex and Head of the Psychology Department at the County Mental Hospital where he was "personally involved in the psychological assessment of drug addicts". He was also in charge of a drug-addiction unit at Greylingwell Hospital and had contributed to many different medical journals about the problems of the young. Married, with a 15 year-old son, he seemed a mild, careful man, not given to strong or even unqualified opinion. In his view, *OZ* 28 appeared to be a minority look at the oppressions caused by the present educational system. Its dominant theme was anti-authoritarian. He disagreed with many of the opinions expressed but, on the other hand, applauded their advocacy of change. As to the methods employed by this particular magazine, he was none too sure. But, certainly, these methods could not be described as harmful.

"One would have to have the sort of mind that is somewhat preoccupied with the bizarre to get any meaning from many of these pictures," he added. Their meanings were by no means explicit. As to the rude words, "these are very commonly written on the walls of school lavatories," he added.

"I think they are in common currency among schoolchildren in secondary schools; there would thus be nothing surprising, or even out of place, in seeing those words."

"Would seeing them published in this way," asked Mr. Mortimer, "...be liable to have any harmful effect upon children and young people?"

"No," replied Haward. "Their effect would be to make the magazine seem more in sympathy with their own feelings."

Asked about the cartoon of the schoolmaster holding his erect penis while touching the anus of a schoolboy, he declared that nothing depicted therein presented such homosexual relations between masters and boys in a favourable light. In fact, he said, he thought such drawings would be quite 'aversive' to the normal healthy child. It was an interesting word, and both the Judge and Mr. Mortimer had to get Dr. Haward to repeat it and then spell it.

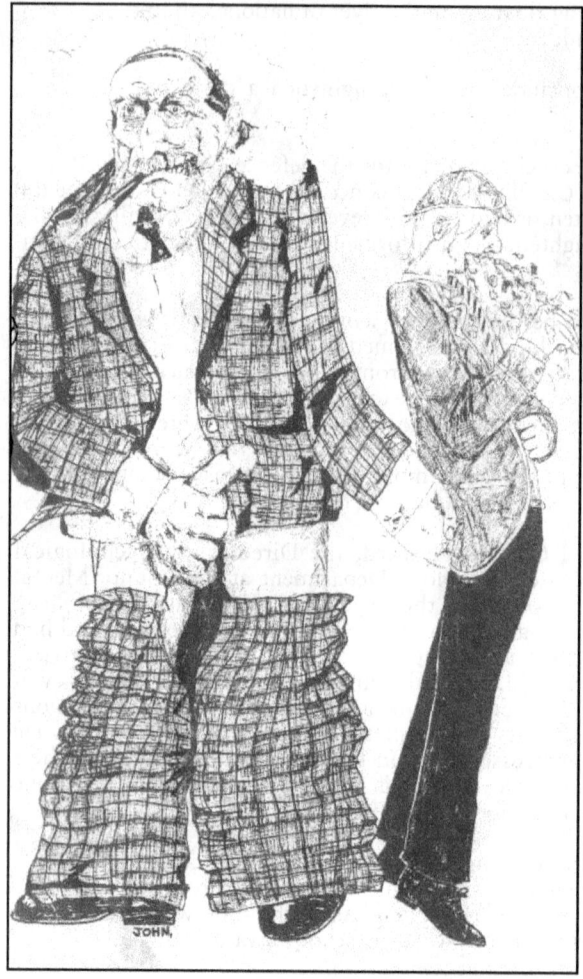

"Pictures such as this," he added, "are frequently used in hypnosis sessions to avert homosexuals from their practices."

Anyway, it was always better for a child to express his grievances than keep them bottled up.

And 'atrocities' by masters, as shown here, had always figured in literature from Edward Arnold to Dickens' 'Dotheboys Hall'.

It was also especially important to encourage open and uninhibited discussion about drugs; this was a subject which inevitably fascinated the young. Pretending that it did not exist would in no way solve any real or imagined problems. Likewise, the encouragement of a free debate about the ways in which schools are run.

"The universities now recognise the need of the students to play a large part in the assessment and derivation of their own curriculum," he added. "It's therefore important, I think, that sixth forms, which act as a bridge between the traditional school period and University, should make this transition easier by adopting in part some of the freedoms which the student enjoys at a university."

In all, he regarded *OZ* 28 as a good magazine which had a number of beneficial features that he would like to see incorporated into many a school magazine. He found some of the drawings rather disturbing because, as a psychologist, he could see what was going on in the minds of the people who had drawn them. But the text was basically sound.

The message of the Rupert Bear cartoon, for example, was a criticism of the lack of dissemination in sexual education. And as for the lesbian cover, "...young people who are exposed to sexual pictures and books," he said, "are less likely later to show sexual psychopathy or sexual deviance."

Like many things in the magazine, the cover and Rupert Bear were basically just shock tactics to awaken adults from their complacency about the way our society is manipulated.

"One of the problems," he added, "of our being able to understand them, the children, is that what is unacceptable to us may be perfectly acceptable

to them. For too long we have assumed that what offends us will necessarily offend or disturb them. There was simply not enough evidence about the differences between adult and child perception to be certain. Often, childhood bravado is mistaken for childhood perversion."

Admittedly, Dr. Haward went on, the erotic cover might induce children to take the magazine and then look to see what was inside it. Who could tell? But, again, the impact on the young child would be very small compared with the impact on the adult. For example, he said,

> "...it's not always clear exactly what is happening in some of these pictures. And all the evidence that has accumulated so far, suggests that literature follows the pressures of sexual need which young people have, rather than itself starting them off. People gratify their needs by selecting certain types of literature, rather than the other way around."

The following morning there was a bomb scare and the defendants had their briefcases searched. A less amusing sidelight occurred when news filtered through of the details of the police raid on *OZ*'s compatriot, the *International Times,* or *IT* as it's called because Lord Thomson, owner of *The Times*, doesn't want the two getting confused. The police had found the *IT* office almost empty - only Joy, the secretary, holding the fort with her boyfriend, a freelance writer called Jamie Mandelkau*. Everybody else was down at the quasi-mediaeval and ecological Glastonbury Fair 'free' pop festival. One of the visiting policemen had expressed disappointment:

> "Last time I was here, you were all sitting round drinking beer," he said.

The police had taken one copy of each of the last three issues of *IT*; one 'bootleg' long-playing record of Jimi Hendrix: and several hundred copies of a 20p book called *Nasty Tales*, a collection of comic strips from the world's underground papers. Beside the work of R. C. Crum of the *Los Angeles Free Press*, *Nasty Tales* features the Largactilites, nasty little creatures with big noses who make noises described as 'meeps'. They are drawn by a cartoonist called 'Edward' (more fully Edward J. Barker). Unfortunately for the police, the cartoons of 'Edward' had then appeared in the *Observer* the following Sunday. The *Observer* had not been arrested. The works of R. C. Crum, however, featured largely in *OZ* 28 - in particular, in the Rupert Bear cartoon.

The inscrutable Mr. McHale had some questions for Dr. Haward which merely repeated what Mr. Mortimer had clearly established, and that left Mr. Leary.

> "I wonder, Doctor," he began, "whether as a psychologist, you regard the relaxation of school discipline as a good thing, do you?"

> "In part," replied Haward. "But I also regard it as a bad thing, in part. In order to develop self-discipline, for example, which most of us would regard as an admirable quality in the adult, we must be exposed to external discipline first. My own personal view is that there should be much more rigid discipline in young children. And only as the child grows up, and particularly as he comes into puberty, should he be liberalised. The misfortune seems to be that many of the young people who protest against the contemporary authority under which they suffer, have not had sufficient discipline in the past to inculcate

* Also manager of *The Pink Fairies* and one of the more important movers and shakers of The Underground of the early 1970s.

the self-discipline which they need in order to deal with the greater personal freedom available to them now."

"May I just read to you, Doctor," Leary continued, "...an opinion we've heard expressed by another witness in this case about the Underground and *OZ*. I want to see if you agree with it.

> 'The Underground itself has its own organs, principally *International Times* and *OZ*. Both are produced with difficulty; printers refuse to print, the police harass them on the grounds of obscenity or because of their attitude towards soft drugs. Newsagents refuse to stock them and yet somehow they carry on. Neither has much to recommend it to the generation over 20...'

Would you agree with that so far?"

"Yes, I would," replied Haward.

"Is this the first issue of *OZ* that you have seen?" asked Leary.

"It was, yes," said Haward.

"I see," smiled Leary enigmatically. "Had you come across *International Times*?" he asked.

"No, never seen it." said Haward.

"I see," said Leary.

"So of those two principle organs of the Underground movement, as expressed by the witness, Mr. George Melly, you have only experience of the particular *OZ* 28, which is the subject matter of this case?"

"Yes."

Obviously, Leary was trying to prove something, although what was none too clear.

"What's your experience with the pop scene?" he concluded.

"Not a great deal," said Haward, "except discussions that one has with young people; but this is all second-hand knowledge."

Meanwhile, the good Detective-Inspector Luff (left) who, throughout the proceedings, sat in the well of the Court either scribbling notes to the seedier crime reporters or else dispatching one of his minions who returned minutes later laden with all the known publications of the defence witness then in the witness box, studied Dr. Haward closely. You could see that he was sure he had seen Dr. Haward before, somewhere.

"What about free love?"

It was Leary who asked, inevitably.

> "Something to be encouraged in our society as it is, or not?" he asked.
>
> "Something which I think one has to accept scientifically as a perfectly normal attitude," replied Haward.
>
> "We would be grateful for your opinion," chuckled Leary; "...something to be encouraged or discouraged?"

Haward refused to be drawn.

> "Let me try and assist you," offered Leary. "Let's deal with the magazine page by page" (again?) "looking first at the cover. On the extreme left, you see there's a young negress with an imitation phallus strapped around her thighs, a dill-doll . . ."
>
> "Yes," said Haward.
>
> "That couldn't be clearer, could it?" suggested Leary.
>
> "Well," replied Haward, "I didn't realise it was a dildo, until it was pointed out yesterday. I'd seen this cover many times before".
>
> "Doctor, may I ask you if that's really so?"

Leary sounded shocked.

> "Yes, indeed," replied Haward. "I was very serious about taking the oath when I came. This goes back to what I said before. It's a question of what one's own experiences have been."
>
> "Well," said Leary; "it may be that I've lived too long in these Courts."

Maybe he had.

> "I think this is all imputing more into the perception of the child, than the picture really warrants," continued Haward. "I am afraid I wouldn't be prepared to admit what you suggest, unless it could be shown in some experimental way that the majority of children would perceive the same thing. My personal opinion is that they wouldn't."

Well, there we are, said Mr. Leary. And there we were.

It wasn't clear which was having the greater effect on the Jury, Dr. Haward's apparent evasiveness or Mr. Leary's apparent common sense. Perhaps neither. After all, said Leary, it was obvious that the magazine was just full of "dirty pictures" and "dirty words" and "smutty drawings", wasn't it? And any child, reading such things, would say to himself,

> "Oh! Here, we see these things in print. There must be something behind all this. It lends a certain authority, doesn't it, in the eyes of a child, to see it in a proper magazine?" asked Leary.
>
> "To some extent, yes," agreed Haward.
>
> "And it's totally unnecessary to incorporate these sort of beastly drawings in a printed magazine?" continued Leary.
>
> "Yes, I would agree with you there," said Haward.
>
> "And look at the smutty reference on the left," shouted Leary.

But there was no need. The use of emotional and perjorative language such as 'smutty' and 'dirty' seemed to preclude any rational reply, or any simple and direct answer. The witness appeared to be reduced to a state of confusion; not wishing to sound evasive, he is forced to be so unless he accepts the moral assumptions of the question. It was no good Dr. Haward insisting that a lot of the material in the magazine was unnecessary but not necessarily undesirable. With Leary dinging around words like sadism, filth, bare bottoms and fucking in the streets, Dr. Haward could have said anything he liked and it wouldn't have made that much difference to the level of debate.

Leary's analysis of another cartoon, that of the Fabulous Furry Freak Brothers, was a gem.

> "The first cartoon," said Leary, "shows a character disgusted because he and his companions have run out of cannabis."
>
> HAWARD: Yes.
>
> LEARY: And one of them is told to go out and score us a lid.
>
> HAWARD: Yes.
>
> LEARY: The character in question, then, in the next cartoon, says that the only place to score weed at that time of night is Ripoff Park.
>
> JUDGE: Well, forgive me, isn't it a fair inference from the first cartoon that those three characters there are all takers from time to time of dangerous drugs [*sic!*]?
>
> HAWARD: I think that would be reasonable.
>
> LEARY: Three drug addicts. And one of them goes off into Ripoff Park where he meets two genuine further drug addicts. Then there appear two flick knives and his last 15 dollars are stolen from him, the money with which he was going to buy the drugs.
>
> JUDGE: That would be robbery, wouldn't it?
>
> HAWARD: Yes.
>
> LEARY: Altogether, there are about a dozen characters depicted there, each one of whom is either on dangerous drugs or involved in violence or crime.
>
> HAWARD: Yes.

LEARY: 'Aversive', would you say?

Had the Judge never heard of Tom and Jerry? Presumably, he hadn't. In any case, added Dr. Haward, "I find nothing in this magazine, and particularly nothing in any of the cartoons or the advertisements, which would convert a latent need into a manifest one."

"But," said Mr. Leary, "...oral sex is fine in married persons, isn't it?"

"Yes," replied Dr. Haward.

"If the female partner agrees to the practice?" continued Leary.

"Yes," replied Dr. Haward.

"But the trouble with oral sex is that some women do not like the male organ in their mouth," said Leary.

"Yes," replied Dr. Haward.

"And, therefore, being a particularly delicate field of sexual behaviour," said Leary, "it's essential that both parties are consenting to the act. Otherwise it can harm a young child and do possible irreparable damage. Let me show you what I mean. You have a young girl, inexperienced in sexual matters, who first sets sail on the glorious sea of sex by having a boy's penis put into her mouth. And she doesn't like it. It may well affect her in later life, mayn't it?"

It was, Mr. Leary said, an interesting question, which indeed it was, although its relevance was by no means apparent. Except that such practices were decidedly 'kinky', as Mr. Leary went on calling them with apparent relish. And what about describing pop as 'fuck music'? Well, replied Haward, Shakespeare had said it much better –

"If music be the food of love, play on, give me excess of it," added Mr. Mortimer a little later.

"Sexual variations are important," reiterated Dr. Haward, "because normal sexual intercourse is often unsatisfactory between married couples. And this is a cause of many of the problems which come up in marriage guidance councils. From clinical experience, one finds that those people who can engage in variations of sexual activity, derive great benefit from them."

Detective-Inspector Luff looked embarrassed and the Judge studied his A-Z. It was all too much and it was time to move on.

Mr. Michael Schofield, social psychologist and author of *The Sexual Behaviour of Young People* was next. A member of the Government Advisory Committee on drug dependence and formerly a member of the Wootton Committee, he too was a mild, soft spoken man and best known for his recent book, *The Strange Case of Pot.* Mr. Luff scurried out to get it.

"I can think of plenty of things in the magazine," said Schofield, "that might cause surprise and shock, perhaps. But not harm. You've got to remember also that drugs are an endless, and even boring, subject of conversation in all schools in the country; indeed, many school children know a lot about drugs already, and it's unfortunate that so little hard information about drugs is

given to schoolchildren. As a result, they tend to find out about it through conversation among themselves, and this is not the ideal way. I get the impression that a large part of this magazine was put out simply for a giggle. I sincerely believe that, were it not for the activities of the police, this edition of *OZ* would have been forgotten a very long time ago."

Luff looked surprised. The Judge sighed and consulted his road map.

He perked up a bit when Schofield admitted in reply to Mr. Mortimer that, obviously, the intention of the magazine's cover had been

"...to attract attention, and to this extent, it succeeded. But, it's not very real. One might almost make out a bigger case for masturbation than for lesbianism. I find it very hard to believe that, in fact, it would stimulate anyone. In fact, I find it hard to believe that the magazine would interest the average schoolboy at all - there is nothing about football in it, for example. Or the average schoolgirl - there is nothing about makeup or fashion or romantic stories. Basically, it is a serious magazine of protest. Indeed, I would have thought it too serious for the average schoolboy or schoolgirl."

Schofield sounded quietly impressive. Calm, collected, rational, above all, reasonable. Who could doubt him? We should see. He thought the children who had contributed to the magazine were probably exceptional. The more enterprising and extrovert minority, perhaps. As for the children themselves:

"I think they would regard it as a unique chance to say what they wanted to say, but may have been unable to say elsewhere. Perhaps, as a result, there might be a tendency to over-react and exaggerate. It would probably do them good, however, rather than harm in that they will have been able to modify their own views by testing them out with other 15 or 16 year-old people. And one would expect them to seize the chance to express anti-authoritarian views and to put their views across. I think young people can only come to good by stretching their minds as well as their bodies. After all, I would have thought there was no doubt at all that the other points of view, the opposite points of view from those we might find here, are expressed much more widely, much more powerfully and much more often."

Mr. Schofield was really warming to his subject now. His sense of dignified outrage, gently encouraged by Mr. Mortimer's intelligent examination, gave to the trial - almost for the first time - a feeling of civilised debate. The cartoons depicting homosexuality in the magazine, he said, would be objects of laughter among children. Indeed, the whole sexual content was either so deliberately unattractive or so self - consciously moral - "fairy stories in which the villain comes to no good and the hero wins out" - as to be almost meaningless to the average child reader. Just so the drug references.

"As I remember, the references to drugs in this edition of *OZ* accept drugs as a fact of life. Admittedly, they don't specifically discourage them. But even the Government committee on drugs, of which I was a member, said that the long-term consumption of cannabis, in moderate doses, is not harmful; so that can be said to have not discouraged drugs either. Indeed, that statement by the Government committee was a good deal more specific than any statement about drugs in *OZ*. Drugs have been glamourised, not only by school kids, but also by adults to such an extent that when you get statements as you do in biographies at the front of the magazine saying, proudly, that 'they've taken

drugs at such and such an age'. I would have thought these had no more effect than if somebody had boasted about how much booze he had had the night before."

Mortimer asked him what he made of the quotation about drugs which appeared in the letter:

"Praise Be; 'Magic theatre. Price of admission - your mind'."

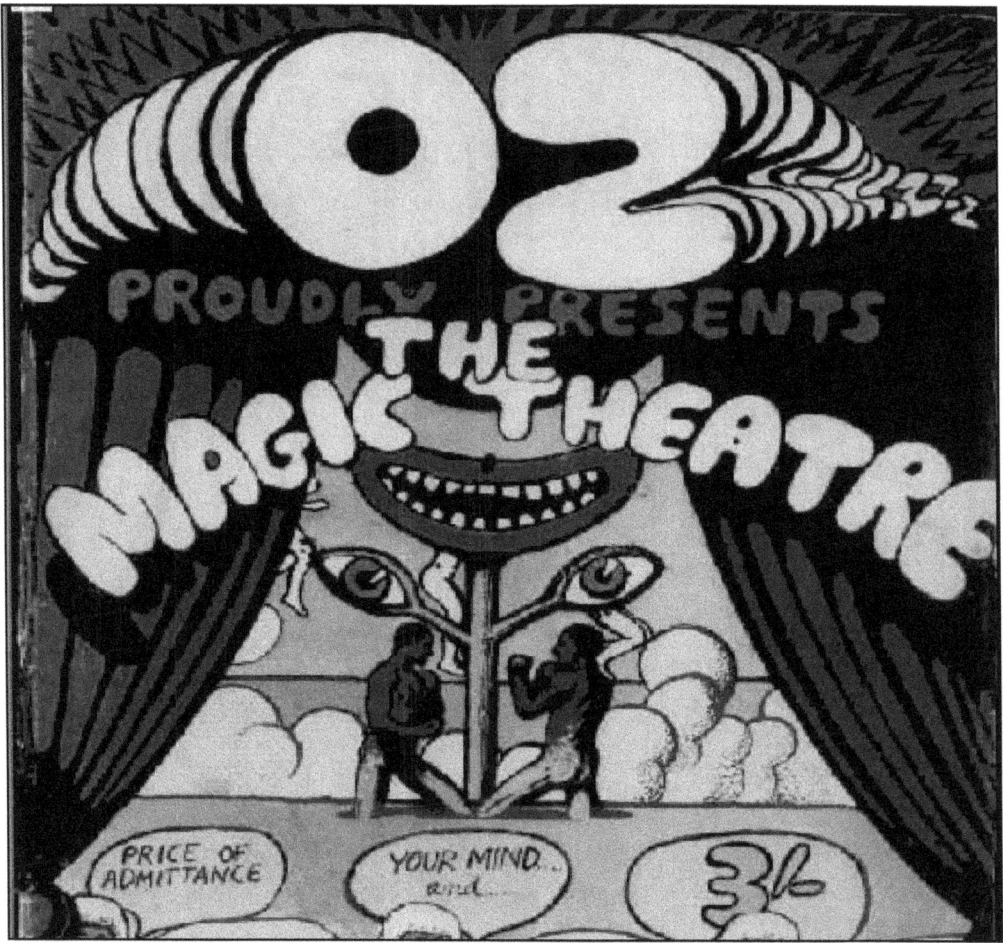

Schofield paused. If anything could be taken as a warning against drugs, he said, that was it.

"It seems to me that it suggests rather a high price for admission; that the price you might have to pay would be to lose your mind. Every young person would simply be put off by that suggestion."

Again, it was the lack of any specific moral imperative that made the statement effective. The small ads, which had exercised Mr. Leary so greatly, would also have no effect on the young other than as a source of jokes. Even if they did bother to reply to the invitations contained

therein, the results could hardly be that damaging. For once, Schofield didn't sound convincing. Mr. Leary was busy making notes.

He scribbled away even more furiously when Neville asked Schofield:

> "In your latest book, *The Strange Case of Pot*, you stated: 'I have never smoked pot or taken cannabis in any form'."

> "That's correct," replied Schofield.

> "Is there anything in this issue of *OZ* which has tempted you, in any way, to change your mind?"

> "Nothing at all," replied Schofield.

> "With your experience, would you think that the use of cannabis leads to crime?"

> "Beyond the fact that smoking cannabis is itself a crime, I agree with the findings of the Wootton Report that there is no association between smoking cannabis and other crimes," Schofield stated emphatically.

> "If it doesn't lead to crime, can it sometimes encourage malpractises among the police?" asked Neville politely.

> "We did get evidence confirming that the police, from time to time, had used malpractices in order to detect cannabis smokers," replied Schofield.

"Well," said Mr. Leary, bouncing into action. "I'm wondering where that question and its answer are getting us in this case?" The Judge threw his pencil down, looked pained and said:

> "Mr. Neville's representing himself, Mr. Leary. It's better to let him ask his questions if he wants to. Yes, Mr. Neville?"

Mr. Argyle seemed resigned by this time to almost anything. Quoting from Schofield's book, Neville continued:

> "'It is possible that our urgent desire to suppress the use of cannabis is confused with our alarm at the way the young challenge our social and political views.'"

> "I still hold those views," said Schofield. "Society progresses," he added, "because young people are discontented with the *status quo*. Obviously."

Next morning, the following story appeared in the *Daily Mail*:

> 'Hundreds of holiday makers joined a crowd which swarmed round a courthouse yesterday as a man appeared before a magistrate charged with two sex crimes against an 11 year old boy.

The man, 46 year-old builder Edward Paisnell, made a two minute appearance in court in Jersey charged with indecent assault and attempting to commit an indecent act with the boy. Police smuggled him out of the building with a coat over his head and none of the waiting crowd caught a glimpse of him.'

"So," Mr. Leary began, looking once more at Dr. Schofield, "do I understand your evidence generally to come to this: that the contents of *OZ* 28 dealing with drugs and devious sexuality would have an effect upon the minds of young children, but it would not be a harmful one? Does that fairly summarise what you have told us?"

"Yes," said Schofield.

"Do you agree that the School Kids issue relentlessly promotes some elements of the 'new culture'; that is a phrase which is, perhaps, known to you?"

Schofield replied:

"As I understand it, it was written by schoolchildren; so, to that extent, it reflects the ideas of people of that age."

"I am suggesting that one of the elements which the magazine promotes is dope?" said Leary, smiling.

"I'm afraid I don't understand the word 'dope'," replied Schofield.

"You don't understand the word 'dope'?" asked Leary, totally incredulously. "Mr. Schofield, let me make it abundantly plain. I'm suggesting to you that this magazine relentlessly promotes DOPE. Agree or disagree?"

"I have to disagree," said Schofield. It was the Leary technique all over again.

"Rock'n'Roll. Agree or disagree?" he asked.

"I speak subject to correction," began Schofield, "but I doubt if you'll find the words Rock'n'Roll in the . . ."

"May I have an answer?" interrupted Leary. "Do you agree or disagree?"

"I'll have to disagree," said Schofield.

"And the final element in the so-called 'new culture' which has been relentlessly promoted, is an element described as 'fucking in the streets'. Agree or disagree?"

Leary paused.

Schofield, a former RAF fighter pilot, now employed by the Health Education Council, looked bewildered. Mr. Leary then held up a copy of Schofield's book - *The Strange Case of Pot.*

"This yours?" Leary asked.

"Put out by you?"

"Well; I was asked to write it," replied Schofield.

"Ye-es," said Leary, flicking through its pages. "You set out in the introduction the following, do you not:

> 'The original title of this book which emerged as *The Strange Case of Pot*, was to have been *The Case for and against Pot*. It was intended to present both sides of the controversy and weigh the evidence before coming to a conclusion. But once the myths were cleared, it became obvious that the case for and against was not evenly balanced. By any ordinary standards of objectivity, it's clear that cannabis is not a very harmful drug; but the simple ranging of issues side by side is too superficial an approach for what is a very complex situation. It is really a social problem, much less a legal problem, and still less a medical problem . . .'

That's how you express yourself in the Introduction?"

"Yes," said Schofeld, "...it expresses my view perfectly."

"'The new law, as proposed at present'," Leary read, "'...will not make much difference to the use of cannabis and will solve none of the problems.'"

Leary smiled. Lawyers always enjoy being told their laws are useless. Leary read on still further.

"'We must accept that we now live in a drug-oriented society.'"

Leary paused, and then asked:

"You're inviting people to accept, you're inviting people, Mr. Schofield, to accept the fact that we now live in a drug-oriented society, are you?"

Leary looked straight at the Jury, amazed.

"I am telling you," replied Schofield, not a little angry, "...you, and everyone who cares to listen, as a fact, that people take a considerable variety of drugs. And the people who take the most drugs are older people, particularly women, who take a vast array of tranquillizers, sleeping pills, amphetamines and all manner of medicines which are founded on drugs. Our whole society now is dependent upon the use of drugs."

The Judge rubbed his forehead. Two policemen giggled. The reporter next to me whispered:

"He'll be telling us we're all bloody fascists next."

"You do realise," Leary went on, "that your book has been advertised in an earlier edition of *OZ*."

"I wasn't aware of that," replied Schofield, "...but I'm very pleased to see it."

"Ye-ess," drawled Leary and plodded on, analysing in detail every last whisker of the lesbian cover.

Suddenly, Schofield got very angry.

"Your treatment of this magazine is absurd," he cried at Leary; "...if I may say so," he added, mimicking Leary. "People do not read a magazine like this as if it were a legal document, as if it were a research report. They read it, it has some minor effect, and then they forget it. To go through it inch by inch, line by line in the way that you do, makes no more sense than if you were to go through any other magazine in this way.

I am anxious to answer any of your questions as to what is in the magazine. But if you ask me to remember every single detail and explain every single line, then I can only say to you that you are judging me and it by a standard which doesn't make sense."

It was a sentiment with which most of those in Court would have probably agreed.

But Leary was not a man to let such an outburst slip through.

"Mr. Schofield; pray listen to me for a moment," he said, waving his finger. "Because I think it's not myself who has fallen into error, but you. You are here to give evidence about this particular magazine. Have you done your homework? Look at the cover. It's sensually drawn, the cover, isn't it?"

"Sensually?" replied Schofield.

"Sensuously drawn. Erotically drawn?"

Leary was being too helpful.

"Little children who are curious about sex sometimes like to watch people fucking, don't they?" he continued.

"Yes," said Schofield tentatively.

"And if that habit exists in adult life, it becomes a deviation: voyeurism; wanting to look, rather than do. Peeking through a keyhole to see what's going on."

The logic of it all escaped even the most tortuous mind. And when they moved on to Rupert, the logic became even more - well, something.

"The cartoon is intended to be humorous," maintained Schofield. "It's a joke. It may not be a very good joke, but I maintain that even the funniest joke in the world would, after you, Mr. Leary, had finished with it, not be very funny. The sexual part in this cartoon is of little importance."

"Of little importance?" asked Leary, astonished.

"The sexual part is of little importance," repeated Schofield. "The main point about it is that Rupert Bear is behaving in a way one would not expect a little bear to behave."

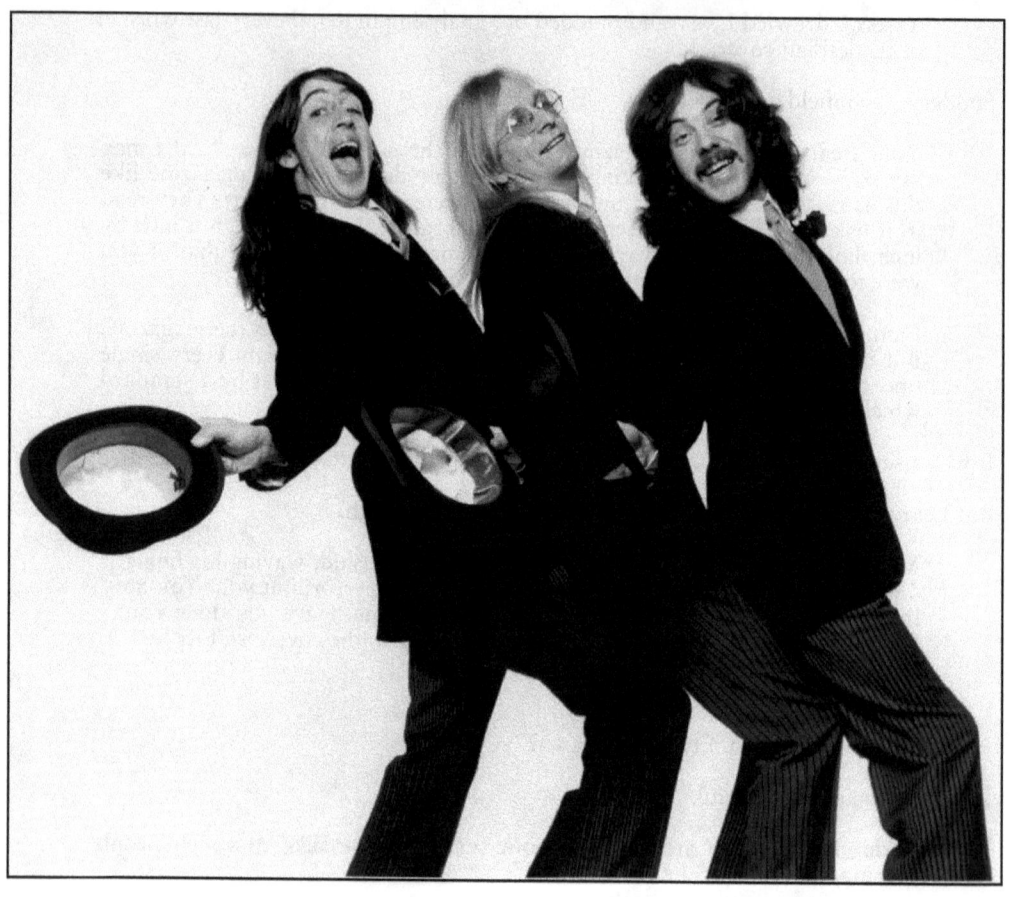

"Yes," said Leary. "But what sort of age would you think Rupert is to your mind; what sort of aged bear?"

Schofield rocked back, not quite believing the question.

"Oh, I'm very sorry," he said, "I'm not up to date with bears."

"You don't have to be," reassured Mr. Leary; "because he doesn't change, Rupert, does he?"

Schofield shook his head in disbelief.

"I think the question is," said the Judge, wishing to help: "What age do you think Rupert is intended to be, a child, adult or what?"

Eventually Schofield said:

"It's an unreal question. You might as well ask me how old is Jupiter?"

"He's a young bear, isn't he?" continued Leary, unabashed. "He goes to school; that's right, isn't it?"

"I don't know whether he went to school or not," said Schofield. "I'm sorry; but I'm obviously not as well informed as you are about little bears. I'm a psychologist, I'm supposed to look for underlying motives. But it does seem that it you're much more expert than me in reading sex into things that don't immediately occur to me."

Mr. Leary, a senior Treasury Counsel, the lover of herb gardens, said to me during the adjournment:

"By the way," he said, "I wouldn't want you to have got the wrong impression about me the other day. About my son, that is. He's actually only my step-son."

I knew immediately that snippet of information was meant to be important.

Moving to the cartoon on the inside back cover entitled 'Speed Freak Fun', Leary got even more entangled.

"What do you understand by the phrase 'speed freak', Mr. Schofield?" he asked.

"What would I understand, or what the average child who reads it would understand?" replied Schofield.

"Well," said Leary wearily, "if you think there's a distinction, by all means draw it, and let us have the two separate definitions."

"I understand the word 'speed' to be slang term for taking a drug," affirmed Schofield.

"'Freak'?" winked Leary.

"I would have thought that it would simply have meant a person," said Schofield.

"So 'speed freak' is a person who indulges in the use of methedrine or any amphetamine drug?" added Leary.

"It originally meant that," agreed Schofield. "But you must understand, and you must accept, that words like these are so overused in society, that their meaning becomes wider and wider; just like the word 'drugs', which now means almost anything?"

"But it hasn't so changed its meaning that it means somebody who exceeds the 30mph limit on the road, does it?"

Leary looked pleased with his extraordinary analogy.

"No," said Schofield; "but a 'freak' usually means somebody in the youth culture."

"Yes," pounced Leary triumphantly.

"But when it's used in the phrase 'speed freak', it means somebody indulging in the so-called youth culture who uses that particular drug - speed - doesn't it?"

"It does not," shouted Schofield. "And you are trying to make me say something which is simply not true: it's a simple phrase; it's an everyday phrase used in the Underground; it doesn't mean all these incredible things which you want me to say. What do you think you are doing by analysing every single word?"

Leary brushed his gown, and then said, softly: "Well, Mr. Schofield, what does it mean if it doesn't mean what I suggested?"

Mr. Leary seemed to be quietly destroying Mr. Schofield.

"It's a headline - a catch headline; it means nothing," blurted out Schofield.

"It must mean something," said Leary, seeming offended.

"Why must it mean something; do most headlines mean something?"

"You don't use a word without it having some meaning, do you?" asked Leary.

"For example, if I were to say: 'I've got the bread, can you score me some speed man', that would mean something wouldn't it?"

To hear Mr. Leary's cultured little Oxford voice tripping out these words, somehow said it all. In the last analysis, the prosecution and those whom the defence and its witnesses represented, simply didn't speak the same language.

"So you see," concluded Leary, "...that the magazine does do precisely what I suggested to you that it did - it relentlessly promotes some elements of a 'new culture' - dope and fucking in the streets."

Schofield finally calmed himself and said fiercely:

"What it *does* promote, is change, and this is what people are frightened of; this is what people are calling a corrupting influence. I have no axe to grind. I have never met any of these three gentlemen in the dock. And I am not being offered any fee or anything like that to give evidence in this case. I felt I wanted to do something to help the defendants because, in fact, in their own way, they are reducing the emotional impact about drugs. The difficulty is that it has become the kind of subject to which people react immediately without pausing to think; people are so worked up about it, that they no longer listen."

It was a brave ending, but it remained to be seen whether it could recover any of the ground already and painfully conceded to Mr. Leary.

It was left to Mr. Mortimer to redress the balance in his re-examination. Quoting from the introduction to Mr. Schofield's book *The Strange Case of Pot*, written by the Professor of Psychiatry at Edinburgh University, Dr. Carstairs, he read:

"'Today we have a remarkable situation where members of the older generation, including many of our magistrates, know much less about cannabis than do the youngsters who are charged with breaking the law. On the whole, adult public opinion strongly condemns the use of cannabis and this is reflected in the extremely serious penalties it imposes. No less than 17% of first offenders found guilty of being in possession of cannabis are sent to prison with all that that implies for their subsequent careers. It seems very likely that cannabis is smoked simply because it gives pleasure. Our protestant ethic, or what is left of it, argues that easily obtainable 'pleasure' must be corrupt, morally if not physically.

In this event, Michael Schofield is very clearly on the side of the young. But he plays fair and tries to present the serious arguments as well as the ill informed prejudices on the anti-cannabis side.'"

Next was **Dr. Josephine Klein**, for 12 years a lecturer in social psychology at Birmingham University and now director of Goldsmith's College in London. A little, sandy-haired lady, with a predilection for the giggle, she was Dutch by birth. A frequent lecturer to the National Association of Youth Clubs, she said that children would read *OZ* 28 simply "to see what is going on in their world".

Asked if she thought the magazine would arouse and implant in the minds of children lustful and perverted desires, she seemed surprised that anyone would even bother to ask such a question.

"Certainly not," she chuckled. "When I was given the magazine, I noticed the pretty cover and that's about all. It's not like toothpaste, you know."

The Judge looked puzzled. The biographies were very much like *The Times'* column of births, marriages and deaths; and as to the now familiar cartoon of three schoolmasters caning one another and sticking their weapons up one another's anuses, this was not an

"advocacy of sadism", she said, but a simple expression of something which many children fear. To have it out in the open, even in this way, could harm nobody.

To Richard Neville she said:

"I have a very factual mind. I don't think in generalities; so please not to ask me general questions."

And referring to the mass of children in the community, she admitted she was a little disturbed about being asked to speak on behalf of 10 million people.

"Do you have any children?" asked Mr. Leary.

"No, I haven't," replied Dr. Klein.

"What sort of age group do you think the magazine would appeal to?" he asked.

"Well," she replied, "...just seeing on the outside 'School Kids Issue' would put a number of people off; most people of school age don't like to be called school kids and wouldn't be particularly encouraged to buy something because it said 'School Kids' on the outside. I didn't examine the cover in photoscopic detail; I just thought how nice it would do for bathroom wallpaper."

"Oh really, Doctor," said Mr. Leary. He could hardly contain himself.

"It's a pretty picture, a nice pattern which has pretty shapes," she continued; "the blue is the kind of blue that you do have in kitchens and bathrooms."

"Have you ever heard the expression 'blue films'?" asked Mr. Leary, astonished.

"Yes," said Dr. Klein, looking equally surprised.

Leary then turned to the cover and pointed out the 'dill-doll' which Dr. Klein asserted that she had not noticed until it was pointed out.

The Judge perked up, amazed, and asked: "Is your eyesight normally and reasonably good?"

Leary did not wait for the reply.

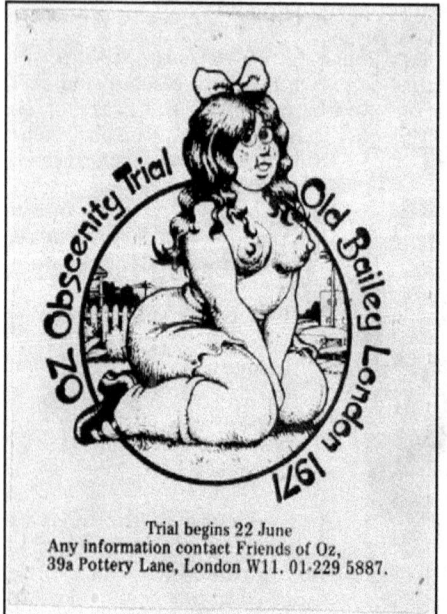

Trial begins 22 June
Any information contact Friends of Oz,
39a Pottery Lane, London W11. 01-229 5887.

"Are you going to tell us," he asked, "really, that it has escaped your notice that the cover of this magazine depicts couples, naked couples, two by two, having it off, in a lesbian fashion; and that that is what you want to see on your bathroom wall? Have you noticed that the girl on the extreme left is wearing a dill-doll?"

"Yes, since you point it out," said Dr. Klein.

"Did that also escape you'?" asked Leary.

"Yes, it did," she said.

"I see," said Leary, smiling.

"I think that you have to be in a place like a Law Court to look at these things so microscopically," added Dr. Klein. "Most people buy the thing and just have a look at it. But you have to be either in a Law Court or sick in the head to go into it as deep as you are doing."

She was tougher than she looked.

Leary had stumbled onto an exchange that was, on reflection, a key to the whole trial.

> "The girl on the right," he said, "has got her right hand down on the pubic regions, hasn't she?"
>
> "Maybe she *has* just got her fingers over the pubic triangle," suggested Dr. Klein.
>
> "What!" shouted Leary, even more astonished: "In a Victorian attitude of modesty! Is that what you think? Actually there's something else in that region, is there not?" he added, mysteriously. "And it is not her hand."

KLEIN: Yes.

LEARY: Did you notice that before?

KLEIN: I had it pointed out to me.

LEARY: Were you puzzled about it?

KLEIN: Yes.

LEARY: Worked out what it is?

KLEIN: I think there was a newspaper report which said it is a rat's tail.

LEARY: Yes; you've read that report?

KLEIN: Yes.

LEARY: And having read the report, does it seem to you that it could very well be a rat's tail?

KLEIN [*laughing*]: It would have to be a very large vagina. You know, this really is a bit silly; this is what I meant about sick minds; this isn't a proper discussion.

LEARY: Well what is it? I'm simply asking you what it is. If it be not a rat's tail . . .

KLEIN: To me, it's just a pretty cover. There's no need to put it through the mangle 50 times.

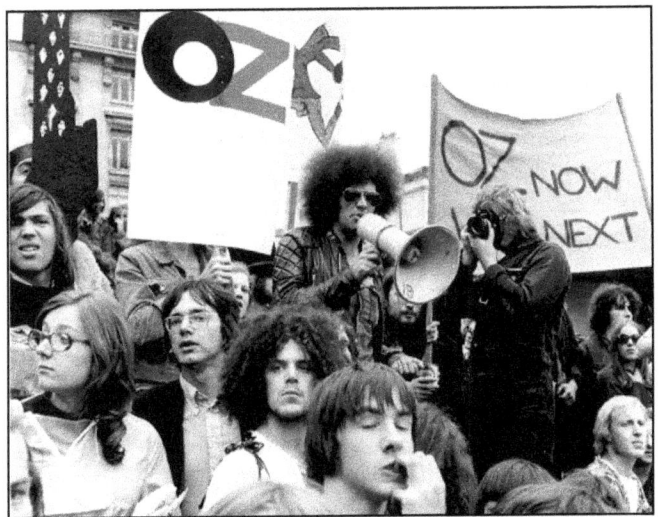

Mick Farren - legendary anarchist, activist and singer with *The Deviants* addresses an *OZ* demo

LEARY: Have you any experience with pornography?

KLEIN: Would you like to give some examples . . .

LEARY: I'm asking you; have you any experience of pornography?

KLEIN: Would you like to define for me what . . . ?

LEARY: I'm asking you a simple question, Doctor.

KLEIN: I do really need a little bit of information as to what is meant in this Court by the word pornography. It's not a concept which I use in my daily life. I don't divide things up into 'this is pornography' and 'this is not pornography'. I think most people don't. I can see that it may be important in a Court of Law; in fact, I can't think of anywhere else that it is important. So you must explain to me what you mean.

LEARY: Would you try, please, to answer my question . . . have you any experience of pornography?

KLEIN: I think I must ask you what the definition is in this Court of pornography. I think I'm entitled to ask that.

LEARY: The answer to your question is either yes or no. Or, I don't know.

KLEIN: That is my answer.

JUDGE ARGYLE: She doesn't know because she doesn't understand the question.

Were these the workings of the Law that we had always been told was so admirable?

Mr. Leary was persistent, if nothing else. Turning his gaze to the cartoon of the three schoolmasters caning each other, he said: "Various people would perhaps think it's dirty."

"I think not," replied Dr. Klein. "I think a more likely reaction would be a dirty giggle; there would be the sort of explosive tension - relief laughter."

"But what's happening is tragic and not comic, isn't it?" asked Leary.

"Yes," said Dr. Klein. "But this is how we deal with tragedy; we have many tragic events and think them comic because we can't deal with them in any other way."

"One of them (the schoolmasters) is having his bare bottom beaten with a cane," said Leary, "...and the other has a cane pushed up his rectum, hasn't he?"

"Well, or between his legs," replied Dr. Klein, "it is quite hard to judge."

"Now Doctor please," said Leary.

"Don't you 'Doctor please' me", affirmed the good doctor. "It could be either, couldn't it?"

At which point, Leary gave up. Dr. Klein was not worth bothering about any more.

Next was **Mr. Michael Segal**. A former probation officer attached to the North London Magistrates' Court, he had subsequently been Head of Children's Programmes for Rediffusion Television. Married, with four children, his ragged beard gave him the appearance of

being slightly down at heel. Unlike some of the expert witnesses who had merely studied *OZ* 28 at the request of the defence solicitors, Mr. Segal was a regular reader.

His reaction to the Rupert cartoon, and he imagined others would react in a similar way, was a belly laugh.

> "He is the kind of fantasy," he said, "that is presented to children which most children resent. It is the sort of fantasy which many parents like to think relates to their children's experience. It very rarely does, in my view."

It has been suggested, added Mr. Mortimer, that the 'three schoolmasters cartoon' "might tip the immature flagellant into an orgy of caning".

> "That is absurd," replied Segal.

> "Within your experience," asked Neville, "what sort of demands are now being made by children?"

Segal's reply was, as it happened, crucial.

"I think they want to have much more say in the conduct of their own lives," he said, "...and in their relationship with various forms of authority, in particular with their parents and school. Some of these demands are about things like dress or clothing or hairstyle; others are demands, or requests, to do what adults are doing - smoke tobacco or drink alcohol.

Some are asking for more say in determining the curriculum of their education; others are asking for some say in determining the whole structure of a particular school or even the whole educational system. Of course, some headmasters and other people in authority resent the fact that information about attitudes and behavioral roles is now readily available elsewhere. School is no longer the dominant source of information. Obviously, this frightens quite a large number of people in positions of authority. And what these youngsters are saying in this magazine, is that the authority they perceive is arbitrary and does not rest on any reasonable grounds; and it ought to be changed."

Mr. McHale, whom most of us had by now come to ignore, popped up and made the good point that nobody objected to taking schoolchildren to art galleries where they could frequently see "...ladies with little attire on."

Throughout the magazine, he added, there is, is there not, "...an objection to hypocrisy"?

"Yes, there is," replied Segal.

"And in the older fuddy-duddies of your generation and mine," continued McHale, "do you think that there has been a considerable amount of hypocrisy?"

"Yes, I would say so," said Segal.

"Do you really want to label yourself as an old fuddy-duddy, Mr. McHale?" asked the Judge.

"I don't really mind very much," said McHale. "I'm afraid that my best years are past."

Mr. Leary then got into a curious muddle about Rupert Bear (again), his "private parts", and Mrs. Bear, although where she had sprung from was none too clear. Mr Leary then introduced the Court to the soon to be infamous centre spread cartoon featuring a bully called Pud, and a reasonably graphic depiction of oral sex.

"Does your experience tell you," Leary asked Segal,

THE TRIALS OF OZ

"...that oral intercourse is a matter of great interest to teenagers?"

"Some interest," replied Segal.

"It's one way of ensuring that the girl doesn't get pregnant, isn't it?" said Leary. "Some children clearly develop more rapidly than others, sexually, that is?" he went on.

"Indeed," said Segal.

"Mr. Segal," said Leary, "I think we may agree about this: the danger in sexual intercourse between young persons is pregnancy, and few girls of 14 are capable of looking after a baby, are they?"

"I would have thought some were," said Segal.

"And a child at the age of 14 cannot be married," continued Leary.

"No," said Segal.

"The baby will be born without proper parents in the eyes of the Law."

What was Leary getting at?

"And if promiscuity is encouraged, there's the danger of venereal disease which, we know, is increasing unhappily in this country, year by year."

"Yes," said Segal.

"And oral intercourse is something which is more attractive generally to men than it is to women."

"Not necessarily," replied Segal.

"But there are a large number of ladies who find it offensive, the notion of taking a man's penis in their mouth, especially little girls who've never tried it before?"

The logic of this argument seemed obscure, to put it mildly. Perhaps Pud would have understood it. He might even have comprehended the relevance of the following:

LEARY: If one goes through all the positions of which Indians are apparently capable...

SEGAL: Apparently.

LEARY: It's an exhausting process, isn't it? Difficult for Europeans to accomplish.

SEGAL: Yes. Boring I would have said.

LEARY: I mean, sometimes it's difficult to follow those little Indian drawings, isn't it?

SEGAL: Depends on your edition.

LEARY: Mmmmm?

SEGAL: Depends on your edition of the Indian drawings.

LEARY: I thought you said it depends on your erudition.

SEGAL: No, no, no, EDition.

LEARY: Edition, I'm sorry. Depends which print of the *Kama Sutra* you're looking at?

SEGAL: Yes.

LEAR: But you see, it again depends at what age that volume first comes into one's hands, doesn't it?

SEGAL: I'm sorry, I'm lost. What depends on what?

Segal was not a man to be thrown by Mr. Leary's labyrinthine mind, however. He maintained that problems such as masturbation were not fit subjects for ridicule, in the way that Mr. Leary was suggesting.

"They are often attempts to comfort oneself," he said. Did Mr. Leary understand that need? Segal asked.

In the last days of the trial, Segal, together with actress Britt Ekland and ex-film censor John Trevelyan, opened a cinema project which had the specific intention of showing new or neglected films for children. One of the first programmes included the classic *The Wizard of Oz*.

Edward de Bono, Cambridge University lecturer, an 'expert', it was claimed, on the patterns of childhood thought, stepped briskly into the witness box later that afternoon. The inventor of a process of thought called 'lateral thinking', or solving of problems obliquely rather than logically, he was in frequent demand as an adviser on all matters of social, philosophical, governmental and legal difficulties. Mayor Lindsay of New York, for example, had consulted him about crime in the streets, public transportation, rats, the housing shortage, drugs and sundry medical problems. He was married but had no children. Very precise, even smooth, suited, complete with waistcoat, throughout his appearance he fiddled with a pen as if marking an examination paper. *OZ*, he said, like most of the Underground press, was very egocentric. Most people just used it as a platform for sounding off, rather like they would a soap box in Hyde Park.

In advertising terms, the magazine was not sufficiently consumer-orientated. Its contributors were more interested in saying what they had to say, rather than in trying to affect their potential readers. The sexual content, for example, was extremely unglamorous - quite the reverse of the normal use of sex in advertising. Even *The Times*, after all, had carried a full-page nude in an advertisement recently, whereas similar things in *OZ* were, by comparison, totally un-seductive.

"Moreover," he continued, "children are, on the whole, not interested in other children's work. Adults are more often interested in children's work than children. And if you want to sell something to children the last thing you do is call it 'a

children's something'. If you want to sell children's gym shoes, for example, you've got less chance of selling them if you call them 'children's gym shoes' than if you call them 'lumberjack's casuals'."

And as to the 'rude words', de Bono thought they would have about as much effect as going to the lavatory and seeing those same words written on the wall.

"Do you think that it's in any way more harmful to see words like that written on a lavatory wall, or to see them in print?" asked Mortimer.

"I would say that we spend longer looking at them on the lavatory wall," quipped de Bono.

Much of what appeared in the magazine fell into the 'remote' category - that is, beyond the experience of most of the children who might come across *OZ* 28. Some rather savage, satirical cartoons by the French artist, Siné, were perfect examples of this. The four pictures occupied less than one sixth of one side of the 48-page issue. One showed a legless man, complete with erect penis, trying to fuck a semi-naked woman; another showed a man naked, except for his socks, fucking a headless, armless and legless corpse. Such necrophilia, said de Bono, was totally removed from childhood imagination. At most, it would arouse minor curiosity but would tend to be so repulsive as to have no actual effect whatsoever. Anyway, he said, Shakespeare had described the stewing of dead children in *Titus Andronicus* and that had not been banned.

He thought the Dr. Hippocrates column eminently sensible in that it made no attempt to moralise; it stated facts which added to the understanding of the reader while in no way endangering the credibility of the author. And as to the small ads, the portable massager there advertised, for example, had been fully described in David Reuben's book called *Everything You Always Wanted to Know About Sex (But Were Afraid to Ask)* which is a bestseller, freely available in paperback at almost every bookshop in the country. De Bono also seemed so sensible, so pragmatic, so matter-of-fact that, particularly when he admitted that there was much in the magazine which he disliked and with which he profoundly disagreed, one would have thought his evidence indisputable. But that would have been to have reckoned without Mr. Leary.

Referring to the cover (again), Leary said:

"I wonder, from your experience, how many school girls have ever seen a 'dill-doll'?"

DE BONO: They probably wouldn't even know what it was.

LEARY: But you see there, on the left, there is one pictured actually strapped on a female. If you know what it is, you can recognise it, but if you did not know what it is, I submit that you would not recognise it.

DE BONO: I had difficulty in recognising it when I first saw it.

LEARY: Did you?

DE BONO: Yes.

LEARY: I see. Again, most school girls these days know the job which the male organ performs.

DE BONO: I would submit that most . . .

LEARY: You don't need to submit anything; you can agree with me, if you wish.

DE BONO: No, I disagree.

LEARY: Look at the next couple of girls, one of whom is nibbling at the nipple of the other.

DE BONO: Yes.

LEARY: And girls at school have passions for one another; they kiss each other?

DE BONO: If you say so.

LEARY: Have you no knowledge of these things at all?

DE BONO: I think these are matters of opinion. I think I would like to know something like the Kinsey figures on male masturbation before I could agree with a generalisation about girls all nibbling each other.

LEARY: But we are not talking about male masturbation; we are talking about what goes on at a girls' school!

And so we were, although it was difficult to imagine or remember why.

Mr. Leary then zoned in on the lavatory wall.

"The lavatory wall," he said, "...is only available to those people who use the lavatory for the purposes of nature; and this particular magazine has, we are told, a circulation that might be put at something like 40,000."

"The turnover of a normal lavatory wall would, I expect, be in excess of 30,000," suggested de Bono, helpfully.

"What!" exclaimed Leary. "One lavatory! 30,000?"

"If you stop to calculate it, I expect so," replied de Bono.

The Judge looked pained again.

"And you know it's a fairly common offence in magistrates' courts," continued Leary, "that dirty old men in mackintoshes suddenly pull open the front of their mackintoshes and expose themselves to young girls?"

"Yes, I accept that that is a common offence," replied de Bono.

"Nothing more horrifying or more shocking for a young girl, is there?" asked Leary.

"Nothing more unpleasant, horrifying, if you like," agreed de Bono.

"And it affects their lives, doesn't it?" said Leary.

"It tends to put them off sex," added de Bono.

"Do you see now, why the Crown's suggestion" (about the cartoon of the schoolmaster masturbating) "...is that this sort of picture would encourage boys to masturbate?"

"I think it would affect about as many people as the average sermon in Church, which I take it you would not consider harmful," suggested de Bono.

"Mr. de Bono, please," said the Judge; "let us not bring the pulpit into this."

"No, my Lord," interrupted Leary; "We mustn't prevent Mr. de Bono from bringing anything into this."

"No," agreed the Judge. "But it's a long jump, is it not, from the dirty old man in a Mackintosh to the pulpit?"

"I think the mental shock of being told that you are going to be burned for eternity, is as damaging as seeing a man exposing himself" said de Bono.

"Perhaps you and I don't understand each other yet, Mr. de Bono," said Leary. "Do you agree that it is a disgusting drawing?" suggested Leary.

"I personally think that it is a very unpleasant drawing," said de Bono.

"Do you think it is disgusting, Mr. de Bono?" reiterated Leary.

"It is not a word that I use," said de Bono. "I am asking you to consider it as a word appropriate to this drawing."

Leary was now banging his desk.

"As a word in your vocabulary, I would accept that you could use the word disgusting," ...said de Bono, calmly.

"Do you agree or disagree that it is a disgusting picture?" shouted Leary.

"I will not use words that I myself do not use, and I cannot agree to use them." De Bono paused.

"Have you never used the word disgusting, Mr. de Bono?" said Leary, more patiently.

"No," said de Bono emphatically.

"Oh, Mr. de Bono," wheedled Leary. "I thought that you were here to assist us."

"Indeed," said de Bono.

"To assist us as to the likely effect upon the minds of young children of the various contributions in this magazine," continued Leary.

"If, sir, you want my opinion, I shall give it," said de Bono. "If you want to put words into my mouth, then that must be your responsibility."

If you had never sat in the Law Courts before, as I had never done, it gave you hope.

Rupert Bear made his entrance, again.

> "What do you suppose is the effect intended to be of equipping Rupert Bear with such a large sized organ?" asked Leary.

> "I don't know enough about bears to know their exact proportions," replied de Bono. "I imagine their organs are hidden in their fur."

> "Mr. de Bono," continued Leary, "...why is Rupert the Bear equipped with a large organ?"

> "What size do you think would be natural?" asked de Bono.

> "Well, forgive me," said the Judge, "...but you mustn't ask counsel questions.

> "*OZ* , " said de Bono defiantly, " *OZ* serves a very useful purpose in the hippy subculture, because it provides a window into the minds of a significant section of society, whether one likes it or not. It is also a very effective way of trying to communicate with that subculture. It's a window; and I don't think windows create scenes. They are merely something you look through."

Mr. Mortimer leapt up and asked that the lady shorthand writer underline that last remark.

> "The lady shorthand writer is here for the Court of Appeal," said the Judge.

> "If she wishes, with my permission, she will try to help. But I don't want learned counsel on either side attempting to score jury points during the evidence by springing up and asking for particular passages to be marked.

> That is not why the shorthand writers are here."

> "Your Lordship is *too* kind," said Mr. Mortimer.

'The Friends of OZ ', an organisation set up by Stan Demidjuk and Sue Miles, to raise funds and awareness for the trial.
FROM LEFT TO RIGHT BACK ROW: Stephen Lister, Stan Demidjuk, Felix Dennis, Richard Neville & Jim Anderson
MIDDLE ROW: Chris Rowley, Pat Bell & Debbie Knight FRONT ROW: Nick Laird-Clowes (then a teenager, later the singer with *Dream Academy*) & Richard Adams

It had become so hot inside the Court Room that Judge Argyle gave his permission for wigs to be removed. It was a revealing moment; the Clerk of Arraigns, almost bald; Mr. Leary, sleeked back and neat; Mr. Mortimer, a mess; Judge Argyle, greying and flat with a high parting.

"Yes, Mr. Mortimer?" he said.

Next into the witness box was **Professor Dr. Eysenck**, the Professor of Psychology at London University. Even the Judge seemed to have heard of him. An almost reverential awe came over the Court as John Mortimer, in the preamble to his examination, listed off the Professor's formidable qualifications. Born in Germany in 1916, Eysenck was a Doctor of Philosophy and a Doctor of Science who had published some 20 books and 300 articles on matters concerned with psychology and psychiatry. Formerly a visiting professor at the American Universities of Berkeley and Philadelphia, he had worked as a research psychologist at Mill Hill Emergency Hospital during the Second World War.

Among many other things, he was now editor-in-chief of *Behaviour, Research and Therapy*, a medical research journal, as well as appearing on the board of 12 other scientific journals. At the conclusion of the trial, he was to fly to Munich to give the opening address at a world congress on behaviour therapy.

He spoke in a diffident, almost shy, manner, and appeared considerably embarrassed as Mortimer reminded the Court of some of his publications. *The Dimensions of Personality* (1947), *The Structure of Human Personality* (1952), *The Uses and Abuses of Psychology, The Psychology of Politics, Sense and Non-sense in Psychology, Know your Own IQ, Experiments with Drugs, Crime and Personality* and more latterly *Race, Intelligence and Personality*.

The Judge scribbled away - or, at least, started to, but then gave up, apparently preferring to polish his glasses and study his A to Z.

"Did you contribute to a Symposium on Moral Values in Children?" asked Mortimer.

"Yes," replied Eysenck, "I did."

"I take it," asked the Judge suddenly, "that among these many books and articles that you've written, you did more than just collect statistics and record facts; you presumably have theories of your own?"

The impertinence of the question escaped Eysenck who merely nodded, rather meekly, and replied in his heavy German accent: "Yes, I have."

"As a result of all your researches and all your publications," Mortimer went on, "can you give us any general idea of at what stage human beings develop sexual proclivities?"

"It's a rather wide question," replied Eysenck. "It varies considerably from person to person. Also, there is almost certainly a genetic element involved in such things as homosexuality or lesbianism, for example. Studies of identical twins leave no doubt that there is a hereditary element in a number of cases at least; so for some people, sexual tendencies are determined at birth.

For others, what happens during the formative years must have a very strong influence. By formative years, I mean probably from six, seven, eight years old and onwards. The suggestion has been made by some writers that very early experiences are decisive. But I don't think there is any evidence to support that view."

"The suggestion is being made," continued Mortimer, "that exposure to this single issue of *OZ*, with its cover that is said to depict lesbianism, might create a lesbian from any young person. What would you say about that?"

"I should think it would be extremely unlikely," replied Eysenck. "Unless the idea was already there in the child's mind," he went on. "I don't think he or she would be able to interpret the cover in that way at all. It wouldn't be meaningful for him. You have to remember that what a person seeks out is determined by his personality and maturity. And there is a distinct tendency for pornographic types of material to be sought out by people who are not necessarily pathological in mind, but tending in that direction. As to this particular cover, the presentation of the nude female form seems to be somewhat arty; it is not, in any sense, a direct incitement to sexual conduct and consequently I don't believe it could influence children in that sort of way at all. I think they would be rather puzzled. I'm puzzled by some of the pictures myself."

Mortimer then asked: "Would you describe this *OZ* No. 28 as a pornographic article?"

"I would think very marginally so," replied Eysenck. "It is less pornographic than the usual kind of material one classifies as pornographic. It has pretensions to artistic presentation which would tend to detract from its pornographic effect. One doesn't get the feeling that it was written in order to be salacious, but that sex is made use of in, perhaps, a semi-political context. The impression I gained from it was an opposition to authority and the Establishment. And since the Establishment tends to be against free love and the open expression of sex, sex is brought in as one of the issues to beat the Establishment with. The only effect that the use of words like 'cunt' or 'bollocks' might have is a worsening of their prose style. The acts of sadism and masochism portrayed certainly don't make them very attractive, and, again, I doubt if they would have much influence.

Further, there's a lot of experimental evidence from studies in the States proving that showing people films which explicitly portray oral sex in a favourable light does not, in fact, except in a very small minority of cases, change their behaviour. Even after seeing 30 hours of films of that kind,

they remain unmoved. So it would seem unlikely that one cartoon would have much effect. It might conceivably lead children to form the opinion that this was something they might experiment with. But I don't think it would do so in most cases."

"I'm sorry I didn't catch that," said a voice. It was the Judge. "Might lead children to what? A few children, isolated cases, it might lead them to what?"

"To indulge in this kind of practice," replied Eysenck. The Judge smiled and added, somewhat mysteriously: "Did you ever hear of an actor called Mr. Fatty Arbuckle?"

It was, you have to admit, an interesting question.

Mortimer now moved to the central question.

"In the world of the child and the young person today," he asked, "how much material is there available to him which he may find sexually arousing?"

"A great deal," responded Eysenck. "Only from works which you would call pornography, or not?" inquired Mortimer.

"The term pornography has no real meaning in the legal sense or even in the psychological sense," Eysenck replied. "There have been things in *The Times*, and in most papers, in fact, which are a good deal more 'arousing' to the average person than anything in this issue."

"In *The Times*?" asked Mortimer gently.

"In *The Times*," said Eysenck, firmly.

Mr. McHale for the Company then made some rather obscure jokes about Victorian ladies exposing their ankles which no-one understood or laughed at, so Mr. Leary blinked into action and proceeded to ask questions which were, for the most part, unintelligible even to Professor Eysenck.

"Early and ample exposure to pornography," he began, "...may affect the youth's view of sexuality and willingness to engage in varieties of deviance. Putting it another way, in slightly more old-fashioned language, his sexual inclinations may be warped by a very early significant exposure. Do you agree to comment on this? I wondered if you agreed with it, or disagreed with it, and we would welcome, all of us, any comment that you might make to have upon it."

Did Mr. Leary ever think in a straightforward way? Or was his mind so convoluted with a lifetime of cross-examination?

While I was wondering what his conversation might be like over the breakfast table, his favourite line of questioning moved into top gear. No, the Professor had not seen any earlier editions of *OZ*. No, he was not familiar with any of the organs of the Underground.

Oh, it's nothing to apologise for, beamed Mr. Leary. The Professor was charmed and admitted that *OZ* 28 might attract children who were sexually precocious, admitted that since it was described as 'School Kids Issue', it would be of obvious interest to schoolchildren, admitted that the magazine was sufficiently well-designed to lure and seduce the unsuspecting mind, admitted that its 'moderately' attractive cover, from an aesthetic standpoint, might well arouse sexual feelings in a boy predisposed towards looking at pictures of naked girls, admitted that the girl on the cover, who appeared to have a dill-doll sticking up her anus, wore an expression on her face of ecstasy, indeed admitted practically anything Mr. Leary cared to suggest, so bored and so indifferent did he, Eysenck, seem to questions which he clearly considered trivial and irrelevant. Finally, he just wandered out.

And yet, still they came. What the defence now hoped to achieve by this apparently endless series of 'expert' witnesses as to the likely effect of *OZ* 28 on the mind of a child, had long since become obscure. What points there were to be made, if any, must surely have sunk already into the consciousness of the Jury, and repetition could only have the effect of dulling their perceptions and alienating their sympathies. Perhaps not.

Anyway, **Dr. Arnold Linken** was next. Luff didn't catch the witness's name and turned to Mr. Mortimer for help.

"Fa-tt-y Ar-buck-le," whispered Mr. Mortimer loudly.

"Thanks," said Luff who dispatched his assistant to look up the collected works. Maybe Luff had a sense of humour after all. Dr. Linken, one-time house-surgeon at the Johannesburg Children's Hospital, was now physician in charge of the Student Health Association of University College, London, and Vice-President of the Association for the Prevention of Drug Addiction, which - presumably - was why he was called. He had been called as an expert on student mental health. What could he tell us that Eysenck and the rest might have missed? Not much. The leaf of the cannabis plant, called 'grass' in America, looked like green tea, he told us; hash looked like an OXO cube; he, Linken, had written an article in the *Sunday Times* as long ago as 1963 which had assessed the increasing prevalence of pot-smoking amongst the young and neither he nor the *Sunday Times* had been prosecuted under The Obscene Publications Act.

"Anyone," he had written then, "of otherwise normal health who becomes a drug addict, is usually a psychologically very disturbed individual indeed."

Oh, yes, and while asking Linken about the smoking of cannabis, Leary referred to 'the reefer'. It was a curiously old-fashioned slip. Had Mr. Leary never heard of 'the joint'?

And there was also another odd exchange – although that was probably another slip as well. Having established that Linken had had experience with venereal diseases, he asked: "Would you mind telling us the circumstances under which you met Richard Neville?"

"At the old Arts Laboratory where I had a medical clinic years ago," replied Linken. "I've seen him in the course of my duties as a doctor."

"Is he on your panel?" asked Leary.

"No," said Linken. "Anyway, I think this is a confidential matter."

"Alas," he concluded, "we are a society that's missed the boat."

THE TRIALS OF OZ

Finally, on Day 16 of the trial, a small, dapper lady in a purple suit was shown into the witness box. Unlikely as it seemed at first, **Mrs. Leila Berg**, the author of nearly 30 books for children, soon looked as if she would prove the most formidable opponent of all for the industrious Mr. Leary.

Married, with two grown-up children, she had recently prepared a provisional 'Charter of Children's Rights'. *

Since Mr. Leary was to brandish it later during his cross-examination of Mrs. Berg like some smutty piece of pornography, it is worth quoting extracts from her 'Charter' here.

"If you stop to consider how we treat children - and compare it with how we treat adults - you would be shocked," it begins. We openly cane children. What would a man think if his boss at the office wanted to strike him for being five minutes late? Boarding schools sometimes censor children's letters. How would a wife react if her husband censored her letters to her mother? Looked at like this, a child's life is tough. He or she lives under a system against which there is no appeal, from which there is no escape. He is denied even his basic rights as described in the UN International Declaration of Human Rights. Rights usually imply responsibilities within any community. But children have few responsibilities. It seems to us that this must not diminish a child's basic rights. To do so can inflict more harm than denying an adult his rights. For children are more vulnerable than adults; between birth and five years a child is being moulded. The love and care he is offered, the experiences he encounters, determine to a large extent his personality for life. More than any other group children need special protection and special facilities. Do children have the protection they need? Are they offered sufficient facilities and experience to grow physically and mentally? Overwhelmingly, the answer must be no.

* The John Lennon song *God Save Oz* references this piece of evidence in the lines:

Let us fight for children's rights
Let us fight for freedom.
Let us fight for Rupert Bear,
Let us fight for freedom.

Interestingly, (presumably as a sop to the American market who would not have heard of the work of Alfred Bestall) the released version replaced 'Rupert Bear' with 'Mickey Mouse'. Another peculiarity is that Lennon was replaced as vocalist by Bill Elliot (a friend of George Harrison and later member of a band called *Splinter*). No-one seems to know why. If anyone can enlighten us please write to the editorial address.

However you look at it, our society does not readily recognize children's rights. As a start, we are printing this draft CHARTER OF CHILDREN'S RIGHTS. It is no more than a draft. It is printed here to provoke discussion, to invite comment. It is offered to make us think about the way we treat children and the way we should treat children. In places it may be ill-phrased. Some 'rights' may be missing, others may be stated too vaguely, or too narrowly. Please write and tell us.

A Charter of Rights is not a legal document. Nor is it a description of what can or will happen tomorrow. It is an ideal statement of how the world might be."

Among its recommendations are:

- children have the right to freedom from religious or political indoctrination.
- no child shall be discriminated against by any person on any grounds whatsoever, including race, sex, religion, ability or any other physical or mental characteristic over which the child has no control.
- all children are entitled to freedom of association both within school and outside.
- children have a right to freedom of expression, both written and verbal. They have the right to publish their opinions on any matter whatsoever.
- children shall have freedom of access to suitably trained and appointed people to whom they can take complaints and grievances. They shall have the freedom to make complaints about teachers, parents and others, without fear of reprisal.
- children have a right to exercise choice in the school curriculum. Such choice should grow as the child matures.
- a child's personal appearance is his own and his family's concern. No child shall be deprived of any right or benefit as a consequence of his mode of dress, style of hair, make-up or any other aspect of dress or appearance.
- children shall have freedom from physical assault, whether under the guise of punishment or in any other form. No person shall have the right to subject a child to such punishment as is intended to mentally or physically humiliate the child, or reduce his self-respect.
- children have the right, at the appropriate age, to such knowledge as is necessary to understand the society in which they live. This shall include knowledge of sex, contraception, religion, drugs, including alcohol and tobacco, and other problems which openly confront every growing child.
- Every child, the charter concludes, has the right to know his rights.

Asked about what effect she thought *OZ* might have on young people, Mrs. Berg replied:

> "I would think the only effect it could have on children or young people would be a very good one. I would also say that any effect it might have on society would also be a very good one."

> "I'm afraid I'm not allowed to call expert evidence about our society," added Mr. Mortimer. Mrs. Berg went on: "I think it is very important that children should be allowed to express the feeling that they have dignity, which is very often denied them in school."

As to four letter words such as 'cunt', "...this release of tension is the first step towards education," she said. Adolescence, she added, is rather a sad thing, and if this magazine incites adolescents into anything, it's inciting them to be thoughtful. For example, the cartoon of the schoolmaster masturbating himself was more a product of a sexually repressed society than it was of anything else.

> "Our society," she continued, "far from being permissive, is exploitive, manipulating and forbidding. As adults, we know that there seems to be scarcely anything we can do now that doesn't unwittingly break some law. But as for school kids, for 10 years of their life they are sent to a place that they have not chosen to go to, where they can be legally assaulted without any redress; if they run away they can be brought back, there to be assaulted again, and if they persist in running away, they can be sent away to something approaching prison."

The Judge, at least, seemed impressed by what Mrs. Berg was saying. He asked her to repeat her statement so that he could note it down in full.

"When children can discuss, and are free to discuss, all kinds of things with their teachers," Mrs. Berg went on, "this results in what I would call true education. Once, I was associated with a magazine very similar to *OZ* that was called *Out of Bounds*. It was written by school kids for school kids and said so.

It aimed at getting corporal punishment banned; it ridiculed the sex repression of many people in charge of schools; it ridiculed the kind of sex talks given to school kids. It declared itself prepared to fight against all these petty regulations which are more suitable for a kindergarten than for boys of 14 to 18.

It issued a manifesto to the national press which received tremendous publicity. I should, perhaps, add that those who worked on this magazine, were expelled, were beaten and were harassed. It was banned from certain schools, and was passed to the attention of Scotland Yard. And all that was in 1931."

"Forty years ago," mumbled the Judge. He could count as well. That particular magazine was never prosecuted, she concluded, because it was edited by the nephew of Winston Churchill*.

"What's that got to do with it?" said the Judge.

Neville then asked the obvious question: was there, in fact, anything corrupting or depraving in this issue of *OZ*? Mrs. Berg fingered the witness box gently and then said:

"I feel," she said, looking at the Judge, "that the whole of this case is corrupting to children. I know that the children are not officially on trial. But, in fact, it is what the children have done that we are all arguing about. These children are simply expressing a normal stage of their development. The bringing of this case has made it very difficult now for them to grow through this stage of development into maturity, because it has associated what they have said and done with guilt and fear. I would be very surprised of all of the young people involved, and all of their families, manage to get through this without a nervous breakdown. I would say that this whole case is perverting the development of these young people, and I consider that to be corruption; I find it altogether horrifying."

"Yes, well," said the Judge, "this is a convenient moment to adjourn."

Mr. McHale, always a dark horse, was at his inscrutable best the following morning.

"You've made children your life's work haven't you?" he asked Mrs. Berg quietly.

"I'm interested in human beings from birth to death," she replied, and went on: "My main concern is that children should keep their own integrity."

McHale then asked: "Have you heard the expression: 'To the pure, all things are pure'?"

"Where does that come from, Mr. McHale?" asked the Judge.

Replied McHale: "I haven't the remotest idea," and roared with laughter.

Alas, there was very little laughter to be had from Mr. Leary.

"Would you agree," he asked Mrs. Berg, "...that in *OZ* 28 there is a wealth of new material made available to some of its child readers, for example, to those children who had not yet practised oral intercourse?"

* Actually by two nephews of Winston Churchill – Esmond and Giles Romilly. A book on their experiences *Out of Bounds: The Education of Giles and Esmond Romilly* was published in 1935, and is so rare now that it commands obscenely (that word again) high prices. The best account of the affair would seem to be in *Hons and Lovers* by Esmond's wife, Jessica Mitford.

BERG: But, as I said already yesterday, I doubt very much whether those children who have not practiced oral intercourse would read . . .

LEARY: *[thumping his-desk]*: I don't care whether you would doubt whether they would read it or not. If they did read it, would it be new material to them or would it not?

BERG: I don't think they would read it, and if they did read it, I do not think it would mean anything to them - it would be quite incomprehensible.

LEARY *[smiling]*: Do you not agree, and this is a simple question, that there is available within the covers of *OZ* 28, a wealth of new material for young readers?

BERG: In the same way that Greek Lexicons are available for children to read who can't read Greek, yes in that sense, yes;

LEARY *[shouting]*: But it's written in ENGLISH, Mrs. Berg, and it's there available for them to read if they want to.

BERG: It is written in English, but it is incomprehensible to them and has no interest for them.

LEARY: Incomprehensible! Really?

Leary then deployed his immense skill over the definitions of 'cock', 'oral intercourse' and 'masturbate'. It left an unpleasant taste.

"Do please concentrate," he told Mrs. Berg condescendingly. "Do you think it's important to protect children from ideas?" he asked.

"I think that the only kind of protection we can give to children," she replied, "is that which enables them to grow up so that they become independent and can take responsibility for themselves and thus deal creatively with their environment. This is what adults are for."

"Yes, that's all very well," continued Leary, "...but some ideas are good and some ideas are bad, aren't they?"

"Yes," she said. "But which are good and which are bad is a matter of opinion, surely?"

"May I ask why you are here?" asked Leary.

"Why I am here?" replied Mrs. Berg, momentarily surprised. "Because I have written a great deal for children and about children," she went on.

"What is the age group over which you hold yourself out as an expert?" said Leary.

"I write for children from the age of about 2 to about 15," she replied. "I write about children from the age of birth to death."

Leary now started waving about Mrs. Berg's Charter of Children's Rights.

"In view of all this," said Leary, indicating the Charter, "do you think it's a good idea that children should indulge in sexual intercourse all over the streets of London, eh?"

BERG: I don't think they would get that idea.

LEARY: But forget about whether you think they would get the idea; if they've got the idea, is it an idea which you would wish to see encouraged?

BERG: That people should have sexual intercourse all over . . .

LEARY: All over the streets of London . . . and elsewhere. Have you ever walked through Hyde Park, at night?

BERG: Ah. You are talking of parks, not streets.

LEARY: I am just wondering if you have ever walked through Hyde Park?

BERG: Yes, I have.

LEARY: Have you seen the increasing number of couples which apparently do these things in public?

BERG: Yes. But people certainly could not lie down in the streets of London and, in the technical word, copulate. I think we are discussing something which is impossible.

LEARY: I am afraid it is not impossible. Is it a good idea or a bad idea? Is it, or isn't it, Mrs. Berg?

BERG: It is a completely hypothetical question.

LEARY [*shouting*]: What is the answer?

BERG: I don't think I can give an answer to a hypothetical question.

LEARY: Or won't.

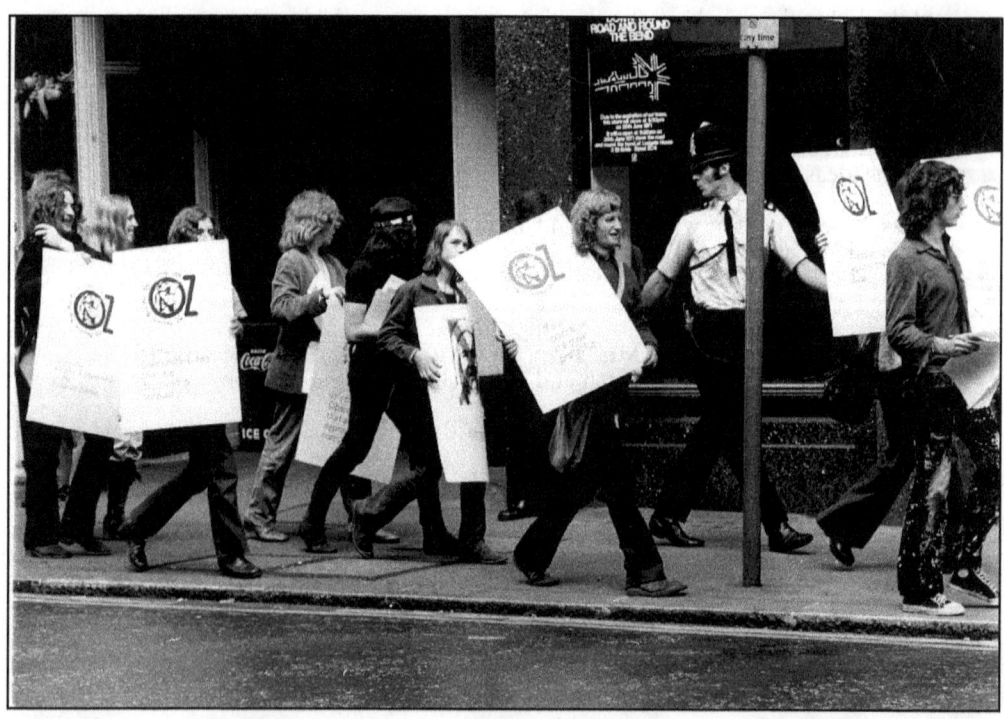

BERG: No. Any answer I give is just not the truth, and I said I would speak the truth.

LEARY: Yes. What I suggest you would say, if you were truthful . . .

It was, as I have observed before, good sport.

Michael Duane, a balding 56 year-old Irish, ex-headmaster of Risinghill Comprehensive School, was Mr. Mortimer's next witness. In his formal statement, Duane noted that:

> "My experience of children in school shows that they came out with the most extraordinary fantasies; and if these are at all repressed, they cause difficulty for the child later on. But if brought out into the open and discussed, they don't become a problem.
>
> The function of this issue of *OZ*, in general, seems to be to give some sort of scope to youngsters to give vent to their feelings in public. It is perhaps important to let adults know that youngsters are not quite so happy as they seem to be.
>
> It may shock quite a large number of pretty conventional people, but in so far as that will make them stop and think, it is good.
>
> No-one could be shocked in a deep sense. I object to censorship over any sort of publication. I was pleasantly surprised that someone was willing to put this stuff in print even though much of it is merely indicative of a great deal of frustration on the part of kids both with the set-up in schools and their own position in society."

Later, when cross-examined by Leary, Duane reasserted his belief that prosecution of 'morals' was absurd.

"You don't judge Milton's morals by what he wrote in *Paradise Lost*," he said.

"No," replied Leary, "but you would perhaps think less of Milton if you knew that he'd written *Paradise Lost* on a 'trip'."

> "If my concern were with the quality of *Paradise Lost*," ...declared Duane, "...it would not matter whether he was on a trip or not. I don't think that the poem *Xanadu** is less effective as a poem because the author, Coleridge, was on a 'trip' when he wrote it. In my experience, young people are not concerned with sex and drugs; what they are concerned with is to shock the older generation into listening to them for perhaps the first time. They know, from experience, that the only things that will shock the older generation are drugs and sex; so they deliberately put these subjects in their magazines, not because they, personally, are deeply interested in those subjects, but because this is the only way they can command attention from their elders."
>
> "Mr. Duane, forgive my interrupting you," interrupted Leary;"...but you appreciate that speeches in this Court are for lawyers."

* Actually he is referring to the poem *Kubla Khan* by Samuel Taylor Coleridge, written in 1797, and published in 1816. It was indeed written after an opium-induced dream, although the word 'trip' more usually signifies the effect of one of the psychedelic drugs like LSD, mescalin, or psylocibin (magic mushrooms).

Indeed, they were.

The urbane, urgent man, who had once taught at Vivian Berger's old school, Alice Owen's, and who now leaned quietly on the witness box, nonetheless eloquently put what most people who had sat through the trial this far had, by now, come to know was the truth.

"An intelligent society," he said, "...would deal with this high-spirited prank in the way in which it deserves. But to blow it up into the form of a crime is, to me, one of the most destructive things that can be done to these young people. It was obscene that apparently mentally deranged people should bring the whole process of law to bear on this schoolboy prank. If I found children in school who had scribbled sexual drawings on the walls of classrooms or lavatories, I would not immediately send for the police. I would be more likely to deal with those children myself and discuss with them what they were doing and why they had done it and explore with them the consequences of their actions. To send for the police would indicate that I was not fit to be a schoolteacher."

Mr. Mortimer asked him if he thought there was, "...anything reprehensible in children being critical of authority?"

"On the contrary," replied Duane; "I think it is important that they should be; only by being critical of authority and then being able to listen to the point of view of authority, can they come to an understanding of why authority behaves in the way it does."

And as to why Mr. Leary then behaved in the way he did, we shall never know. I suppose he was only doing his job. Duane had already explained that, because of a re-organisation of the education programme in his area, he had lost his job, and Risinghill had been closed*.

> LEARY: I suppose as soon as Risinghill school closed, you were anxious to continue your work as a headmaster?
>
> DUANE: Yes.
>
> LEARY: Is it right that you applied for over 30 posts as a headmaster?
>
> DUANE: Over a period of five years, yes.
>
> LEARY: Since the closing of Risinghill?
>
> DUANE: Yes.
>
> LEARY: And haven't yet obtained a job as headmaster to another school?
>
> DUANE: No. I'm still being paid as a headmaster, however.
>
> LEARY: And I think over the past two years, you've tried for some 10 or 12 jobs as Principal of different small training colleges.
>
> DUANE: Yes, about 8 or 10.
>
> LEARY: And, again, have been unlucky?
>
> DUANE: Yes.

* Risinghill School was an early Comprehensive school opened in 1960 in Islington, under the headmastership of Michael Duane; a charismatic advocate of progressive and non-authoritarian education. The school's methods prompted criticism in the media and disputes with the London County Council. The school closed in 1965.

LEARY: Your job which you undertake at the moment, do you believe that the educational authorities would consider that a harmless one, as far as you're concerned?

DUANE: Yes.

LEARY: I don't know if you consider that you've been unjustly treated by the educational authorities in this country?

DUANE: Unreasonably treated, perhaps, yes.

LEARY: Yes. Because, can I suggest in a sentence, that you are a very progressive teacher?

DUANE: No. Because the word 'progressive' is bandied about by some people as a word of abuse. It needs definition before one can clearly accept it or reject it.

LEARY: Your ideas, are if you prefer, way out in front of the vast majority of teachers in this country?

DUANE: On the contrary; my ideas correspond with some great educators from Plato onwards.

LEARY: Yes, I was dealing with this country today, rather than the past and other countries.

Really? It was becoming impossible to believe.

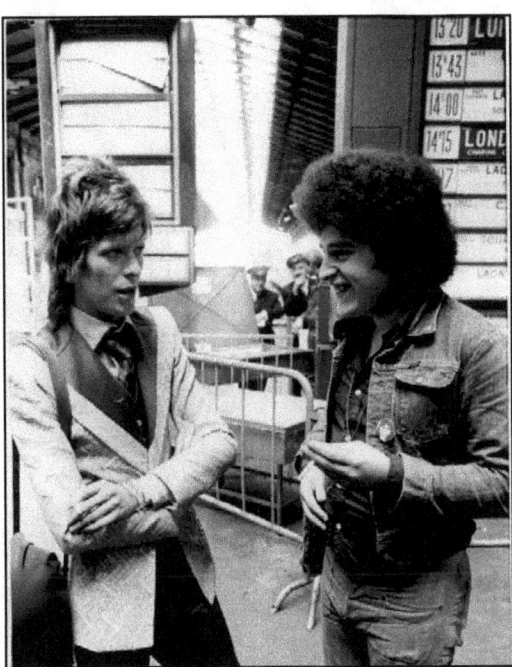

Major Tom (aka David Bowie) and Charles Shaar Murray at the barricades

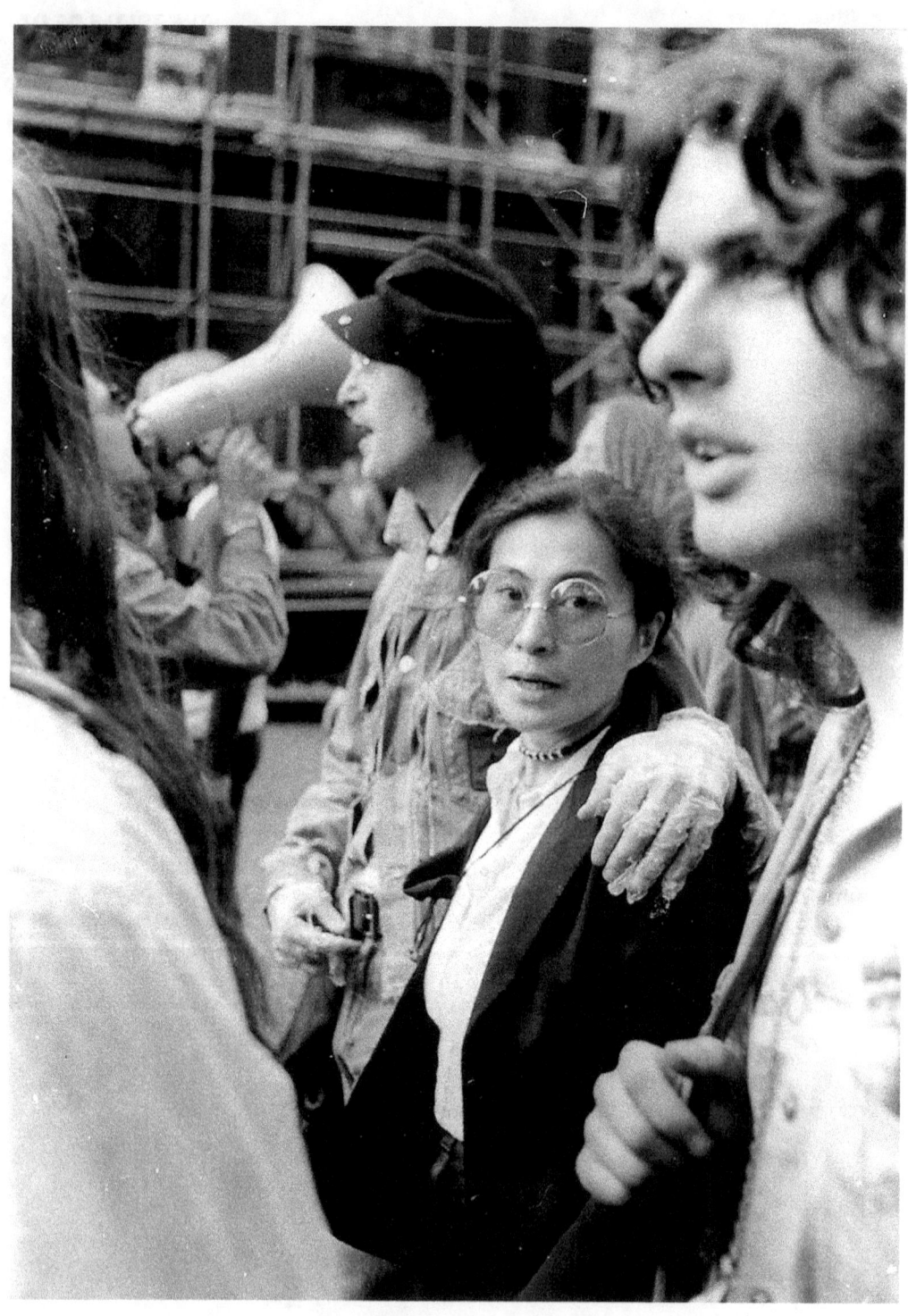

John and Yoko at an *OZ* demo
(Felix Dennis Collection)

CHAPTER SIX

Under Section 4 of the Obscene Publications Act (1964), it became possible to find that a magazine or a book or a film, whilst being considered obscene, was nonetheless of especial interest to art, science, literature or learning and not, therefore, liable to prosecution. For reasons which no doubt were well considered, the accused chose to invoke this particular defence and so called John Peel, the BBC disc jockey, to speak for the musical criticism contained within *OZ* 28; Marty Feldman to affirm as to its comic elements; Mervyn Jones, the ex-deputy editor of the *New Statesman* to testify as to the magazine's literary qualities; and Feliks Topolski to describe its artistic merits, if any.

There were some who argued that such a defence would be thought not only irrelevant but damaging, since its success depended to a large extent on the willingness of the Jury to consider *OZ* in any way valuable. To the Jury, it might seem that the threat of a lengthy defence of OZ as if it were a work of art would be not only tedious but positively insulting to their middle-aged, middle-class prejudices. So it was argued, and so we should see.

John Peel had about him that low, flat air of cultural infallibility. Dressed in a scruffy T-shirt and suitably hirsute in the current manner, he spoke softly in his carefully cultivated Liverpool accent. A product of Shrewsbury (the school) and National Service, he had worked for seven years in America, sometimes in Oklahoma, sometimes in Dallas and finally in Southern California.

John Peel
(Felix Dennis Collection)

Returning in 1967, he had been employed by the pirate ship, *Radio London*, where he was soon given his own late night show called *The Perfumed Garden*.

> "Basically, it was supposed to be only a music programme," he said. "But after I'd been doing it for three weeks, I realised that none of the Radio London staff were up and listening at that time, so I expanded it to include talk about things which related to the music. I used to read poetry, for example, which I did very badly, but the people who had written it were obviously unavailable on a ship in the middle of the sea. By the time the pirate radio stations were closed down, I was getting about a couple of hundred letters a day about the programme."

Since then, he had worked steadily for the BBC and frequently given lectures about music and related subjects to schools. Now he ran a Saturday afternoon two-hour Radio One programme called *Top Gear*, on which he frequently played music described as 'underground' or 'progressive'.

> "The music I try to feature," he added, "is that which I consider to be constructive and made by people who are basically honest and good people. While it might not be as generally accepted as more commercial popular music, I think it is probably more durable. People are much more likely to be listening to it in 50 to 100 years' time, than they are to the kind of stuff we normally hear on Radio One."

Top Gear, he said, had won many awards and its success had been very gratifying. He had read *OZ* since it had first appeared and often mentioned it on his programme, if he felt it contained something relevant. As to its musical criticism, he thought it was of a very high standard. It was frank and accurate and very perceptive, particularly the piece in *OZ* 28 'Brown Shoes Don't Make It'. He wished he'd written that particular article himself. The fact that it was by someone of 18 would give it even greater impact. Likewise, the article about Jeff Beck whose guitar playing Peel certainly thought could be described as Art. Even the hostile review of my own pop book, reluctantly he had to agree with.

Neville then asked him to consider the progress of pop music and pop culture over the last four years.

> "In 1967," said Peel, "there was a period when we were very optimistic; I really thought there was likely to be a lot of social change. People were starting to think more about one another instead of just acquiring property. Unfortunately, this has obviously turned out not to be the case, except in the area of music. Here, bands had broken away from the control of people in show-biz who manipulate everything. For example, I now have a very unsuccessful record company of my own; we have made about 12 or 15 LPs and lost something to the order of £18,000. Yet we have found people whom I thought merited the attention of the public and who had something to offer. Although this has proved to be economically disastrous, we have made some nice records. But nobody's bought them."

OZ, he maintained, served a useful function in the pop world.

> "It doesn't suffer from the sort of psychopathic preoccupations that I think the other newspapers suffer from," he said. "A lot of other newspapers merely write about people who are friends of the journalists. Or else their criticism is influenced by those who might buy advertising space."

Yes, if he had a daughter and she were old enough, he would let her marry Richard Neville.

Mr. Leary moved into action. Pointing to a section of the 'Brown Shoes Don't Make It' article, he asked Peel if he thought it were a compliment to have said of one's music:

> "'I'd love to meet a chick who could fuck like *Led Zeppelin One*, but she'd wear me out in a week.' Is that the nicest thing you could do - make love to music?" ...Leary asked.
>
> PEEL: If I were to write music, then I should be very flattered to think people were making love to that music.
>
> LEARY: Yes, I see. You used the expression 'making love'.
>
> PEEL: Yes. ·
>
> LEARY: Would you consider it bad taste to use the word 'fuck', rather than 'making love'? Which would you prefer?
>
> PEEL: I think the expressions are not different. You could mean either one in this context. I just felt because I was in Court, I should say 'make love'. But everybody else seems to say 'fuck', so I will say 'fuck' as well.
>
> LEARY: Do we gather that you think it impossible to use the word 'fuck' in a Court, but perfectly alright within the covers of *OZ*?

PEEL: Well, that's difficult to answer. I've not been in Court before, so I'm not really aware of what you are permitted to do and not to do.

LEARY [loudly]: It's not a question of what is permitted; it is a question of what is desirable.

PEEL: Well, if you go into it, I think it's quite desirable to say 'fuck'.

LEARY: But why is it more relevant, when writing a piece of music criticism, to use the word 'fuck' rather than the other expression, 'to make love'?

PEEL: But it's synonymous, and the people who read the paper know what it means.

LEARY: Ye-es.

PEEL: If I'd have been anywhere other than in Court, I'd have said 'fucking'.

LEARY: I see. And on the air?

PEEL: No, not on the air, because there would be a number of complaints. I once got a letter from a vicar who suggested that I should be castrated and deported for allowing a man to say 'fuck' on the radio.

Peel shifted around the witness box, uneasily. He was obviously not used to anyone questioning him in this way. But then, who was? Sex, said Mr. Leary. Has that got to do with pop music? Yes, replied Peel.

> "I'm sure that sex has always been an important part of music since the earliest days of dance. A lot of early music was written or played for fertility ceremonies and things like that. If you wanted to do a scholarly study of it, I'm sure you'd find a sexual element running through music from the earliest possible times."

> "Yes," replied Leary: "...have you heard of musical criticism about Mozart or Beethoven, however, which deals with somebody having an orgasm?" Leary paused and smiled at the Jury. "I would be right in thinking, would I not, Mr. Peel, that you have a large following of young people? Were you present in London on the day the trial opened?" he asked.

Peel hesitated.

"I'm not absolutely . . . yes I was," he said.

"When there was a processional march?" asked Leary.

"Yes," said Peel.

"Were you in the march?"

"Yes."

"Leading it?" inquired Leary.

"No, I was at the very back," said Peel with a grin, "...pushing a bicycle."

"What was the object of the march?" said Leary.

"Well, it was just to show support for the defendants," replied Peel. "We cared enough to turn up, to let them know that we were there and we were thinking about them."

Leary smiled again. "Have you had venereal disease?" he asked.

It was, on any reckoning, a shocking question.

"Yes," said Peel.

Leary coughed; "Am I right in suggesting," he said, "that you thought it right to announce this over the air, so that anyone listening could hear the fact that, unhappily, you had contracted venereal disease?"

"Yes, and I would do the same thing again today," Peel replied positively.

"I wouldn't be surprised to learn that quite a few people in this Court Room had had - at one time or another - a venereal disease, whether they would admit it or not."

The BBC, he said, had prepared a programme for broadcasting on Radio Four about venereal disease.

"But the main problem was that in trying to combat the disease, people were not prepared to admit that they had had it and so were not prepared to discuss it openly. So I thought it would make it easier for listeners if I mentioned the fact that I had had it myself, and so enable them to talk about it more freely."

Mr. Leary looked at his most outraged.

"When you made the comment that you daresay a number of people in this Court had had it and never mentioned it," he said angrily, "which part of the Court had you in mind?"

"I would say all parts of the Court." Peel answered immediately. "It is a very common disease."

The Judge seemed affronted; he could hardly speak.

"Let's go on to another topic, Mr. Leary," he ordered.

"Do you mind if I ask a few more questions?" Leary replied.

"Well, I don't think so," said the Judge. "A great many accusations about people in this Court have been made," he said. "I can't see any point in pursuing it. If the witness wishes to persist, he is perfectly entitled to do so, I suppose."

"I didn't bring it up in the first place," replied Peel. But there was worse to come.

Upon reflection, the evidence of **Marty Feldman**, called by Mr. Neville to describe the magazine's contribution to humour and satire, seems full of common sense. At the time, however, it seemed not only preposterous but ill-mannered and ill-timed. *The People* newspaper, with appropriate banality, put it more succinctly.

Stinking Feldman

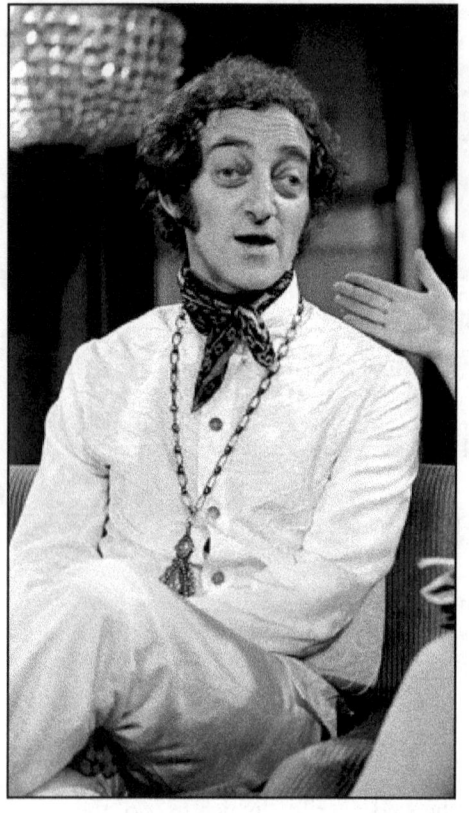

"Marty Feldman," it wrote, "...your performance STANK."

Feldman's brief appearance seemed to prove nothing except that stand-up comics in Law Courts should get their scripts more carefully prepared. If anything cast doubt upon the credibility of the defence, this was it.

Heaven knows what Judge Argyle must have thought of it, although one didn't need to be the Deity to observe that, after an initial attempt at courtesy, the Judge put down his pen, turned his back, and waited for Mr. Feldman and his faded denims to go away.

Curiously (and ominously), in spite of the apparent wittiness and even logic of some of Mr. Feldman's remarks, I did not see a single juror smile.

Okay, said Feldman, when he bounced into the witness box,

> "...just ask me your questions. I'm not swearing on anything, so just ask me what you want me to say."

"Mr. Feldman," the Judge began politely; "if you wish to give evidence in Court in this country, the Crown says you must either take the oath of any religion which you happen to practise, or, if you don't practise a religion, you can do what's called 'affirming'. This means exactly the same in law, that you're bound to tell the truth".

"Okay, I'll affirm," said Feldman breezily.

"Why do you wish to affirm?" asked Argyle.

"Because I think there are more obscene things in *The Bible* than in this issue of *OZ*. Anyway, I don't practise any religion that you would approve of."

Argyle sighed. 'Doesn't practise any religion,' he wrote down, trying to be helpful.

"I have my own religion," said Feldman.

* Marty Feldman (Martin Alan Feldman), 1943-82, was in his day one of the leading surrealist comedians of his generation. He won two BAFTA awards for his television show *Marty* and starred in several films including *Young Frankenstein*. The son of Jewish immigrants from Kiev, he pioneered the relationship between free-form jazz and stand-up comedy which influenced an entire generation of comedians popular today.

"Mr. Feldman, please," interrupted the Judge. "We've been here five weeks!"

"Where did you go to school?" asked Neville.

"I went to several," replied Feldman; "a primary school in East Ham, a boarding school in Brighton; and I was expelled from some."

"What were you expelled for?" asked Neville.

"I ran away from my boarding school - three times," joked Feldman, "...and was pursued by a homosexual master a couple of times. Eventually, they got me."

"And then you went to a grammar school in London, did you?" said Neville.

"No, I went to a grammar school in Finchley."

No-one laughed. Feldman looked thrown, as any comic would - lacking an audience.

Feldman then recounted his contributions to *Educating Archie, Round the Horne, That was the Week That Was* and, more recently, his own *Marty Feldman Show*. A frequent award winner, he had - even so - come across his own share of censorship problems, especially with the BBC.

"Johnny Speight, when writing *Till Death Us Do Part*," said Feldman, "argued with his Head of Department who said he, Speight, was to be allowed two 'bloodies' and one 'bastard' if he took out 'tit'. Or it could have been a couple of 'bloodies', if he took out a couple of 'tits'."

"I don't know if it matters," said the Judge, "but I can't hear."

Feldman replied: "I think it matters."

Asked about the cartoon of the schoolmaster masturbating, Feldman quipped:

"I knew a headmaster that looked exactly like this. This is fair game, yes. Quite a lot of us, as children, knew sadistic masters at school. I think a child has a right to record this."

"But does it - as an illustration - achieve its comic purpose?" asked Neville.

"I can't really judge if it's funny," said Feldman, "because you could get busted for not being funny."

Mr. Neville directed Feldman to look at Rupert Bear.

"It seems to me," said Feldman, "that the Establishment's getting uptight about Rupert because Rupert, in some ways, represents their own childhood; the Establishment's being attacked, and it's okay for anybody to attack authority. If authority is secure, it does not fear attack. Ridicule is a valid weapon, I think. In a dictatorship, one of the first things they try to do is to outlaw ridicule. Hitler did this and Franco did this, and there are some who're trying to do this today.

Anyway, comedy is personal; what makes you laugh, doesn't necessarily make me laugh. So I don't think any subject ought to be outlawed. If you can discuss a subject seriously, then you should be able to discuss it humorously, especially at school.

I mean, we were all at school, probably even the Judge here. Am I speaking loud enough for you, Judge? Sorry, am I waking you up?"

Poor Mr. Argyle; he had suffered so much. Feldman went on to say that even the cover of *Punch* was surmounted by the familiar comedy figure of Punch clutching a girl in one hand and an erect penis in the other; no-one had banned that magazine as far as he knew.

"You're not easily offended, are you?" asked Leary. "And you did comment that there was more obscenity in *The Bible* than in this issue of *OZ*?"

"Yes," said Feldman, "*The Bible* is much more depraved."

"Ye-es," said Leary and sat down, smiling at the Jury.

"The Old Testament is vicious," Feldman went on; "vengeful and I don't think that's a good thing for children to read."

"Have you another witness, Mr. Neville?" said the Judge.

"Oh, is that it?" said Feldman as he chuntered out, muttering. As far as he could tell, he said, the Judge was quite unaware that he, Feldman, had even been there... "the boring old fart".

Someone it would have been impossible to ignore, even if one had wished to do so, was **Ronald Dworkin**, at 39 already the Professor of Jurisprudence from Oxford University where he had only recently succeeded his famous predecessor, H. L. A. Hart.

"Who?" said the Judge.

"H. L. A. Hart," repeated Neville.

"Spell it," said the Judge.

"H-a-r-t," said Neville.

The Professor grinned, toothily, and blinked, bewildered, through his round, thick glasses. 'Geoff' Robertson, an Oxford student who represented in Court the defendants' solicitors Messrs. Offenbach, assured me this was the 'star witness'.

Among the professor's published works, Neville reminded us, were *Lord Devlin and the Importance of Morals*, *Taking Life Seriously* and the *Rule of Law*.

A frequent broadcaster, the Professor then defined for us the meaning of 'jurisprudence'. The Judge polished his half-moon glasses and slumped back on his chair.

"In Oxford," Dworkin began, "jurisprudence is considered to be the study of the theory of law, sometimes called the philosophy of law. It deals with general questions about the connection between law and morality, between law and society, as well as the function of law in the community. It deals with general questions of that sort rather than with detailed questions about the content of a particular body of law. In my work, for example, I've been concerned with the connection between private morality and public morality and in the analysis of that concept."

"Have you seen a copy of *OZ* 28?" asked Neville.

"Yes, I have," said the Professor.

"Considering your expertise in questions of legal morality," asked Neville, "may I ask you whether you think that *OZ* does, in fact, debauch or corrupt public morality?"

"That is a complicated question," replied the Professor. Indeed it was.

"There are many different ways," he continued, "in which a publication or speech might tend to corrupt public morals. One way, for example, would be this: it might persuade someone who held certain moral opinions to give up those moral opinions and do something that is contrary to those opinions. Suppose that I persuade my son, who now thinks that it's wrong and immoral to steal, that it was, in fact, right to steal and that it didn't matter whether we stole, and thus encouraged him to start stealing. In that way, I would have corrupted him. If I did that to a large section of the community, I would be corrupting the morals of that community. So let me say first that, in my opinion, this magazine would not corrupt anyone's morals in that sense.

Against the background of what is available in the community and also of what children know, what teenagers know, what young adults know, it seems to me that this kind of publication would not in itself persuade people to give up views that they hold firmly.

The second question is this: supposing you took one particular person and changed him from being a person in whose life morality played a considerable role, in other words he regarded himself as a moral person, and you changed him into a person who acted out of selfishness, or out of motives that showed no concern for the feelings of other people, then I would say you had corrupted that person's morality. And if you did this to a section of the community, I would say you were corrupting that community. Now it seems to me quite obvious that this magazine does not corrupt morality in that sense either, and for several reasons. The movement, of which this magazine forms a part, takes as its end to increase the role that morality plays in public and private behaviour. You might not like the language in which it's put; you might not like its style. But, certainly, one of the messages of this movement is to encourage a greater role for morality in our daily life. Second, it seems important to remember that the morality of young people is a concern for toleration and freedom of expression. These are values which young people, especially in this country, think are terribly important. Now, in my view, the publication of a magazine like this, is a way of indicating this toleration. Although we may not approve of some of the articles, the very fact of publication..."

"This is not a lecture theatre," interrupted the Judge angrily. There was a terrible pause. The Professor, young though he was, looked even more bewildered.

"I think the fact of the publication of a magazine like this is a vindication of some important moral principles," repeated the Professor. There was another awful silence.

"In my opinion, this prosecution is, in this sense, a corruption," he stuttered, "...a corruption of public morals."

"What did you mean by that?" said the Judge.

"A successful prosecution would be..." began the Professor.

"That's begging the question," interrupted the Judge, even more angrily. "I am a Judge," he said, "and I'm here to conduct a fair trial with the help of the Jury. Why do you say that this prosecution, which follows a complaint from a member of the public, can possibly be a corruption?"

Again, there was a terrible silence.

"Your Lordship," began the Professor, "...may I ... I'd like to make this clear..."

But there was no need. The damage had been done in the eyes of the Jury at least, who were sniggering among themselves.

"Keeping in mind the visit of the American Bar Association to this country . . ." began Neville.

"Wait a minute," said the Judge. "What's that got to do with this trial?"

"Well," said Neville, "I was just giving a little preface to my last question . . ."

"I don't know whether your next question is the last or not," said the Judge. "Will you please omit any reference to the American Bar Association unless it has something to do with this trial."

Neville looked flustered. The Professor looked amazed.

"I withdraw," said Neville. Instead, he asked nervously: "Do you think this case would succeed in the US Courts?"

"Well, how can the witness possibly answer," glared the Judge, "...when he hasn't heard any of the evidence."

Neville now seemed determined.

"Your Lordship," he said; "I only asked because I see in the *The* (London) *Times* that Lord Hailsham, the Lord Chancellor, and Chief Justice Warren Berger agreed that the Courts of this country and of the United States have a great deal in common."

The Judge sighed and flung down his pen.

"Well, if you think you can ask that question, go ahead and ask it," he said.

Once more there was a long silence. Finally, Neville asked:

"Do you think this prosecution would succeed in the United States of America?"

The Professor hesitated.

"If your Lordship will not..." he began. "I'm not familiar with all the evidence, but I have read the magazine and I believe that this prosecution would be unconstitutional in the United States by virtue of the first Amendment, which prohibits the infringement of the freedom of speech."

And there was another, agonised, silence.

Mr. McHale asked a few questions, but everyone was so stunned by the Judge's hostile treatment of the witness, that no-one seemed to be listening.

"Do you want to ask any questions, Mr. Leary?" asked the Judge.

"I hope the witness won't consider it a discourtesy," said Leary, smiling, "and I hope the Court will understand," he continued, looking at the Jury, "...if I dissent from asking the witness's opinions."

"Now, Mr. Mortimer," said the Judge, totally ignoring the perplexed Professor, "shall we get back to the matter in hand?"

"This way," bawled the usher to the Professor, indicating the door.

No-one could quite believe that such an eminent academic had been treated with such apparent disdain by the bench. What was it Mr. Duane had said?

"My experience of young people," he had declared, "is that the more they are prevented from expressing their real feelings about authority, the more likely they are to develop feelings of frustration and a desire to do something damaging; expressing themselves in more violent ways. The more access they have to the expression of their points of view about authority, the more likely they are to develop rational ways of coping with authority."

Later, the *Daily Telegraph*, under the banner headline *'Bare busts and a boost for circulation'*, was to print the following, referring to *OZ*:

"A senior policeman said: 'There has to be constant police interest in all these publications because of the volume of public complaint and the implications of the magazines. We suspect that extreme Left-wing activists are behind the campaign'."

An Underground Press Syndicate Directory, published from Phoenix, Arizona, defines the underground movement as "a secret movement opposing the Government or enemy occupation forces." The directory says Canada, Britain, France, Germany, Italy, Belgium, the Netherlands, Japan and some South American countries are among those where the enemy is "ourselves, our parents or our own elected governments". There is no mention of any Eastern European country, Russia or China.

The directory adds:

> "We are moving on to the streets and into the administrative buildings . . . a community exists which is a tremendous force for joy and change. It is also a nice place to hang out till the revolution."

Feliks Topolski was then called by the defence to demonstrate that *OZ* 28 was, broadly speaking, in the interests of Art. (Under the 1964 Obscene Publications Act, it was no longer necessary to prove that the article in question was 'of artistic merit'.) Polish, educated in the Academy of Warsaw, an official war artist from 1940 to 1945, Topolski's works were now to be found in the British Museum, the Victoria and Albert Museum, the Imperial War Museum, the Tate Gallery and many other galleries throughout the world.

> "My observation of *OZ* in general," he began, "and of this issue in particular, is that it is meant as a satirical send-up of erotic, pornographic, commercial publications.
>
> In other words, this is not in my opinion a straight pornographic attempt, commercial or otherwise, but satire. I think the drawings are not very good, but very efficient. An artist is usually aware of and reacting to everything around him, and throughout the history of art one finds that every artist from antiquity to Rembrandt to Picasso has a branch of his work devoted, for one reason or another, to erotic scenes."

Small, neat, bald, and speaking in the heaviest of accents, Topolski went on:

> "The drawing of the schoolmaster masturbating is the best in the issue - artistically. It's drawn by a very gifted person. As to its subject matter, it's a very obvious satirical statement, not necessarily reality but fantasy, which seems to denote a moral theme."

And the Rupert cartoon?

> "This, to me, is a tremendously clever and witty putting together of opposite elements from the 'comics' culture, thus creating a riotously profound clash. I think it is a great invention, if one accepts the satirical basis of the whole concept of the magazine."

The Judge looked up from his notes.

Mr. Mortimer proceeded to ask Topolski about the Siné drawings.

> "Siné," he said, "is a tremendously well-known French cartoonist, whose political cartoons are used widely in French papers. He's a very vicious satirical draughtsman and in these drawings he is commenting on the concept, much in evidence today, of sex being paired with violence."

"What sort of a comment is it?" asked Mr. Mortimer.

> "It's adverse," replied Topolski, rather surprised that anyone should ask such an obvious question.

But then, as the Judge had pointed out to Dworkin, he, Topolski, had not heard all the evidence.

The Judge then made a surprising, and revealing, intervention.

> "I am no judge at all," he said; "Thank goodness I don't have to make a judgment in this trial on these things, but it does seem to me that someone like you could look at these various illustrations and see at once whether they're that difficult to do, which require the greatest skill, the greatest draughtsmanship and so on... But maybe you can't," he added as an afterthought.

> "Can magazines be important in promoting an understanding of art and the arts?" asked Neville; "and in that respect, do you think that *OZ* has played a useful part?"

> "Very much," said Topolski. "I've been looking through *OZ* and buying *OZ*, not every number but a great many, and I think it's an inventive paper which has introduced a completely new graphic approach."

Mr. Leary had been silent for so long that when he eventually rose to question Mr. Topolski, some of us had forgotten all about him. It was a foolish error.

> "Mr. Topolski," he began, "I know you're here to help us about art with a capital A as applied to *OZ* 28; that's the position, isn't it?"

Topolski seemed confused.

> "Well," he replied, "I am told that I came here as an expert."

> "And we all appreciate [...**pause**...] very well [...**pause**...] what an expert you are on matters of art," said Leary, charming to the last. "But as to pornography," he went on, "I gather you're not suggesting that you are - in any way - an expert?"

> "Well, I think as far as pornography goes, probably I'm as good an expert as the next man," replied Topolski.

> "I see," said Leary, waiting for Topolski to continue.

> "In other words," offered Topolski, trying to be helpful, "not an expert really."

> "No," said Leary. "And you did say, did you not, that artists from Rembrandt to Picasso have devoted themselves to erotic themes?"

Leary paused and looked at the Jury.

> "But Rembrandt never painted lesbianism, did he?" asked Leary

> "Never painted...?" enquired Topolski.

> "Lesbianism," repeated Leary pugnaciously.

"I know of erotic drawings and etchings by Picasso," said Topolski.

"I'm asking about Rembrandt," said Leary. "I only mention Rembrandt," he went on, "...because he was the first artist whose name you mentioned."

"No," replied Topolski. "I had said from antiquity, from antiquity to Rembrandt to Picasso."

"Well," said Leary confidently, "we'll deal with antiquity in a moment."

Inevitably, it seemed, we turned to the Rupert cartoon. The achievement of the cartoon, maintained Topolski, lay in its juxtaposition of hitherto unrelated elements - the American comic strip from which the storyline had come, and the head of Rupert Bear taken out of a *Rupert Annual*; Rupert provided a fantastical and nostalgic quality to the cartoon.

"I'm very bad at quotations," Topolski said, "but I think that it was Koestler who said that unexpected elements when brought together produce the act of creation, of creativity."*

LEARY: I'm not dealing with the act of creation. I'm dealing with the *Rupert Annual.* Could you help us as to whether or not Rupert on his own, as he appears in this *Annual*, as he appears in a national daily, is that Art?

TOPOLSKI: Well, he's here a symbol of a certain state of mind and when in the central position of the page

JUDGE: No, Mr. Topolski, you haven't understood. What Learned Counsel is asking you is this; suppose you went into a bookshop and bought the *Rupert Annual* to give someone as a present, would you regard that as Art?

TOPOLSKI: No, I personally wouldn't, but many probably would. But I have to add that in this case we are not facing Rupert alone. We are ...

LEARY: I fully understand what you mean about bringing two things together. I want to separate them for a moment ...

TOPOLSKI: But that's unfair to the situation on this page.

LEARY: I won't be unfair. I want to understand what you're saying. Do you agree that Rupert as he appears in the daily strip in a national daily and in the *Rupert Annual* is not Art?

TOPOLSKI: Not to me.

LEARY: And to you, I imagine, this comic strip, again, is not Art? And you say that bringing the two together makes it [...**pause**...] different?

TOPOLSKI: Yes.

LEARY: Does it make it Art in your opinion?

TOPOLSKI: It makes it satirical art.

LEARY: Satirical art. I see. The Fabulous Furry Freak Brothers, who you'll find on the next page. Art?

TOPOLSKI: Well, I remember there was a famous essay on strip cartoons which treated them seriously, as a form of Art which showed the social situation.

* The quotation appears to be from his 1964 book *The Act of Creation*

THE TRIALS OF OZ

LEARY: We're wanting your opinion, if you please, Mr. Topolski; the strip cartoon, in your opinion, Art or not?

TOPOLSKI: Strip cartoon art.

LEARY: But what does that mean?

TOPOLSKI: I think one should accept that any visual performance, if executed in earnest, is a branch of artistic creation. The assessment as to whether it is good or bad is changeable.

A few years ago, pop art wouldn't have occurred to us as a serious art. Yet now it is.

LEARY: On page 37, you see there a couple photographed in a sexual embrace.

TOPOLSKI: I've looked at them.

LEARY: Have you heard the phrase 'artistic poses'?

TOPOLSKI: Artistic . . .

LEARY: 'Artistic poses'.

TOPOLSKI: Yes, yes.

LEARY: Is that an 'artistic pose'?

TOPOLSKI: Well, it's obviously intended as such.

LEARY: But is it Art? You see the photograph of a portable massager depicted on page 36 under the headline 'Every Home Should Have One'?

TOPOLSKI: Those are advertisements which . . .

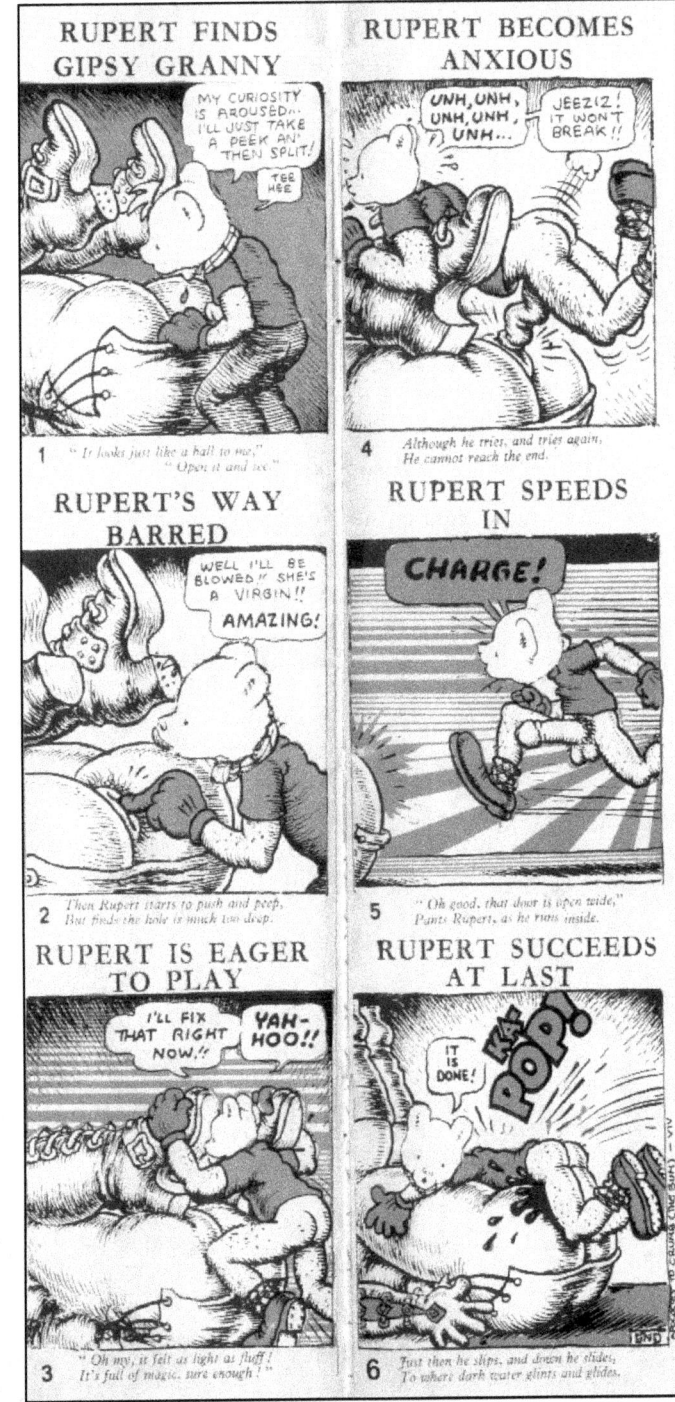

LEARY: But are they Art?

TOPOLSKI: I think they are, from the point of view of the advertising art.

LEARY: So, as you define Art, it can comprehend everything from Mickey Mouse to Rembrandt . . .

TOPOLSKI: Indeed, yes.

LEARY: . . . and take in any satirical drawing, however ill-executed. Is that right?

TOPOLSKI: Yes. But may I remind you that this is a schoolchildren's issue, which has a large proportion of material that is immensely interesting precisely because it is produced by schoolchildren.

Turning to a cartoon which depicted a girl with her hand up the trouser leg "of somebody who appears to be fiddling in his pocket", Mr. Leary asked; "Are you saying that, in your opinion, this drawing has been done by an artistically gifted person? A simple question."

"Yes, I would," said Topolski.

"Do you put him in the same category, for example, as the person who drew the schoolmaster?" asked Leary.

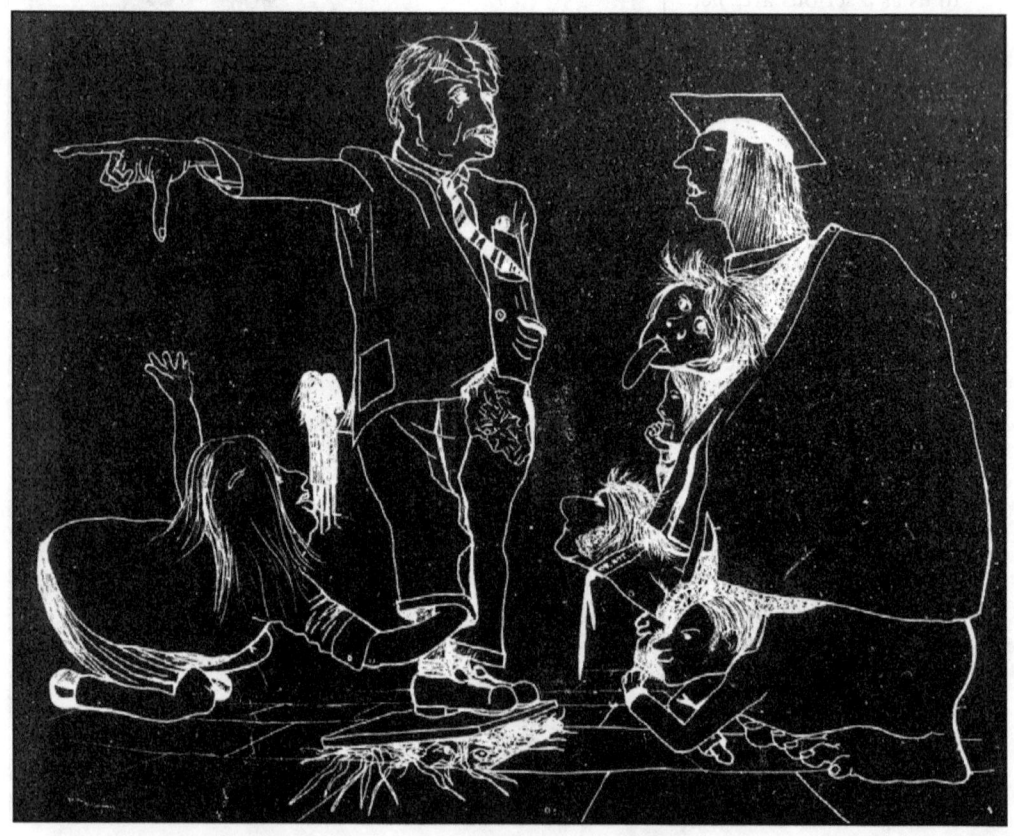

"Oh, no" replied Topolski.

"You appreciate, Mr. Topolski," said Leary, "that they've been done by the same person."

Leary smiled. It was a clever trick.

"Has it?" said Topolski, incredulously.

"Yes," blinked Leary.

"Truly?" asked Topolski, less confidently.

"Truly," beamed Leary.

"How extraordinary," said Topolski, laughing. "Well then, I've blundered."

"I wouldn't suggest that for one moment," said Leary.

Mr. Mortimer rallied the crestfallen Topolski, but only briefly. Picasso's later etchings were crowded with sex, said Topolski, as were the satirical drawings of Gilray. And Roy Lichtenstein, who had glorified the strip cartoon, had several such exhibits in the Tate Gallery. Less than a year ago, Topolski went on, there had been an entire exhibition at the Institute of Contemporary Arts in London devoted to the comic book.

"Looking with your knowledge down the corridors of the history of art," Mr. Mortimer asked, "do you think that there is any human activity of which an artist has felt himself forbidden to comment?"

"No, definitely not," replied Topolski, and added; "...he wouldn't be worthy of the name of artist."

Next up was **Mr. Mervyn Jones**; short, bearded and possessed of a loudly confident voice.

"Mr. Jones, I want to make it clear," said Mr. Mortimer, "that I'm calling you as an expert on the art of literature, and your evidence will be entirely directed to literary matters."

"Yes, I understand that," replied Mr. Jones. Novelist, journalist, traveller, he had been assistant editor of the *New Statesman* from 1966 to 1968. "I would say", he said, "that it's a very great encouragement to any young person with ideas to express, and particularly to any young person who hopes to write, to even get into a school magazine, let alone something which is to be sold to the public. This can be a very great help."

Of the quality of writing in *OZ* 28, Mr. Jones said that

"...the standard is very high, much higher indeed than one would expect from a group of young people. I could, if I wished, point to items which I think are badly written, others which are just the same as one could expect in a school magazine. But I could also point to a few which are very well-written and I think there are a couple of contributors who might at least become good journalists.

I don't want to take the time of the Court, but I think that the phrase from the end of the first paragraph of the piece by Alan Clayson, 'half-things, former things, and rotting things (mostly chicken skulls)', is a remarkable piece of imagination. I think also that the phrase which I find lower down; 'his doom was to wander for miles every day looking for work and money to feed his starving, unsmiling family,' is a very fresh choice of words.

As a work of journalism, moreover, *OZ* 28 is competently edited, and what is of interest about it is not only that the children had the opportunity to write, but that they had the opportunity to write freely'".

"In the present climate of literary expression," asked John Mortimer, "is there anything unusual in these schoolchildren using the sort of four letter words which they use in expressing themselves in this magazine?"

"No, I don't think so," replied Jones. "I use four letter words myself in my novels. I think it's important to establish that what has changed recently is not what a writer wants to express, but what he's *allowed* to express. When I started to write, which was all of 20 years ago, I used to skirt round things, both in terms of language and in terms of subject matters. I used to have to say to myself, 'Dare I write that?' Whereas now, I write very much more freely.

One can now use words which are part of the English language in the sense that they are used by the mass of the population."

'Cunt', he went on to say, had appeared frequently in *Lady Chatterley's Lover*, and 'fuck' was in common currency in novels, newspapers and on the stage. Mortimer asked:

"And is it unusual to link descriptions of sexual intercourse between young people unaccompanied by moral judgments as to the desirability of such acts?"

"It's not really the job of the novelist or the creative writer to make moral judgments," replied Jones. "It's his job to describe the realities of life, and that's all."

Mr. Leary, for only the second time in the trial, got into a muddle. When asking Jones about why some of the school kid authors had preferred to use either initials or pseudonyms to hide their identity, he didn't even notice Jones' strange reply. Pseudonyms had often been used in literature, said the ex-assistant editor of the *New Statesman* and cited, as an example, Jane Austen.

Jane Austen, of all people, was not a pseudonym.

"But you're not suggesting that *OZ* is on the parallel with the works of Jane Austen?" asked Leary.

"No, but I think any writer has the right to remain anonymous if he or she wishes," replied Jones. And again, Mr. Leary let this curious mistake slip by.

Instead, he concentrated on the use of the words 'cunt' and 'bollocks'. No, agreed Mr. Jones, he did not find any tenderness in the magazine, but he found many expressions of love which were probably more important.

In a sense, the personification of that love now appeared in the person of Mrs. Berger, the mother of Vivian, the contributor to have been called as a witness for the prosecution.

Mrs. Grace Berger was a dumpy lady; born in Rhodesia, now divorced, she had three children - Vivian, and his two sisters aged 12 and 10. For the last five years, she had been working in industrial market research as well as being associated with the National Council of Civil Liberties of which she was now Chairman. She had not only known about Vivian's involvement with *OZ* 28, but had actually encouraged him.

Her only concern had been that he, Vivian, was already over committed, what with his O-levels and his audition with the National Youth Theatre. She had seen all his contributions in the magazine and discussed them with him fully. Again, her only concern had been that he had named particular members of the staff in one of his articles and this she thought unwise. But, she said, "he convinced me that it was important to him; so I agreed with him in the end and said fine."

> "Now let me just ask you this," said Mr. Mortimer. "At any time during your conversations with Vivian whilst he was engaged in the production of this magazine, did you gather that it was his intention, or the intention of anybody in the dock, to deprave and corrupt the morals of children and young persons?"

> "When I saw this indictment in *The Times* newspaper," replied Mrs. Berger, "I have never been so distressed by anything in my whole life. I was really sick and had to call a doctor."

She then dispelled the mystery surrounding the 'pseudonym' Kylastron with which Vivian Berger had signed some of his articles.

> "Oh yes," she said, "that was a nickname he had chosen for himself when he was about 13. Everyone who knew him was aware of it".

It was obvious that this generous, open hearted woman had a very close relationship with her son. To see him escorting her across the road during the lunch adjournments, almost protecting her from the traffic, was quite moving. Had the trial brought them this close, or had it always been so? The jibe in his biography that he had 'smoked at 9 and tripped at 11' had made her angry; it was so blatantly untrue.

> "Has the experience of having taken part in this magazine", asked Mr. Mortimer, "done him any harm?"

> "The fact that what he believes was published, has done him no harm at all," replied Mrs. Berger. "What has done him harm is the fact that the whole thing has now been blown up out of all proportion. I think it is a good thing that children can feel that they are people who can do things that they want to do," she went on, "and are not forced into a kind of straight jacket. Vivian had been given responsibility because it is only by having such responsibility that he could end up being a full member of society, able to trust in his own judgment?"

> "I think you are used to addressing meetings, Mrs. Berger," said Leary, rather peremptorily.

Was he referring to her attempts to answer his questions? But no. Instead, he went on to paint some elaborate picture whereby Mrs. Berger had once spoken on the same platform as Michael Duane - which puzzled everyone, not least Mrs. Berger.

Then she made an important revelation. Was it not true, asked Leary, that the headmaster had confiscated Vivian's copy of *OZ* 28 and sent it back to her?

Yes, that was true, replied Mrs. Berger. Suggesting to you, Mr. Leary went on, that he considered it undesirable to have such a magazine in the school? The Judge looked up. As did Detective Inspector Luff. Because it was on assumptions like this that complaints had been made by such headmasters about *OZ* 28, School Kids Issue, and thus we were here at all. Mrs. Berger smiled.

> "No", she said. "He had found some child reading it instead of doing his chemistry lesson. I pointed out that that wasn't Vivian's fault and gave it back to him. The headmaster did not say he had banned the magazine from the school. In fact, he had not. It was just the child reading it in a chemistry lesson."

Mr. Leary hurried through his notes, apparently not liking that last reply. Why had Vivian insisted on the naming of certain schoolmasters, he asked? Because he had thought that was more honest, replied Mrs. Berger.

> "But the point he was making - you can agree with this or not - was that one of his masters, a Mr. Butler, might have got a sadistic thrill out of caning," asked Leary. "True?"

> "Absolutely," agreed Mrs. Berger.

> "Do you not agree that that was a very nasty smear? To spread in print? About one of the masters who was helping with your son's education?"

Mr. Leary looked indignant.

> "Never," replied Mrs. Berger emphatically. "My son had suffered a beating and I think that was a far nastier hurt, and not part of his education at all. Vivian was interested in seeing that it was not done in the future; I can't understand why writing about it is a smear. He was asking a question. He was asking a question about the nature of people who beat boys as part of their education."

She looked defiantly at Mr. Leary, waiting for him to challenge her. But he desisted. Instead, he slipped over to Rupert Bear.

> "It was a joke," maintained Mrs. Berger.

> "A joke?" asked Leary, clutching his sides.

> "Yes, a joke," repeated Mrs. Berger. "And the joke was this; to put into print what every child knows, that is that this innocent little bear has sexual organs. Children today are surrounded by, and cannot escape from, the sexual nature of our society - newspapers, which are sold by having advertisements based on sex, and which include gossip also based on innuendos about the sexual relationships between people who are not married. This is the world in which our children grow up."

> "So this was hitting out at one of the national dailies?" asked Mr. Leary, totally innocent of the absurdity of his question.

THE TRIALS OF OZ

What was it Mr. Duane had said?

> "In its own crude way," he had said of the Rupert cartoon, "it's perhaps the funniest thing in the magazine. It is simply an attempt to shock those of the older generation like myself who have been brought up on the nauseous fact that Rupert and Enid Blyton books and all this kind of rubbishy sentimentality, are suitable for children. The cartoon, therefore, brings together the notion of Rupert, a horrible sentimental little bear, with the more realistic activities of a male human being, in such a way as to cause an element of shock. This can only be to the good if it helps people to realize just how bad, how destructive in the long run, such mush as Rupert is."

Even to the most objective observer, it was becoming apparent that there was a remarkable degree of unanimity among the educationalists and psychologists as to the purpose and likely affect of some of the key sections of the magazine. I wondered, for a moment, what Mr. Leary really thought when he was not 'doing his job'. A sophisticated, intelligent, lucid man – would be, when not decked out in his legal finery, would he really choose to ignore such evidence so completely as he now appeared to be doing? He began to ask Mrs. Berger about the effect of the magazine on her young daughters.

Would it be possible, she pleaded, for the Press not to report her answer? Her daughters had suffered enough as it was. No, the Judge would not allow that. Was it not Leila Berg who had said that the trial was obscene because it, and it alone, had paraded the work of schoolchildren as if that work were something sinful? Can you imagine the damage that it will do to them when they read what has become of their work, she had asked?

So, said Mr. Leary triumphantly, changing the subject. Vivian Berger had been to see *Hair*.

"Yes," replied Mrs. Berger, "I took him."

"Is *Hair* an article?" asked the Judge.

Hair is a play, said Mr. Mortimer helpfully. "It's been running for about three years." *

Did no-one know that Princess Anne had been to see *Hair* - twice? Why was *she* not in the dock? To the Judge, Mrs. Berger said: "Vivian was not ashamed of what he did and I am not ashamed for him."

Two Junior Counsel, one of them clutching a copy of *Private Eye*, giggled at the back of the Court. One of them was wearing two different socks, one green and the other blue. The green one displayed a big hole.

* *Hair: The American Tribal Love-Rock Musical* is a musical with a book and lyrics by James Rado and Gerome Ragni and music by Galt MacDermot. A product of the hippie counter-culture and sexual revolution of the 1960s, several of its songs became anthems of the anti-Vietnam War peace movement. The musical's profanity, its depiction of the use of illegal drugs, its treatment of sexuality, its irreverence for the American flag, and its nude scene caused much comment and controversy.The musical broke new ground in musical theatre by defining the genre of "rock musical", using a racially integrated cast, and inviting the audience onstage for a "Be-In" finale.

Hair tells the story of the 'tribe', a group of politically active, long-haired hippies of the 'Age of Aquarius' living a bohemian life in New York City and fighting against conscription into the Vietnam War. Claude, his good friend Berger, (a strange slice of lexilinking synchronicity) their roommate Sheila and their friends struggle to balance their young lives, loves and the sexual revolution with their rebellion against the war and their conservative parents and society.

Throughout the proceedings, Neville had conducted his own defence with the assistance of an assortment of helpers. Most of these were not directly associated with Neville's solicitors, Messrs. Offenbach, but had come along at Neville's request to give what assistance they could. Inside the Court Room, for example, he was accompanied by David Widgery, a final year medical student, whose jeans and bare midriff had added a little touch of colour to an otherwise black and white affair. He had been replaced in the third week by a frizzy-haired Warren Haig, a leading spokesman for the Gay Liberation Front. Both acted as liaison officers between officialdom and Mr. Neville, and Argyle increasingly gave the impression that he would tolerate their antics and no more.

Both Widgery and Haig were invited by Neville to sit at the solicitor's table in order to confirm a principle considered important in radical circles - that is, the right of a non-lawyer to assist a person defending himself. Such people are known as 'McKenzie lawyers', following a High Court precedent (McKenzie v. McKenzie), and had been used in a series of so-called political trials in magistrates' courts during the previous year.

This was the first time that a McKenzie lawyer had ever sat at the solicitor's table in the Old Bailey. As I said, neither Widgery nor Haig were at all connected with the defending solicitors, Messrs. Offenbach. As I also said, these were represented in Court primarily by an increasingly puffed-up and preening Australian solicitor, 'Geoff' Robertson, currently a Rhodes Scholar at Oxford with an overweening sense of his own importance. In his student days, he had been a legal correspondent for Australian *OZ*, and later said that "All three defendants were Australian", although in fact only Neville was Australian born. It was he, together with another Australian Rhodes Scholar, Julian Disney, who claimed to be co-ordinating the defence strategy.

Outside the Court Room, moreover, particularly in the early days of the trial, a variety of well-wishers had turned up with predictable regularity to take the defendants out to lunch. Among them were Marchioness of Dufferin and Ava and Auberon Waugh, son of the novelist Evelyn. Solidarity is everything, I suppose.

The only disadvantage of such a multifarious support team was the almost inevitable complications that it caused. For example, when one witness was contacted by a defence supporter before his appearance in Court, he was asked to say why he thought he was qualified to appear. Somewhat surprised by the apparent silliness of the question, he could only reply: 'Because I was asked'. 'Yes', said the voice. 'But why are you *qualified*?' The witness said that he did not understand the question. If he had already been asked to appear for the defence, presumably the defence thought he was qualified so to do. Ah, said the voice; "I see."

The witness in question was **Professor Richard Arthur Wollheim**, Grote Professor of Mind and Logic in the University of London since 1963, called by Richard Neville to consider the broader implications of a trial such as this. He was the last witness for the defence and, in a way, summed up the entire proceedings. Among his many publications had been *The Nature of Law* and *The Limit of State Action*. He had also been a member of the Labour Party Commission on Advertising set up in 1963 under the chairmanship of Lord Reith, founder of the BBC whose famous injunction that the main purpose of the media (he meant radio, but it could, and should, equally apply to all media) was to "inform, educate, and entertain". The majority of newspapers, television and radio stations reporting the trial completely ignored the first two injunctions.

Neville asked Wollheim to dispose of the myth surrounding the infamous small ads.

> "In our society" said the Professor, "as it is structured at the moment, these small advertisements might have a certain beneficial effect; that is to say that I think that they might do something to mitigate the kind of loneliness and distress which many people suffer. I don't necessarily think that, in the ideal society,

there would be a need for this sort of advertisement. But in our kind of society, these advertisements perform a useful kind of role."

The Judge put down his pen very carefully, folded his arms and sagged once more back in his seat.

Referring to the article which contained the phrase 'fucking-in-the-streets', Neville asked Wollheim to comment.

"The first general comment I would make", he said, "would be that this article is probably the best and the most interesting thing in this number of *OZ*. I say that because I think that one does find here an attempt to try and come to grips with certain subjects which are extremely important for people of this age in helping them to form their own moral views. It is partly concerned with morality as such, and partly concerned with the rather different issue of how far morality should be enforced by law. How far should the Law go along in insisting on certain things which we might think to be right?

I think that it proceeds by a method used by many moral thinkers. It shows how something which is forbidden is really very like, and very close to, something which is not forbidden, thus raising the question that if the one is allowed, why is the other forbidden? And this allows people to arrive at a reasoned conclusion. And that, in itself, is an essential element in the formation of an individual's moral conceptions."

"Do you think that there is any danger of this article leading to a sudden outbreak of fucking in the streets?" asked Neville.

"No", said the Professor.

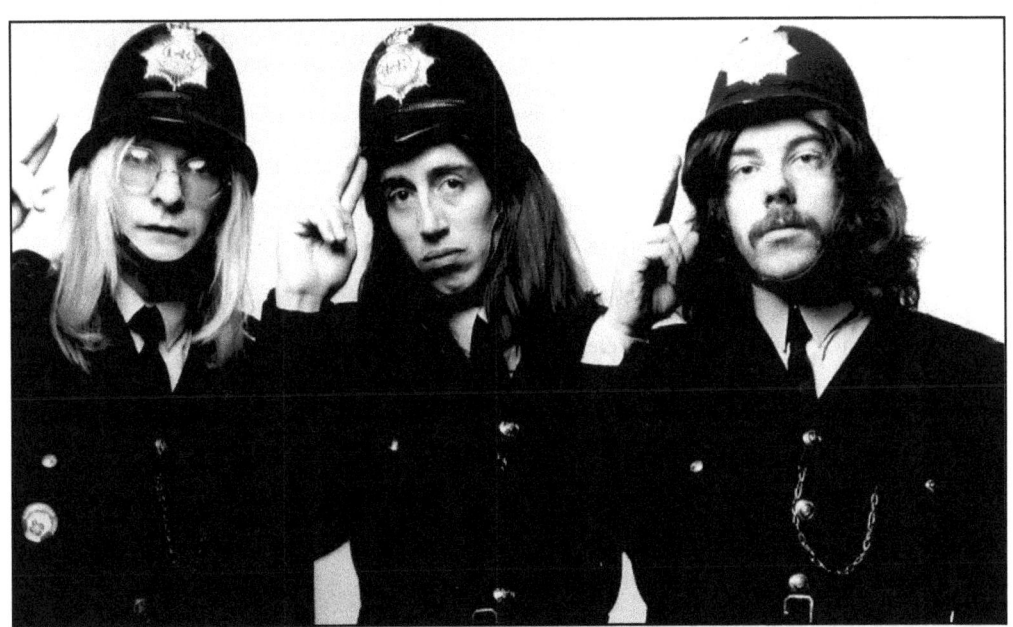

"Finally", asked Neville, "could you define for us what is meant by 'to debauch and corrupt public morals'?"

The Professor paused then said, loudly and clearly:

> "To establish that something debauched or corrupted public morals," he began, "you would really have to establish three separate things. First, that the reading of whatever it was did have a direct effect upon the behaviour of those who read it; a *direct* effect upon the behaviour of those who read it. Second we would have to establish that this behaviour isn't something that people wouldn't ordinarily have wanted to do before they had read the thing which did debauch and corrupt them. It isn't simply a matter of being presented with the opportunity; they must have already had their wishes or desires influenced by the reading of whatever it was. And third, one would have to show that the behaviour itself was against the public morals, against the morality of society."

> "So, keeping that in mind", asked Neville, "do you think that *OZ* tends to debauch and corrupt the public morals of the society in which we live today?"

> "No," said the Professor.

Mr. Mortimer asked him if it was a known and acceptable technique of someone wishing to produce discussion that they advanced highly exaggerated propositions. Yes, said Wollheim. That is a method which has been used by some of the greatest moral thinkers of our civilisation. In response to Mr. McHale, who asked again about the article 'I wanna be Free' which included the phrase, 'fucking-in-the-streets', the Professor said:

> "In a liberal society like ours, we are partly interested in getting people to conform to rules which we think to be reasonable, and we are partly interested in people forming their own moralities, forming their own conceptions of human life and what a human being should do. These two things sometimes come into conflict; but it does seem to me that the kind of discussion, of which this article is an example, is something which would contribute to both these two things. It would get people to discuss the reasons for conformity to the norms of the society, and it would also get them to try and work out some morality of their own."

> "Did I hear you say a 'liberal society'?" interrupted the Judge.

> "Yes, I did say a liberal society," replied the Professor.

> "To which society were you referring when you said that?" asked the Judge.

Mr. Leary said that his questions to Professor Wollheim were "thankfully few". They were also swiftly and convincingly rebutted. Do you agree that increased promiscuity is a problem among today's students, he asked. It doesn't seem to me to be so, replied the Professor.

> "I was wondering," asked Neville of the Professor, "whether you had any comment as to the effect that this prosecution might have on the community?"

The Judge became agitated once more.

"You see, once again Mr. Neville," he blustered, "you keep on bringing up the consequences of the verdict in this case. It's quite irrelevant, quite irrelevant. If Juries and Judges started to think at this stage what is going to happen if a certain verdict, one way or the other, eventuates, then you're absolutely on the wrong track. No barrister would be allowed to ask that question."

He flung down his pen, yet again, and looked for support.

"I'm certainly not referring to the verdict," began Neville, "...but just the..."

"Yes, you are..." thumped the Judge.

"But that's really what the case is all about, two mentalities fighting each other," replied Neville, fiercely.

The Judge, his patience at an end, just said;

"Ask any question you like."

There was a silence. Later, the *Sunday Telegraph* was to write:

> "Every unbiased person who has heard the Judge at work during this trial, must acknowledge that he has bent over backwards to ensure that every possible point of any relevance to the defence has been put fairly and fully to the Jury."

"This is my last question, Professor," said Neville, at last and quite calmly. "Do you feel that the machinery put into motion by this prosecution, will have any effect on the community?"

The Professor hesitated. It was obvious, at least to some of us, that this was the essential question. Finally, Wollheim said:

"I think that there are two ways in which, as I see it, the bringing of this prosecution against *OZ* could be socially damaging. It does seem to me, in some ways, to endanger, or be a threat to, an attack upon the morality of toleration which is a large part of the morality of a society like ours. And second, I do think it might do something to produce the kind of polarisation in our society which we already see in existence in other societies such America. And this seems to me to be extremely damaging to society."

"No more questions, your Lordship," said Neville.

CHAPTER SEVEN

"Now, ladies and gentlemen," began Judge Argyle, "we've reached the point in this trial where the evidence has all been heard, or seen or tabled, and under our law no more evidence of any sort is admitted from now onwards. This is all the evidence there is. What happens next is that you will hear addresses from learned Counsel and from Mr. Neville from their different points of view. And when that is over, I shall start summing up the case to you."

"M'Lord, members of the Jury," Mr. Leary began; "...you've been sitting there now for so many days and listening to so many words that your brains must have become by now well nigh ossified - and I make no apologies for making a rather bad joke *[so bad, in fact, that no-one even noticed it]* ...to start with because, Members of the Jury, it shows two things; first, that humour can sometimes lighten a heavy burden, and second, that jokes don't have to be sexy in order to provoke a response. OZ No. 28, School Kids Issue, is a magazine which you have to judge as a whole. It can be looked at from a number of different standpoints, but those standpoints must be based - when you come to consider your verdicts - upon the indictments. Members of the Jury, this is not, as the last witness said, in any sense contest between the prosecution and the defence in the way in which it has be...
you. This is a criminal case; an i...
criminal case, upon the charg...
before you can convi...
Company - of a...

Fr

THE TRIALS OF OZ

time not to mention that of the 12 jurors. To bring this case, the police had spent a great deal of time travelling around the country talking to printers, publishers and suppliers. Even so, Ableman was acquitted on the charge of publishing obscene material although found guilty of the lesser charge of sending indecent material through the post. The cost of the case was estimated to be £10,000.

Second, consider the case of the Unicorn book shop in Brighton, which is owned by one Bill Butler. On January 22, 1968, four policemen raided the bookshop and seized copies of *IT*, *OZ* and various books. The police brought a charge of selling obscene material. After a four day trial in a Brighton Magistrates' Court, the valiant Brighton Constabulary won the case. To get this conviction, they spent over £4,000.

Third, there was the case of *The International Times*, *IT*, and its three editors Graham Keen, Dave Hall and Peter Stansill. They were prosecuted under the Obscene Publications Act for their classified ads section in December 1970. The trial ran for six days, again at the Old Bailey. At the committal of evidence, the police called 30 witnesses plus printer. They had seized all the classified ad files, letters and allied material and spent six months reading and following up all these letters. The cost to the police in this case was also about £10,000.

In other words, on these cases alone, the total cost to the taxpayer had been, at least, an estimated £24,000, an enormous sum in 1971.

CHAPTER SEVEN

"Now, ladies and gentlemen," began Judge Argyle, "we've reached the point in this trial where the evidence has all been heard, or seen or tabled, and under our law no more evidence of any sort is admitted from now onwards. This is all the evidence there is. What happens next is that you will hear addresses from learned Counsel and from Mr. Neville from their different points of view. And when that is over, I shall start summing up the case to you."

"M'Lord, members of the Jury," Mr. Leary began; "...you've been sitting there now for so many days and listening to so many words that your brains must have become by now well nigh ossified - and I make no apologies for making a rather bad joke *[so bad, in fact, that no-one even noticed it]* ...to start with because, Members of the Jury, it shows two things; first, that humour can sometimes lighten a heavy burden, and second, that jokes don't have to be sexy in order to provoke a response. OZ No. 28, School Kids Issue, is a magazine which you have to judge as a whole. It can be looked at from a number of different standpoints, but those standpoints must be based - when you come to consider your verdicts - upon the indictments. Members of the Jury, this is not, as the last witness said, in any sense contest between the prosecution and the defence in the way in which it has been suggested to you. This is a criminal case; an important criminal case. It's based, like any criminal case, upon the charges which the Crown has to prove to your satisfaction before you can convict any one of these three accused young men - or the Company - of any offence.

From time to time during the course of this case, you've been hearing all sorts of matters introduced into this case which are *not* evidence. But you are bound, according to the oaths which you've taken, to act upon the evidence, and you will, I know, be careful to do so."

Meanwhile, the 'Friends of *OZ*' put out a statement which contained the following information. Consider the case, it said, of *The Mouth* by Paul Ableman, published by Running Man Books. That took up 10 days of Old Bailey Court time and 10 days of a High Court Judge's

time not to mention that of the 12 jurors. To bring this case, the police had spent a great deal of time travelling around the country talking to printers, publishers and suppliers. Even so, Ableman was acquitted on the charge of publishing obscene material although found guilty of the lesser charge of sending indecent material through the post. The cost of the case was estimated to be £10,000.

Second, consider the case of the Unicorn book shop in Brighton, which is owned by one Bill Butler. On January 22, 1968, four policemen raided the bookshop and seized copies of *IT*, *OZ* and various books. The police brought a charge of selling obscene material. After a four day trial in a Brighton Magistrates' Court, the valiant Brighton Constabulary won the case. To get this conviction, they spent over £4,000.

Third, there was the case of *The International Times, IT*, and its three editors Graham Keen, Dave Hall and Peter Stansill. They were prosecuted under the Obscene Publications Act for their classified ads section in December 1970. The trial ran for six days, again at the Old Bailey. At the committal of evidence, the police called 30 witnesses plus printer. They had seized all the classified ad files, letters and allied material and spent six months reading and following up all these letters. The cost to the police in this case was also about £10,000.

In other words, on these cases alone, the total cost to the taxpayer had been, at least, an estimated £24,000, an enormous sum in 1971.

"You see, once again Mr. Neville," he blustered, "you keep on bringing up the consequences of the verdict in this case. It's quite irrelevant, quite irrelevant. If Juries and Judges started to think at this stage what is going to happen if a certain verdict, one way or the other, eventuates, then you're absolutely on the wrong track. No barrister would be allowed to ask that question."

He flung down his pen, yet again, and looked for support.

"I'm certainly not referring to the verdict," began Neville, "...but just the..."

"Yes, you are..." thumped the Judge.

"But that's really what the case is all about, two mentalities fighting each other," replied Neville, fiercely.

The Judge, his patience at an end, just said;

"Ask any question you like."

There was a silence. Later, the *Sunday Telegraph* was to write:

"Every unbiased person who has heard the Judge at work during this trial, must acknowledge that he has bent over backwards to ensure that every possible point of any relevance to the defence has been put fairly and fully to the Jury."

"This is my last question, Professor," said Neville, at last and quite calmly. "Do you feel that the machinery put into motion by this prosecution, will have any effect on the community?"

The Professor hesitated. It was obvious, at least to some of us, that this was the essential question. Finally, Wollheim said:

"I think that there are two ways in which, as I see it, the bringing of this prosecution against *OZ* could be socially damaging. It does seem to me, in some ways, to endanger, or be a threat to, an attack upon the morality of toleration which is a large part of the morality of a society like ours. And second, I do think it might do something to produce the kind of polarisation in our society which we already see in existence in other societies such America. And this seems to me to be extremely damaging to society."

"No more questions, your Lordship," said Neville.

THE TRIALS OF OZ

"There is no doubt whatever," Mr. Leary continued, "...that *OZ* 28 was sent through the post. It has been formally admitted. The only issue for your determination, therefore, ladies and gentlemen, is whether or not it's been proved that the magazine is *either* indecent or obscene. Indecent is clearly less than obscene; it is something which is less dirty, less depraving than obscene. It's interesting, is it not, to see how the minds of the accused men react to questions as to what is, or what is not, indecent?

You remember Mr. Anderson, for example - he's the one with legal training, the one who worked in the Attorney General's department in New South Wales. He thought about it for some time and then came up with this suggestion: that if someone urinated in front of him, in this Court Room, that would be indecent. Members of the Jury, he was then asked to have a look at the Siné cartoon which shows us a lady with her private parts exposed, urinating on a pot which contains a phallus in the form of a cactus. He said, no, that was not indecent. But he's got it all wrong, hasn't he? He lacked the imagination, did he not, to provide us with an example other than passing water in this Court Room? When he was asked about that schoolmaster masturbating, (which is clearly grossly indecent is it not?) he said it was not in his judgment an indecent drawing, but that the act, that is the indecency, against a schoolboy, could be considered to be indecent. And he went on to describe it as a balanced, honest

and beautiful drawing. Members of the jury, whatever it is, it is not that, is it? It's not great Art. It's indecent, and I need go no further than to say it's an indecent drawing concentrating on the private parts of a dirty old schoolmaster who is masturbating himself, while at the same time committing an indecent assault upon the school boy. And that's just one example of what is found within the covers of *OZ* 28.

Mr. Felix Dennis too, was asked to cite an example of what he considered to be indecent. The best he could do, as you remember, was to say that it would be indecent to sweep venereal disease under the carpet, and if I have got him wrong about that, then, no doubt, I shall be corrected in due course. It was also Mr. Dennis, you will remember, who said, when Detective-Inspector Luff was on the premises with his search warrant: 'You will get us under the Post Office Act', clearly recognising thereby that what had been sent through the post in the shape of *OZ* No. 28, was an indecent publication. And therefore Members of the Jury, I hope that I may be forgiven for passing from that count in the indictment to those other counts which allege that *OZ* 28 was not only indecent but obscene."

"It is for you, ladies and gentlemen of this Jury," Mr. Leary went on, "to set the standard by which we shall continue to live in this country. Don't forget that the evidence shows that the circulation of this particular magazine might have reached as high as half a million citizens of this country. It may have reached, you may think, those whose minds were in the process of being formed".

It might also have been of interest to note in passing that among those whose minds are already, presumably, 'formed', was Dr. John Sparrow, 65, Warden of All Souls' College, Oxford, who held that *Lady Chatterley's Lover* should not have been acquitted because one passage suggested that Lawrence condoned buggery.

"I find the novel extremely distasteful," he had said, "...and think it is a failure both as a moral of sociological tract and as a work of art."

Also Sir Gerald Nabarro, 58, the Conservative MP for Kidderminster. He attacked *The Little Red School Book* and urged prosecution of Dr. Martin Cole's film *Growing Up*.

"The author of this film is a thoroughly immoral man," he said.

"We must all of us accept responsibility for our actions," continued Mr. Leary, "and it's no good if you publish two pages of small advertisements - many of them wanting partners for sexual deviation - saying afterwards: 'I didn't contemplate that anything would happen as a result of that.' These accused men agreed to publish a magazine which would carry the banner of what they called 'the alternative society'.

Members of the Jury, look at that magazine. Read it through and read it and read it, and ask yourselves: what is this 'alternative society?' Dropping out of society? Expecting the State to provide, and by the State, I mean nothing more than you and me, those of us who don't mind working, and who think it's right to work, those of us who are fools enough to work? The alternative society puts forward as a way of life, sex as being something to be worshipped for itself until you reach the ultimate state, which has been called fucking in the streets. Kicks, promiscuity, sex with minors. It includes also, does it not, being allowed to experiment with drugs? Especially cannabis. I leave aside LSD; I leave aside

amphetamines; I leave aside heroin. Cannabis is put forward as a harmless drug, which allows you to sit about happily dreaming whilst nothing gets done. It is something which is to be encouraged, and if the Law forbids it, then the Law is a silly law, which nobody should bother about too much because it's unenforceable.

And it may be, ladies and gentlemen of the Jury that you have reached the conclusion, having listened to each of these three young men, that every form of sexual licence can be enjoyable. Grown-ups can do all these things, so why shouldn't children have the same rights? The same privileges? So, in this way, the accused debase the purity of youth. Young people, as we all know, are inclined to be selfish when they're young, unless they're taught that selflessness is a much better ideal. But this magazine does nothing more nor less than encourage every form of personal self-indulgence and selfishness, with a capital S.

All these three young men are alleged to have agreed together with Vivian Berger, the accomplice, and 20 or 30 other young persons, to produce this magazine, *OZ* 28. Berger told you that, subconsciously, his idea was to shock our generation and show that his generation was different in moral outlook. And so it is, if the contents of *OZ* 28 be a guide. It's no good a lot of psychologists and psychiatrists coming along and telling us what they think; we're concerned with the effect which this magazine might have had upon young people of Vivian Berger's own age.

But is the deflowering of a virgin as depicted in the Rupert cartoon, the equipping of Rupert with an organ of heroic dimensions, is that what life is all about? What I ask you to do, Members of the Jury, is to contemplate the effect of seeing that sort of thing upon little girls, seeing the blood pouring out of the vagina as Rupert goes in plonk. It's time for schoolchildren to do their smutty little drawings and pass them round amongst themselves if they wish; but there's all the difference in the world between that and responsible adults putting out for public consumption a magazine which they realise will have a readership of some half a million. Members of the Jury, Vivian Berger told us that he was portraying obscenity but not himself being obscene. Unhappily, as we know, he comes from a broken home, a home without a father where he and his two sisters live with Mrs. Berger who takes a great interest in public works. And unless your magazine's gonna be spiced some way or another, you're gonna lose the reader's interest. That's why these offensive cartoons are included; that's why the articles on sex got into this magazine; that's why this magazine sold, not upon its contents, but upon that erotic cover."

Outside the Royal Courts of Justice in the Strand, where the Lord Chief Justice works, a host of girlie magazines are on sale at a street stand. Among them is *Forum*, the 40p 'journal of human relations', which began four years ago and dissociates itself from 'quick-quid copyists'. It claims medical and social backing and its contributors include Mr. Michael De-la-Noy, former press secretary to the Archbishop of Canterbury. There are a host of others, including *In Depth* (40p), *Open* (40p) and *Search* (50p) which is already circulating about 45,000 copies a month after only five issues. These concentrate on publishing articles like 'Sexual Fantasies', 'Incestuous Behaviour' and letters from readers which are always anonymous. The content of these letters, moreover, varies little from magazine to magazine, and specialises in homosexuality, lesbianism, voyeurism and perversion. The larger-sized magazines include *Heat*, 'a magazine concerned with the more extreme stars in the sexual hemisphere', and *New Direction*, 'the magazine of the sexual revolution.'

"Let us now consider the accused," Mr. Leary continued. "The first, and the most intelligent of the three, is Richard Neville. Richard Neville who is the master, perhaps, of the medium. He knows quite a bit about different media. His intention in publishing *OZ* 28 was to inform himself of what young people were thinking. He believed, did Richard Neville, that the Rupert cartoon was extremely successful and worthwhile putting in *OZ* 28. He agreed that it was an editor's duty to present a balanced picture; but that is precisely what is *not* given in this magazine, is it?

OZ, as Mr. Neville agreed, goes in for cheap sensation - but only as a parody of parents' fears, he said. He was asked about his attitude to fellatio or oral sex. What he said was that if school kids wished to indulge in it, then it's okay by him. Is it? The Crown suggests that that isn't a proper attitude of mind for somebody who says that his sole object was to help young children to grow up. As I sought to point out to Mr. Neville, it isn't every lady that likes to take into her mouth a man's erect penis. It's all very well, if one is happily married and both partners are content to practise that form of intercourse; but that's not the sort of thing that children ought to experiment with until they're of an age to know what sex is all about, is it?

Ask yourselves what good ever came out of OZ 28? What lesson is there for us to learn? Members of the Jury, there is none, is there? Save that sex is a god to be worshipped for its own sake; save that doing one's own thing is an ideal to be looked up to by young and old alike no matter how selfish that attitude may be. Neville was asked about those small ads which depict all manner of sexual behaviour; he agreed that those advertisements pander to unfortunate and victimised minorities. Members of the Jury, this 'service' which was available for lonely people through the columns of this magazine, includes lonely little boys and lonely little girls. Unhappily, there are little girls who are still at school who act as prostitutes in this country as they do abroad. There, if they want to increase their clientèle, is the opportunity provided for them in School Kids OZ.

And what is there, within the covers of this magazine, which will help you reach the conclusion that Mr. Anderson's expressed desire to improve society was carried into effect in any way?

It is, incidentally, a strange attitude to the Law that there should have been some agreement to have printed hundreds of shirts, one of which Richard Neville was wearing on the day that Jim Anderson was giving evidence, depicting on the front a lady whose upper parts were bared and surrounded with the words 'OZ Obscenity Trial, Old Bailey'. Mr. Anderson says: "Our freedom to speak is on trial". But they've got it all wrong. They believe something which is quite false.

Nobody's pillorying these accused men just because they've gone into print with some ideas which the Establishment, as they put it, does not like. Nobody minds about schoolchildren complaining about bad school meals, complaining that they aren't given a voice in the affairs of the schools. This case isn't about the right to speak; this case is about a dirty magazine. Is it dirty or isn't it? It's as simple as that. We know, because we've got the evidence, (if evidence were needed), that venereal disease is on the increase and that it's promiscuity which leads to venereal disease. And is unlimited and unlicensed sex a thing to be encouraged amongst young children of school age? It isn't every booklet or

pamphlet that you can buy that gives you the facts and information on LSD, is it?

And so, Members of the Jury, I pass from Mr. Anderson's evidence, reminding you, as I do, that his example of an indecent act was passing water in Court. I move on to the evidence given by the other accused who gave, as his example of indecency, the sweeping of venereal disease under the carpet, Felix Dennis.

Copyright is irrelevant, he told us. It doesn't matter what you steal from anybody else; it doesn't matter whether they mind your using their material. You can lift whatever you please, and reprint it as you will, making your own magazine up from other people's contributions without paying them for it. The Crown has not, in this case, called any evidence to state what is obvious - that is, the likely effect upon the community of *OZ* No. 28. Members of the Jury, that would have been a completely time-wasting exercise for the Crown. You won't, I know, be as ready to sneer at accepted values as some of the witnesses in this case have done. After all, as Inspector Luff told you, did he not, he felt that the magazine was undesirable - from the family point of view?

Caroline Coon, whose organisation, 'Release', really concerns itself with drug addicts, told us that *OZ* was a forum in which young people could express their ideas. At the end of her evidence she also told us that she honestly believed that it was young people's life-style that was on trial. John Peel, the young man who appeared in a T-shirt which bore the picture of a pop star, was reluctant to bring his private life into this Court. But if he has this devoted following amongst young persons, they might get the impression that their hero had done something of which one might be justly proud. And venereal disease is certainly nothing to be proud of, is it? One must beware of the state of mind which thinks of venereal disease in much the same way as one does the common cold, something which is liable to happen to anyone of us. Is he the sort of person who you would be happy to see married to your daughter? It may be fine to have Richard Neville as a son-in-law, but would you welcome Mr. Peel as the putative father-in-law of yourself or your son?

Mr. Melly believed that the pop revolution is necessary. He helped us a little as to what the alternative society meant; it was, he said, one which is trying to evolve its own lifestyle. Now Mr. Melly comes from a very advanced household and, no doubt, there are homes in which the word 'cunt' is an everyday occurrence. Maybe that there are homes in London where both parents sit around talking about nothing but 'cunt'. For him as for Caroline Coon, this trial was about a certain attitude of life, a sexual attitude of life. He thought that quite a lot of people, including some quite lukewarm liberal people, had that impression. In fact, he said, you could read it in the *Guardian*. Well, I don't know whether you, ladies or gentlemen, ever read that particular publication.

Now I'm going to pass on to another class of witnesses, those who the Crown would describe as persons with 'progressive' ideas. I include under the heading the social psychologist, Dr. Klein, who told us that children and young persons would read this magazine to see what is going on in their world. If so, all that the people in *OZ* 28 seem to be getting up to is sexual deviations, group sex and all sorts of things up to which children should not get. If you remember, Dr. Klein said of the cover that she would have chosen it as wallpaper for her

bathroom. Lesbians in the lavatory - around the walls; Members of the Jury, that's perhaps where they should be left.

Then there was Michael Schofield who said that 'but for the activities of the police, this edition of *OZ* would have been forgotten a long time ago.' Members of the Jury, if he would forgive my saying so in his absence, this is again the wrong attitude. If a criminal offence has been committed, it's quite wrong that these matters should be passed over and no action taken. Had he, for example, really considered the possibility of a small boy already, if you like, with his mind going towards homosexuality with older men - because there are such boys about - seeing the small ads page with those two advertisements, one for teenage models and one for the 'Gaye Guest House'?

And so I come to Dr. Linken, the venereologist, who apparently knew Richard Neville because Neville had once consulted him upon medical matters, although he wasn't his doctor. Members of the Jury, I don't want to waste time on Leila Berg, the witness who followed him. You will recall her standing there in that mauve dress with the white collar and cuffs, the lady who took her glasses out of the white handbag and told us that she had studied the effect of the written word on children. She was the one who had considerable faith in children's natural morality; things don't affect children, she said, unless their natural growth is affected by grown-ups. One couldn't agree more; but it's their natural growth which the Crown suggests is being invaded and altered for the worse by exposure to *OZ* No. 28. She believed that reading cannot corrupt children. But if she's right, it means that nothing which is pornographic, no book, no novelette, no novel, no little account of sexual intercourse or sexual deviation, however titillating, which one can go into a Soho bookshop and pay £3 for, could ever be prosecuted in this country - because it can't corrupt you.

It's odd, isn't it, to find a lady such as she is, saying that cunt, cunt, cunt, bollocks and cunt, words which are spread across pages 10 and 11 of the magazine, are the first step in education? She reminded us that all children go through a homosexual phase and told us that this whole case is perverting the development of these young people. It was this that which she found corrupting. Seeing cunt in print, she said, makes children less ashamed of their parents. All I can say is well - really, I don't say much for Leila Berg.

Mr. Duane was somebody who knew Leila Berg. It appears that Michael Duane also knows Mrs. Grace Berger. Next there was Professor Eysenck who was independent, so far as one could determine, from *OZ* magazine. It's awfully difficult to know, he said, what effect the exposure to pornography is going to have on children and young persons. That's why people can talk till they're blue in the face; it's *impossible* to assess scientifically. The best we have been able to do, he said, is carry out a series of interviews with adult people and find out from them. You've got to consider,

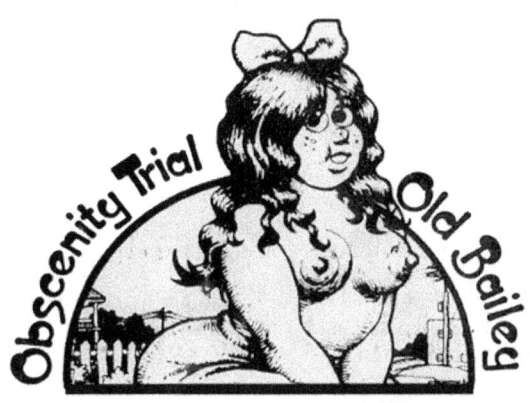

CHAPTER EIGHT

It occurs to me that during the course of this book I have been somewhat unfair to Mr. Leary. His skilful cross-examinations were as devastating as anything one might find in a work of fiction; they were as sharp as they were barbed. After all, it was he who had coined the phrase 'Pornography is that which places sensuality in an attractive light.' There were those who took the view that his only technique was one of persistence - drag it out for long enough and even the most coherent witness would become confused. It was Leary who was blamed by some for the inordinate length of the trial.

The case of Lady Chatterley had taken, by comparison, only six days during which the defence had called 36 witnesses; in the trial of *Last Exit to Brooklyn*, which had lasted a fortnight, the defence had called 32 witnesses. *OZ* called only 19 witnesses, but with immense doggedness Leary had reduced the most formidable of intellectual opponents to near gibbering idiots, and all with a smile as effortless and as persuasive as any lover. Few had been able to resist and only Professor Wollheim had, perhaps, emerged with his credibility intact. The Professor was asked a question; he paused, took off his glasses, paused again, put on his glasses and then, and only then, answered in careful and measured words. As to the rest - well, maybe that's better left unsaid. Leary was the personification of a system of law whose success relied, to some extent, on the personal charm and magnetism of its Counsel. A boring and dreary barrister could lose a case that had previously seemed won by his very inability to convince the Jury that he was the man to be believed. And it must surely be no accident that the greatest lawyers are also the most plausible. Personality is everything, and Mr. Leary possessed that in abundance.

His closing speech, therefore, had been a disappointment. Muddled, tortuous, often relying on innuendo, it had done him less than justice, if that's not too obvious a slip. On the printed page, his speech hardly stands up to close scrutiny; but in the Court Room, its effect had been altogether different. One had got the impression that he could have been speaking Chinese and it would still have sounded convincing. Accordingly, the

delicate balance between what was being said and how it was being said possibly tilted slightly in favour of the latter with Mr. Leary. And did he really believe as he maintained he did that, for example, young children would want to find out about the masseuse described in one of the small ads? Would they really ask: 'what's a voyeur, what's a homosexual?' And would they really say: 'I wonder if there is any money in teenage modelling?' and so indulge in the "sort of prostitution of youth and the prostitution of sex and the debasing of love and making it just plain sex, which is evil"?

Whether or not he did believe such things, we shall never know.

Suffice it to say that the method by which the criminal law had chosen to examine a complicated matter of moral consciousness, caused such questions to be asked. Referring to the definition of obscenity, an American judge had said in evidence to President Johnson's Pornography Commission; "I know it when I see it." But was the whole problem as subjective as that? And if not, who was to decide? The Law? The Church? Or whom? Again, it was difficult to believe that a man as intelligent as Mr. Leary was totally unaware of these questions. But then, it was becoming difficult to believe anything about this case with any certainty anymore.

"Ladies and gentlemen of the Jury," Mortimer began.

"We have sat here through a very large number of days and thousands and thousands of questions while the best part of the summer has passed us by, Wimbledon tournaments have been and gone, and we have almost entered the Common Market. Meanwhile, we have turned over and over and over again the pages of a little underground magazine. We have done it so often that we may feel that The Furry Freak Brothers have entered our sleeping as well as our waking hours. A huge quantity of public time and money has been spent in the ardent and eager pursuit - of what? Of what that intelligent and moderate man, Mr. Duane, called, a 'schoolboy prank'. In pursuit of that prank, ladies and gentlemen of the Jury, and to squash this little outburst, to gag a little cheeky criticism, to suppress some lavatory humour and some adolescent discussion of sex and drugs, we had rolled out before us the great, majestic engine of the Law. The threat to our nation of 48 blurred pages of schoolboy ebullience, has been countered by the rolling prose of indictments, by the tireless researches of Inspector Luff, by the inexhaustible cross-examination of my learned friend, Mr. Leary, and by the deep and carefully preserved sonorous solemnity of a great criminal trial. And one may be tempted to feel, Members of the Jury, that the prosecution is like some nervous public official who, when a child puts his tongue out at him in the street, calls in the Army.

Even so, the fact of the matter is that these young men sitting in the dock are charged as criminals. They are charged as if they had done something like stealing a car or forging a cheque; and so we must continue, Members of the Jury, to treat this matter as a criminal trial of these three young men. And we must remember, whenever we feel disposed to laugh, of the seriousness of this trial for these young men of hitherto perfectly good character, who stand and sit in peril in that dock.

And in this criminal trial, ladies and gentlemen of the Jury, what is your function? Yours is the most important function of us all. You are the judges of the facts in this case. During the course of this trial, you have heard opinions expressed from many sides. But these, ultimately, are not of paramount importance; what is important, is *your* view and *your* opinion. My learned friend, Mr. Leary, said, in his speech to you, that you were to sit here, somehow, as the

arbiters of taste, as the people who were going to set the standards for the rest of the nation.

With the greatest respect to him, that's not your function at all. You are here to try a criminal charge in a criminal court. You cannot find a verdict of guilty against the accused unless, on the evidence you have heard, you are fully satisfied that the charges against the accused persons are proved. And, Members of the Jury, you are chosen to do so because it is you who have the experience of the outside world. It is you who live in it. It is you who know, better than anybody, what the world is like today - a world by whose standards we must judge this particular magazine. Perhaps it is most important that a case like this *should* be judged by ladies and gentlemen such as yourselves. Lawyers, traditionally, are suspicious of change.

Perhaps, because they are nervous of having to learn a lot of new laws, they look with frosty eye upon the suggestion that laws might possibly be criticised or might possibly be changed. A lawyer's life, by reason of his close association with his fellows, by reason of the fact than if he's any good at it, he becomes so hardworked that he rarely goes out in the evenings, tends to lead a life of somewhat monastic seclusion. Therefore, it is of vital importance that this little magazine circulating in the world as it is now, is judged not by those isolated in Law Courts, but by those who come from the world outside.

And, Members of the Jury, your views - as ordinary men and women - are very important for another reason; as we burrow down into *OZ* No. 28 and begin to scrutinise it as if it were a Bill of Sale or an Act of Parliament, as we get out our magnifying glasses and peer for the hundredth time at Rupert, are we not in danger, as lawyers, of making the Law look rather foolish? Are we not in danger of losing our legal minds down a maze of cross-examination and suspicion and speculation and questions? You, ladies and gentlemen, with your common-sense and your experience of the outside world, are there to restore to us our sense of fairness, our sense of proportion and, above all, our sense of humour. So imagine, therefore, that you had merely bought it yesterday from a newsagent's round the corner, together with the *News of the World* and the Sunday supplements and the other magazines we have heard of - *Playboy* and *Penthouse* and *The Continental Film Review.*

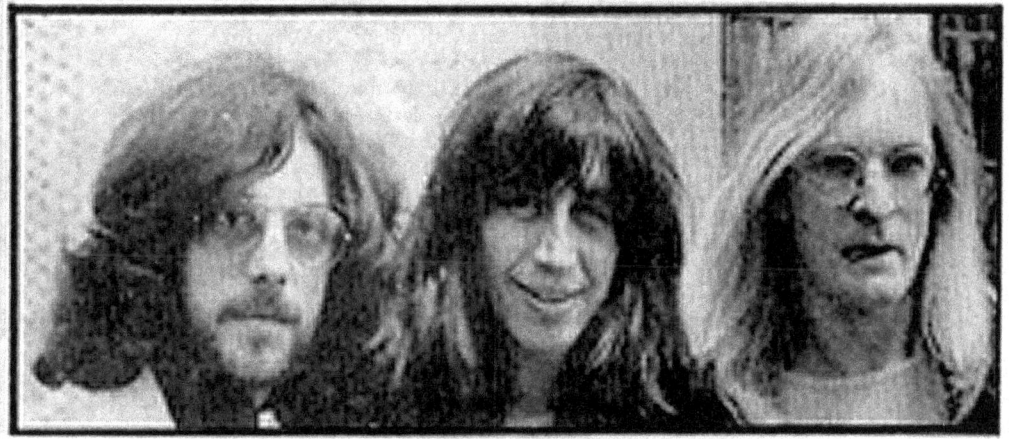

So you, Members of the Jury, are the judges of the facts in this case; it is your right and your duty. But in this particular case what are you to judge? I don't know what you expected to discover when you first came into this Court. I don't know what sort of case you expected that you might find. I don't know what sort of people you expected to find sitting in that dock. Perhaps you expected to find burglars or murderers or forgers of cheques. If so, the matter would have been perfectly simple; it would have only been a question of fact. You would have been able to discover at the end of the case who, in fact, forged the cheque or stole and drove away the motor car. But obscenity or depravity – these words are not really susceptible of being judged only according to the facts. They remain largely matters of opinion. Obscenity is, to a very large extent, in the mind of the beholder. One man's obscene article could be another man's nursery reading. And so the difficulty of cases such as this is to come to a decision as if it were a question of fact, when really all that it amounts to is a point of view. And if it is merely a point of view that we are deciding, then it must be possible that there exists another point of view. And if it really only comes down to a matter of opinion, there must always remain a *doubt* as to the question of the tendency to deprave and corrupt."

Lord Longford, meanwhile, when asked about the apparent one-sidedness of his pornography committee, said;

"What's the point of having people who are opposed to the idea? They'll only try to sabotage it. They've got to have open minds."

Among the members of this committee is Gyles Brandreth, ex-president of the Oxford Union. He said; "Of course I'm against pornography – whatever that is."

"So if there are two possible opinions," continued Mr. Mortimer, "as there are throughout this case. What guide-line does the Law give you? Well, it gives you this; the 'burden of proof '. This applies to the short-haired, Sunday-School teaching, pin-striped bank manager who may find himself in that dock on a charge of embezzlement, just as it does to the long-haired, colourful clothes wearing hippy who may also find himself in a similar situation. Neither one, ladies and gentlemen, stands in danger of being convicted by any one of you, unless each and every one of you is satisfied, beyond reasonable doubt, that the prosecution has proved the case which it set out to prove. Mr. Leary has pronounced his view that there is a possibility of this magazine encouraging mothers to suckle their young on their cannabis cigarettes. But other views are held by persons of such weight as Professor Eysenck, Professor Wollheim, Dr. Haward, Dr. Linken, Mr. Michael Schofield - to name only some of them to you. When we come to the end of this case, ladies and gentlemen, what we shall have to ask is this; if those views are put forward by persons of the highest honesty, probity and repute, how can it possibly be said that the prosecution's view has satisfied each and every one of you beyond this reasonable doubt?

Members of the Jury, I was amazed to hear my learned friend say that what is being attacked here is not freedom of speech. For myself, I find it impossible to comprehend how a case that places young men in the dock because of their editorship of a small magazine which, it is conceded is not hard core pornography and which is attacked because of the views it puts forward about sex and drugs, can possibly be held not to be an attack on the freedom of speech. My learned friend found himself saying that the editors of this magazine should be convicted because they have allowed their publication to express certain

opinions, certain doctrines and certain thoughts of which the prosecution thinks we should disapprove. And so if we inflict upon this magazine what amounts to an act of censorship, we must be very careful to see that we are not tempted into such an act unless the prosecution has strictly proved its case according to English Law. In some countries, the freedom of speech is guaranteed in their Constitution. We, in England, don't have a written Constitution, but we still have a Constitution which believes in, and which relies on, the freedom of speech and the freedom of the Press. If it were not for those freedoms, we should indeed be in a parlous, dangerous state."

Ink, issue No. 14, carried the following story:

> "For the second time in its relatively short career, Yorkshire's new alternative paper, *Styng,* has run foul of the law. Two plain-clothes policemen from Leeds visited the paper's Barnsley offices last week in connection with no less than six possible charges. The charges all relate to *Styng* 2, which appeared several weeks ago. They include Indecency (thrice), the Official Secrets Act (twice!) and something to do with some obscure ancient Press Act. According to *Styng* editor Roger Hutchinson, the charges follow a complaint made by a member of the public who bought a copy of *Styng* 2 at a Leeds bus station, (At any rate, that's what the police told him.)
>
> The two policemen asked Hutchinson 16 questions from a printed form, and then told him that they considered *Styng* 2 to be indecent. Earlier in the day, the same two policemen had visited the printing firm where *Styng* 4 was about to be run off. They told the printers that charges might be made against them if they went ahead, so, not unnaturally, the printers chickened out."

"The Obscene Publications Law," Mr. Mortimer went on, "...is not to be used, and we must be anxious to see that it is not used, to stifle opinions which we find unsympathetic under the guise of calling them dirty or obscene. The real division between the philosophy of those who have given evidence for the defence and the views put forward by Mr. Leary, is this: are there certain subjects which are taboo? Are there certain things about life which we mustn't discuss, however honestly? You may remember that young disc-jockey Mr. John Peel; when he was giving evidence, he said he had spoken about venereal disease in a radio interview. He was attacked by Mr. Leary for having done so. 'Are there not certain things better not spoken about?' he was asked. Is that a view which you find sympathetic, ladies and gentlemen of the Jury? Or do you not think that human dignity and human responsibility to our fellow citizens enjoins us to discuss everything as honestly and as frankly as possible? It's very easy and simple to be tolerant and to allow freedom of speech when what people are saying is that with which we agree. But if free speech and democracy mean anything at all, they imply tolerance and freedom for people with whom we *disagree.* And the odd thing is this; it is very rarely the people who are putting forward what Mr. Leary would call 'the progressive point of view' who want to censor the opinions of others. Nobody, on behalf of the defence, is suggesting that the schoolmaster who says that people should not have sexual intercourse before they marry, should be suppressed by law. The act of censorship is always one-way.

A great and wise Frenchman, who found himself in England, once said that he disagreed with every single word that his opponent said. But he would defend to the death his right to say it. And those words of Voltaire should be emblazoned in gold above the chair of every Judge trying an obscenity case, and should be emblazoned on the door of every Jury Room of every Jury which has to consider matters of obscenity. Tolerance means protecting minority opinions, particularly the opinions of minorities with whom we disagree. So if we disagree with the views promulgated in *OZ* No. 28, we must be careful to see we don't allow such views to be suppressed simply because the police, or people in public office, find them unsympathetic. And oddly enough, debate is usually free except when we come to such subjects as sex and drugs. Then, a curious lack of logic starts to cloud the mind; deep personal emotions become involved and an instinct seems to rise up that discussion should be stifled."

After the trial, Duff Hart-Davis wrote in the *Sunday Telegraph*;

> "It is impossible to believe that any ordinary parent would gladly let young children see (this) magazine; nor could anyone easily claim that its sexuality was redeemed by beauty or literary merit - both conspicuously absent from the crude and garish production. Most people, in other words, will be relieved that this latest attempt to subvert the remains of our morality has been hit soundly over the head."

"Ladies and gentlemen," Mr. Mortimer continued, "we have heard a lot during this case about an 'alternative society'. The truth of the matter is, however, that our society, our country, contains many 'alternative societies'. All of them may have different ideas about bringing up their children; all of them may have different ideas about sexual morality. But the important thing is that we should live with each other and that we should be tolerant of the alternative ideas which we debate. We should be free, and one sort of person should not seek to stifle another. 'Doing your own thing' is a phrase that Mr. Leary criticised and used as if it were something that only applied to the Underground. But all of us, Members of the Jury, in one way or another, do our own thing. The stockbroker playing his Saturday golf, the lady in the cathedral embroidering hassocks for the vicarage garden party, are both doing what they wish to as much as the young hippy dancing in the discotheque. It would be a sad and dreary and mundane and colourless world if it wasn't full of people who felt free to live their own life. And to live according to your own life, means to be free to debate. And to be free to debate, means that we can't be restricted in the subjects which we discuss. May I, members of the Jury, if you would have patience with me, take an example: before 1967, homosexual conduct between consenting adult men was illegal. But that didn't mean that that subject couldn't be discussed. It was discussed at large. It was discussed in the Wolfenden Report and everybody debated about it. Some people said the law should be changed; some people said that it should not be - but nobody tried to put a stop to that debate.

Eventually the law was changed and the subject even now continues to be discussed. The same is true about cannabis. Many people take the view that cannabis is extremely harmful and leads to a person becoming hooked on dangerous drugs. And nobody can say they're not entitled to that opinion or that they're not fully entitled to express it. But others take the view that

cannabis is not, in itself, harmful. It doesn't lead to drug addiction. And nobody has suggested that this debate should not take place. Or that, if it takes place, it is an encouragement to other people to take drugs. The law about cannabis may never be changed; it might remain exactly as it is. On the other hand, it may be changed; and so, in a free society, such a debate must be free. And in order for there to be such a debate, facts must be known; and in order for facts to be known, people - including those who have had experience with cannabis - must feel free to describe what such experiences are. What on earth is coming over us, Members of the Jury? What curious, irrational fears are haunting us if, suddenly, we fear that the mere description of an experience is to become such a threat to our society that the great machinery of the criminal law must be used to stifle such information?

But, of course, what the prosecution will say is that such freedom entails risks. Of course, that is absolutely true. Freedom means risks. If you give your son freedom to ride a bicycle to school, there's a possibility that he may be run over by a lorry. But you've got to weigh whether you wish your son to grow up a responsible boy who is allowed to ride his bicycle, or to remain constantly protected and thus become incapable of any independent action. If you had a totalitarian State in which no-one ever mentioned the word cannabis on pain of being hanged by the neck until dead, if you say that sex is a forbidden word and we'll all be executed if we ever mention it, then, no doubt, all these risks could be ruled out. And, of course, if you live in a society such as exists in Russia or China, then you can minimise these risks by having a dictatorship. But that isn't the sort of society, ladies and gentlemen of the Jury, which we choose and wish to live in. And whilst we choose and wish to live in a free society which we enjoy and which we are proud of, and while we choose to be able to express our thoughts without censorship or fear, then we must accept that there is a minimal risk that persons may be affected. But that is a risk which we say is eminently worth taking. In the days of the ancient Japanese emperors, there was an offence known as dangerous thoughts. I'm sure none of us would wish to live in a society where it was a crime to think dangerous thoughts.

Let me deal with another suggestion which is made against *OZ*. It is suggested that it presents a one-sided view. But this is a fallacious argument because it assumes that *OZ* exists in total and splendid isolation. The real situation is this: admittedly *OZ* does present one view. But there are many, many organs in the rest of society which present the contrary view. An article is not to be banned simply because it presents only one side of an argument. Nobody criticised the Conservative Manifesto because it didn't quote, in full, the speeches of Mr. Wilson. Nobody would seek to ban the *Catholic Herald* because it didn't contain the sermons of Mr. Ian Paisley.

So, Members of the Jury, if there is freedom, as we say there must be, of debate and discussion about all sorts of topics, and if adults are allowed to have that debate or discussion about children, then surely it must be a debate in which children and young people are entitled to share. We no longer live in a world where children can be regarded as little cuddly toys. Young people can vote at 18. By 15, they should be trying to direct their thoughts and discover what they think about the matters that concern them. Even if their views are exaggerated, even if their views are downright silly, that doesn't mean that they shouldn't be allowed to take part in that discussion. And in any discussion, people express themselves with exaggeration; some of them express themselves

THE TRIALS OF OZ

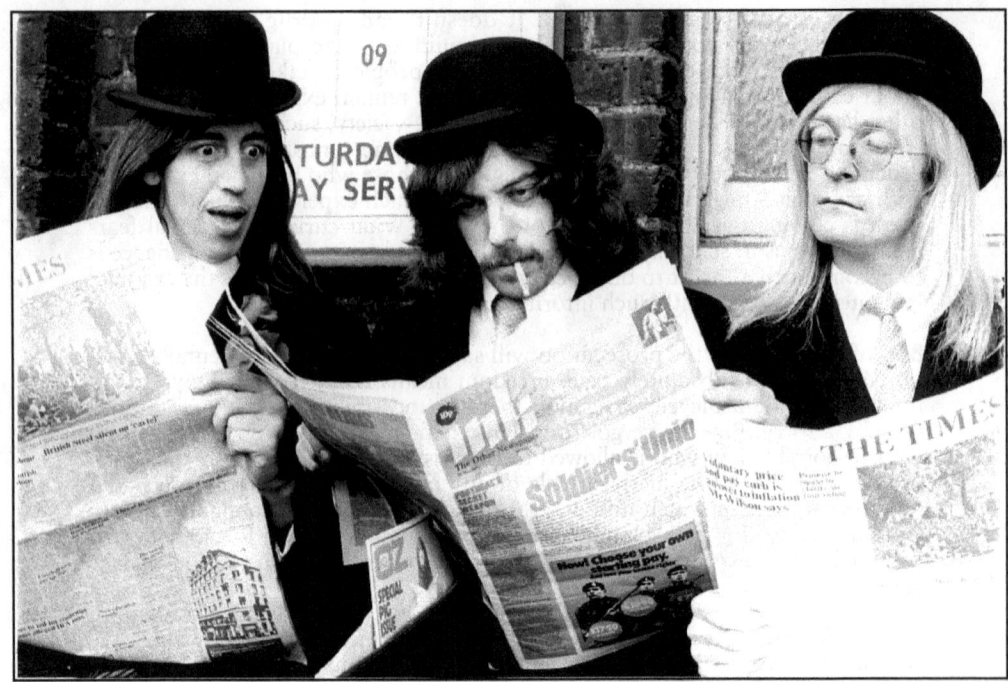

very stupidly. Our legislators and our public figures are perfectly capable of saying things which are exaggerated, which they don't really mean, which, if you examine them carefully, might be said to be rather foolish. But that doesn't mean that those exaggerated views should be suppressed.

So, inevitably, one goes on from that to ask why, exactly, are these three young men in the dock? And the unhappy and uncomfortable suspicion enters one's mind that they are not there because of what they've actually done. They are not there because of what has been published in *OZ* No. 28. They are there because of what they are. Because they don't dress like other people; because they have longer hair than other people; because they are part of a small community which excites the disapproval of people who may, perhaps, be referred to as the Establishment. And if that's the reason, then maybe we begin to suspect that this may be not merely an unreasonable prosecution, but an unfair prosecution. After all, this court would be stacked to the ceiling if I were to ask you to look at all the newspapers and all the documentary films and all the television programmes which have discussed cannabis, for example, perfectly freely, over the last 10 years. It's even a subject about which people have made jokes. And it's certainly a subject which everybody has discussed.

You see, we are being asked to look at this little magazine as if we had just landed from Mars and we'd read no other magazines and seen no other books and seen no other television. If that were so we might find this magazine strange. But this would be a totally artificial way of looking at this magazine. Take, for example, what Mr. Leary calls the 'invitation to free love'. Now, if this were the only magazine that a young person were ever to see, then you might reasonably say that, possibly, it did offer him 'free love'. But consider

how a young person today is bombarded from all sides by 'invitations to free love'. Sex rears from every hoarding, beckons from every advertisement, shouts and murmurs at him from every television commercial. If you want to advertise bath salts, for instance, you suggest that having a bath in a certain sort of bath foam will immediately produce a naked lady riding up to your door on a white charger. But are those advertisements hauled up before this court as 'an invitation to free love'?

Or take Count 1 of the indictment: to arouse lustful and perverted desires. Lustful and perverted desires are aroused every time you go down the escalator in the underground. Do you think a picture of a girl in Mr. Leary's 'kinky' boots, advertising a shoe shop, is something which will be prosecuted? And what do you think young people are reading nowadays? Young people from 10 or 11 upwards? Among their favourite reading is books about secret agents who are travelling around the world, often victims of blood-stained assaults and hair-raising adventures. But when there's a lull in the blood-stained assaults and when there's a lull in the hair-raising adventures, what happens then? Why, the secret agent is popping into bed with any young Japanese, Chinese, Oriental, Russian, French or English girl he can lay hands on. And the pages of those novels don't contain a warning that we must be careful to see that the Chinese girl is over the age of consent, or that venereal disease is dangerous, or that the permissive society is something which we should all regret. Mr. Leary says that this magazine 'glorifies free love'. Well, he would have to spend the rest of his life in criticizing everything which surrounds us if he were to ban every article which 'glorifies free love'. If one were to stifle all the material which gave a view of love outside marriage, you would put a stop to almost the entire study of English literature. *Romeo and Juliet* - the story of sex and marriage with a girl under the age of consent. *Hamlet* - the unhealthy concern with incest. *Antony and Cleopatra* - the glorification of adultery. *King Lear* - with its scenes of gouging out eyes and stamping on eyeballs that Mr. Siné did not even contemplate in his weirdest nightmare. With that vast plethora of similar material, how on earth can this one little magazine make the slightest difference one way or the other? It is "perhaps fortunate for Shakespeare that he is no longer with us. Obscenity is indeed in the eye and mind of the beholder."

Dr. Coggan, Archbishop of York and a member of Lord Longford's committee, said recently;

> "The stage is being disgraced by the kind of stuff being put on in London now, when sex is lampooned instead of reverenced."

"So," Mr. Mortimer went on, "...let us come down to the criticism of the magazine which says that it should be thought of as obscene because it contains rude words, or Anglo-Saxon words, or four letter words. In 1960, 11 years ago now, Lady Chatterley was prosecuted in these courts. When opening the case for the Crown, learned Counsel for the prosecution announced to the Jury that he'd discovered that in *Lady Chatterley's Lover* the word 'fuck' or 'fucking' occurred no less than 30 times. Shit, and ass, six times. Cock, four times. And piss, three times. Mathematics did not prove effective, however, because Lady Chatterley was acquitted. And in this particular magazine, *OZ* 28? Cunt appears three times, instead of the 14 which were found not to be fatal to Lady Chatterley.

My Lord has ruled that this case should not be accompanied by laughter and I have absolutely no criticism of that ruling. This enormous trial is in itself no laughing matter. But OZ No. 28 is not to be judged only as it appears in the artificial atmosphere of a room from which laughter has been removed. It's in the interests of the prosecution to persuade you that all of this magazine would be greeted with the greatest possible solemnity. And it's quite easy for them to do this, ladies and gentlemen of the Jury, because by a time a joke gets into Court and has been heard at least 56 times, and particularly by the time my learned friend Mr. Leary has had a go at it, any vestige of humour which it may possibly have once have had, has been totally anaesthetised. But if you're laughing, you're very unlikely to be corrupted, are you? Laughter is a great cleanser. Laughter is something which is never present in strip clubs or at erotic shows. Those breathless old men in mackintoshes are viewing the ceremony with the most extreme seriousness, and a good giggle would break the spell at once. So if we are giggling at this magazine - if our reaction is a giggle, which is what some of the witnesses said - then we are certainly in no danger at all.

Mr. Leary called this magazine 'dirty'. But 'dirty' is not a word which has any very precise significance. Perhaps it is best known to us as applied to a joke; a dirty joke is a joke about sex or going to the lavatory. You may hear a dirty joke in a club. But do you then emerge from that club depraved and corrupted? Are you never quite the same again? Members of the Jury, if we have been depraved or corrupted by all the dirty jokes we heard when we were at school or in the army, we should now be very corrupt individuals indeed, which I don't honestly think we are. So 'dirty' is not a word which has any significance in this case.

'Nasty', said Mr. Leary. But nasty doesn't necessarily mean depraving or corrupting either. You may think that something is sexually offensive; but would you emerge from the experience corrupted? 'Disgust' - that's another similar word which has been used by the prosecution. Well, Members of the Jury, if we are disgusted by it, then we are likely to be against it rather than depraved or corrupted by it. Take, as an instance, the cartoon of the schoolmaster masturbating. We may find that a most disgusting and nasty cartoon. Maybe it's similar in its disgusting effect to those drawings which were done by great artists in the past depicting the horrors, the barbarities, the mutilations and the bestiality of war. The effect is to put us off. So no-one is going to be lured into a homosexual relationship with an elderly schoolmaster by that nasty cartoon. They are going to be disgusted at the idea of such a possibility. No-one is going to be lured into flagellation by the picture of the three old schoolmasters with canes. They are going to be disgusted and think that to be a disgusting experience.

And then another word used by the prosecution in its criticism of this magazine was one which is quite often used by prosecutions of written matter, the word 'unnecessary'. Good Heavens, what on earth does that mean in the context of this case? As Mr. Mervyn Jones said, most of literature, from the strictly utilitarian view, is 'unnecessary'. If every bit of print, every film, every book had to justify itself as being 'necessary', 99 per cent of it would never get written at all. It's rather like coming to you, ladies and gentlemen, and saying; 'What's necessary about you wearing a tie?' 'What's necessary about having a pair of china dogs on the mantelpiece or a plastic gnome on the front lawn?'

So, finally, we come to the meanings of 'corrupt' and 'deprave'. What is corrupt and depraved behaviour? Does it mean the same thing as illegal behaviour? Now we have been taught, as lawyers, that there are many areas in which the law and morality are not the same. You may do many illegal things which are not necessarily immoral, like having taken three more drinks than you should have done when you are breathalysed. But is sexual activity really regarded by us as something which leaves permanent corruption and depravity? Or is it merely something which we all know to be a part of growing up? We all have weaknesses; we all have strengths. But our value as human beings is that we contain both and live with both. We have become, in these sort of cases, so obsessed with the subject of sex, that we only think of corruption in terms of sex. But there are many, many other forms of corruption which are a great deal worse. One speaks of public servants being corrupted, or being corruptible for money. One speaks of corrupt police officers who take bribes or give false evidence. One speaks of books like Hitler's *Mein Kampf* which have led to racial hatred and mass murder on a gigantic scale. Those are the sort of things which corrupt people; and they are totally different, are they not, from what it is suggested that these young people have done - which is merely to be frank and tell the truth, as they see it, about certain aspects of their lives? And one of the penalties which we pay for such free and open discussion in this country is that we must take the risk of the odd person getting it wrong.

It's quite foolish, moreover, for the prosecution to suggest that there was any agreement which involved the intention of corrupting young people. The most they can allege against the defendants is that sincerely, but wrongheadedly, they produced something which had a harmful effect, but that wasn't their intention. No-one seriously thinking about it can really contend that these young people, among them Vivian Berger, put their heads together and said; 'Come on chaps, we will produce an *OZ* 28 which will corrupt the morals of young people'. Of course they didn't. Nor can it possibly be suggested that they were doing this for money. Think of the evidence which is undisputed; £800 a year is the highest salary which gets paid. They'd be better off being attendants at the public baths. Pornographers don't work for £800 a year.

The erotic temple carvings of India, the erotic drawings of Picasso, the erotic paintings in the Roman houses of Pompeii, have all been a part of our culture which we have been able to live with for thousands of years without becoming totally depraved. Erotic art is a part of our lives. So what if this magazine has an erotic cover? What do the prosecution suggest to you about that? It is a cover, says Mr. Leary, showing scenes of lesbians; and there's no doubt at all, he says, that it would turn hesitant lesbian schoolgirls into fully blown lesbians. But the idea of 15 or 16 or 17 year old schoolgirls looking at this cover and rushing out to buy 'dill-dolls', or whatever Mr. Leary calls them, is ludicrous. Pictures of couples taking more than a moderate interest in each other are the stuff of advertising, and it is impossible to say, in our submission, that such advertising would, in any meaningful way, deprave or corrupt.

There has been a great tendency by the prosecution in this case to rely on non-existent evidence. It's been suggested to you by Mr. Leary, for example, that there are psychoanalysts who would come and say that *OZ* No. 28 could harm young people – a suggestion totally unfounded by any evidence. If there had have been such people, we should have seen them. We are left to guess. But it is football pools, or the results of The Derby, which is solved by guesswork, not criminal charges which involve the peril of young men of good character.

THE TRIALS OF OZ

Consider the sexual references in *OZ* No. 28. What do they really amount to? Juvenile and adolescent cheekiness, the desire to shock. Mr. Duane and some of the other witnesses had a more interesting interpretation to put upon it than that. Mr. Duane said that they wanted to say something serious, these young kids, about their schools and their exams and the way in which they weren't really listened to with any seriousness. And so, to call attention to themselves, to prove that they were there, they said the sort of things which they found shocked *us*. If, instead of listening to me with great courtesy and attention, ladies and gentlemen, I found you were nodding gently off to sleep, I might be tempted to utter a rude word in order to wake you up. That's really what *they* did, these schoolchildren. Look at us, they're saying. We're grown up - we want to talk about drugs. We want to talk about sex. They had seen from press reports that sex and drugs were things that alarmed adults; and so they assumed, rightly, that these were topics that would compel attention. So it's not the drawing of attention to drugs and sex that was in their mind, but the drawing of attention to their need for a dialogue with the older generation.

And if one looks at the Fabulous Furry Freak Brothers, no-one in their right senses could think that this strip cartoon makes the drug scene attractive. If they do, one despairs of any reasoned argument or approach to this case. Those engaged in the collection of drugs are presented first of all as physically hideous, as comically stupid and as deformed as it's possible to be. Second, in the pursuit of drugs in the dark of night, they go out to a park where people are fighting with knives and cutting each other up in an atmosphere of danger and of horror. It's impossible to conceive how one could possibly say that either the taking of drugs, or the drug world itself, are made attractive to young people

Ladies and gentlemen, not one single witness of any sort has come forward on behalf of the prosecution in this case to say that this magazine would have a tendency to deprave and corrupt. You may remember that Sherlock Holmes, in discussing one of his cases, said that the most important piece of evidence was the dog in the night time. And when a puzzled Dr. Watson said to him: 'The dog did nothing in the night time', Sherlock Holmes said: 'Yes, that is exactly the most important piece of evidence.' And you may think that one of the most important pieces of evidence in this case is the doctors, the psychiatrists, the sociologists, the people experienced with children who never came forward to give evidence on behalf of the prosecution. Compare that with the experts called for the defence. These were not just ordinary experts; they were people of the highest possible standards, the most unimpeachable integrity, the most prolonged experience in dealing with psychological and medical questions effecting children and young people. Are we really seriously going to say that we can totally reject all of that evidence? Could we ever be in a position of saying that, in the face of that body of evidence, the prosecution has proved its case and that you are assured beyond any reasonable doubt? Do you really think that such people as Dr. Eysenck and Dr. Linken and Dr. Haward could be persuaded to come here and give evidence in support of a case which they did not believe? Of course they couldn't. And if that is the case, they must surely be with you in the Jury Room; they must be in your minds. You will never, in our submission, be able to say that you feel that their opinions can be totally ignored.

Learned Counsel for the prosecution dealt with them by engaging them in argument by putting forward his own views. But at no time has he been able

to engage them in argument by putting forward the views of other experts. And when he hasn't been able to put forward opposing views, he has applied to them, with the delicate artistry of a water colourist, smears. He has suggested with these delicate, but no less smearing, innueudos that, perhaps, they are biased. Or perhaps they are - and this, in his mouth, becomes curiously a term of abuse - progressive. Ladies and gentlemen of the Jury, I hope that we would all wish to call ourselves progressive, in that we believe in slow and reasonable progress in this world. To use that as a term of abuse seems to imply nothing but the poverty of the prosecution in this case.

It is, of course, the fate of such experts to be cross-examined and be told that ordinary people would not accept what they say. Years ago, Galileo came to the conclusion that the world was round; he was cross-examined and told, no doubt by Counsel for the Prosecution, that it must be quite obvious to the ordinary man in the street that the world was as flat as a pancake. But, in time, expert opinion tends to be proved. You may remember, perhaps, Dr. Haward, standing there in that witness box a long time ago, looking less like the idea of any hippy professor than everybody's friendly neighbourhood bank manager. One of the most conventional and respectable and, in his work, admirable figures of a witness that you could hope to see. And he told you, ladies and gentlemen, about the way which all people nowadays have to deal with the young when they are trying to advise and to help them. He said that it was absolutely useless moralising or telling them such and such a thing

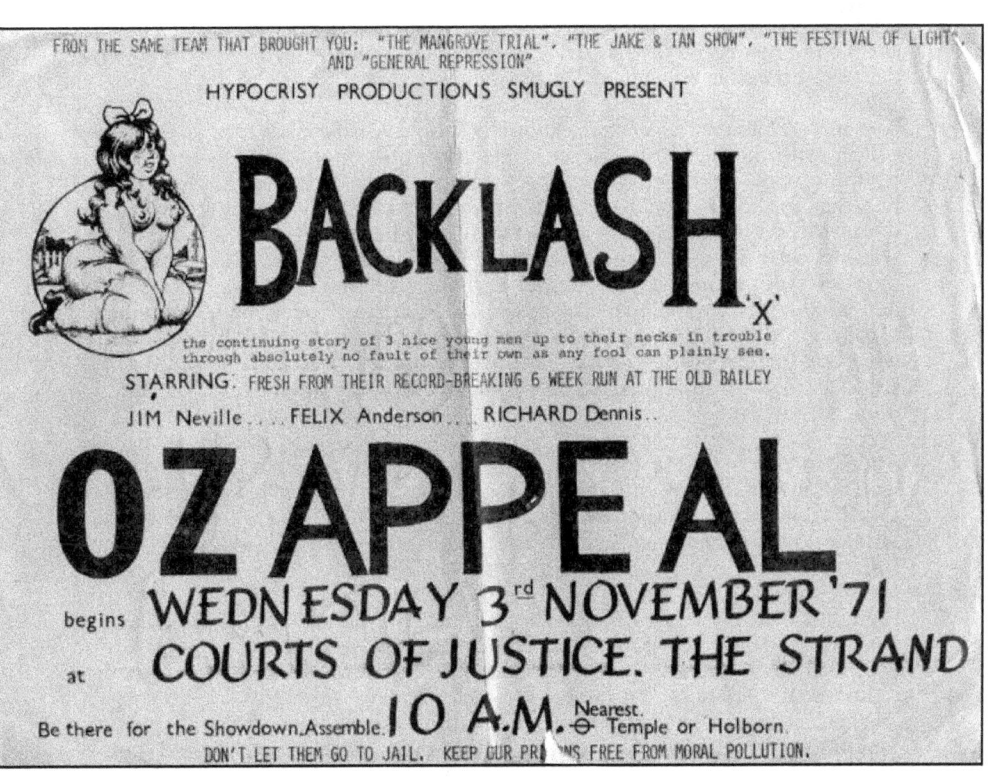

is illegal. Immediately, you will lose their confidence and immediately you have lost their confidence, you can no longer help them.

And then we had Mr. Michael Schofield, a gently voiced, deeply intelligent man, the author of many works some of which have been commissioned by government sources. He said that drugs were an endless and even a boring subject of conversation in schools throughout this country, and that this magazine certainly wouldn't tell children anything that they didn't know. If a young person read this magazine, he said, the impression made upon him wouldn't be very deep. Even if children were shocked and disgusted, he said, the shock and disgust would have very little harmful effect on them, and certainly no lasting effect. He said that researches have shown that 10 per cent of young people learn about sex from dirty jokes, and one of the reasons that the School Kids Issue would be very unattractive to school kids is that school kids wouldn't want to read a thing called School Kids Issue. They would want to read something which they felt would be more grown up. He also said that teachers now gave school seminars about drugs - children were perfectly used to hearing them discussed, he said.

Exposure to erotic material, moreover, had little or no effect, and a single exposure, as with this magazine, would have no effect at all. Professor Eysenck was to say that there had been experimental evidence from the United States suggesting that even showing films explicitly portraying oral sex in a favourable light, does not, except in a very small minority of cases, change behaviour. Even after that activity has been portrayed in a favourable light for 30 hours, if one can conceive of such an experience! So what on earth can one exposure to a cartoon which shows it in an extremely ugly light do? What possible effect can that have?

You may remember Mr. Segal. And why would Mr. Segal, a former probation officer, a former head of children's television programmes, come and say that he found this publication totally harmless? A married man with children? Because, for some obscure motive, he wants to help these young men in the dock? Mr. de Bono said that *OZ* was valuable because it gave us a window, a window through which one could look into a particular sort of society, into the interests of young people. He said, and you may think that this was a sensible and a valuable remark, that a window doesn't create the scene which you see through it; the window is simply something through which you look and see what is going on in the world. Of course, what the prosecution would ask us to do is to draw the curtain, ladies and gentlemen of the Jury, so that we don't see anything.

And then I come to the evidence of Professor Eysenck and a more revered or world-famed authority there could scarcely be. It is, perhaps, a comment upon this trial that there is no prosecution Professor Eysenck. You all remember him. Sitting down. Quietly spoken. In the witness box. Talking with the utmost frankness and honesty. Not always making his evidence the easiest possible for the defence. Not bending it in any way, but telling you exactly what he thought the effect of this magazine on children and young people would be. Uncontrovertibly, he said, it wouldn't do them any harm. And this is from a Professor of Psychology; a professor of the Institute of Psychiatry, who had written some 20 books and some 300 articles dealing with psychological subjects. We are getting an opinion based solidly upon the findings of the Professor of Psychology at London University, based upon *facts* which would not be

twisted by him, you may be assured ladies and gentlemen, in order to fit any theory which might happen to be convenient to the defence. And he said, did he not, that the total effect of the dope references, the drug references in this magazine would either be nil or possibly negative? Accordingly, it becomes, does it not, totally impossible to conceive that there should be a conviction in this case.

John Gordon, writing in the *Sunday Express* after the trial, said;

> "If the Old Bailey Judge decides in the end to commit (the accused) to a mental institution, this would seem to be most appropriate."

"And then, on the question of drugs," continued Mr. Mortimer, "came that vitally important witness, Doctor Linken. And again, the little smear brush came out and it was suggested that in some way he might be affected because at one point Mr. Neville had been his patient. This was a man, and a medical man, who is in daily and hourly contact with the medical problems of young people. 'I could find very little that would affect young people's drug-taking' he said. 'I felt *OZ* was very balanced in its presentation', he went on, 'by giving medical viewpoints, criticism, as well as allowing people to express their feelings about drugs'. 'Balanced', says Dr. Linken.

And so let me remind you of this. I am not here in the position of having to prove anything. The defence in a criminal case never has placed upon it the burden of proof. I don't have to establish to you beyond reasonable doubt that the evidence of Professor Eysenck and Michael Schofield and Professor Wollheim and Dr. Linken and Dr. Haward is all proved. I think that I could do so, but I don't have to; that is not my burden. All I have to suggest to you, for the purposes of securing an acquittal, is that in the face of all their evidence, you cannot possibly be convinced that the prosecution has proved its case.

When we come to the defence under Section 4 of the Obscene Publications Act, both Mr. Mervyn Jones, as far as literature is concerned, and Mr. Feliks Topolski, as far as art and drawing are concerned, have given you a picture of the climate of literature and the climate of art as it is in this day and age and in which *OZ* No. 28 plays only a very, very tiny part. But it benefits, nonetheless, from that same freedom of expression and freedom of speech and freedom to describe all parts of human activity, which writers in novels and writers in magazines, writers for the stage and writers for the screen, accept now as their natural right."

During the course of the trial, it was reported that the Compendium Bookshop had been raided for obscenity under the Customs and Excise Act and the Obscene Publications Act. The first summons was that Compendium 'did procure to be sent' 25 copies of *Suck* No. 4 through the post. The second was that they possessed for gain several copies of *Suck* No. 3. Both summonses were against Diana Gravil (Paddy), Compendium's proprietor. The case was due to be heard at Clerkenwell Magistrates Court on Thursday July 15, but was postponed. Meanwhile, the case brought against the *International Times*, HQ for 'conspiring to outrage public decency' by publishing homosexual contact ads, entered its final stage: a hearing at the House of Lords. The Court of Criminal Appeal rejected an appeal against the convictions handed out after a five day hearing at the Old Bailey last November.

THE TRIALS OF OZ

Knullar (Publishing, Printing & Promotions) Ltd, publishers of *International Times* at the time, had been fined a total of £2,000 and its three working directors, Graham Keen, Peter Stansill and David Hall given 18 month suspended jail sentences and ordered to pay £200 costs each. The charges concerned the columns of small ads through which homosexuals could openly contact each other. The column had been running for two years when police raided the *IT* offices in April 1969 and seized correspondence, unopened replies to box numbers and small ad files.

"Ladies and gentlemen," Mr. Mortimer continued, "don't let us lose all sense of proportion; let us remember the general climate of literary expression as described by such a reliable and sensible author as Mr. Mervyn Jones. It is important for literature, he maintained, that young people should be able to express themselves without censorship. They should be allowed to say what they think, and write what they can. It is important for literature that grown writers, mature writers, should know what is in the minds of young people, so that when they come to write about young people they may accurately describe them. It is important for all writers, he said, that we know exactly how people live in this world around us. And it's not only important for us now; it will be important for people in the future to have a picture, to have an honest and an uncensored picture of the world which we now inhabit. 'It's interesting', said one learned Judge, 'that, throwing one's mind back over the ages, the only real guidance we get about how people thought and behaved is in their contemporary literature. Where should we be today if the literature of Greece, Rome and other past civilisations portrayed, not how people really thought and behaved, but how they didn't think and how they didn't speak and how they didn't behave'. That, of course is how the prosecution would like us to write about ourselves today, pretending that we're something we're not. 'Rome and Greece, it is not uninteresting to reflect,' the learned Judge went on, 'elevated human love to a cult, if not to religion, represented by Venus in the Roman world and Aphrodite in the Greek. The goddesses in the form of women. Then Greece and Rome, like other civilisations, were swept away. When we reach the Middle Ages, we find an entirely different approach. The priesthood was encouraged to be celibate, and a particular qualitative holiness was attached to the monks and nuns who dedicated themselves to the cloistered and sheltered life'. You may think it is lucky that the people were not all quite as holy as that, because had they been so, we should none of us be here today.

We all of us are equal in our aspirations and in our ambitions", Mr. Mortimer concluded. "Free speech should be as permissible to the schoolboy taking part in the sixth form debate, as it is to the Prime Minister and the leader of Opposition in their political debates with each other. My learned friend accused this magazine of propaganda, a word which, I think, derives from the offices of the Roman Catholic Church. It is, however, a magazine, which expresses opinions. Some of them contradict each other; it contains criticism of itself within itself. He said that in this magazine, sexual activity is admired for itself. But that is a criticism which might equally be levelled at the religious practices and the religious art of ancient Greece and ancient Rome. And anyway, there is no doubt at all, is there ladies and gentlemen of the Jury, that sexual activity can be pleasurable and be admired? So let's not judge this magazine, or its effect on young people, by looking back into our pasts, seeing ourselves as young children, and thinking about what the effect would have been on us then.

Because the world is a very rapidly changing place. Children and young people now live in a world which some of us may find it difficult to understand and

totally know about; and one of the values of this publication, is that it may help us. For they live in a world in which satire has changed. The sort of jokes which everybody makes, have changed. The emphasis on sex is quite different. The freedom of speech about sex is quite different. It's a world where drugs have become a subject of importance; where giggling about cannabis is no more or different in quality, perhaps, than the giggling about having a whisky on the way home from the football match may have been in our childhood. So let us beware of importing memories of our past on to young children today. Let us be guided, I would suggest to you, ladies and gentlemen, by those who have spent their lives with the children and young people of today; who know how they react, what makes them tick, what their world is all about, and who can assist us, and assist us genuinely, in judging as to the effect of this on children and young people.

That Presidential Committee in America recognised that legislation cannot possibly isolate children from pornography. It also recognised that exposure to sexual material may not only do children no harm, but may, in certain instances, actually facilitate much needed communication between parent and child over sexual matters. And what is finally important in this case is the relation between parents and children, the respect and sympathy which children should have for their parents and the sympathy and respect which parents should show towards their children. And in that relationship, the important thing is tolerance and understanding. The importance is for us all to be able to say what we feel. And if, in putting forth their feelings, however mistakenly, however clumsily, children find that our reaction is to trundle out the law, to attack and suppress and censor, then there is a danger that they will shrug their shoulders and smile and turn away from us. Then, we shall indeed be a lonely generation, because we shall have lost them forever."

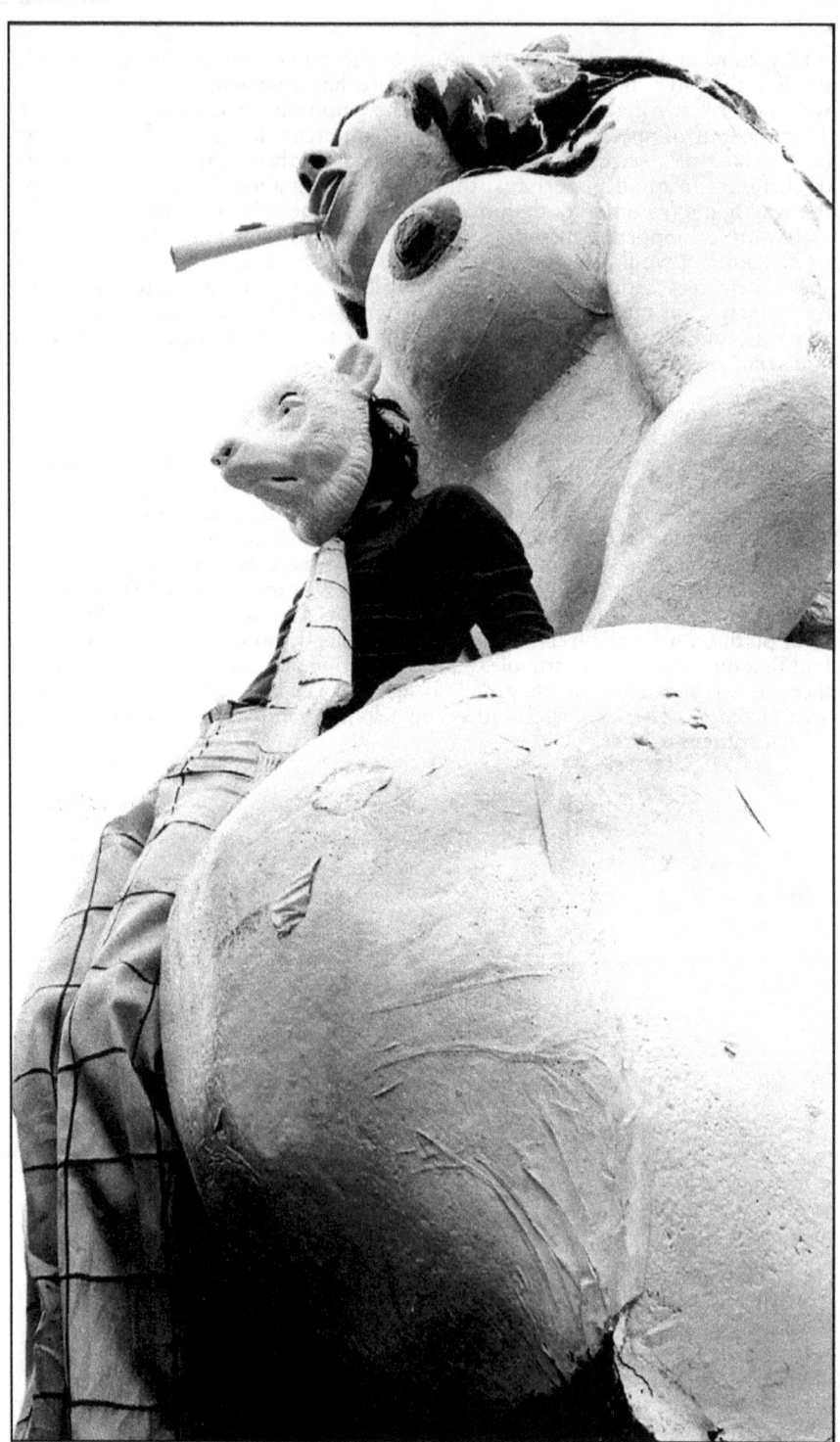

CHAPTER NINE

"As you know, I appear for the unseen defendant," began Mr. McHale; "the unheard defendant, whose full name is *OZ* Publications Ink Limited. The very name is a joke, but that is the Company which published the magazine that you're concerned with. It admits publication - there's no question about that."

One couldn't help feeling some sympathy for Mr. McHale. He had an impossible task. Always having to follow John Mortimer, always having to appear in a subsidiary role, it was not his fault that he had tended to fade into insignificance. Outside the Court Room, he cut a dapper figure, sprucely dressed and often sporting a red carnation in his button hole. Very little was known about him; indeed, every barrister that I asked had never even heard of him. Now, in his closing speech, he had one last chance to impress the Jury.

"We know that some complaint was made by some person who has not been brought forward to talk about it," he said, "and that the Director of Public Prosecutions - a member of the staff no doubt - thought that this was a case for a Jury to consider. The prosecution set out to establish that the magazine was directed to children and young persons. But consider the evidence of Mr. Barry Smith of Basingstoke, one of the shopkeepers who sold the magazine. 'When we sold *OZ*,' he admitted, 'it was usually to male persons aged 17 years of age and over. To my knowledge neither I nor any of my staff sold copies of this particular magazine to anyone younger.' In the teeth of that - their own evidence - the prosecution have the effrontery, the impudence to suggest that this is a case in which young men have set out, as it were, to capture a market of youngsters and fill their minds up with filth. That's what the Crown says. And yet they didn't call any evidence to that effect. On the contrary, the evidence which is before you and is, as I understand it, unchallenged, is that this magazine went out through the usual channels of distribution, to the usual *OZ* readership.

"Oh yes!' says Mr. Leary, but by Jove you call it School Kids Issue don't you? Isn't that going to attract the tots?" And you may think that at a very early stage of this trial, this, the cardinal allegation of the Crown that the magazine was *aimed* at children, fell completely to the ground. There was nothing left

of it at all. And that's why, isn't it, that the cross-examination which we've heard has been directed to what might happen if children got hold of it.

So much of our time has been spent in this case going over the magazine with a fine toothcomb, as though a reader, never mind the young reader, is going to pay the attention to this magazine that we have paid. Is that how people - children - look at their magazines? It's not a bit of Shakespeare they have to learn off by heart. It's not a novel that they're going to have to submit to examination upon. Do your children, when they pick up the *TV Times* or *Radio Times*, pore over every inch of the cover, examine every corner of it closely, or do they pick it up, have a quick glance at it and then look at what's inside? We have had evidence from more than one witness who hadn't noticed the article in the bottom left hand corner of the cover about which Mr. Leary waxed so eloquent. Didn't notice the article on the right hand bottom corner which Mr. Leary suggested in Court to one of the witnesses was a rat's tail.

But what if it were? What if it is erotic? What difference does it make? Another smear of Mr. Leary's was about the lady on the cover whose chest is on display. 'That well-formed shape', he said, as if there was something wrong with having a well-formed shape, as though there's something disgraceful about having a well-shaped pair of breasts instead of something a little less attractive. I don't know whether you saw an advertisement in *The Times* not very long ago. We don't have it in evidence so I mustn't go too far into it. But the lady depicted there wasn't exactly flat-chested. But did we have any complaints about her shape? About her being there even? Or is it only an anti-Establishment magazine which is to be criticised for showing a well-formed lady?

I don't pretend that what I am going to read to you now," he continued, "is a full and complete account of all the evidence. We do our best, but we don't always get it down complete? But if my note is something like right, this is what Dr. Haward had to say about the cover: "It is a question of perception" he said. "I don't find the picture unpleasant. It's delicately drawn, and has aesthetic qualities. Unpleasant qualities are in the experience of the perceiver. I may be unshockable, but in my opinion, this cover would not do any harm." What are you going to do, ladies and gentlemen of the Jury? Are you going to rely on the opinions of experts or are you going to do as Mr. Leary suggested, and chuck all the evidence overboard? And there is more to come. Mr. Schofield said that the cover is intended to attract attention and it succeeds. "I have made studies of homosexuality," he said; "with all the pressures there are to normal sex from the time of birth, it is impossible to believe that this picture will alter a girl's sexual direction. It would not encourage experiments in lesbianism.

Repetitively and repetitively and repetitively, Mr. Brian Leary put to witness and after witness, would you encourage this or would you encourage that? Now, of course, there are all sorts of things that you don't encourage children to do; but these are not necessarily harmful. Picking your nose, for example. Do you encourage your children to pick their noses? The answer is presumably not. But does it do them any harm? Are they going to have their poor little psyches bruised forever because they see somebody picking their nose? It only has to be said for one to realise how ludicrous is the suggestion that, because you don't encourage children to do something, to expose them to it, must of

necessity be harmful. And my submission to you is that the evidence that no harm results from the cover, is overwhelming.

You see, ladies and gentlemen, whenever complaints of this sort are made about writing, photographs or anything else, it's never the chap who is making the complaint who is being depraved or corrupted. It's never Counsel who has to deal with the case who is depraved or corrupted. It's never the jurors who are depraved and corrupted by looking at it. It's always him over there. It's always some other person who has been affected. But why, if it is so obvious that it does have a bad effect? Or is the truth of the matter that such a person cannot be found because such a person cannot exist; and such a person doesn't exist because there is no tendency to deprave. Of course, Mr. Leary said, perhaps you wouldn't mind if your children saw this magazine. They have, no doubt, been brought up in a good home. But what about your neighbour's children? Always the other fellow. Is it only children who come from bad homes that are going to be affected? Is that what he's saying? Or is it again simply another attempt to induce in your minds the idea that somewhere, sometime, not anybody you know, not anybody I know, not anybody Mr. Leary knows, but somehow there must be some poor little waif who will be badly affected by reading this magazine. Well, this is speculation, pure speculation.

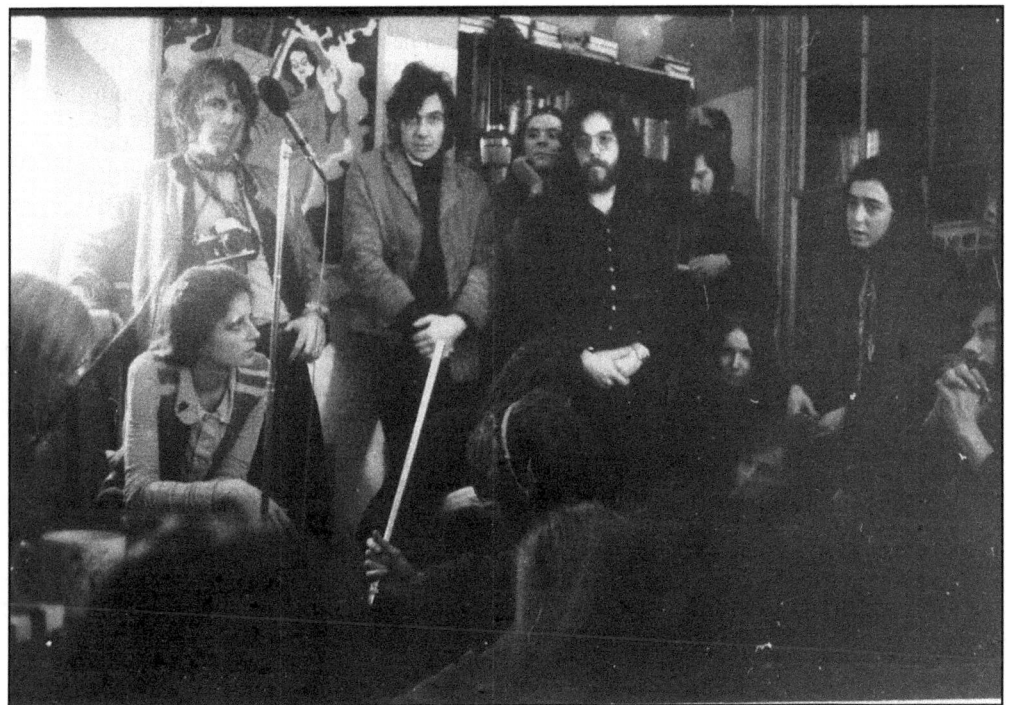

The 'Release' offices at Holland Park. The only people Felix can identify are himself, Andrew Fisher and Caroline Coon (seated left). The picture was taken following the attempted 'coup' by squatters and others to take over 'Release'.

> You see, what Mr. Leary has done is failed to call any evidence. He gave some sort of passing excuse, but if his case was so open and shut, why didn't he? The fact is he has no evidence. He has asked you to speculate. That's putting it kindly. What he's really saying to you, when you boil it all down and cut away the little frills and look at it in a hard cold light, is this: 'Disregard the unanimous views of the experts who have been called before you. You stick to your old-fashioned prejudices'."

Well, well. Mr. McHale was swinging into action at last, and not a moment too soon.

It was terse, but impressive; unlike the other Counsel, he spoke largely without notes.

> "You remember that we had evidence about the number of schoolchildren who'd had contact with drugs. Yet when we see evidence of this in the magazine, Mr. Leary says: 'How absolutely dreadful; they actually go into print saying that children have had contact with drugs'. And, upon my soul ladies and gentlemen, that is intended to be a genuine criticism! You may find it laughable. Day after day after day, we read in the papers about drugs, people being convicted of drug offences, hauls of drugs at the customs. It's known throughout the length and breadth of the country that there are people taking drugs; and it's known through the length and breadth of the country that there are schoolchildren who are taking drugs. So what you're being asked to do is this; under the guise of a high moral tone, you are being asked to take the line that hypocrisy is the thing - sweep it under the carpet, it doesn't exist! Alright, it exists for the *Daily Express* but it doesn't exist for *OZ*. It exists for people who are going to read the *Stockton-on-Tees Gazette*, or whatever, but they mustn't read about it in *OZ*. Do you think that's a responsible attitude? Do you think it's a proper attitude? Don't let people go on the wireless and say 'Yes, I have had venereal disease and been cured; if you've got it, you do the same thing.' Hide it away! Be dishonest about it! Be a hypocrite. Because that is what Mr. Leary is asking.
>
> The real consideration is this. Are the accused, and the Company, to be prosecuted and treated as criminals because they have observed society as society is, rather than in the way that the Director of Public Prosecution's representative in this Court would like you to pretend that it is, when you know perfectly well that it is not. Paint a false picture and all will be well, he's saying. Tell the truth and that's where you end-up."

Mr. McHale waved imperiously towards the dock.

> "Mr. Mortimer put his finger on it, didn't he? The conspiracy of silence. Is that what he wants? Is that right? Is that proper? Is that a logical or a sensible attitude to take, or do you think that people who have minority views have a right to express them, have a right to put them down in a magazine and don't have to say 'I mustn't say this in case the kiddies get hold of it.' Mr. Leary said that the question that should be asked by a person who is considering publishing such material is not, dare I publish, but, should I publish? Well, heaven help this country if all the editors took Mr. Leary's view and feared to publish. Where would we be then?
>
> I wonder how many of you bought an *Evening Standard* on Friday or *The Times* this morning and went through its pages, perhaps looked at the editorial, the news items, the letters which form the meat of such a periodical? And I

wonder how many of you went through the advertisements? Of course, if you are looking for a new house, or want to buy a second-hand motor car, then you might well turn to the columns in those newspapers which advertise that sort of thing. But do you know how much time and attention and questioning and cross-questioning have been devoted, for example, to the *Suck* advertisement which appears on page 28? One might think that it were the most important part of a magazine. What is it? $2^1/_2$ by $1^1/_2$ inches, or something of that sort, in the corner of one page of a 48-page magazine.

But, you know, if you can't publish an advertisement because a child might ask questions, where do you draw the line? Are we not to be allowed to announce the fact that our wives have given birth to children in case some child reads it and says: 'Mummy, births? How do births come about? Where do children come from?'

Mr. Leary may, by his very skilful questioning, have succeeded in arousing the deep recesses of your mind; but don't let those prejudices get the better of you. There is humour, one hopes, in all of us; there is no doubt sexual humour in most of us. There are people, of course, who frown on the smutty joke. What's more, there are people in Court, on the television, on the wireless, in print, whenever they are in their official capacities who frown on the smutty joke, but who will laugh like the rest of us when they hear one in private or hear one after dinner. There is nothing so terrible, is there, about a smutty joke? It's the double set of values that you are being asked to adopt; one for your public thinking when you are in Court, and another for your private thinking.

Do you have no faith in the ability of children? Do you really think they will run off and commit an offence just because they have read about it? The papers are full of stories about crime and social disorders. Is it to be said that none of these matters should be put in a paper of general circulation? In such newspapers, a child will read advertisements about contraceptives without apparently expressing great interest and dashing off to find out what they are all about. Little girls will read about various forms of sanitary protection for women in their mothers' magazines without getting debauched.

There's no quarrel that these magazines were sent by post. And you may remember that Mr. Leary, when he was opening this case to you, suggested that a naked man on the seashore was indecent; and if he started behaving in a certain way, then his action became obscene. He chose a gentleman. But the same thing goes with a lady doesn't it? If everything which has nudity in some form or another, and upon my soul that's very nearly everything today isn't it, is not to be sent through the post without there being the commission of an offence, where would we be?

And lastly, I have a word about the principal charge in this indictment, the conspiracy count. In my submission, there can be no two ways about that. You've heard the evidence and it's perfectly clear that, whatever you may think of their business methods, whatever you may think about the publication which resulted, whatever you may think about the desirability or otherwise of providing a platform for the expression of other people's views, the one thing you can't say is that in turning over the magazine to those young children, the accused intended to damage or deprave and corrupt the minds of their readers.

Moreover, this isn't the sort of case where a company has set out to make a pile of money not mindful of the laws of the country.

We're all grateful to you, Members of the Jury, for the attention that you've shown in the course of this long and, no doubt, at times, tedious case; I know also that, in one sense, it may have seemed that Counsel for the Company was supernumerary. I'm sorry about that; it's in the nature of events."

"Not at all, Mr. McHale," said the Judge. "You've never appeared supernumerary. We're grateful to you for the help you've given us."

And that was that. All except for Mr. Neville.

In February of 1966, when demolition of neighbouring buildings had commenced in preparation for the new extensions to The Bailey, some interesting archaeological discoveries were unearthed. Some 30 yards east of the Old Bailey wall, for example, the City excavation group uncovered the brickwork of the cellar of the Royal College of Physicians in Warwick Square. This College had been designed by Sir Christopher Wren after the Great Fire of London in 1666 had destroyed most of the City. But the most interesting find for the experts was the stone foundation of a large medieval building, the Warwick Inn, so named after its patron and owner, the Earl of Warwick. And the Earl of Warwick, without his title, was called Richard Neville.

"Sitting in this court for five weeks," began Neville in his final speech, "listening to the allegations and suggestions made by the prosecution, I have felt at times as though I had got caught up in one of *Dr. Who's* time machines; that I had been transported back through time to a wonderland of wigs and starched collars, of liveried courtiers and secret passageways; that I had been deposited amidst an eternal, antique stage play where - at regular intervals - everyone bowed to the leading man, and people talked as though the outside world stood still. And most of what went on in that world, moreover, was probably irrelevant.

In one respect, Members of the Jury, you and I have more in common with each other than those who spend their days in Court Rooms such as this and their evenings in clubs, while at weekends they whip away to country mansions and fox hunts.

You and I can go to the local cinema and see films such as *Little Big Man*, *The Wild Bunch*, *A Man Called Horse* or *Soldier Blue*. *Soldier Blue* - a film which reveals, in gory close-up, details of the massacre of an Indian tribe, with children maimed and beheaded, women raped and brutalised. And you can watch in 70 mm Panavision Technicolor while a struggling Indian squaw has a breast cut off. No magnifying glass is necessary there. Personally, I have a dainty stomach; but just like you, ladies and gentlemen of the Jury, I can exercise my discretion; I can choose not to see such films. I can also choose not to buy certain books and magazines overflowing in abundance at my local newsagent.

We have had evidence in this Court that it is not so much sexual material that seeks out the individual, but the individual who seeks out sex. And for the curious, there is ample reward at even the most respectable of newsagents. Thick glossy paper and full clear colour; the girls are not stylised or fantastic, but full, live, red-blooded gatefolds who - in the last two years - have sprouted bushes of pubic hair. In the display cases outside such newsagents and I am *not* referring to Soho, you can read all sorts of ambiguous invitations. Last

night, I looked at the board outside my local sweetshop in Kensington Church Street, and was offered: 'Leather wear for sale'; 'Young coloured student gives French lessons'; 'Riding school mistress seeks superior position - full course of instruction'.

I raise these matters because there is some doubt in my mind whether the Prosecuting Counsel is aware of the contemporary climate, of what's going on outside this Court Room. He seems to live in a world where people pass around something called a 'reefer', where oral genital sex is practised only within happy marriages, where venereal disease is something cloaked in dangerous embarrassment, where, all too hastily, one's fellow man is labelled a pervert, where adolescent children should be seen and not heard, where wearing an *OZ* T-shirt is somehow sinister, where rock 'n' roll is a coded plea for fucking in the streets. There are, however, West End productions in which real live people are actually naked and simulate sexual intercourse. These are plays which do no harm to anyone but help make the theatre what it's supposed to be - a varied reflection of contemporary tastes.

There are some people who see all these things as part of the rising tide of pollution, and have formed committees and plan regular excursions to Soho and Copenhagen. Others defend the new sexual tolerance as though it was some sort of cultural renaissance, a new religion.

I think that both points of view are too extreme. There is greater freedom now than ever before in entertainment and the arts, but none of it is compulsory. If you don't want to see *Oh Calcutta*, there is a Noël Coward revival just around the corner. For every new book about masturbation, there is a new romance by Georgette Heyer or Barbara Cartland. Sex is coming into the open and we are all going to be healthier for it. Mr. Leary talked mysteriously about child prostitutes; well, there were far more child prostitutes in Victorian times when everyone pretended sex was to do with storks and cabbage leaves. In Sweden, incidentally, which has a liberal attitude towards sex, there are no prostitutes at all."

It was a noble beginning. The Jury looked interested. The Judge was studying his A to Z.

"Whatever you, feel about the increasingly free climate of sexual expression," Neville went on, "I would ask you to rely on mankind's common sense. I would like to remind you of a very famous experiment with children that is in all the textbooks on psychology. This is known as the cafeteria feeding experiment.

Children of all ages were allowed to select their own food from an appetising Smörgåsbord available to them. For the first few days, the children stuffed themselves with cream cakes, custard pies and all sorts of goodies imaginable. But, in a surprisingly short time, the children began broadening their choices, taking fruit juices and green vegetables. Soon, the experimenters found that the children, completely of their own volition and without help or guidance, were automatically selecting the same foods as were recommended by trained dieticians.

This connection between freedom of choice and good health is not accidental. The price of freedom is high. But the fruits of freedom are a healthy community. Freedom demands that we trust our fellow man; and yet we have built a society which does not seem able to trust its members. Thus, the weapons we use to repress and to stifle man's natural sexuality are guilt, and the threat of condemnation by others. The pretext is the concept of an ideal, happily married

family. I have been criticised throughout this trial for seeming to stray from the central issues; but these issues have no meaning unless understood in the context of the society around us. It is not honest of the prosecution to attempt to confine discussion to the scrap of white paper known as the indictment.

The attacks of the prosecution have concentrated upon our personal beliefs, on the philosophy of OZ and on the integrity of our witnesses. Yet the prosecution itself has introduced into this Court Room a whole community of people who are concerned with the outcome of this case, a concern which has shown itself, for example, in the public gallery - a gallery, incidentally, which was referred to with contempt by Mr. Leary as though the presence of the British public is further evidence of a conspiracy. I must also add that I noted with alarm His Lordship's continual threats to clear the gallery, as though the handful of remaining press were any guarantee whatsoever of this trial being regarded as public.

Members of the Jury, you cannot see the gallery from where you sit; but throughout this trial, people have been quite arbitrarily cleared from their seats at the slightest display of any emotion. I think we have to ask ourselves just what sort of temple is being constructed here by people in the name of a law which can expel anyone who smiles.

We cannot confine our discussions, our beliefs, our laws, to little white bits of paper; for each maxanadn must understand the consequences of the Law, and, just like a publisher, he must take responsibilities for his decisions. Those who turned on the gas ovens for Hitler said they were merely obeying the Law, just as did those who burned witches at the stake. 'I was just doing my job,' said Adolf Eichmann, when asked why he slaughtered two million Jews. 'We're just doing our job,' say Mr. Leary and Inspector Luff, when asked to consider the consequences of this prosecution.

This case has not been without its absurdities. We are charged with debauching and corrupting the morals of young people within the Realm. And yet there have been young people - one only 14 years old - sitting in the public gallery throughout the course of the trial. Occasionally, they were expelled for an afternoon for being human, but the State otherwise made no attempt to protect them from the lengthy discussions about the homosexual headmaster or Rupert Bear. So, if we are guilty of debauching and corrupting, then the Crown, especially as it has placed a persistent and unhealthy emphasis on sex, must be double guilty of corrupting minors in the public gallery. Do you remember the day the visitors' benches opposite were suddenly filled with eleven young men in school uniforms? They arrived just in time to see Mr. Leary undertake one of his dramatic re-enactments of Rupert Bear meets the Fabulous Furry Freak Brothers and find happiness with coffee and ice cubes*. The boys stayed the whole afternoon before returning to their school in Surrey. So far, there has been no reported outbreak of fucking in the school playgrounds."

In his lime green pullover, the unlikely figure of Mr. Neville pressed on with his argument.

"You may remember that in my opening speech I referred to the fairytale of the naked Emperor. It was a child who first noticed that the Emperor had no clothes and his immediate response was one of laughter. While it is no enemy of truth or justice, laughter thrives on pomposity and falsehood. It is the barometer of

* Some singular advice (one might call it word of mouth) from the *Suck* advert.

social sanity and the nightmare of every dictator. In this respect, I would like to remind you of Marty Feldman. Mr. Leary attacked his performance in this Court Room. Let me try and put his side of the story. He thought School Kids *OZ* was funny and, like many people, he was upset by the prosecution. He is not a friend of any of us and, despite his round-the-clock work schedule, he agreed to come along and try and help. He was very nervous. The only Court Room he had ever seen before was made of cardboard and peopled with actors. So he stumbled, over the ritual of oath taking; the very next minute, it was being suggested that his evidence was inaudible and that it didn't matter anyway.

Suddenly, he sensed the attitude of authority, the same authority that had expelled him from all those schools for being funny, the same authority that censors his television shows for making jokes about the wrong subjects. Mr. Feldman reacted, perhaps overreacted. Humorists are highly sensitive to their environment; he is a comedian, and we had brought him to a place which does not recognise comedy. He is a laughter-maker and we had brought him to a place where laughter is outlawed. He was a man who was alienated by this Court Room, because this Court Room seemed, to him, alienated from life.

Mr. Leary began his closing speech by painting a cheap stereotype: lazy, good-for-nothing hippies, who worship sex for its own sake when they are not lying around in some drug-induced stupor. Maybe this was a clever way of enlisting your prejudices, but I'm afraid we just aren't like that at all. As Felix told you, people on *OZ* work a 70 hour week. We might start at midday and end at 3.00 a.m. the next day, but it's still work. Perhaps the difference is that we enjoy our work. Mr. Leary's next allegation was that because we believe the drugs laws of this country need reform, we are, therefore, inciting drug taking. Were it true that every call to reform was an incitement, then a good many Lords and politicians of both sides of the Houses of Parliament, Baroness Wootton and her entire Committee, Lord Thomson and the editorial staff of *The Times* which published full page advertisement stating that the current drug laws are immoral in principle and unworkable in practice, should all be on trial. To my knowledge, Inspector Luff draws the line at harassing people like that, despite the fact that *The Times* reaches many more homes than *OZ* ever does. Reforming drug laws, like reforming any laws, is quite a respectable activity."

Mr. Malcom Muggeridge, the commentator, was later to dismiss the whole affair in a letter to *The Times*;

"...the squalid, illiterate antics of *OZ*," he wrote.

"Another example", Mr. Neville went on, "of the way the prosecution has sought to put on trial what it chooses to describe the 'alternative society', is its continual insistence that *OZ* promotes dope, rock and roll and fucking in the streets. This proposition was maintained in the teeth of the total disbelief of almost every witness. We have really been prosecuted therefore, for what the prosecution likes to think are our views and not for the written words and pictures that were published in *OZ* 28.

And of all the distortions of our views, the one which concerned most, the one which disgusted us most, was the imputation that I, we, the alternative society, *OZ*, *OZ* 28, and whatever else was within range at the time, was harmful to children.

But if anyone is exploiting children in this case, it is the prosecution. They knew that a prosecution of our earlier issues could not succeed, because, despite the deliberately inflated claims made for them in our 'Back Issue Bonanza', they pale into insignificance besides the sex material easily available in every newsagent. But they thought they could convict us - and thereby silence us - by preying upon your natural fear and anxiety for children.

Throughout this prosecution, they have taken advantage of the emotional and protective feelings aroused by children - they have dangled the image of 'some little boy or little girl' before your eyes, ignoring the fact that this *OZ*, like all others, was aimed not at children, but at the normal *OZ* readership.

Not one of the previous 27 issues had been prosecuted – an admission that none of these issues were considered obscene. So listening to Mr. Leary throughout this trial, it would seem that *OZ* has been prosecuted under a misunderstanding. Had we omitted the words 'School Kids Issue' from the front cover, there would probably have been no prosecution. But these three little words, which meant to us simply that it had been edited by school kids, have been singled out as proof that this *OZ* was specially directed to, and promoted for, a readership much younger than usual. But the evidence we have called shows first that this was not the case - it was aimed at the normal *OZ* readership; and second, that even putting 'School Kids Issue' on the front cover did not make the magazine more attractive to schoolchildren.

Mr. Leary has continually flattered me as a master of the media. And he had some elevating comments to make about the responsibility that an editor has to his reader. This responsibility I do not disown. But it was precisely that sense of responsibility to the *OZ* readership which caused me to print, uncensored, the thoughts of the school kid contributors. The *OZ* readership is not interested in censored viewpoints, and neither Jim, Felix nor I had any intention of playing a confidence trick on them. We live in a society where the mass media are, for the most part, controlled by powerful proprietors whose political affiliations determine the views expressed. The *Daily Telegraph*, for example, is solidly Conservative, the *Guardian* is solidly Labour and the *News of the World* is solidly profit. Our readership is aware of this editorial perspective in most overground papers and is very cynical about it. That's one reason why they read *OZ* - to get a variety of opinions outside the conventional political spectrum. They would cease to buy it if we wielded the blue pencil for reasons other than space. To have played the headmaster, and censored school kids' contributions, would have been to have abdicated from that responsibility.

As for sex; although we have heard so much about the sex in the pages of this magazine, the items concerning sex either written or selected by the school kids are really very few indeed. In fact, there is only one article which deals entirely with sex. Admittedly, sex is used to make points in several of the other articles, but the points involved are not themselves sexual ones, and most witnesses have accepted that sex is not the dominant message. We are left with a total of three pages out of 48, or five contributions of 83, which deal with sex.

Our suggestion that *OZ* had the intention of improving society has been heavily derided. But that has always been our intention and always will be. We felt it was of social value to find out what adolescents were complaining about, in the hope that when their complaints were published, someone might do something about them. Young people, as they go through this no-man's-land between 15

and 18, are socially impotent. Even if some of the criticisms expressed in *OZ* 28 are crude and silly, we believe it was of sociological and educational value that they should have been openly expressed.

It was illuminating to listen to Mr. Leary also deriding our claim that our freedom to speak is on trial. The first thing he said was that every opportunity had been given to us in this Courtroom to say what we wanted to say. That is true. But it is one thing to speak one's ideas in Court, and entirely another thing to be allowed to *publish* those same ideas. It is that freedom - the freedom to publish ideas - which is on trial. Perhaps now you can understand why the National Council for Civil Liberties wrote in their Annual Report last year: 'The activities of the Obscene Publications Squad raise a serious civil liberty issue. For 1970 saw it in a new political role, a role that enabled it to decide which magazines can be printed and which can't, what is obscene and what isn't, what is good and what is bad for us. It is all too reminiscent of other countries, other times. It doesn't matter whether you personally liked the style of *OZ* or *IT* or agree with their content. The fact is that thousands did and are now being prevented from reading it. This is political censorship.'

Another interesting exercise in deception was Mr. Leary's attempt to explain away the fact that the prosecution had called absolutely no evidence to show that *OZ* depraves or corrupts. He pleaded that this had been a time-saving device. But the only inference that we can draw from this failure is that they could obtain none to call - and certainly none of the reputation and eminence of the ladies and gentlemen called for the defence.

Let me turn to the small ads page. As the trial has progressed, and the inflated claims concerning the other pages were greeted with scepticism by witness after witness, the prosecution has retreated page by page to make its last stand upon a handful of these small ads. But on close examination, it turns out to be the last stand of a Colonel Custer. Vibrators can be seen in many chemists' windows on high streets throughout the country. The prosecutor admits that they are advertised in *Tribune*, in *Private Eye*, and in many glossy magazines which are far more likely to be left around the home than *OZ*. Books of erotic stories can be bought throughout Soho. Glossy pornography in the pages of *Playboy* and *Penthouse* is on display at W. H. Smith in Doncaster, Basingstoke and Epsom. The third class of advertisements relates to dating services, those latter-day lonely heart clubs which advertise in all sorts of magazines, including *The Times* and the *Daily Telegraph*. Sex is no more and no less an object of the lonely people and visitors to London who answer these advertisements, than it is for those who answer computer dating services in other magazines.

Fourth, there are those ads which are placed to attract erotic minorities - the wife swappers, the bisexual young man, and the submissive man seeking a dominant female. The propriety of including them has been defended by no less eminent persons than the Professor of Jurisprudence at Oxford University and the Professor of Mind and Logic at the University of London; and I have already told you of finding advertisements like these in the windows of my local tobacconist. Finally, there is the Gaye Guest House and the teenage male models. If it ever came to my attention that some elderly man was using the columns of the paper, of which I am one of the editors, in order to entice a boy or girl for sexual purposes, I would absolutely refuse to have anything to do with the advertisement.

None of us in the dock have a closed mind. We don't believe that everything we have ever done is right just because we have done it, and I have sat through this last five weeks trying to give careful consideration, in an open-minded way, to the arguments advanced against *OZ* 28. For the most part, they have been invalid or absurd. So when we come, at last, to the teenage male models, I must make this admission. The prosecution has raised in my mind a doubt as to whether this is a *bona fide* advertisement. But if all advertisements were the editor's sole responsibility, no newspaper would ever be published because much of his time would be devoted to checking out the *bona fides* of advertisers. As Professor Wollheim, who served on Lord Reith's Committee on Advertising, stated in this Court Room, the duty for tracking down immoral advertisers rests squarely on the police. It is they who should investigate advertisements which they suspect to be a front, and search out any immorality or criminality therein. Until now, all magazine editors, myself included, have worked on the assumption that it's the police who have the responsibility to stop such practices.

But let us now consider what has happened. For the last seven months, Inspector Luff has had in his possession the book in which is to be found the name and address of the person who inserted that advertisement for a teenage male model. In this trial it has been alleged, without any proof whatsoever, that the advertisement was obviously inserted by a sex deviant for the purpose of getting teenagers into his clutches. Yet at no stage in the last seven months, to my knowledge, has any police action been taken to establish the identity of that advertiser or the nature of the activity for which he required teenage boys. For the last seven months, they have done absolutely nothing to bring that alleged offender to these courts. In other words, they seem quite happy for this man to molest young boys while being far more concerned with convicting the three of us. So much for their sense of priorities. So much for their concern for children and young people within this Realm.

Finally, just before I leave Mr. Leary, let me say this. His whole approach was viciously Victorian. Throughout this trial, his favourite word has been 'necessary'. Witnesses were taken through the magazine article by article and asked whether each piece was 'necessary'. Dr. Haward, many weeks ago, pointed out what might be unnecessary is not necessarily undesirable. The great statesman, William Pitt, had another answer to those who would pick documents to pieces in this way. He said in a speech of 1783:

> 'Necessity is the plea for every infringement of human freedom. It is the argument of tyrants; it is the creed of slaves'.

Let me read you the judgment of Mr. Justice Stable in an earlier case of this sort: 'During the closing speech for the prosecution,' he said, 'it seemed to me that there was a certain confusion of thought. It was suggested that you (the Jury), by what you decide today, are to determine whether books like this will or will not be published in the future. May I venture to say that your task is nothing of the kind. We are not sitting here as judges of taste. We are not here to say whether we like a book of that kind. We are not here to say whether we think it would be a good thing if books like that were never written. You are here trying a criminal charge. The burden of proof in this criminal case rests on the prosecution from start to finish.

The literature of the world from the earliest times when people first learned to write, so far as we have it today - literature sacred and profane, poetry and prose

– represents the sum total of human thought throughout the ages and from all the various civilisations that human pilgrimage has traversed. Are we going to say in England that our contemporary literature is going to be measured by what is suitable for the 14 year-old schoolgirl to read?

Throughout this trial", Neville went on, "the prosecution has failed to draw the distinction between an act and the depiction of that act. Thus, a naked bather in the flesh might be indecent, but on the roof of the Sistine Chapel, in a feature film or even in the *Sunday Mirror*, he or she is not. A man actually urinating in court is indecent; we all agree on that. But a drawing of a man urinating in court need not be indecent. The prosecution talks about Rupert's penis being 'thrust in our face' as though it really exists; they seem to think we are actually in the firing line of the masturbating master.

But one of the strangest and most menacing allegations levelled throughout this trial, is that we are part of a community without love.

'Sex is worshipped for its own sake,' said Mr. Leary, who went on: 'Why have we heard nothing of love?' The answer is - we were never asked. Mr. Leary did not introduce it until his final speech. Throughout this case he has been solely concerned with venereal disease, homosexuality, fucking in the streets and pissing in the courts. Since he has chosen to hold against us an answer that we didn't give to a question that was never asked, let me answer now.

Read again that passage headed *Rupert Dancing*, by that most controversial of contributors, Vivian Berger:

> 'Rupert Dancing is another daisy in the fields of the Underground. It started when people just linked arms and flew around the Roundhouse in multi-coloured ribbons. Everyone thought it was such a groove that a Rupert Dancing was called in Hyde Park. All the Rupert people tripped gaily down to the cockpit one blank, grey afternoon. When about 40 people had arrived, the dancing began and we danced in and out of the Serpentine, around trees and people. The numbers grew and about 70 people Rupert Danced their way towards Marble Arch, where we decided with all our happiness and love that we'd levitate the Arch. So we sat down with guitars and so on, and played, sang and danced (to the amazement of the tourists) and managed to push Marble Arch forward five inches'.

No wonder the tourists were amazed. You don't often come across a group of white Westerners in the middle of a capital city radiating happiness and love. Most people are too busy being busy. But don't you remember that love is how hippyism began... just like Christianity? Don't you remember *The Beatles'* hit song, "All You Need is Love, Love, Love?"

In one of its first issues, *International Times* announced that 'love need not remain a banal cliché, but is and must be a constantly original divine verb. Love-ins exploded all over the world as people began to see if they really could 'love thy neighbour as thyself'. For a while, there was so much love around that a whole generation almost died of an overdose. You don't hear so much about love nowadays, because the alternative society has become more practical and political. People got tired of turning the other cheek. Among young people, love has no

power or magic if it just means loving your wife until the divorce and meanwhile hating black people, homosexuals, communists etc. Love entails tolerance and compassion - not for the person you want to possess, like a sports car - but for those people who are in most need of support. Sometimes our horizons are limited by our immediate needs. We're so busy trying to survive as comfortably as possible in a frenzied and confusing world, that we find it difficult to care about people that we cannot see or hear. Of course, a dramatic earthquake in Peru or a cyclone in Pakistan can twinge our consciences enough to give a few bob to Oxfam; but this is not the same thing as caring, really caring, for those who are fighting for their freedom in all sorts of different ways.

These are the battles of individual liberation through collective action. Unless you are a part of one of these groups, it is difficult to understand their problems, much less identify with their demands. His Lordship reminded one witness that you don't have to be a prostitute to understand the evils of prostitution. Likewise, you don't have to be black to understand the evils of racial discrimination; but it does require compassion, deep affection and love for one's fellow man in order to become involved in his struggle. When you see long hairs or black people or women marching in demonstrations, they are not there because they want to destroy everything that you believe in; they want to rebuild it and re-distribute it, so that everyone receives a fair share. Women, for example, are now beginning to reject their male-defined role as housewife, nappy-changer, male ego-booster, decorative side-kick... and the concept of romantic love. That is the sort of love I suspect Mr. Leary was searching for in *OZ*. Violins, moonlit terraces, tuxedos, lace hankies and E-type Jaguars. The sort of world characterised by the novels of Barbara Cartland, where dashing young bucks cannot afford to kiss the satined debutante until marriage. To reject that sort of love is not to reject love at all. It is to reject a myth and an image of love which is not only unattainable but, in the guise of ennobling women, actually enslaves them. I think that what *OZ*, or at least the community of which *OZ* is part, tries to do, is to re-define love, to broaden it, extend it, re-vitalise it. It is true that contained within this re-interpretation of the concept of love, is a more candid sexuality. But I think this is indicative of a healthier and more honest relationship between men and women.

Finally, on this question of love and sex, I want to remind you of the advertisement for *Suck*. No doubt you all must think that the newspaper from which it came, *Suck*, must be disgusting and pornographic. But, like so many things in this Court Room, it has been misrepresented. I would just like to read you an extract from the manifesto of the people behind *Suck*.

> 'Tenderness, mutual respect, freedom and tolerance - these are all words we should associate with sex and love. The act of making love can be a statement of profound tenderness and concern for another human being. In this world of different languages, religions, races, cultures and classes, sex is an incommonality - something common to all. It is sexual frustration, sexual envy, sexual fear which permeates all our human relationships and which perverts them. The sexually liberated, the sexually tolerant and the sexually generous individuals are open, tolerant and generous in all their activities. Therefore we wish to encourage sexual freedom, sexual tolerance and sexual generosity.'

Now, you may hate *Suck* newspaper, and you may disagree with the philosophy behind it; but these are not evil men who wish to re-enact the decline and fall of ancient Rome in England. People's attitudes to sex are changing, because people's attitudes to life are changing. And many people believe that happiness and goodness are directly related to sexual well-being. Unless a society is sexually healthy, all efforts to build a good society are bound to fail."

The *Daily Mirror*, in its editorial, later wrote:

> "The School Kids Issue of *OZ* 28 was repellent. It was sex without tenderness; lust without love."

"Sex is just part of the revolution of values which is taking place," Neville went on, "...primarily among the young. Drugs are another part. It seems to me, therefore, that the question to ask is not: 'Why does *OZ* include references to police as 'pigs'?' But what sort of pressures make a 15 year-old girl refer to those who are paid to protect her, the loveable British bobby, as 'pigs'?

The reason is that her friends are being gaoled for smoking a drug not sanctioned by her parents. A drug that in her opinion – if not in yours - is relatively harmless. That girl, like many of her friends, is, in the eyes of the

Law, a criminal. You may not know that running parallel to this trial, there has been another case at the Middlesex Quarter Sessions where the former head of the Drugs Squad, Detective Chief-Inspector Kellaher, has been severely castigated by both the prosecution and defence Counsels. He (Kellaher) is not to be believed, they said. The Judge remarked that 'When a case of this nature arises, those who run the police must be gravely concerned', and a formal enquiry has been launched to investigate the activities of this, the former head of Scotland Yard's Drug Squad. Meanwhile, it is people like Detective Chief-Inspector Kellaher who are putting your children in gaol. So while you might think it is shocking that a 15 year-old girl calls the police 'pigs', her anger is similar to the anger that many young people feel about those who plant drugs, falsify evidence and invade the privacy of people because of the way they look. An Englishman's home is his castle - except when it's a pad in Notting Hill Gate.

Those who grew up in the early fifties were known as the 'Silent Generation' because they seemed to accept that the most important goal in life was to get rich as quickly and ruthlessly as possible, while ignoring those who were poor, homeless and discriminated against. But suddenly it became too dangerous to be complacent any longer. Old gentlemen with cigars and curly moustaches could push buttons which might blow up the whole world. So young people came into the streets with their duffle coats and guitars to protest. They discovered they had a collective identity, a fellowship, a brotherhood. Sometimes these people rejoiced in the discovery of their own identity. They sprouted bright plumage to distinguish themselves from their predecessors and gathered in large numbers to hear their particular style of music. As they searched for new values and experiences they stumbled upon an old drug, cannabis, which would also distinguish them from their parents' generation. Each generation has a duty to develop a new culture and new values. It faces a different world from its parents, with fresh excitements and novel dangers. Bob Dylan sang nearly ten years ago:

> *Come mothers and fathers throughout the land*
> *Don't criticise what you can't understand*
> *Your sons and your daughters are beyond your command*
> *Your old road is rapidly ageing.*
> *Please get out of the new one if you can't lend a hand*
> *For the times they are a' changin'.*

Will you lend a hand, Members of the Jury? With your verdict, you have a chance to bridge the generation gap, the culture gap, the ignorance gap, call it whatever you like. You have a chance to demonstrate that parents are not necessarily intolerant of the young, or unsympathetic to change. Acquitting *OZ* does not mean that you endorse what is in the magazine, but it does mean that you have confidence and compassion for the tender ideas of the young, for people who, in Dr. Linken's words, want to solve old problems in new ways.

I have learned a lot from this trial. If we did School Kids *OZ* over again, I would do it differently. I would try and ensure the message came through clearer. I can see how some of the contributions are open to misinterpretation. Also, while I regard the bringing of this prosecution as dangerous and destructive, I have no personal animosity for Mr. Leary. While I think he has misunderstood the magazine as well as our intentions and has been unfair to

some of the witnesses, he has, overall, carried out his duty with a sense of fair play. Before all this began, a friend remarked to me that we were lucky to be fighting the trial in England. I absolutely agree. Although the atmosphere in this Court Room has not always been the most conducive for the presentation of complicated ideas, I have certainly been allowed considerable freedom of expression. There are few countries in the world which would have granted us such latitude.

But it is cases like this which test that latitude, which test our rights of freedom of speech, which keep the tradition of tolerance flexible, alive and up-to-date, and able to cope with changing voices and changing generations. It is cases like this which see whether we just play lip-service to such high sounding notions, or whether we are prepared to act on those beliefs, even at the expense of our own ideas of taste and decorum. A free trial in an open Court Room only has any meaning if the voices of reason are listened to, if decisions are made according to evidence, if people are prepared to leave this building with different ideas from those with which they entered, if the freedom within the Court Room is extended to the society outside and if the verdict is a verdict which will confirm the values of tolerance, reason, freedom and compassion. Let it be a verdict which helps to remove the barriers between us all, which helps us understand one another even through our disagreements, which enables us to live together as many communities with many alternatives, and yet still at peace and love with one another."

It was, in all, a remarkable speech. Peregrine Worsthorne, writing later in the *Sunday Telegraph*, said;

> "I cannot take the editors of *OZ* very seriously, and as they outlined their case in Court, almost every sentence demonstrated how hopelessly unable to communicate their convictions they had been to any but the dedicated faithful."

In concluding this, Mr. Worsthorne had one distinct advantage over his colleagues in the Press. He had not attended one single day of the trial and had not heard a single word spoken.

CHAPTER TEN

And so, at last, we came to the summing up by His Honour, Judge Michael Argyle, QC. In a sense, it was this moment that we had all waited for since the earliest days of the trial. One of the Court policemen told me that, in this case, there would be two final speeches for the prosecution, and the second one would be better. During the five and a half weeks of the trial so far, there were some witnesses who had openly accused the Judge of being asleep, boring or biased. Now we should see.

Much of this book has been possible because the Judge allowed the proceedings to be recorded from the well of the Court on a tape machine. The transcripts obtained thereby have provided the best possible means by which to corroborate verbatim notes made at the time. If in any doubt, one could always listen to the tape to check. But Judge Argyle let it be known that he did not wish his summing up to be so recorded. Mr. Walker-Smith, on behalf of Mr. Mortimer, protested, but the Judge said his mind was made up. He gave no reason. It was suggested that Mr. Luff had been busy behind the scenes and had tried to prevent all the final speeches from being recorded. After all, the Court shorthand writer had not been required to be present for these speeches; so had it not been for the tape recorder on those occasions, no accurate record of what was said would now exist.

As it is, what follows is only my hearing of what Judge Argyle said; the official shorthand writer was present for his speech, but, alas, her transcript is not available to me. However, having sat through nearly six weeks of evidence and having become well accustomed to the Judge's tone of voice and style of enunciation, I think it unlikely - although possible - that I substantially misheard what he said.

> "We now approach the last stages of this trial," he told the ladies and gentlemen of the Jury.

> "We have sat here for 25 days and a baby born in the first week would now be over a month old. The lady juror whom I discharged would now be in her seventh month of pregnancy, and were it not for the Act of Parliament which allowed me to release her, she might now be in considerable discomfort. But I would remind you, ladies and gentlemen, that 11 are just as capable of reaching a verdict as if there had been 12.

I'm going to try very hard to cut out all references to history or to the reading of poetry. We've had a lot of that from every side and, no doubt, it has been very helpful. I see my task in quite different terms. We've now heard all the evidence. There is no more. It doesn't matter now who called it or whether it came from the witness box, the magazine or the exhibits - it has now all come together and it is from that and that alone which you must judge this case. We must assume that every party has put forward the evidence that has been most helpful to them. Finger prints or forensic evidence do not come into it. You have got to judge this case on the evidence you have - and we've had a very great deal of it in the last five weeks.

Now, in important criminal trials, it is not necessary to reach a unanimous decision as to the verdict. But we've not reached the stage in this trial yet where it is necessary to consider the possibility of a majority verdict; so, for the moment, Members of the Jury, would you, when you retire, please reach unanimous verdicts. My job is to direct you as to the Law - and, again, there is a lot of it in this case. And if I direct you wrong, there is a Higher Court which will put me right. That is the *end* of my job.

But you, ladies and gentlemen, you are the deciders of fact. That is your job. It is for you to say which witnesses you believe; for you to decide what weight you attach to any particular piece of evidence. It might appear to you in the course of my summing up that I am expressing an opinion. From time to time, you will have noticed that I've come under criticism for the way in which I've conducted parts of the evidence. So, if I now express an opinion, and you agree, well, that's alright. If not, you can disagree.

You do not have to do what I tell you. What I think is irrelevant. *You* have to decide."

It was like listening to a friendly, village schoolmaster - kindly, thoughtful and considerate. Judge Argyle spoke quietly and with some dignity, pausing over each little sentence as if it were a philosophical pronouncement of the utmost profundity.

The excitement of the last weeks seemed far, far away; as did the boredom. We each of us, for our separate reasons, hung on his every syllable.

"I want you to consider each charge separately," he went on. "You mustn't lump the charges or the verdicts together. Whatever your verdicts, don't fall into the trap of lumping the charges or the verdicts together, I beg you. May I suggest, therefore, how you approach your decision? First, you should consider Count A, that is, sending obscene articles through the post and you should do this in relation to the three named accused. Then you should consider Counts 2, 4 and 5 - the charges under the Obscene Publications Act and here you should direct your verdict first to the three named accused. Finally, look at the Conspiracy charge, and, again, consider your verdicts in relation to the three named accused. I want to say something now about the liability of the Limited Company which is, after all, merely a piece of paper.

Again, there is a lot of Law relating to this, but the Law is quite clear and it is open to you to convict the Company. In the past, it has been maintained that a limited company cannot commit murder. That's obvious. Before, murder was punishable by death. Now, that is no longer the case. Well - there we are. And, obviously, you cannot hang a piece of paper; but when it comes to an obscene

publication, if the evidence is there, then you can convict. If all the principal officers of that Company put their heads together and use a limited company to commit a crime, then the company is culpable. Hence my questions to Dennis about who was actually in charge of the Company; as a result of those questions, you may think that we have the full strength of the directors of that Company here in Court. A precedent in 1944 states that 'A criminal act of an agent, is the act of his company; and when the Jury is satisfied, then you may convict!'"

Thus far, it really was a gentlemanly performance. Apart from the casual aside - "Well, there we are" - when referring to the abolition of the death penalty, it seemed impossible to fault the Judge. The defendants appeared mildly relieved by Mr. Argyle's scrupulous fairness - thus far. The Jury looked impressed.

"Next," the Judge went on, "it is my duty to remind you about the question of burden of proof. In this, as in any other criminal trial, that burden remains with the prosecution. Concentrate on that, please. The three people in the dock, or the Limited Company, don't have to prove anything. It is not compulsory for them even to appear in the witness box, let alone call any witnesses. So what is the standard? Guilt must be shown, and if there is any real doubt, you must bring in a verdict of not guilty. Only if you are so driven, must you say: 'Guilty'.

Now, on Counts 2, 4 and 5, it is possible that, under Section 4 of the Obscene Publications Act, a special defence can be invoked, the defence of public good. In other words, if you are satisfied that they have published an obscene article for gain, nevertheless the public good excuses the defendants, or some of them, from conviction. In this case, however, the burden of proof moves to the defence. It is for them to prove the public good. But the burden here is not so high as it is for the prosecution in the other charges. So, if you decide that *OZ* 28 is not obscene, that's the end of it. But if you think it *is* obscene, then, please, go on to consider Section 4.

Now, let us consider the meaning of the word 'conspiracy'. Brought up as we are, we automatically think of conspiracy in terms of Guy Fawkes and the Gunpowder Plot. That, indeed, was a conspiracy; it was also treason, murder and a good deal else. Yet, in law, 'conspiracy' has a less romantic feel about it. It is simply this - 'an unlawful agreement between at least two people' - and a criminal agreement, at that. It is not even necessary that every member of a conspiracy should know all the details; some play major parts, some lesser. In the Great Train Robbery, for example, there were 16 accused. I appeared on behalf of two of those conspirators and it was of no relevance whether they had played greater or lesser parts when assessing their guilt. Nor is it necessary, in order to prove a criminal agreement to effect a crime, to have that much said or even written out. One looks at what they did, or published and then decides. Did they commit a conspiracy with some positive act in order to achieve that conspiracy? In other words, did they all publish a magazine? Well, that is admitted. What the Crown has to prove, therefore, is that there was a conspiracy, that these three and the Company conspired to produce a magazine containing obscene, indecent and sexually perverted cartoons and articles, with the intent to debauch and deprave the morals of young persons within the Realm. Now, Mr. Neville has suggested that this is an out-of-date charge. It is not."

[It is.]

The finality of those last three words caused a stir in the overcrowded Court Room. At one time, it seemed as if there were more policemen on duty than there were members of the public. Mr. Luff sat in the well of the Court, fiddling with his pencil.

"For your help, ladies and gentlemen of the Jury," the Judge went on, "I shall try and define for you the words mentioned in the Conspiracy count."

At last. Had it really been necessary to wait nearly six weeks for the definitions upon which, common sense told us, the whole prosecution rested?

"Corrupt," said the Judge, "means to infect or taint; to destroy the purity of something; rotten, depraved, wicked. Debauched, or depraved, means to make bad, to pervert. An earlier obscenity case defined, 'depraved' as: 'to make morally bad' - and this has not been challenged."

One couldn't help feeling that those dictionary definitions somehow begged the central question; according to what standards did one assume something to be morally bad? And which morals? And why? However, it was now becoming slowly apparent that such niceties were not for us.

THE TRIALS OF OZ

"These words," continued the Judge, "are contained in the Obscene Publications Acts of 1959 and 1964. They are quite modern Acts of Parliament. Now it is Parliament which makes the Law, and everyone is presumed to know the Law. One witness has told us that these Acts of Parliament were liberalising measures."

[Really? Which one? I don't recall any witness saying exactly that.]

"Let me read you the Titles of those Acts; these are not part of the charges, but you may find them of interest. The 1959 Act, for example, is an Act 'to amend the Law; to provide for the protection of literature and to strengthen the Law relating to pornography'. And the 1964 Act is 'to prevent publication for gain'. Thus, the guts of these two Acts are contained in the charges here today.

What, therefore, is the test of obscenity? An article shall be deemed to be obscene if, taken as a whole, persons shall be corrupted or depraved by it if they see it, hear it, or read it."

In other words, according to the Judge, something was obscene if it depraved. And if it depraved, then it was obscene. Very circular - but no doubt it made sense to some. The Judge flicked through his ledger in which he had kept throughout the trial what he considered to be key pieces of evidence.

"Mr. Duane told us," he continued, "that the word 'obscene' came from the Greek and meant things not to be shown to the public on the stage. Thus the matter is not limited to matters of sex. It also can include drugs or violence. Some witnesses have said that violence is a greater obscenity than any reference to sex. Nevertheless, you may think, ladies and gentlemen of the Jury, that we have been primarily concerned in this trial with sex - perverted sex. Even so, I want you to consider the magazine as a whole. This does not mean that you have got to count up the relevant passages and assess it in that way. We've been going through the magazine and dissecting it so many times, that, no doubt, we no longer need to even open the page to know what passage is being referred to.

But you are entitled to take into account its original impact on you. It is not necessary for the Crown to prove that the whole magazine is obscene. No-one, for example, has suggested that School Kids *OZ* is in the same category as the *'Ladies' Directory*, which, as you may remember, was little more than a catalogue of prostitutes and was thus successfully prosecuted. And no-one denies that *OZ* contains many articles which are not to do with sex. It is, therefore, the general impression with which you must concern yourself, and does that impression tend to corrupt."

Again, apart from the inadequate definitions of the key words - obscene and deprave - it was difficult to question the Judge's guidelines to the Jury. Maybe all our fears and suspicions about him which had arisen because of his curious handling of parts of the trial, amounted to little more than our over-sensitive paranoia.

Except for one minor fact. Perhaps Argyle had forgotten, or all maybe he did not know, that in 1961, Lord Reid, when discussing the case of Shaw and the *Ladies' Directory*, said:

253

> "There are wide differences of opinion today as to how far the Law ought to punish immoral acts which are not done in the defence of the public. Parliament is the proper and only place to settle that. Where Parliament fears to tread it is not for the Courts to rush in."

At this stage, however, there seemed little possibility that Argyle was rushing in.

> "Publication of *OZ* 28 is admitted," he continued, in the same reasonable meandering way; "so what the Crown has to prove is that, by such publication, it has tended to corrupt a significant proportion of its readers. We are not interested in convicting *OZ* because it may have corrupted one or two mentally ill or depraved people. I remind you again of the meaning of obscene; 'loathsome', [...**pause**...] 'repulsive', [...**pause**...] 'filthy', [...**pause**...] 'lewd' [...**very long pause**...]"

The Judge pronounced it 'lee-ooed' with obvious distaste, and as he did so gently rested his left hand upon the copy of *OZ* 28 lying on his desk.

> "The motive for this obscenity is irrelevant," he went on. "The reason for pornography is obviously to make money and when *OZ* 28 was published, it was clear that the hope of making a colossal amount of money was unlikely. All the Crown has to prove, therefore, is this: did they publish it? Is it obscene? It was clearly done for gain - after all, it says 4 shillings on the cover; but this does not necessarily mean that it was done for profit.
>
> Count 3 is less than 20 years old and is in modern language," he said, looking at Mr. Neville. "Under Section 11 of the Post Office's Act, it is forbidden to send through the post a packet containing an indecent or obscene article. Now it is freely admitted that *OZ* 28 was sent through the post, so there we are. All you have to decide on this Count is what is the nature of *OZ* 28?
>
> 'Indecent' means 'unbecoming', 'immodest'. It is at the bottom of the scale of such words. We have had a number of examples given, but I think that the original illustration given by Mr. Leary was the most helpful. If a woman takes off her clothes on a crowded beach, we think that is indecent in this country."

[Mr. Leary had actually said; "If a *man* takes off his clothes" - but, no matter.]

> "We just don't do that sort of thing," Argyle continued, "in this country, on a crowded beach. Similarly, if we behold athletes with their beautiful, lithesome bodies and they are so scantily dressed that one can see their private parts, we say that that is indecent."

[Do we?]

> "Now obscenity involves something deliberate. The woman or man who is seen naked on that crowded beach and who masturbates - that is obscene. But, of course, the one shades into the other. Therefore, it is left to you, Members of the Jury. If you acquit on Count 3, that is, decide that *OZ* is not indecent, then you must acquit on all the other Counts since the magazine is, then, clearly not obscene. If, on the other hand, you decide that it *is* indecent, then it still might not be obscene. And even if you come to the conclusion that it is obscene, then

you must go on to consider Section 4. In other words, is it of interest to science, learning, literature or art?"

The Judge was now in danger of boring the Jury almost as much, one suspected, as others had done before. But, suddenly, almost casually, he moved to the nitty gritty.

"Now, of course," he began with a smile, "there are many art treasures which are on public show in this country which, taken in isolation, might be considered as obscene. But they are world famous and, therefore, are not liable to prosecution. And the defence has maintained that *OZ* 28 should be put on the same level as our great national works of Art!"

The defence solicitors looked up, horrified. That was an exaggeration, to put it mildly.

But did the Jury believe it, or even realise it?

"So what you must consider," the Judge went on, blandly, "is first, the number of people who are likely to see this [...**pause**...] 'work of Art' - one in every hundred, according to Mr. Dennis. Second, the strength of its tendency to corrupt or deprave, and third, the nature of that depravity. Consider the magazine on its 'merits'."

[As if *that* were any longer possible.]

"And that is all I need say about the actual charges," he concluded.

The Jury strained forward; one was taking notes. Another picked his nose.

"All the three accused," Argyle continued, "are of previous good character; they have never been convicted of any offence. In a place like the Old Bailey, this is very important. A good character is like a deposit account in a bank. As we go through this weary vale of tears, exposed as we are to all manner of temptation, the older we get, the more valuable it becomes - our deposit account, that is. Richard Neville is 33, Anderson is 29 and Dennis is 24"

[He had got it wrong. If he could get such simple facts wrong, what chance the rest?]

"We all come into this weary world with a good character," he continued. "But even the greatest criminal in the world," he said, looking at the accused, "has to be convicted for the first time".

Next, let us consider the accomplice, Vivian Berger. We see many people like him here. He is, what we would call, a police informer."

Mrs. Berger, who was sitting at the back of the Court, got up to protest at what she thought to be a libellous suggestion, but, for the moment, was restrained.

"As such," the Judge went on, "he is protected from prosecution by the police."

[Vivian Berger, at this time, was 16 years old; none of the other schoolchildren involved in the editing of *OZ* 28 had been threatened with prosecution.]

"Having given evidence in this way to the police, we mustn't take anything that he says that seriously. Juries never do - or very seldom."

[Which did he mean?]

"Therefore, you must look for evidence coming from independent sources to make it likely or not that what Vivian Berger says is true. You may think, ladies and gentlemen, that there is evidence capable of corroborating *his* evidence from the three accused; but it is a matter for you, the Jury, to decide."

During the adjournment, Mrs. Berger, visibly distressed at hearing her son - who had freely cooperated in the editing of *OZ* 28, who had freely given evidence to the police in the hopes of helping the three accused and who had exchanged no promise from the police that in return for his evidence he would not be prosecuted - called 'a police informer', said to me: "My God. I'll sue that man for every penny he has got."

Judge Argyle, an Additional Judge of the Central Criminal Court since 1970, had formerly been Recorder of Birmingham. There in July 1966 he had warned thieves that:

> "...the maximum sentence for burglary is life imprisonment and for housebreaking, 14 years. In appropriate cases, this Court will steel itself to pass such a sentence and will leave to others the responsibility of deciding when and in what conditions the former criminal is to be released. *To start with,* persistent criminals must expect to get sentences of five to eight years. Speaking generally, these crimes will no longer be tolerated in this City and no criminal who is arrested should, in future, expect to have the chance to return home for a very long time..."

> A member of the Kennel Club Committee, "He is absolutely charming to live with," says his wife; "I can promise you that. He is a great family man and wonderful with our three daughters. He loves the country. He is Derbyshire born and bred. But on the bench, a different character seems to come over him. He does rather feel that fairly strong sentences are needed - if only to protect the public; under our present system, he feels, there isn't any alternative."

"When police officers interview suspected persons," he continued now in his summing up to the Jury, "this is normally done alone. Common sense tells us that any particular piece of evidence only relates to that person and to no other. But now, here we are. We can hear everything that has been said and is

> said; and if you disagree, you can challenge. You can stand up and say; 'Hey! that's not right. That's not what I said.' We have also heard a great deal of evidence from people calling themselves experts - so-called. But this is not a trial by experts. It is the quality of witnesses that counts, not the quantity. You don't win or lose a case by the number of witnesses you can call. Anyway, *we* have the advantage over them, because we have heard *all* the evidence.
>
> *We* know, for example, how much the police had warned the accused, don't we?
>
> So let us now consider the nature of their defence. In Mr. Anderson's defence, Mr. Walker-Smith said, quite rightly in my view: "First of all, our defence is a negative defence. The Crown has got to prove the magazine obscene. Secondly, we have a positive defence - that the magazine is beneficial". Now, the defence don't have to prove this. But you may think that they have made some very good points. In spite of Mr. Neville and his views of my conduct of the case..."

[I wondered what he had in mind]

> "I have tried to underline the good points that they have made. I think it is beyond dispute that there are many things in the magazine, such as 'Xam Blues', which are good."

[I wondered which others he was thinking of?]

> "So, before I review the evidence in detail, let me make a few last general remarks. As Mr. Mortimer said, we do not have a great earth-shaking task on our hands; we are dealing with just one case. We are trying five quite standard charges - not the whole nation. Outside the narrow and heated confines of the Old Bailey, the rest of the Old Bailey grinds on, London grinds on, the world grinds on. Let us not elevate ourselves into something more than we are. I have been criticised for not allowing laughter..."

[Except his own.]

> "...but the best method of conducting criminal business, is formally. This has been found over the centuries. So where do you draw the line? Are we all going to be allowed to chat, drink and smoke? This is not a debating society. This case has been conducted exactly the same as any other.
>
> When the members of the American Bar Association were in Court and let out a guffaw, I issued the sternest of warnings. This is *not* Chicago. This Court is *not* a respector of persons."

Indeed, it was not. In 1967, in one of the many appeals against Mr. Argyle's judgments, the Lord Chief Justice said of Mr. Argyle, in the case of Regina v. Harper, that his remarks when jailing a man were 'improper'.

> > "This Court", said the Lord Chief Justice, "feels there is a real danger that the appellant was given his severe sentence because he had pleaded not guilty and had run his defence in that way. The Court thinks it is quite improper to use language which may convey the

> impression that a man is being sentenced because he had pleaded not guilty and run his defence in a particular way."

A fellow member of the Carlton Club told me that His Honour, Judge Argyle, QC, was not the most popular member of that club.

> "So now we come to the evidence, ladies and gentlemen of the Jury," said Judge Argyle. "We had read to us the statements from the four shopkeepers - Mrs. Taylor of Epsom whose business is at Banstead; Mrs. Sutton of Leeds; the shopkeeper in Doncaster who sold 91 of his 96 copies - all to students of between 18 and 25."

[Why no schoolchildren, as the prosecution had persistently maintained?]

> "And Mr. Smith of Basingstoke. Then Vivian Berger answered the advertisement which is on page 46 of the magazine and which we've seen so many times."

[It is not on page 46. It is in an earlier issue of *OZ*. Wrong again.]

> "Vivian Berger thought it was all about the reform of the educational system. But there is evidence to suggest that a lot got into the magazine which has nothing to do with school reform. You may remember Dennis' letter in which he said: 'They seem to have chosen to eliminate sex and politics almost entirely.' If that is right, how did so many of the articles and the small ads get *into* the magazine?

> Mr. Duane said that the only way for children to get adults to take any notice of them is to use sex in this way. But does this make sense ? That when it says 'fucking in the streets', it doesn't really mean it? Do you believe it? Do you? Do you believe him when he says that cartoons like Rupert are passed around class every day? Do you find it amusing, that cartoon? Do you?"

The Judge held up his copy of *OZ* 28 and said once more:

> "Do you?" dropping the magazine on the bench as he spoke.

> "Do you?" he repeated, softly.

> "The case for the Crown took only three days and then we had Mr. Neville's opening address. Alas, so much of it missed the point. Most of it had nothing to do with the issues that we have to consider. 'We are not on trial; you are on trial,' he said. Well, there we are. If you convict, ladies and gentlemen, you must remember that this is not a political prosecution; you are not convicting schoolchildren. Look at the cover; is it a rat's tail or is it the cord of a tampon used by a woman to protect herself when menstruating? Look at the back with its phallus and its dildo. There it is. As Neville admitted, it doesn't have much to do with a reform of the school system."

[When did Neville admit that? I don't remember it.]

> "There it is – *OZ* 28 - on sale in Great Britain. So much of the defence has been based on the assumption that much of the material in *OZ* 28......

[...and again, the Judge held it up and then dropped it disdainfully on the bench].

THE TRIALS OF OZ

> "...such as drugs, for example, has nothing wrong with it; the problem is how to 'deal' with it, or, in other words, how to 'score' best. Note also the cartoon in the centre spread which is about [...**pause**...] ...fellatio - I wonder how many of *you*, Members of the Jury, had heard of fellatio before you came into this Court?"

[Really?]

> "'I can see,' said Mr. Neville who has no experience of children, 'that fellatio is quite alright for children.' This centre spread went in very late on - it is admitted; and you may wonder why. Well, there we are.
>
> Of course, it's perfectly all right to dissent, to differ; but what we must ask ourselves is what about the method used here?
>
> Neville openly talks about drugs, illegal drugs, and advocates their use by other people's children. And he is an editor of the magazine. But look at the small ads. What do they contain?"

At this point, Argyle held up his hand and enumerated the box numbers with his fingers, slowly and carefully, pausing long after each item.

> "Number one - dirty stories. Number two - dirty postcards [...**Pause**...] Number three - call girls [...**Pause**...] Number four bisexual young men, committing sodomistic practices [...**Pause**...] Number five - group sex [...**Pause**...] Number six - submissive males [...**Pause**...] Number seven - male models [...**Very long pause**...]
>
> Nothing to do with sex? Really? It's a matter for you. A matter for you."

In legal circles, Argyle is known for the severity of his sentences. He always sentences people for five or three years.

> "And then we came to Mr. Melly," he went on, "and very verbose he was. He mentioned cunnilingus - and again, I wonder how many of you, ladies and gentlemen, had heard words like that before you came to this Court? Mr. Melly told us that pop is an impoverishment of the language. 'I use words like "cunt" and "bollocks" in front of my children,' he said. Well, there it is. Melly said 'publish everything'. I asked him if he really meant everything? Not hard porn, he replied, although he did add that there was nothing wrong with hard porn in itself.
>
> So again, ladies and gentlemen, I direct your attention to the small ads, particularly the *Suck* ad which, everyone admits, is hard porn. The question is how *did* these ads come to be there?
>
> Then there was Caroline Coon - but did she *really* assist the defence with regard to obscenity? Some of you may think that she sounded like an old fashioned British Imperialist; she reminded us that Middle Eastern countries have stiff penalties for hard drugs."

[Had Argyle forgotten that this was in response to his own promptings?]

> "These countries, ladies and gentlemen," Argyle went on, "have 30 generations of experience. It's all right, you may think, for hash or pot to destroy other countries, but here it doesn't matter.

What Miss Coon's views on sex are we don't know, and perhaps it's just as well. After her, we got down to the more sordid details. There was a Mr. Smith - I don't think we need comment about him.

Mr. Anderson was asked about the *Suck* advert, which describes fellatio - 'many children experiment like this before having intercourse,' he said.

You may find that very surprising. We don't know who the character 'Berti' is in the magazine, yet you may consider that she is a prime example of 'the certain other young persons' who had conspired.

According to Neville, Berti is full of hate for the police because her friends have been sent to prison. In fact, ladies and gentlemen, we do not send people to prison who are under 21, except in the most extraordinary of circumstances. Berti is described in the magazine as 'Jail-Bait'; I wonder, ladies and gentlemen, how many of you knew *that* expression before you came to this Court?

As 'Jail-Bait', she is nubile and able to be . . . able to have sexual intercourse. She tries to be happy, she says in her biography, and deserves to be. Well, that's a matter of opinion."

In 1967, in sentencing a Jamaican to five years for possessing cannabis, the Recorder of Birmingham, Judge Michael Argyle, QC, said this:

> "It has recently been said that the dangerous drug marijuana, or cannabis, should be removed from the list of dangerous drugs.
>
> It has also been said that to punish persons using it, or dealing in it, is unfair.

Berti, 15. Aldershot. Pisces. Female despite name. Small dark, fragile and very beautiful, fringes and velvet. Amazing artist. Very gentle, very quiet. Her ideal lifestyle involves the formation of a commune. Her instinct is towards trusting people rather than not. Is secure about herself 'up to a point'. Likes all colours, wears brown. Tries to be happy, deserves to be. Hello.

> A full-page advertisement earlier this week in a national newspaper (*The Times*) signed by many persons in prominent places in this country, said that persons dealing in cannabis, or using it, have been exposed to public contempt in Court, insulted by uninformed magistrates, and sent to suffer in prison.
>
> In the City, and in this Court, the question of cannabis is not an intellectual or an academic exercise.
>
> We've seen in this Court over and over again, kids - one cannot describe them as anything other than children - from good homes, and with good work records, suddenly, literally, change their preferences in every way, finishing up as what can only be described as human wreckage.
>
> So now we come to the expert witnesses,"

Argyle continued at the Old Bailey.

> "Much of what they say is very favourable to the defence, I admit. But you, ladies and gentlemen, have to look at the double standard of these so-called expert witnesses. They all started off by saying that nothing in this magazine was obscene. Some said that it was all very well to let other people's children see it, but not their own."

[Oh, really? Which one? There were none that I recall.]

> "Eventually, most of them had to admit that the magazine was obscene, or else tell lies. There was Dr. Haward and his qualifications. You may think them very important. But, like many experts, he didn't know what 'Jail-Bait' meant – he had to have it explained to him. He said that many of the cartoons in the magazine are aversive. But this is surely the key. You don't need aversive treatment until you are ill. And were we to assume that the readers of *OZ* were already ill? The Furry Freak Brothers, he said, is aversive. But, ladies and gentlemen, if you really find that an edifying cartoon, lifted as it is out of an American comic, well, there it is with its gags about pig-fuckers [...**pause**...] yellows and reds. Dr. Haward also said that children's intelligence is limited,"

[Did he?]

> "...and may be confined to pictures."

[Ah, but that's a different point.]

> "So, ladies and gentlemen, don't worry about the text, don't worry about the words. Just look at the pictures when you're trying to decide if it's obscene. There's nothing *wrong* with some of them, he's saying, because they're aversive! But aversive treatment is for ill people, isn't it? This was the first issue he had ever seen; he found some of the illustrations offensive, but, then, he was middle-aged and square. Much of *OZ* was a cry for help, he said, but the magazine didn't offer any."

[Haward had also said why it didn't. Had the Judge forgotten?]

> "'Cunt' or 'bollocks' did no harm, but he didn't use them in his home. Rupert Bear would offend well-brought up children; we use it for sick minds, he said."

[He didn't - at least not in so many words.]

> "Oral sex may be socially desirable, but it was not necessarily to be recommended."

The smooth voice rambled on. He was making a good and honourable selection of the material available to him, was the Judge.

> "Then there was Dr. Schofield," he continued, "a Fellow of Clare College, Cambridge. There was nothing in the magazine to encourage the taking of drugs, he said. A large part of this magazine was not depraving; it was put out for a giggle. If it had not been for the police, it would have been forgotten long ago.
>
> Maybe. But *we* know about the previous warnings and the difficulties with the printers, don't we? The contributors were not typical, said Schofield, of the regular readers. Having white-washed pages 10 and 11..."

[The ones with the schoolmaster masturbating.]

> "...he then said that the cannabis laws encouraged malpractices among the police. I suppose that is a very interesting point of view. Yet he is not married and has no children. None of the drawings in *OZ*, he said, would have had any effect - do you believe that? Do you? "There *is* such a thing as obscenity", he said. "I am not saying that *OZ* is good; but nor is it bad. As to 'fucking-in-the-streets' - it is absurd to suggest that this is what it says". And so, looking merely at the photo of the authoress of that particular phrase, he said; "I can *guarantee* that she would not do it"," with which assertion, Argyle picked his teeth with his little finger.
>
> "Dr. Klein, who affirmed, was next - a lady of Dutch birth."

[Was Argyle implying that a witness who affirmed was somehow not to be trusted - especially if she was Dutch?]

> "She thought the Siné cartoons were reassuring. But you had to be very careful, she said, with unformed minds. The mechanical aids advertised were primarily for divorcees. No doubt, ladies and gentlemen, you remember her. Whenever she was asked a perfectly simple question, she waited before she replied and seemed unable to answer.
>
> "What is pornography"? She was asked. She said she didn't understand the question. "Cannabis should be legalized", she said, "so that children can find out for themselves". If you find her evidence totally incredible, or that she was just being evasive, you are quite entitled to do so. She said that she never made general statements but she was quite prepared to say that cannabis should be legalised so that children could find out for themselves. She said to Mr. Leary: "I am closer in touch with young people than you are". Yet she did not understand the meaning of 'grass'. She said that the girl in the 'Pud' cartoon being forced to suck off the bully is 'winning'. When I asked her what that meant, she said that it doesn't appear that the girl is biting his penis.

Well," said the Judge, lifting up his battered copy of *OZ* 28 once more and then dropping it, "...there we are."

"Next was Mr. Segal. You may think he has changed his role in life with very great personal success. He gave up being a probation officer in 1966 and is now a freelance film producer. He too went through the pages of the magazine and, of course, gave it a good report."

[Of course.]

"He'd read several pornographic books and films out of curiosity, and the books were more erotically stimulating. He was in favour of children satisfying their sexual curiosity, although he agreed that the Rupert cartoon was in bad taste and said the schoolmaster cartoon was grossly offensive."

[When? Where?]

"Borstal boys and girls, he said, were very interested in blue literature although it could be harmful, even to them. I thought he was a jolly good witness. He wasn't prepared to whitewash all of *OZ* like some of the other so-called experts and I can't say fairer than that."

[No, you can't.]

"And so we came to Mr. de Bono, a gentleman from Malta."

[Malta? Dutch? Foreigners again.]

"The one thing he didn't lack was self-confidence. "Are you a world figure in the field of thought"? he was asked. "Yes, I am", he replied. He himself had written for *OZ* in issue No. 8 - 'Think Sideways with Edward de Bono', it was called. You may remember, ladies and gentlemen of the Jury, the description of *OZ* No. 8 in that 'Back Issue Bonanza'. '*OZ* 8 - the most unreadable *OZ* ever.' *OZ* 28, he said, makes "sex into a caricature. The cover is silly and the sex is unglamorous. Rupert is a cartoon of innocence". These things were stated with great confidence, but he then admitted he had no statistics to support such contentions. As to 'Teacher Loves to Run His Fingers Through my Hair': "...the fairest piece of writing I have ever seen about the attitude of young girls towards the loss of their virginity", he said - and that from a leader of world thought. The subculture now is 'do your own thing'. 'Smile if you had sex last night' does not refer to sexual intercourse; later, he said it might. Later, he said it was probable. He frequently got all his details wrong and obviously hadn't done his homework. Necrophilia was nauseating, he said, but he wouldn't mind his children seeing it. Finally, he said that *OZ* was a window on the world of the hippy culture. Well, ladies and gentlemen, sometimes that window needs cleaning.

Dr. Eysenck said that the cover would not convert people to lesbianism unless such a tendency was genetically there already. Pornography is only sought out by people who already have a taste for it. *OZ* would be read by people who had had some sex or who were abnormal. *OZ* is only marginally pornographic. As to the aversive therapy contained in the cartoon of the school-master masturbating, elderly children might be mildly titillated by it, and, I think, that was the first time we had heard that ghastly phrase. He

admitted that he didn't understand the Furry Freak Brothers so maybe we shouldn't take what he said about that too seriously. You may think, anyway, he went too far. The *Suck* ad, he said, was a standard piece of pornography

The Siné cartoons were disgusting and children would just turn the page.

"Too early exposure to sex", he said, "may well damage a child's personality". He agreed that LSD is a very dangerous drug. The cartoon of the schoolmaster masturbating was disgusting and would be a nasty shock - the equivalent of a dirty old man exposing himself. Other pages were disgusting and unnecessary."

[I must have been asleep when Eysenck said exactly that. I admit it.]

As to Pud; "I have never seen oral intercourse between children portrayed before', he said, 'and children were easily offended by such things".".

The American Presidential Commission goes on:

> "If a case is to be made against pornography in 1970, it will have to be made on grounds other than demonstrated effects of a damaging personal or social nature. Empirical research designed to clarify the question has found no reliable evidence to date that exposure to explicit sexual material played a significant role in the causation of delinquent or criminal social behaviour among youths or adults."

Judge Argyle continued:

> "Dr. Linken was another eminent medical man called for the defence. I hope I've got his name and qualifications down. A South African..."

[Maltese, Dutch, South Africans - whatever next?]

> "...from Witwatersrand University, who had worked in Johannesburg's Children's Hospital and written a great number of books about children between 16 and 30 including *Drug taking among Young Patients* for the Institute of Venereal Disease. And in 1969, he wrote *Drug Taking among Students*. He knows Mr. Neville and said that *OZ* 28 would have been read by a great number of people at upper school and university levels. I find very little in it, he said, that would influence young people's drug taking habits.

> He didn't take the references contained in the biographies too seriously. He thought they were sardonic - even political. Young people usually start on dangerous drugs by the smoking of a joint. He agreed with the concept of doing your own thing. "I personally never give advice", he said. I have standards, but these are not used. 4 out of 20 on drugs, as described in the biographies, is about the right proportion for the people *they*......

[The editors?]

> "...chose. He didn't think that the Furry Freak Brothers had anything to do with drugs, although we know, don't we, that they don't have much to do with anything else? I don't know what smack is, he said, and you may think,

ladies and gentlemen, that is odd coming from a man so expert. However... "It is because of their unreliability that dangerous drugs are a menace", he said. "*OZ* is mainly read by mature, middle-class people. These wouldn't be affected, but others might". 'Speed Freak Fun', he said, uses humour.

Well - there we are.

I do know, Dr. Linken repeated, that organised crime takes part in the use of dangerous drugs.

Mr. Neville, Members of the Jury, mentioned a case at the Middlesex Sessions where there have been accusations of police corruption. But, ladies and gentlemen, the main part of that case dealt with the illegal import of vast quantities of hashish, and has nothing to do with this case.

Dr. Linken then said that he felt that drugs are a psycho-social problem. I feel we've missed the boat, he said. Well, there we are.

He also quoted a 1968 study which showed that there is a high connection between venereal disease and dangerous drugs; one quarter of all delinquents who have VD are on dangerous drugs, and one in five would introduce their siblings to it."

[To what? VD?]

"Siblings, ladies and gentlemen, is a Viking word meaning brothers and sisters. Dr. Linken was the man who had written that article for the *Sunday Times*, you may remember, and the *Sunday Times* was not prosecuted. But then, he admitted, the *Sunday Times* has a fairly limited circulation. And you may think this next piece of evidence is particularly important - that anyone who becomes addicted is psychologically disturbed, whether through bereavement, divorce, or something that had happened in their schooldays.

Next was Mrs. Berg, the author of a number of children's books. She regards herself as an expert on children. She was welcome in most schools, but not all. It wouldn't have bothered me to have had *OZ* 28 in my home, she said. She had a great belief in children's natural morality. "What distresses me", she said, "is that the word 'cunt' is used with such hate - it should be used tenderly. Visiting educationalists", she continued, "are appalled that corporal punishment is still used here. Rupert is not about sex at all" - indeed, a number of witnesses have said that what appears to be about sex, is not about sex at all and we haven't got the message. "In any other language", she said, "these things would be anthropology or sociology". Ladies, and gentlemen, you may think that this is one of the key points - that other language was not used. Look at the *Suck* advertisement. 'Incomprehensible', she said. And yet, ladies and gentlemen, *all* the words used there are monosyllabic, Anglo-Saxon words."

The Judge then read the offending advertisement - very slowly and pondering over each phrase.

"But I can open my throat pretty well if a guy has a really long cock", he read. "'Actually, I prefer one that's not too long - six inches is plenty but I love the fat ones that fill up my mouth. If the guy is really groovy, he's stroking my neck and shoulders and breasts while I'm sucking him - and now he can

say those words, because now is when they're real. I love to hear a guy tell me how he wants me to do it, whether he wants it harder or softer or faster or slower. And I love it when he cups my face in his hands for those last few strokes. By that time, he's pumping and it's so great to be looking straight at his pelvis and seeing it drive his prick into me. And I love the taste - that sharp, salty taste with a bit of chlorox in it. Well, it's just beautiful, that's all - and, like I said, I dig fucking, too, but I never want to give up sucking!'"

Mrs. Berg said it would be utterly *incomprehensible*. Do you believe it? Do you? Really?

Siné - she found that funny. Mr. Neville then asked her a number of questions, particularly about children being sent to prison. Well, the minimum age for that is 17...

[A little while ago he had said it was 21]

"...so I don't know what she meant by that. It wasn't clear to her that the woman on the cover was wearing a dildo and, anyway, no young man, she said, would be interested in these lesbian postures. "Adults are hypocrites", she said, "but I am able to look at this with the eyes of a child". You may think, ladies and gentlemen, that this is one of the witnesses who brought in a great deal that went far beyond the confines of the trial. If you accept that it wasn't clear to her that the woman on the cover was wearing a dildo, then you are entitled not to believe her evidence.

It's a matter for you.

With John Peel, we came to the first mention of music in this trial. You may think it was not at all helpful either to the defence. When he had his radio show, *The Perfumed Garden,* he had got 200 letters a day, although he didn't say whether they approved or not. "My sort of music", he said, "is made by honest, genuine people, and is out. But it is durable and will be heard in a hundred years".

Well, we shall never know. As to 'Brown Shoes Don't Make It' - its author had not been exploited by people who were in pop to make money. The *Led Zeppelin* were English and the Jeff Beck piece was a good article, and he thought it was Art.

Well, ladies and gentlemen, you've read it. "Our policy", Peel said, "is to give musicians complete freedom". As to 'fuck music' - "I use the word "fuck" because I'm in Court", he said.

[He did not.]

"On radio it wouldn't be allowed! There is a connection between pop and sex", he said. "And *OZ* is here in Court because people think they're missing something".

Next, we had Mr. Dennis, who recounted how the magazine was put together. You may have found what he said very interesting. I wonder. All the ads were

seen by the schoolchildren, except for Print Mint (the one that included the *Suck* advertisement) which arrived very late. Well, we haven't seen any of the school kids, so we don't know.

"As a professional", he said, "a lot of what the school kids had done was a disaster. But this is what they wanted. 'The Back Issue Bonanza', he said, 'was written by himself and Richard. The kids thought it was very funny" - although we haven't heard any evidence about that. As to the small ads - he said he'd only recently put up the rates to discourage such advertisers. In answer to Neville, he said that a 'freak' was someone who didn't work from 9.00 to 5.30, and he then gave a demonstration in the witness box of the Black Panther salute.

'Fucking in the streets' did not mean open copulation, but free sexuality. You are entitled to ask yourselves, ladies and gentlemen, *why* use *those* words? Publicity from this trial, he agreed, would sell a lot of copies of the next issue.

He said that the kids had not been exploited because they had only been paid expenses. Remember his description of what he called the 'harassment' of Detective Inspector Warren? 'You're pushing it'. He is, of course, entitled to complain. But it's a matter for you, ladies and gentlemen, a matter for you. After *OZ* No. 23, he confirmed that they had been called to Scotland Yard and there warned officially; and yet he was surprised that they were prosecuted.

'Obscene', he thought, meant not talking openly about VD.

The magazine was read by about one in every hundred of the population, and this is very important, ladies and gentlemen of the Jury. Because what you have to consider is whether the magazine, by its obscenity, will tend to corrupt a *significant number* of people."

[Who has said it's obscene — yet?]

"LSD, he said, is a very dangerous drug", unless taken properly, and he agreed that the *Suck* advertisement might titillate some younger readers. He personally had pasted up the small ads page. "Homosexuality", he said, "is not a perversion". Well [...**pause**...] there we are.

Group sex? – 'I do not disapprove of it among children', he said; 'it depends on the circumstances.'"

[That is a travesty of the discussion that I recall between Leary and Dennis, to put it mildly.]

"He agreed that the centre spread was a great success because a great number of people must have read it. "We don't recognise copyright", he said; "I can see no objection to lifting things from other people's publications". Well [...**pause**...] there we are.

"Most young people I know", he added, "when talking about cannabis call it 'shit'."

Then we had Mr. Dworkin, a Professor of Jurisprudence, no less. He was brief, fortunately. He told us: "I am the expert in public morals". And he then gave us a lecture on morals which, I am sure, was of great benefit to all who heard it. This prosecution, he said, would be unconstitutional in the

> United States. That may be. But we are not, as yet, an adjunct of the United States.
>
> It was interesting to me that such a man could have walked into this Court and, without having heard any of the evidence, tell us that the entire prosecution was a corruption. So you can attach what weight to his evidence that you wish.
>
> Mr. Duane arrived next, but I'm not intending to go through his evidence because the burden of what he said was the same as we'd heard from a great many other witnesses."

[Well, not quite.]

> "'The sex references', he said, 'are not about sex at all' - you may, ladies and gentlemen, consider this a dangerous line to take, but he took it.
>
> Some of his evidence, moreover, had nothing whatsoever to do with this trial. The people who had brought this prosecution were apparently mentally deranged. 'Children', he said, 'had a strong sense of justice'.
>
> Mrs. Berg was well known to him and had written a book about him called The *Rising Hill Affair.** [sic] He also knew Mrs. Berger, although this was not in any way relevant. He too had never read *OZ* before. 'If I discovered one of my pupils had this issue', he said, 'I would discuss it with him and hope he would throw it away'.

[A mistake, to put it mildly. Duane had said no such thing. What he had said was that he hoped such a pupil would throw any *hard porn* away.]

> "'It is disgusting', Mr. Duane had said.

[Did he, Duane, say that? And, even if he did - which I do not recall - was that really the import of what he said ?]

> "Mr. Mervyn Jones was called as an expert on literature. He had written three serious books, but none of them had anything to do with this case".

[Who had said they did?]

> "He is writing a book now about a hippy and a businessman, where the hero - a businessman - is bewildered by his encounters with the hippy culture. Well [...**pause**...] there we are. It was a very great encouragement, he said, to any young person to get anything published. "We were very short of good writers - especially young ones". No-one, I think, would disagree with that. He sometimes uses the word 'cunt', but tries to use it accurately and not as a term of abuse. "The suppression of ideas goes on all the time", he said. "There was no expression of tenderness in *OZ*, but there was love". But then, *he* writes mainly for adults.

* Leila Berg's book was actually called *Risinghill: Death of a Comprehensive* (Penguin 1968)

Next, we had Mrs. Berger - if you choose to accept what she says, you may find it does corroborate what her son said, about whose evidence I warned you yesterday. She is now Chairman, no less, of the National Council of Civil Liberties. It was untrue that her son had smoked at 9, and tripped at 11. Other editions of the magazine were usually left in Viv's room, but this issue she had twice been forced to show to her nine year old daughter.

[But didn't she also say why, Mr. Argyle? Didn't she?]

"I am not ashamed of Viv," she said. Mr. Topolski was a little unlucky, since he had only been asked by the defence to look at certain pages. He was very embarrassed by his inability to recognise the qualities of the other pages. Well [...**pause**...] there we are.

The difficulty of accepting what he said, is this: he claimed that any visual drawing done earnestly, is Art - possibly, he added. Possibly, but *is* it Art?

When he was shown some pages, he thought they were schoolboy Art; Rupert was satiric Art. The Furry Freak Brothers, cartoon Art. Siné was Art. Snoopy was Art. "I wish to bracket Mickey Mouse with Rembrandt", he said".

[He did not.]

"Mickey Mouse was now considered High Art. The small ads were advertising Art. The photograph on the ads page was photographic Art.

Well..." once more lifting up his copy of *OZ 28* and then dropping it, "...there we are.

So that was the end of Mr. Dennis' case.

Now Mr. Neville called Marty Feldman. He spoke at 250 words a minute, which was too fast for the very expert shorthand writer that we had here, so his evidence was taped. "Nothing offends me", he said, "but then, I am not easily offended". He compared *OZ* with *Punch* which, he said, had had an obscene cover for over a hundred years. In reply to a question from Mr. Leary, he said that *The Bible* was obscene. You may remember that Mr. McHale had quoted earlier 'to the pure all things are pure'.

Mr. Feldman repeated that "there was more obscenity in *The Bible* than in this issue of *OZ*", and that he thought "*The Bible* was un-Christian". But I would remind you of the well-known words in the *Book of Matthew**: 'But who so shall offend one of these little ones which believe in me, it were better for him that a millstone were hanged about his neck and that he were drowned in the depths of the sea'."

It may be interesting to note that the charge – 'Conspiracy to Corrupt Public Morals' - is nearly as old as the translation of *The Bible* from which Judge Argyle quoted. In 1663, one "Lord Sidley relieved himself from a balcony in Covent Garden upon the passing crowds below. *Law Reports* described it as 'pissing'.

* Matthew 18:6

To their surprise, the Judiciary discovered that no law existed to deal with his Lordship's behaviour, and so hurriedly invented this new common law offence to prevent such eventualities from happening in the future. Following an indictment, the offence was to be tried before a Judge, with no limit on the sentence and/or fine that could be imposed. By the 20th century, the offence had faded into obscurity. Indeed, not one single charge was brought between 1900 and 1961 when a man called Shaw started up a *Ladies' Directory* which, in effect, was a prostitutes' *Who's Who*.

Shaw was convicted and sentenced to two years. Apart from the successful prosecution of the *International Times*, the Director of Public Prosecutions had only used this archaic law on one other occasion - that of *OZ*. Had the defendants been tried before a Magistrates Court on obscenity charges alone, the maximum penalty would have been a fine of £100 or six months' imprisonment. But because of the conspiracy charge, they were never given this possibility. Parliament had not been unaware of the absurdity of the conspiracy charge. When the Conservative Government introduced its amendments to the Obscene Publications Act in 1964, Sir Peter Rawlinson, then Solicitor-General, gave a categorical assurance that legal proceedings would never be used...

> "...so, as to attempt to evade the statutory defence of public good."

In other words, the statutory charge would not be invoked as an excuse whereby to examine the life-styles of defendants charged under the Obscene Publications Act.

> "A conspiracy to corrupt public morals,"

Rawlinson said again in the House of Commons,

> "...would not be charged so as to circumvent the statutory offence."

This statutory defence should have ensured that, in this case, the witnesses were not cross-examined about their personal beliefs, whether about drug-taking or sex. It did not. Sir Peter Rawlinson was (in 1971) the Attorney-General.

> "Finally," continued Argyle, "Professor Wollheim said nothing that had not been said before, except that this prosecution would suppress liberal thought. And before I finish, ladies and gentlemen, I want to remind you of the evidence of Detective-Inspector Luff. He was called first, but his evidence comes last in the story.
>
> About that evidence, there is remarkably little dispute. He told us of the visit to the *OZ* offices at 52 Princedale Road on Monday June 8 at 3.30 in the afternoon. There he found a small ground floor office, about 12 feet square. When Anderson arrived and was asked about *OZ* 28 he said; "It's terrific, don't you think? I'm proud of it!" Mr. Dennis arrived and said to the Inspector: "You just don't understand what we're doing". And later: "Right on; be sure you get that right. OK. So you'll get us under the Post Office Act, but not the other one".
>
> In cross-examination, Mr. Luff agreed that previous issues had been seized, but returned. "I was not trying to close it down", he said. "I'm not qualified to say if it has corrupted me", he went on, "although the article about sucking penises dirtied the mind". He agreed that the accused felt that what they were doing was not obscene, but good. The complaint was

passed on to the Director of Public Prosecutions on June 5, and the search warrant obtained on the 8th. I want you to remember those dates, ladies and gentlemen."

During his seven hour summing up, Judge Argyle summoned the Court Sergeant three times and ordered him to maintain absolute silence throughout.

"Then we had the closing addresses," said the Judge. "Mr. Leary for four hours. Mr. Mortimer for six hours. Mr. McHale for two and a quarter hours and Mr. Neville for four and a half hours."

(It may have seemed that long to Argyle, but, in fact, Neville only spoke for two and a half hours.)

"I shall not refer to them as they do not form part of the evidence. Except for one thing. Mr. Neville compared the Court with Eichmann who had also considered that he was just doing his job. "Was this case political"? he asked. It was the prosecution who were harassing the children and not the defendants.

Now you may remember those dates, ladies and gentlemen, those dates early in June last year. They coincide, do they not, with the last General Election? I don't know if that is relevant but there is the suggestion that somehow a political party initiated this prosecution. You may think, ladies and gentlemen, that that suggestion is ludicrous. Let us try to keep this case in proportion. This is not a case of the Government trying to crush some small magazine because it frightens them. The defendants are not being tried over this issue of the magazine because, as individuals, we may think its contents are nasty or dirty, but because it is alleged that these articles, and the magazine as a whole, infringe the obscenity laws of the country. We have quite enough on our plate in dealing with the charges against them without having to consider any wider implications."

And so the Jury retired at 12.45 p.m. on the 26th day of the trial, to consider their various verdicts. They returned after two hours and 25 minutes with a note which was passed to the Counsel, to Mr. Neville and finally to the Judge. It said that the Jury had failed to agree and would the Judge please re-define 'obscenity'.

"First of all, the Crown has to prove obscenity", repeated the Judge, "...and not the defence, before you are entitled to say guilty. The test of obscenity..." he reiterated with obvious annoyance, "...is whether an article shall be deemed to be obscene if its effect, if taken as a whole, is such as to be likely to tend to deprave or corrupt. May I also remind you again..." Argyle went on, "...of the definition of obscene in the dictionary. It is from the Greek – 'ob-scene; not appropriate to be seen'."

And then, once more, he read out the key words, very slowly and painfully.

"Repulsive, Filthy, Loathsome, Indecent. Or Lewd. Or any one of those things. An earlier judgement said: 'to make morally bad'. To infect, or taint. To destroy the purity of. The Crown has to prove, moreover, that a significant proportion would tend to be depraved or corrupted. Now just because this case has been going on for so long, ladies and gentlemen, this doesn't necessarily

mean that it is difficult. So would you think again? Go back and try once more."

While the Jury were out for the second time, I too looked up the dictionary definition of 'obscene'. Argyle had made a fatal slip, or omission. Repulsive, filthy and loathsome were described as archaic meanings of the word obscene. This only left indecent and lewd, or 'leooo-ed', as he pronounced it. According to the same Shorter Oxford dictionary that Argyle had consulted, lewd meant indecent. Which left indecent. And indecent, as everyone had agreed, was a matter of opinion.

It was, by now, the longest obscenity trial in history, and after three hours and 20 minutes, the Jury reappeared again - but with another note. This said that one of their number still disagreed with the majority verdict. Argyle, by now visibly angry, said that it was only necessary that 10 should agree for a verdict to be reached.

"But please try to agree," he said, and sent them out again.

At 4.49, they finally returned, having been considering their verdicts for three hours and 43 minutes. The three defendants and the Company were found Not Guilty on Count 1, the conspiracy charge - a unanimous verdict. A sigh of relief went round the Court Room. Guilty on Count 2 - publishing an obscene article - a majority verdict, 10 to 1. Guilty on Count 3 (also a majority verdict) - sending such articles through the post.

"We find the article obscene and indecent," ...said the Foreman.

And Guilty on Counts 4 and 5 (also majority verdicts), having such articles for profit and for gain. Vivian Berger was at the back of the Court, crying. He was told by a police officer to stop crying or get out. There was a scuffle and both he and his mother were manhandled out of Court. It had taken 10 minutes for the Foreman to read all the verdicts.

The Judge asked whether deportation papers had been served on Richard Neville who was, by birth, an Australian. Detective-Inspector Luff said they had. Argyle then said he would hold the three of them in custody pending antecedents as to the characters of the three accused, and until such times as they had been interviewed by a probation officer and full prison medical, psychiatric and social reports had been prepared. Mr. Mortimer got up to protest; it was inhuman to keep them in suspense, he said. Neville did likewise.

"It was all a lot of bureaucratic nonsense, as you well know," he shouted at the Judge.

"I do not accede to your requests," said the Judge. "Send them down."

There was booing and hissing in the Court Room. In the hubbub, the Judge thanked the Jury for their patience and dismissed them for life.

"Although the result has nothing to do with me," he said, "may I say how much I agree with the verdict."

That night, Independent Television News carried a brief report of the proceedings which only made mention of the charges and the verdicts. Andrew Gardner, the newscaster, then added:

"The prosecution said that the subject matter of *OZ* was homosexuality, lesbianism, and sexual perversion."

Next morning, the *Daily Telegraph* printed the following leading article:

> "So Mr. Neville and his two colleagues have been found guilty of publishing a dirty magazine, namely the 28th, 'schoolkids', issue of *OZ*. Judge Argyle remanded the three in custody, saying that he wanted 'social, medical and mental' reports about them before pronouncing sentence. That, in our view, just about puts the matter in the right perspective. These people, and others like them, may not be potty in a technical sense, but their state of mind almost certainly requires expert examination. They may, of course, just be in it for the money (and the 27-day trial, in which they have all been legally aided, has resulted in publicity which should greatly assist their future money-making capacities), but there must be more to it than that.
>
> They seem to belong, in fact, to the great amorphous group existing in non-dictatorship countries which gets a kick out of pretending to be out to 'destroy' society. It is particularly disturbing

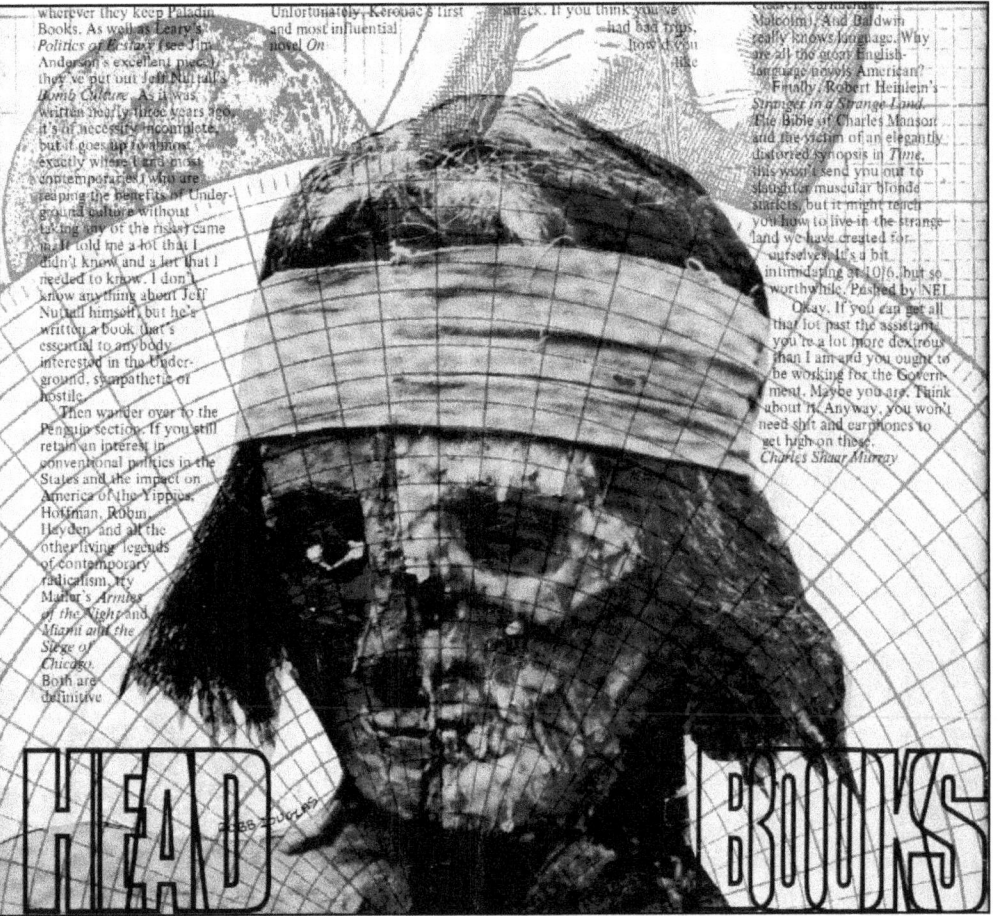

when these people turn their attention towards young children. Innocence is a great protector. They go out to break it and remove the protection. Most children are unaware of sadism or homosexuality until they are told. Telling them with lurid details must risk corrupting them. An American directory describes the enemies of the 'underground' as being 'ourselves, our parents or our own elected governments'. In listing countries with 'underground' papers, it does not include any East European country, Russia or China. Freedom of publication democracies must have; but also vigilance and firm action against obscenity pedlars."

The *London Evening News* followed up in similar vein that afternoon:

"It was appropriate, you may think, that the Judge in the *OZ* case sent the defendants for medical examination. There must surely be something wrong with the minds of men who not only produce a magazine like that for children but enlist the help of children in producing it. There is surely something else wrong with their minds if they think that their irresponsible activities are going to help the cause of those who wish to see an end to all censorship. The jury have condemned the shabby little magazine as obscene. Their decision will delight the would-be book and picture-burners who would love to extend censorship even into the areas of serious art. The defendants in the *OZ* case have, therefore, not only offended against the laws; they have offended against the very cause, they, perhaps cynically, claimed to serve."

The following day, Charles Curran, the Conservative Member of Parliament for Uxbridge, wrote:

"Why should the Law bother about obscenity? Is it a matter of opinion? Have we any right to act as censors? Fair questions these. To answer them, we must do what the Jury did - and take a look at *OZ*. *OZ* No. 28 was labelled 'School Kids Issue'. 20 boys and girls all under 18, were invited to contribute to it. They did too. One of them was a boy of 14. He drew some pictures of a bear having sexual intercourse with an old woman. These were published. So were articles extolling various sorts of perversion.... Among the activities advocated were sadism (which means getting sexual pleasure by the infliction of cruelty) and necrophilia (which means making love with a corpse) The people who produced it

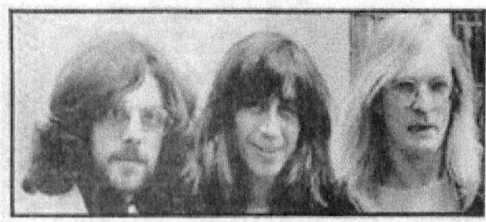
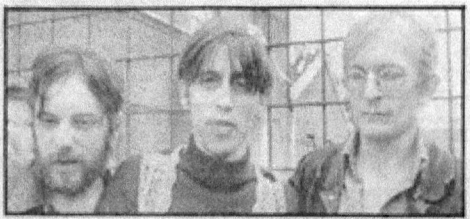

were making money out of it. Professional pornographers who suppose that anything goes in the Britain of 1971, are making a mammoth mistake. After all, an Old Bailey jury this week convicted the publishers of *OZ*. I applaud that Jury. I believe that it spoke for 99 per cent of the British people."

Two days later, an application for bail pending sentence made before Lord Justice Karminski, Mr. Justice Lawton and Mr. Justice Forbes was turned down, although a limit of one week was set on the time the three accused could be kept in prison awaiting Argyle's decision. Argyle was referred to as 'the Judge below'. While being held in custody, the three accused were forcibly shorn of their shoulder length hair. *Ink*, the weekly newspaper of which Neville and Dennis were two out of the four directors, announced that its next issue, No. 15, would be its last until further notice.

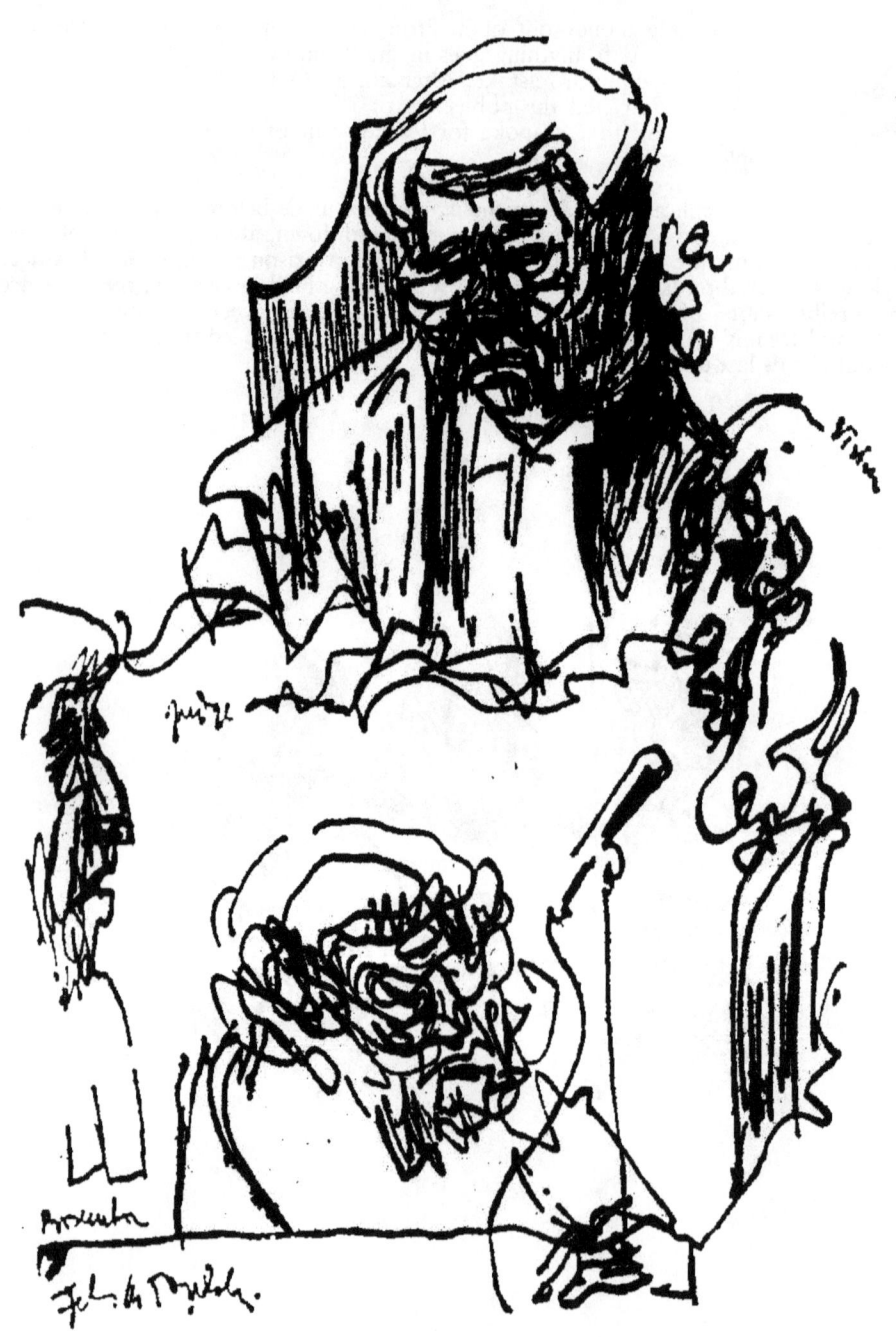

CHAPTER ELEVEN

Thus, suddenly, it was all over. More than £80,000 and five and a half weeks after the 'Friends of *OZ*' had marched bravely from Lincoln's Inn Fields to Smithfield Meat Market, the Trials of *OZ* had eventually ground to a halt - for the moment. Passions spent, eloquence exhausted, arguments defeated, the Jury bewildered - could it really be that we had witnessed the Great Debate about censorship and the freedom of speech that we had been promised? The diligence of the Law, which had compelled us, time after time, to consider what was, after all, not a very good issue of a not very important magazine - can that diligence be said to have been justly rewarded? Could the bumbling childishness of the prosecution with its apparent relish for dirty old men in mackintoshes and its obsession with filth and perversion hidden, somehow, in every syllable; could the perniciously wicked questioning and summing up by Judge Argyle; could the witless and mostly inaudible interventions by Mr. McHale for the Company; could the self-important and constantly busy defence solicitors dragging up witness after witness, some good, mostly bad - could all this be said to have been a credit to that law?

"Well, man, that finishes them as credible leaders of the alternative society."

Maybe. But if so, and if one assumes that the workings of the English law ensure a fairer trial than any other, then this doesn't say much for the rest. Quoted out of context, the transcripts of the proceedings read better than the Marx Brothers. Witnesses of the highest integrity were mocked and made to sound absurd; like the Professor of Jurisprudence from Oxford University who maintained that, in the United States, a trial such as this would be unconstitutional. Yes, thank you, said the Judge, and showed him the door. Like the Professor of Psychology who was told he didn't really comprehend

what the magazine was about because he hadn't understood some of the jargon contained therein.

Much of what actually happened never reached the newspapers. Some of the crime reporters obviously could not follow the tenor of the debate. "Bloody rubbish," one said to me after Professor Wollheim had affirmed that what was on trial was not a magazine and its three youthful editors, but the way of life which they seemed to represent. For the most part, it was a trial that few cared about and with which few felt involved. Yet, as Mr. Mortimer said, it was cases such as this which decide what it is that we can print and say in public, without fear of prosecution. It was a curious twist of irony, therefore, that what was sometimes written up in any particular newspaper merely reflected the scandal-seeking attitude of its editor. Too busy listening for the smut, some of the hacks of Fleet Street missed the detail, and missed the atmosphere in which this parody of justice had been enacted. Like the Judge, who studied a road map of England (or was it Greater London?) when witnesses seemed to displease him; like the police, who passed little notes to the crime reporters which apparently contained extra bits of lurid information. Like the Detective-Inspector, a sincere although, perhaps, misguided man, who padded seedily around the Court Room offering advice as to how the prosecution should and must be conducted. This was not a theatre or a theatrical entertainment, warned the Judge. Indeed it was not, for at such events, humanity, intelligence, humour and a knowledge of the world as it really is, play their part.

In Court Room No. 2, however, laughter was forbidden, except when the Judge found something amusing. The visit of the American Bar Association halfway through the trial which noisily treated the spectacle as if it were some geriatric circus; the hordes of Conservative Association Ladies who thought it was all part of some fund-raising Garden Party; the distinguished cast list of extras including Sir Alec Guinness and Sir Alec Douglas-Home who just popped in for a peep - what can they have imagined they were coming to see? Long-haired sex-maniacs about to be hanged by their balls? It was all good sport; unless, that is, you were in the dock.

The Spectator, almost alone among the regular Fleet Street journals, carried an anonymous editorial which differed from the majority.

> 'However corruption may be defined', it began, '...it involves change. It is obvious that the published word can affect, which is to say change, behaviour: in their different ways *The Bible* and the Koran, Newton's and Einstein's laws, *Das Kapital* and *Mein Kampf*, have changed men's beliefs about the world around them and have consequently changed their behaviour. On a more humdrum level, journalism neither would nor could exist unless it were generally believed that writing about the affairs of the day might affect behaviour. It is axiomatic that the Press, whether or not it be mightier than the sword, exercises some influential power.
>
> And before anything else is said, it must be stated that freedom of expression is a very important good indeed. The best test between a 'free' society and a dictatorial or totalitarian, or communistic, or fascist society, is the degree of freedom of expression which is tolerated. Many would say that freedom of speech itself - the simple freedom to say out aloud whatever a man wishes to say - should be without any legal restraint whatever. Others would argue that such freedom be limited only by the obligation not to cause religious or other offence, and there is a

censorious orthodoxy which preaches that to utter words which incite this or that disharmony should be a punishable crime.

The framers of the American constitution have taken the view that the good of the freedom of the Press outweighs the bad, and that in the long run society is better preserved or less corrupted by license than by censorship. In this country, bereft of any written constitution or of any entrenched Bill of Rights, we have been inclined to take comfort in the supposed freedom and responsibility of the Press, while restraining the general freedom of expression so that nothing much is written, said or done which would outrage the respectable or cause affront to the genteel.

A compromise has been achieved whereby it has been comfortably believed that the Press, in the exercise of its liberty, has restrained itself from becoming licentious, and that thereby the evil of excessive censorship has been avoided.

This uneasy compromise has now broken down. Something like a total freedom of expression is claimed, and in part exercised, in publications and in public performances. In their different ways, sex films, the *OZ* trial and Lord Longford's private commission on public pornography, illustrate all too well the nature and the extent of the breakdown of which they are themselves symptoms.

Should efforts be made to halt this drift? The answer which leaps readily to mind is, 'Yes!' There is no reason to suppose that adults and adolescents and children who are constantly exposed to sexual titillation of one kind or another (and who provide a ready, large and growing market) are not to some extent affected by what they choose and pay to read or see. But is the change in behaviour a corrupting change? There is very little evidence that it is. There are those who argue that because something is obscene or offensive in itself it ought to be banned, whether or not it corrupts; but it is very difficult for the Law to take a stand on matters which essentially are those of taste and are subject to fashion.

The reverse argument, more frequently used, that what may be obscene or offensive in itself may nevertheless be permissible or desirable in its context - that art (or religion, or politics) may justify the otherwise unjustifiable - this again requires judgments to be made which courts of law are neither suited, nor designed to make. The tendency of the Law to make the test not that of taste but of corruptiveness, has had the effect of increasing the permissible without removing the confusion. The irony is that a Jury of average people, if they were dealing with a publication likely to be read by a significant proportion of average people, can with honesty only declare a publication to be depraving and corrupting if they themselves have been depraved and corrupted as a consequence of their jury service.

It may be that descriptions or performances or representations of sexual behaviour do in some cases both deprave and corrupt their readers or witnesses, or indeed their publishers, authors and performers; but if the consequential depravity and corruption is small and incapable of proof, then it might be better not to seek to constrain such publications and performances by law at all.

There is much that is offensive to many people which the Law takes no account of. A manual on the manufacture and use of small arms or bombs, or gases, or drugs may well be far more depraving or corrupting than any manual of sexual techniques. The practices of governments and police forces and armies may be far more depraving and corrupting than any conceivable orgiastic description or performance. Those who argue that the real obscenities are the public violence of States may well be on far firmer ground than those who seek, from the most honourable motives, to halt the general drift towards an almost unconstrained freedom of expression. The right of any man to express himself as he wishes should not be constrained unless he interferes with his neighbour's right not to listen or to look."

And so what, if anything, was finally achieved by those 26 days? Were any great principles of justice established beyond all reasonable doubt? Had society really turned into a new and darker alley of permissiveness? Would Lord Longford and his gang of public reformers gain fresh evidence for the degeneracy of youth that some of those on his 'Committee against Pornography' seemed to believe was the root cause of all our evils?

Probably - who could tell? Only the passing of events will enable a true historical perspective. Only then will we know whether this trial stood at the cross-roads of the long battle against censorship, as the defence maintained, or whether, in fact, it was a speck which diminished even in the memories of those it had affected most deeply at the time. It is possible to argue, of course, that if one were to look upon this trial as merely a conflict between the Establishment and the young, then the Establishment came off far better. Whereas the straight press occasionally was a model of tolerance towards the Underground in that it allowed unorthodox ideas to be fully expressed, it is doubtful whether in a similar situation the underground press would have been nearly as tolerant towards, for example, the *Daily Express* had that newspaper found itself charged with obscenity.

"Sir! It's about the obscene drawings in the prison magazine!"

It is a known psychological fact, moreover, that children are disturbed by anarchy, by the lack of rules. And it is assumed, therefore, that their parents will inculcate some sense of discipline in order to combine mutual tolerance and respect later on. Yet it is precisely this responsibility which the young seek to throw off.

Thus, the total freedom advocated by the Underground is probably the cause and not the result of much of the present tension, and the *OZ* affair unwittingly highlighted this dilemma.

Further, will the youthful editors of *OZ* be as understanding towards their children who might well dismiss some future *OZ* 28 as childish and silly, as they now deemed that their elders be for them? It was a question unasked and, consequently, unanswered.

We are notoriously weak, most of us, about speaking up for our real or imagined liberties and particularly when it comes to matters of moral consciousness. Some matters seem so remote, so foreign to the humdrum job of daily survival. Why should we devote so many hours and so much energy to such peripheral matters, we argue, little realising by such an attitude, we allow a far greater permissiveness than that which we seek to condemn? The drug-orientated, sexually obsessed, flippantly destructive society that we have encouraged, through our laziness, to fester in our midst, is decadent in a way that one hundred million *OZ* magazines could never achieve. And the outrage expressed by those who contributed to the School Kids Issue is but a small cry when compared with the universal moan of oppression that haunts the world.

While the Law saw fit to pounce on what was at the very worst, a juvenile prank, untold horrors of political torture and imprisonment and starvation were being perpetrated by the leaders of societies closely allied, in law, with our own. What was achieved at the trials of *OZ*, therefore, was a denigration of the human spirit, a slur on the conscience of our disintegrating democracy.

You may think these are grand words, out of proportion to the triviality of what occurred. But when John Mortimer read out, at the very beginning of the trial, the indictment of Socrates and noted its similarity with that of Messrs. Neville, Dennis and Anderson, the level at which he at least wished to conduct the debate was exceeding clear. The very process of the Law, however, as exhibited in the Old Bailey, very nearly prevented him from doing so. The legal mind, for example, appeared incapable of understanding that which was not fact; opinion, not susceptible to the absolute truths of yes or no, was dismissed as hearsay, prattle or gossip, and not the business of the Court. Morality was assumed to be capable of definition; psychological conjecture was thought to be self-evidently quackery unless substantiated by fact. What was good for one man, was assumed to be universally so. Behaviour, it seemed, was at the discretion of the Judge, his education, upbringing, his environment, his genetic inheritance, his intelligence, even his emotional capabilities.

Of course, it was the Jury who decided, those two women and nine men who sat wearily on, being cajoled and appealed to, winked at and persuaded; those 11 whom chance had thrown together either, as the prosecution said, to set a standard for the rest of society, or, as the defence insisted, to adjudge the guilt or otherwise of defendants charged with criminal offences. It is impossible to believe that they were not touched by the former, although they may have consoled themselves with the thought that they were only fulfilling their function in implementing the latter. Will they now consider themselves to have played a part in an historic verdict, or will they merely dismiss the whole affair as a welcome change from their otherwise unglamorous lives? Will we ever know what roles they saw themselves as playing? And does it matter? After all, they had not asked to be involved in this corrupting business. And so the prosecuting Counsel had returned to his herb garden and his holidays in Acapulco, content with a job well done, as he put it; Mr. Mortimer to his plays and theatre in another place; the Judge to his chambers hopefully to study the efficacy of the Law. The vision of a 'good life' which he upheld, smeared the Court as much as the colourful language contained in *OZ* 28 was supposed to have smeared the minds of children within the Realm.

If you consider the former accusation unjust or absurd, pause for a moment to consider the unjust absurdity of the latter. Not a single child was produced in evidence by the prosecution to prove their assertion that the magazine had tended to corrupt or deprave youth. Not a single child psychologist or social worker or parent could be found to justify such an accusation.

In all, an outdated and archaic law had been invoked to justify the activities of a righteous police force, ever powerful in its pursuit of ill-defined concepts of right and wrong.

But this was also a case, as with Lady Chatterley, in which the object under scrutiny was held to be of special interest to art and literature; yet the witnesses brought by the defence to assert that this was so - Feliks Topolski, Marty Feldman and others – were as pathetic as they were dangerous. They mistook the nature of the game as surely as they misunderstood the nature of their audience. It became apparent that there was a choice between either obeying the rules by which the Law was administered and risk winning this particular game with dishonour, or breaking those rules and emerging, defeated, but honourable.

Because what was ultimately on trial was not the artistic merits or otherwise of the magazine; not the freedom to express minority opinions which the majority might find distasteful; not the ultimately feeble-minded defence by the accused of their belief in children's rights; not the obscenity or otherwise of *OZ* 28; not the extent to which the so-called permissive society should be allowed to flourish; not even the simple need to disagree.

What was on trial was the Law itself, the machinery of justice, and its ability to comprehend ideas as opposed to facts. And on this particular occasion, the Law and its administration was found not only wanting, but guilty.

While the accused were being held in custody at Wandsworth Prison, the *New Law Journal* said of Argyle in its editorial that his decision to remand all three defendants in custody for medical reports...

> "...is scarcely likely to be cited in years to come as one of the more intelligent or enlightened instances of the use of the remand system."

Argyle, it continued, had prolonged the agony of all concerned in a trial of already unprecedented length by refusing to set any date for sentences. In a reference to the Court of Appeal's decision not to grant bail but to allow the men to renew their application if not sentenced within a week, the editorial went on:

> "It is quite beyond us to understand their Lordships' reasons for maintaining that whereas the circumstances of the case were against bail between July 28 and August 5 (today), the same circumstances might suddenly point to precisely the opposite conclusion on the latter date, and so make it worth applying again."

The editorial then made reference to the enforced haircutting of the defendants which it called a "monstrous violation of an individual's personal integrity."

Under the Prison Rules this may be done 'as may be necessary for neatness'. But...

> "...are the prison authorities so out of touch with today that they still imagine that neatness is synonymous with 'short back and sides'?"

The accused were kept in prison for seven days. Their medical, social and psychiatric reports each took 12 minutes.

On the eighth day, Thursday August 5, they appeared once more before His Honour Judge Michael Argyle, QC. The previous evening, John Mortimer's latest play *Voyage Round My Father* had opened at the Haymarket Theatre in the West End of London to general critical approval. The following morning he said:

"It's like having two first nights in a row."

Mr. Argyle was seven minutes late.

Detective-Inspector Luff was asked again if the deportation order had been served on Richard Neville. Yes, replied Luff, it had been served on July 28. Luff was then asked by Neville how many complaints had actually been filed against *OZ* 28 by members of the public. 45, replied Luff, including one from the National Union of Teachers.

Mr. Mortimer made it clear in cross-examination that this was only 45 out of a circulation of 40,000 - not a very significant number, he added. As well, he pointed out, there had now been 36 issues of *OZ* and only No. 28 had fallen foul of the Law.

Mr. Alan Robbins, a Probation Officer to the Central Criminal Court, read out social reports on the accused which he had prepared. They had declared, he reported, that there were various aspects of society which appalled them. They did not regret their association with *OZ*, and felt that it reflected the views of an increasing number of people; what's more, they wished *OZ* to continue as a platform of new ideas. Mr. Robbins considered the three accused to be most articulate and highly intelligent. They were not interested in material gain, he said, and could obviously earn much more elsewhere. They held to their belief that the verdict was a political

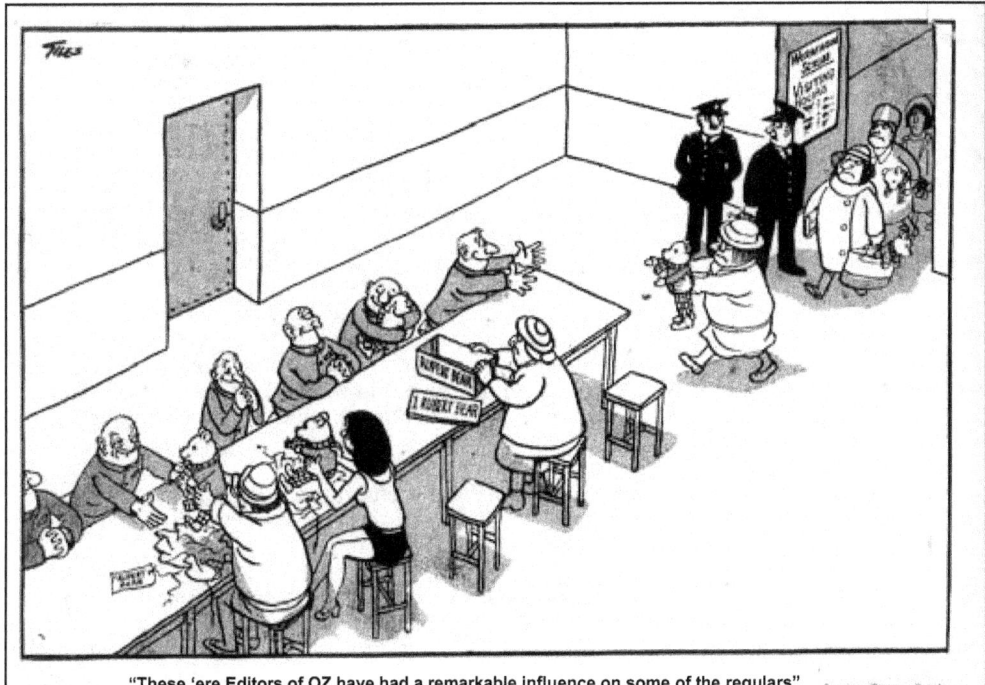

"These 'ere Editors of OZ have had a remarkable influence on some of the regulars"

decision. They had all been polite and courteous and thought that the Jury had been conditioned by the Judge's summing up.

Mr. Dennis had said: "*OZ* has a message which will not be denied."

Then began the pleas for mitigation. Mr. Neville observed that they had all been acquitted on the conspiracy charge by a unanimous verdict. The other verdicts had only been reached by a majority. However, this prosecution, he went on, had developed into a trial by press in that most people were still convinced that the three of them had been 'interfering' with children. Somehow, somewhere, as the *Observer* had put it, there had been an 'abuse of power'. Speaking directly to the Judge, Neville said; "Our case became unrecognisable in your mouth." But, even so, this was not done out of malice, thought Neville, but out of a total lack of understanding of the issues involved. The Judge's mind, he said, was too literal, too obsessed with trivia. When he, Neville, had referred to this being a political trial, he did not mean that it devolved from any particular political party. It was the clash of ideas that was at stake, ideas about how society should be run.

They had all been surprised about how often the legal mind had been wide of the mark.

> "If you do jail us', warned Neville, "you will do a great damage, not to us individually, but to the already fading optimism of a generation".

Prison did not worry them - the food wasn't bad and they were all in need of a good rest. But the worry was more crucial than that; a jail sentence would harm the concept of this society being tolerant and being capable of absorbing change and alternatives. Instead of this being a society which is healthy and plural, we should come to the conclusion that it was sick and polarised.

> "You will show", he said to the Judge, "that your generation - while appearing to listen to us politely - is, in fact, deaf".

Asked to give a guarantee as to his future conduct, Neville could only reply that everyone knew that he disagreed with the verdicts. Although he did not pretend to be leading a children's crusade, he wished to retain his right to publish what he wished. But, he said, although he might be tired of *OZ*, he was even more weary of trials. Mr. Mortimer added that we were dealing, he said, with an area of law in which it is extremely difficult for a young person to know with certainty that what he is publishing is illegal.

In this case, he said, these young people may have blundered over the line which, when all was said and done, it was almost impossible to draw with clarity. Since the promulgation of the Obscene Publications Act in 1959, there had been no case of anyone who, it was conceded, was not a hard-core pornographer, being sent to prison. In the trial of Hubert Selby's book, *Last Exit to Brooklyn*, for example, which was far more specific in its description of oral sex, the publisher was fined a mere £100.

In this case, concluded Mr. Mortimer, passions had been aroused on all sides. Surely it was time to take the temperature down a bit. To cast the accused in the roles of martyrs thus giving them perhaps an undeserved heroic light, would be foolish.

Mr. Dennis then made a brief plea on his own behalf. He was truly sorry that they had all failed to communicate their intention to the Court and to the public. He agreed that the "flagrant misrepresentation" of their case had not been deliberate. Rather, it was yet another example of this failure of understanding. Yes, he said, corruption and obscenity were the cornerstones of this and every other issue of *OZ*; the obscenity of poverty amidst wealth, of

blind and repressive authoritarianism, of obsessive materialism, of homelessness, of the mindless pollution of the environment, of sexual repression - these were the obscenities with which *OZ* concerned itself. It had been said in the trial that *OZ* was a mirror; and if that mirror reflects anything, he went on, consider for a moment what it reflects.

> "If the face fits, wear it," he said defiantly. "I emerge from the trial", he concluded, "...confirmed in my views about the lack of communication and understanding between myself, as a young person, and you, as a Judge."

Mr. McHale then said that the Company's assets were only £750. Argyle interrupted him:

> "It has never been my intention," he said, "to close this magazine down. I know it is a poor company, although I note that largely as a result of the publicity accruing from this trial, the company has made a profit of £5,000 in the first six months of this year."

McHale pointed out that Argyle had misread the figures. In fact, the company had made £2,500 over two and a half years.

> "In my view," Argyle went on, "one of the main features of this obscene little magazine and of this trial is the fact that some people who should know better have encouraged by their views things which are contrary to the Law. Mrs. Klein, for example. Also, that some of the most objectionable contents of the magazine may well appear out of context, even against the author's original wishes. Things were lifted wholesale from other publications - without permission. Only little over half of *OZ* 28 had actually been contributed by the school kids.
>
> Therefore," Argyle went on, "I fine the Limited Company on each of charges 2, 4 and 5, £300, and on charge 3, £100 - making a total of £1,000. In addition, they must pay up to one quarter of the prosecution costs to a sum not exceeding £1,250."

[In effect, this meant that it was a fine directed against the accused, since it was they who were the Company].

Next, the Judge turned to Neville, Anderson and Dennis.

> "All of them being over 21," he said, "probation would be inappropriate. As they are poor, a fine would also be inappropriate. Which brings me to a custodial sentence. The only other question is whether it should be suspended or not, and Mr. Dennis has made it quite plain this morning that he intends to continue his activities. Mr. Neville: you are a man of very great ability and very great intelligence. But I have no alternative other than to sentence you on counts 2, 4 and 5 to 15 months imprisonment, and on Count 3 to six months — these to run concurrently, making a total of 15 months.
>
> I also recommend that you be deported".

> "It was predictable," said Neville to the Judge.

> "Anderson: I sentence you, on Counts 2, 4 and 5, to 12 months, and on Count 3 to six months - also to run concurrently, making a total of 12

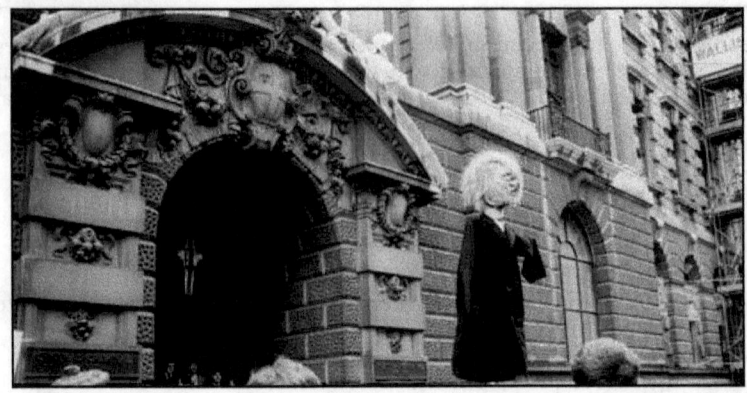

Burnt at the stake - Argyle, the truth or some dubious moral principle?

months. Dennis; I sentence you, on Counts 2, 4 and 5, to nine months, and on Count 3 to six months - again, concurrently, making a total of nine months."

"I'm very sorry you had to do that," said Dennis.

It was 12.24 p.m. on Thursday August 4th.

As Richard Neville was taken down to his cell at the Old Bailey, he met a fellow prisoner.

"What did you get?" said the man.

"Fifteen months," said Neville.

"That's terrible," said the man. "I got the same - and I tried to murder my wife."

That afternoon 13 Labour Members of Parliament put down a motion in the House of Commons condemning the severity of Judge Argyle's sentences. The Home Secretary, Mr. Reginald Maudling, said that in future people being held in custody would not be required to have their hair cut. One of the jurors said afterwards:

> "When I first picked up *OZ* I thought it was a filthy magazine. I thought the swear words and drawings were obscene and completely unnecessary. But when the contents of *OZ* were explained to the Jury I felt more sympathy for what the defendants were trying to achieve.
>
> The trouble is they are sincere, but completely misguided. If my children had come home with such a magazine I would have been appalled and, before this trial, I would probably have torn it up. But now I would sit down with them and tell them why I think it is wrong and have a discussion on the subject. That is how the trial has changed me."

In Cambridge, one academically respectable bookshop re-organised its shelf space, boldly labelling one section 'pornography'. Later, the label was taken down following a complaint by Lady Page, wife of the Master of Jesus College.

"We are always being told about the silent majority," she said. "I hope this was a blow in the right direction."

Outside Court Room No. 2 at the Old Bailey is inscribed the legend:

"The welfare of the people is the supreme Law."

Outside the Old Bailey itself a crowd of some 300 staged an impromptu demonstration. Among other things, they burned an effigy of Judge Argyle.

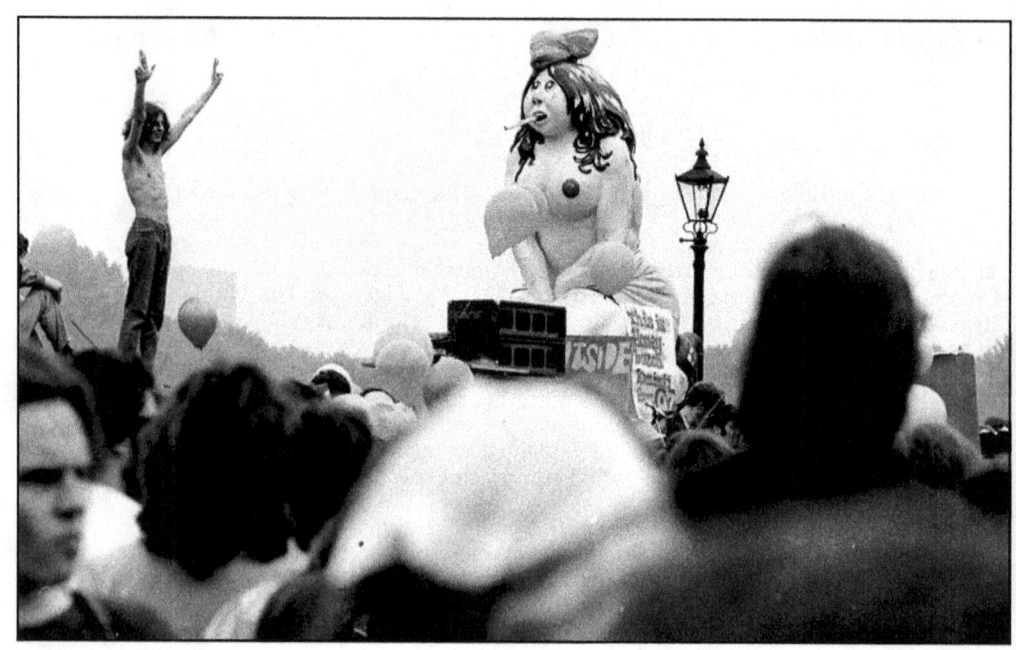

Nemesis or Honeybunch?

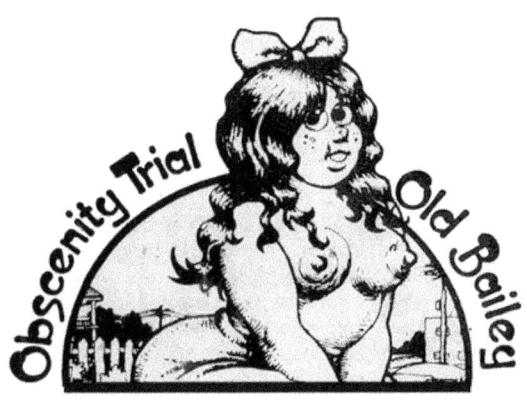

THE TRIALS OF OZ
POSTSCRIPT

So what happened next? The original edition of this book was published very rapidly, within three weeks of the three defendants being sent to prison. Given that the defendants appealed almost immediately, the entire book was in danger of being held in contempt of court pending the results of the appeal process. But such was the public concern about what had happened in the Old Bailey, to the publisher's relief (mine too) no action was taken against the book. It was rubbished by 'Geoff' Robertson, the junior of juniors; Neville thought later I had been unfair in my descriptions of some of the witnesses. "Sour" was his description. Nonetheless, the book was subsequently pillaged by all and sundry as the basic text for plays in the theatre and on television with no acknowledgement whatsoever. Later it was used as the basis for the script of at least one cinema film without so much as a by-your-leave. But more of that anon.

In the immediate aftermath of the trial itself, the first appeal was against the refusal of Judge Argyle to allow bail for the three defendants pending appeal against the sentence itself. After seven days in Wormwood Scrubs prison among "deranged thieves, rapists and axe murderers" (according to Neville), the application for bail was heard in the High Court by Mr Justice Griffiths, who found that the sentences "were considerably more severe than usually imposed" and granted bail of £100 for each of the defendants. John Birt, later Director General of the BBC, and myself guaranteed the money.

Three months later at the Royal Courts of Justice in The Strand, on Thursday November 3, wearing full-length wigs, Neville, Anderson and Dennis heard John Mortimer say to the Lord Chief Justice Widgery that their "brother below" (Argyle, and Mortimer repeated this phrase several times with obvious relish) had "misdirected the Jury on seventy-eight occasions – fourteen times on points of direction and sixty-four times on points of law." Leary, the Prosecuting Counsel replied, that in his view Argyle had done his very best to achieve a "fair trial", for instance having allowed the defendants to call any witnesses they liked. Leary had spent the intervening months since the end of the first trial on holiday in Acapulco and looked remarkably cheerful and sun-tanned.

Dennis later claimed that on the night before the appeal was heard, the three editors were taken to a secret meeting with Lord Chief Justice Widgery, who reportedly said that Argyle had made a "fat mess" of the trial, and informed them that they would be acquitted, but insisted that they had to agree to give up work on *OZ*. Dennis added that, in his opinion, MPs Tony Benn and Michael Foot had also interceded with Widgery on their behalf. This seems unlikely.

The fact is that late the following day Widgery, with a copy of my book *The Trials of Oz* clearly visible on his bench, quashed the convictions, albeit with qualifications. The prison sentences under the Post Office Act were upheld, but suspended for two years, and the recommendation for Neville's deportation was cancelled. Explaining the judgment, Lord Widgery said that the trial judge had seriously misdirected the jury on the definition of obscenity in the 1959 Act, and that for the future there must be no widening of the formula to introduce colloquial notions of obscenity or concepts imported from the less serious indecency offences. The Lord Chief Justice also took the view that Argyle had failed to put across fully the defence argument that articles on sex and drugs in the magazine could deter people rather than encourage them. "These two matters put together form a very substantial and serious misdirection," he said. The Court of Appeal was also in agreement that the Judge was biased against experts as a group, and was inclined to make little of their evidence whenever he got the chance to do so.

Although the convictions were thus quashed, Lord Widgery had a warning for those who in the future might be convicted under the Obscene Publications Act: "We would however like to make it quite clear in general terms," he said, "that any idea that an offence of obscenity does not merit a prison sentence should be eradicated. There will be many cases in future in which a prison sentence is appropriate if the court imposing the sentence thinks fit; and any general impression to the contrary should not be retained."

The ruling was criticised by Mary Whitehouse who called it a "disaster". "I do not have anything personal against the three men", she said, "but I think it is an unmitigated disaster for the children of our country. If they cannot be protected by the law from this kind of material, then the law should be tightened up. The first thing I am going to do is get on to the Attorney General." Subsequently she instituted what became known as the Nationwide Petition for Public Decency, which eventually amassed well over a million signatures and was presented by her and the Bishop of Leicester to the Prime Minister Ted Heath.

Despite their supposed undertaking to Lord Widgery, *OZ* continued to be published after the trial, and thanks to the intense public interest the trial had generated, its circulation briefly rose to 80,000. However its popularity faded over the next two years and by the time the last issue *OZ* 48 was published in November 1973, *OZ* Publications was £20,000 in debt and the magazine had "no readership worth the name".

Dennis was stung by personal comments made by Argyle that he was of limited ability and intelligence and a dupe of the other defendants. He has since become one of Britain's wealthiest and most prominent independent publishers as owner of Dennis Publishing (publisher of *The Week* and other magazines), and in 2004 released a book of fine, and often hillarious, children's poetry. Ironically, it has become the favourite book of poetry of my nine year-old son who can quote whole stanzas of it from memory. By 2010, with his sixth book of verse published and five national poetry tours completed, Dennis had a fair claim to being one of England's most popular poets.

In 1995 Argyle again reiterated allegations about Dennis in *The Spectator* magazine. As this was outside court privilege, Dennis was able to successfully sue the magazine, which agreed

to pay £10,000 to charity. Dennis refrained from suing Argyle personally: "Oh, I don't want to make him a martyr of the Right: there's no glory to be had in suing an 80-year-old man and taking his house away from him. It was just a totally obvious libel."

Neville eventually returned to Australia, where he has become a successful author, commentator and public speaker, later styling himself as a 'futurist'. His books include *The Life and Crimes of Charles Sobraj* (1979), a critically praised account of the life of French/Vietnamese serial killer Sobraj, who preyed on Western tourists travelling on Asia's so-called 'hippie trail' in the 1970s. The book was later adapted for a successful TV mini-series starring Art Malik. In the 1990s Neville published a memoir of his years with *OZ*, entitled *Hippie Hippie Shake*. Beeban Kidron directed a film adaptation in 2007, which was originally scheduled for released in 2008. The film starred Cillian Murphy as Neville, Chris O'Dowd as Dennis, Sienna Miller as Neville's girlfriend Louise Ferrier and Emma Booth as Germaine Greer, who vehemently repudiated the movie in her *Guardian* column. "You used to have to die," she said, "before assorted hacks started munching your remains and modelling a new version of you out of their own excreta." Greer refused to be involved with the film, just as she had declined to read Neville's memoir before it was published (he had offered to change anything she found offensive). She did not want to meet with Emma Booth, who portrays her in the film, and concluded her article with her only advice for the actress: "Get an honest job."

In fact, making the film had been fraught with difficulties. Citing 'creative differences,' director Beeban Kidron walked off the production - her husband, screenwriter Lee Hall, had already quit. Dennis said: "I was eventually, after asking several times, permitted to see a copy of the film, which I think is quite possibly the worst film to be made in the 21st century," he told *People* magazine, adding that he was sure the film would be "an absolute stinker ... a dog's breakfast made of a terrific story." In 2010, Universal Pictures announced that the release of *Hippie Hippie Shake*, which had cost its producer, Working Title Pictures, a reported £20 million to produce, was to be "shelved indefinitely."

Partly because of its suppression by both Australian and British authorities (many editions of London *Oz* were banned in Australia), copies of both incarnations of the magazine are now rare and the British issues at least command high prices among collectors - individual copies of the most sought-after editions are now worth several hundred UK pounds each.

Detective-Inspector Luff, described by *OZ* as "a man with a Wyatt Earp fixation", was a person of stern Christian principles. He had also led an earlier notorious raid on the London Arts Gallery in Mayfair which was exhibiting some lithographs by John Lennon and his wife Yoko Ono (a charge that was subsequently thrown out by the Magistrates). And in the same year, he was reported to have acquired two tickets for Kenneth Tynan's 1970 nude review *Oh! Calcutta!* under a pseudonym, and with Detective Sergeant Ann Cox had attended a preview of the show. Luff said that he was horrified by the performance, during which three couples had "stormed out." The 'Dirty Squad', as Detective-Inspector Luff's team of police Rottweilers became known, was later found guilty of being "institutionally corrupt" and many of its officers were sent to prison and the squad disbanded. It emerged they had targeted *OZ* because they were taking so many bribes from pornographers that their 'arrest record' was rather poor.

Argyle suffered a worse fate, one is tempted to say 'tragic'. Educated at Westminster School and later at Trinity College, Cambridge, he had been called to the Bar in 1938, but with the coming of the Second World War his career was interrupted almost before it had begun. He served with the 7th Queen's Own Hussars in the Middle East, India and then Italy where he had been awarded the Military Cross for organising a tank crossing of the river Po in the Italian campaign.

He described himself as a 'country and sporting man', who could not understand that his wife's racing colours "Nigger Brown, black cap" might cause offence. He was also a noted whippet breeder and was keen on promoting terrier racing. He paid regular visits to bookmakers near the Old Bailey. In the early 1950s he had unsuccessfully contested seats at Belper and Loughborough on behalf of the Conservative Party.

After the war, his best-known criminal case was his appearance for Ronald Biggs in the Great Train Robbery of 1963. Later he sent a contribution to the fund for Jack Mills, the train driver injured during the robbery. As Recorder of Birmingham from 1965 to 1972, Argyle soon became known for his unusual 'judgments'. Amongst these were his comment to an attempted rapist on whom he imposed a suspended sentence: "You come from Derby which is my part of the world. Off you go and don't come back."

Others included: "You are far too attractive to be a policewoman - you should be a film star"; "a vicious little sodomite from Glasgow" to a mugging victim; and, when a strike had cancelled television coverage of a Test match in the West Indies, "it is enough to make an orthodox Jew want to join the Nazi party." It is Argyle to whom the term "Thief-row" is attributed, following a spate of thefts at Heathrow airport.

It appears that he had seen the *OZ* trial as one on which the survival of Christian civilisation depended. Years later, on Central Television, he commented that "...the traffic in soft porn and drugs (has) resumed. If firmer stands had been taken by those in authority, a lot of people who have since been on drugs would never have been on them." He was a judge who believed that crime could be controlled by stiff sentences and that hardened criminals really only understood prison. While in Birmingham, he had threatened life imprisonment for burglars, something which produced a reported, if temporary, 40 per cent drop in the crime rate in the city.

But he was also one of those judges who actually took a genuine interest in the welfare of those defendants whom he believed needed help, and he would work throughout his luncheon trying to find employment for young offenders. He attended night school to learn more about penology, and was well ahead of his era when he suggested that the criminal justice system should pay more attention to victims.

The end of his judicial career came with injudicious remarks at a speech to law students in Nottingham in July 1987 when he suggested that there were five million too many immigrants in Britain and that judges should be allowed to impose the death penalty in cases which carried penalties of more than 15 years. The then Lord Chancellor, Michael Havers, reprimanded him, and two months later Argyle announced he would retire the following year.

After that he continued to write to the newspapers about his *bêtes noires*, suggesting that Lord Longford had become a bore over his continuous championing of Myra Hindley, and that the tapes of the children's cries as she and Ian Brady had tortured them should be played on prime time television and radio. "I warrant that more people will tune in than watched (the ice-skaters) Torvill and Dean." He believed that when Britain had extricated itself from Europe and the United Nations, things would get better and the weather would pick up. As for a suggestion by probation officers in 1990 that non-dangerous criminals should not go to prison, he considered that "claptrap", at the same time reiterating his call

for a return of the death penalty. According to Dennis, Argyle later said that the proper sentence for the publishers of *OZ* magazine would have been between 12 and 15 years "hard labour".

Eventually he was prosecuted for failing to settle his debts at The Dorchester Hotel and according to some died almost penniless, still President of a campaign to bring back hanging.

FELIX DENNIS, unrepentant to the last, gave an interview for his own publication *The First Post* on the occasion of John Mortimer's death in 2009. When I asked if he would contribute to this new edition of my book, he suggested I quote from his obituary of John Mortimer.

> "For John Mortimer, this was just another case in a long career spent defending freedom of speech. His real life was filled with much else, not least his stage plays, screenplays, stage performances, journalism and the famous Rumpole novels; his love of wine and good food; his extended family; his travels; his Dickensian utterances; his great work for the Howard League for Penal Reform, and many acts of quiet kindness.
>
> But for me personally, whenever I think of John Mortimer, I shall conjure the image of a champagne orator, his wig rakishly askew, standing in the well of Court No 2 of the Old Bailey, the spittle drying white around his mouth, as he persuades a jury to stand up to a judge choking on venomous bile and a prosecution fuelled by cynical spite.
>
> Today, the 1970s seem as remote as the Middle Ages, but I would make three points: When you hear the word 'conspiracy' in a court of law, you can be almost certain there is monkey-business afoot.
>
> Secondly, prisons in Britain are overcrowded because we imprison more of our citizens than all but a few countries in the world. Many of these prisoners are mentally ill.
>
> Lastly, the judiciary in Britain is deeply flawed. More than one senior barrister had refused, against their sworn oath, to represent *OZ*, probably because they felt that to do so might harm their career. We were fortunate that John Mortimer finally accepted our case: he cared far less for his career in the law due to his growing fame as a playwright.
>
> Our own trial judge (Argyle) was so eager to convict us that his summing-up has become a byword for incompetence and bias. And the judiciary's political masters, including the Home Secretary and others, were involved in the whole shabby episode up to their wattled necks.
>
> No system of law can be perfect and I have heard it argued that much has changed for the better, judicially speaking, in recent years in Britain. Maybe. But I doubt it. I very, very much doubt it."

He also suggested including a poem he had published in his anthology *Homeless in My Heart* (2008), of which this is part:

"And after - after we learned
What I guess we already knew,
That as far as the law is concerned,
There is no such thing as 'true'

Or 'false'- there is only 'the norm',
And the stick-brittle words of a judge
With his 'duty to perform',
(Serving a politician's grudge),

With his wig and his worldly squint,
Spouting his sanctimonious bile,
Happy to see his face in print,
Smiling his dry-lipped crocodile smile,

Explaining away, with shop-worn mirth,
To twelve good men and true,
Just what 'the evidence' is worth
Of a man like me or you,

As he bends and buckles to fit
Some Cinderella's pump
On an elephant's foot, the crafty git,
And gives the bench a thump

As he waffles and witters away,
Hinting between the lines
That a judge knows more than he can say
(Or cares to share with Philistines)

But he knows when 'a thing is lewd!'
And brings himself up short,
Then sends the jury out to brood
And toddles off for his port...

While lawyers we can't afford
Caw like a murder of crows
That 'his Lordship's summing-up was flawed,
But that's the way it goes...

Most helpful on Appeal...
Quite frankly, a disgrace...'
And leave us to toy with our meal
Knowing we'd lost the case.

For me, there is only before
And after - after the slam
Of the Bailey's iron door,
Where the jackal lies with the lamb,

(And) drowned in the clatter and roar
Of piss-filled buckets and pails -
Carried from each cell door
To a place where all hope fails,

Where men are buggered and reamed,
Their bodies bruised and numb,
And those who scuff are double-teamed
While playing deaf and dumb,

Where a squealer finds ground glass
Has sweetened his morning brew,
'Now shut your effin' mouth, you arse,
There's nuffink you c'n do.'

And nor there is - you understand?
Not in the bowels of the law,
Not in the jails of this fair land.
For me, there is only before

And after - after the key
Had turned on a sliver of doubt,
As word came down from the powers that be
To let the buggers out.

And a Law Lord let us go,
And the free air tasted sweet,
But there wasn't man who didn't know
He spoke for Downing Street.

And I swore myself an oath
That if wealth and clout would serve,
Then I should apply myself to both,
To hold them in reserve

In a world where the rules are clear:
That only the rich have wings,
And the one beast all such bastards fear
Is coin, and the power it brings."

My sentiments precisely.

On June 13th, 2011, 40 years almost to the day that Neville, Anderson and Dennis had first stood in the dock of the Old Bailey, three other men were jailed after they admitted running an international paedophile ring that distributed millions of indecent images and films of children to over 40 countries around the world. In the first case of its kind in England and Wales, Ian Frost, 35, and his partner Paul Rowland, 34, and Frost's brother Paul, 37, along with 32-year-old Ian Sambridge, pleaded guilty to various charges of making, distributing and possessing indecent images of children. Lincolnshire Police said "smashing the ring" had resulted in 132 children in the UK being protected and safeguarded, and a considerable number of paedophiles being taken out of positions of trust, including teachers, doctors, youth workers and police officers.

Mr Justice Calvert-Smith jailed Ian Frost and Rowland for 33 months. Paul Frost was jailed for 15 months - while Sambridge was given a 12 month sentence, suspended for two years. Neville, Anderson and Dennis had been jailed for a total of thirty six months.

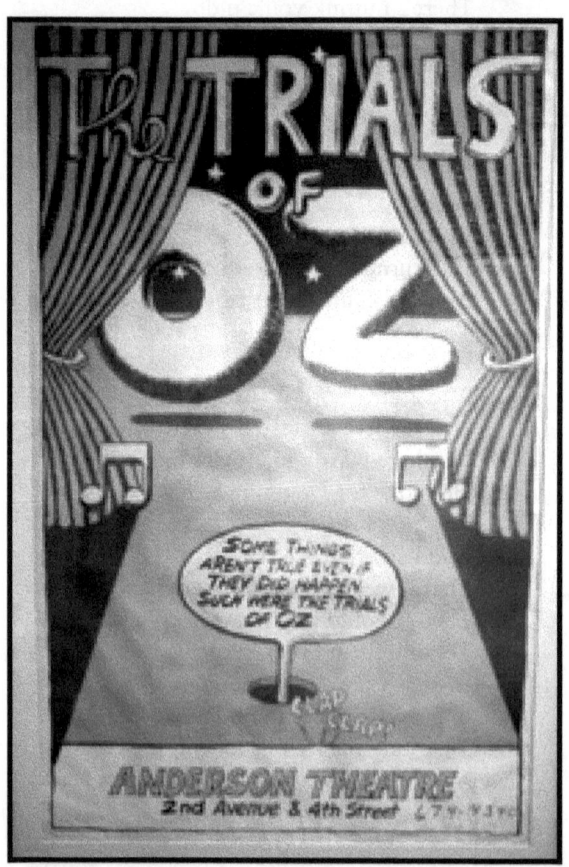

40 Years On...

Life after the Trial – A Conspirator's Tale

by Jim Anderson

Following the successful appeal, *OZ* began to feel less like an alternative way of life and more like a conventional magazine. I commuted each day to our new and plusher digs behind Cambridge Circus, had my own office as Art Director with a metaphorical nameplate on the door and worked more or less 9-5. I had the sense of a reversion to what I had emphatically run away from ten years before at the Department of the Attorney General in Sydney. I was still in the sixties "let's change the world for the better while we have the momentum" mode, but wanted to do it some other, as yet unknown way. Richard and I produced a final *OZ*. Felix decided to continue, but a few months later, towards the end of 1973, he too called it a day with his own final flourish. Richard and I both contributed farewell pieces.

A 'simple twist of fate' brought an end to any overly grand plans I might have had. Maybe the pressure inherent in those plans was what helped send me around the bend. There was bi-polarity in my family (manic depression it was called back then with my father on lithium for many years after a major breakdown), which in me was triggered by hubris and hauteur, drugs and drift. Something of a mystery really. Perhaps it was *worry* about what these factors were doing to me as a Mr Nice Guy - i.e. to the modest and relatively uncomplicated man I saw myself as.

With the *soupçon* of revolutionary fervour I still had at my disposal, I was persuaded to write a book about various aspects of my life - an eight part non-fiction work about my association with the counter culture from the viewpoint of a queer libertarian - drinking days with the Sydney Push and Baby Push, my dumping of beatnik duffle coat for hippie beads and bells, the International Pot Trails from Bali to Tangier, Gay Liberation Front and the homosexual sub-culture in San Francisco's Castro district, *OZ* Magazine and the Trial of course and so on. It took me some months to prepare a synopsis. By the time I was presented with the contract from Harcourt Brace and Jovanovich, I was so mentally and physically debilitated I could scarcely sign my name. It would have been more honest not to sign at all, but I took the first tranche of the big American money and ran - to western Ghana where my uber-yippie friend Adam Lisowski – accompanied by the chatter of talking drums and Ghana highlife - to cure me with Otto Meuhel's Action Analysis therapy, an unholy combination of Arthur Janov's hands-off Primal Scream and Wilhelm Reich's hands-on massages, a quick fix for all that ailed me.

As the months went by with me not submitting a single line, Tony Godwin, the editor at Harcourt Brace, unaware that there was anything wrong, became concerned. Adam's dubious therapies in themselves did not do me much good but I appreciated all the attention given me by his group, all of them, like me, much in need of help. The fact that naked screamings took place on somewhere called Busua Pleasure Beach certainly helped; but after a while, it seemed crazy to be crazy in such a calm and happy place.

Back on my own in London I realised I was still as mad as a hatter and was in danger of being committed to some kind of modern Bedlam. Fortunately I was sensate enough to take a pre-emptive flight to San Francisco. With the help of Jon Goodchild, (former designer of *OZ* working there for *Rolling Stone*), I finally got down to writing. I finished the first two sections of my book, sent them off. Tony Godwin expressed extreme disappointment, and told me to start again.

A couple of months later, I sent him my somewhat scabrous version (another 50,000 words) of the *OZ* Trial, entitled *Arseholes on Your Pad, Mr. Leary?* (from a note that John Mortimer scribbled under the doodlings on Leary's legal pad while the prosecutor was on his feet haranguing one of our expert witnesses). Weeks went by with no response from Tony Godwin, unusual for him, so one day I summoned up the courage to ring his office only to be answered by a distraught secretary who had come in and found Tony dead on the floor, suffocated from an asthma attack.

In fact, by the time of Tony's death I had moved to foggy Bolinas, a feisty little town not far from San Francisco, full of people like me, recovering from various excesses of the sixties. I began a series of full moon peyote meetings run by the local shaman Magda, whom I had met on that node of the international hippie trails. The dusk to dawn peyote meetings were turbo-charged healing rituals, and after twelve full-moons of earthy guidance under the benign, if mischievous (everything and nothing is sacred), influence of Mescalito, the antic god of the cactus, the worst of my manias and depressions, anxieties and despairs, were a thing of the past. There was no more denying or resisting what had happened to me and I settled into a new and different persona. I thought a change of name would be appropriate, couldn't come up with anything and waited for one to be given me. None materialised, except Magda's derisive Jiminy Cricket. She found me vacuous, too light on my feet and disrespectful of her shamanic status. There were many people in Bolinas who had assumed new names and it wasn't long before I met some of them - Sky, Sunshine, Hawk, Raindance, Lotus, Lovejoy, Ponderosa Pine, Pluto, Eat Dog, Ikon, Boaz, Bijou, Dharma and Ginjohn for example.

A new born arrival had been given the name of Breath.

There were many roads which led to wellness in Bolinas and I pursued several of them. I joined Piero Resta's Totem Sutra Theatre, discovered I could paint backdrops, make masks and create elaborate costumes. I performed in them in his productions and in local events like the Floating Sun Festival, July 4th, Halloween, Thanksgiving and so on. Even Labor Day. People there, all attempting to make a fresh start in life, tended not to speak of their past, and I did not tell anyone about *OZ* Magazine or the Obscenity Trial. So when Felix Dennis, in the course of making his first millions, came visiting, (sensationally, in a white stretch limo which his chauffeur parked outside the People's Store which specialised in organic produce), I did not introduce him as a former fellow editor, just a London business man down here on a visit, as Christopher Isherwood might have put it.

With no more money coming under the book contract, I needed to find work. Magda had suggested a job as barman in Smiley's Schooner Saloon. I also became 'Monday Editor' of the *Bolinas Hearsay News*, the local paper, 6 or 8 foolscap pages, which came out three times a week. I had to find artwork for the front cover. I couldn't paint or draw but soon discovered a talent for collage. I began a peyote influenced stream-of-consciousness column commenting on the previous week's multifarious cultural and political affairs. I found I had fallen in love with a town, with a community, in the same way I had fallen in love with *OZ* six years or more earlier.

I mounted an exhibition in the Bookstore Gallery of my art work, (*Remote Corners of the Garden of Eden Revisited and Other Locations in Time and Place*) and took a trip back to Sydney, partly to assure Mum and Dad of my sanity. I had not told them anything of my breakdown, but had been proudly sending evidence of my recovery - copies of the *Bolinas Hearsay News* - although my mother was beside herself with worry. The AIDS diaspora was beginning and many men settled in friendly Bolinas, often to die. My former boyfriend and dance partner, Dexter, was one of them.

With many regrets, I eventually left Bolinas, a place I had come to regard as home, and returned to Australia in 1993 after thirty years away. I have never looked back, but it took me a long time to adjust. I'm still catching up. Perhaps *LAMPOON an historical art trajectory* 1971-2011, my retrospective exhibition in 2011 at the University of Sydney's Tin Sheds Gallery, was an indication that I am now at home here. And have the confidence to look back and think of past achievement instead of being lured forever into the future by the sense of incompletion that accompanies creative endeavour. Maybe an innate laziness and a certain lack of ambition have made for a happy enough passage to the present.

I turned my earlier novel *Billarooby* into a screenplay for a big budget feature, *From a Death to a View,* but it has never made it to the silver screen, despite being much praised. As an artist, I am not only forever preoccupied with scissors and paste (or the digital equivalent thereof), but also with a comedic novelisation of what happened to me post-*OZ* and long ago on that beautiful beach near the Ivory Coast border in West Africa.

In one way or another, the *OZ* Trial and its reverberations, have followed me, welcome and unwelcome, (with the pluses far outweighing the minuses) all my life, as they have I suspect for Richard and Felix, with both of whom I have maintained a close friendship over these many years. Both continue to do remarkable things. As soothsayers have always foretold, 2011 marks the fortieth anniversary of that Old Bailey kerfuffle - our formative performance piece on a London stage under the auspices of the forces of law and order.

Jim Anderson
July 2011

Charles Shaar Murray then and now

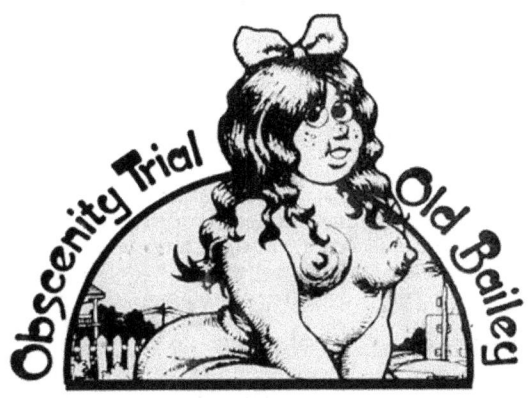

I was an *OZ* schoolkid
by Charles Shaar Murray

The *OZ* obscenity trial was as much a clash of two Britains as the Lady Chatterley case had been a decade earlier: two landmark events in a cultural war which, as the moral panics over *Brass Eye, American Psycho* and *Crash* would suggest, is still going on.

And it all started so innocently, too.

"Some of us are feeling old and boring," began the ad in *OZ* 26. "We invite our readers who are under 18 to come and edit the April issue. We will choose one person, several or accept collective applications from a group of friends." *OZ*, it concluded, "belongs to you".

Early 1970, with spring in the air. I was about to be sprung from what felt like a life sentence in Net Curtain Land (Reading, to be precise). I wasn't under 18. In fact, I had only a few more months to go before becoming 19. Nevertheless, there was no way that I was going to ignore an opportunity to meet and work with the glitterati of the metropolitan underground. It seemed like my last chance to escape becoming a civil servant or a librarian.

So half a dozen of us hitched up to London and soon found ourselves in a dimly lit and exotically furnished basement flat in Palace Gardens Terrace, off Notting Hill Gate, alongside 20-odd other 15 to 18-year-olds. The flat was home to *OZ* figurehead Richard Neville, the charmingly louche 30-year-old apex of the editorial triumvirate. His co-conspirator Jim Anderson, four years older, lived upstairs: camp, ironic and softly spoken, he was the first out gay person I had ever met. Finally, there was "freak with a briefcase" Felix Dennis, the youngest at 25 and the magazine's business manager and reviews editor, his chocolate-brown pinstripe suit clashing with his Louis XIV hair and wildman beard.

All three were at least as interested in us as we were in them. As actual (rather than notional) kids, we were interrogated for our opinions on education, politics and society as well as on sex, drugs and rock 'n' roll. Given access to the magazine, what would we want to say? Over the next few weekends, crammed into Jim's flat, we found out through the process of saying it. Along the way, we started to learn about magazine production in the days of

web-offset printing. When I brought in the typescript of my first piece, Richard scrawled "bold, unjustified" at the top. I was quite offended until I realised this was an instruction to the typesetter rather than a comment on the article.

The company of schoolkid editors included Peter Popham, subsequently a respected foreign correpondent for the Independent; Deyan Sudjic - the posse's sole skinhead - founder of Blueprint, editor of Architectural Digest and a front-rank commentator on archi-tectural issues; Colin Thomas, a successful photographer; Trudi Braun, who became a senior editor at Harper's; Steve Havers, cultural commentator turned web designer; and Vivian Berger, whose juxtaposition of the head of Rupert Bear with a Rabelaisian cartoon by Robert Crumb helped generate some of the most surreal exchanges ever heard in a British court.

Schoolkids' *OZ* didn't sell particularly well, and the *OZ* team had practically forgotten about it when, two months later, the obscene publications squad crashed into the *OZ* office in Holland Park, locked the doors, disconnected the phones and began carting away every-thing remotely connected to *OZ* 28.

Next stop, a year or so later: the Old Bailey, with Richard, Felix and Jim up before the beak for having "conspired with certain other young persons to produce a magazine" which would "corrupt the morals of children and other young persons" and was intended to "arouse and implant in the minds of those young people lustful and perverted desires". The same Obscene Publications Squad, which permitted orthodox Soho pornbrokers to proceed with business as usual in exchange for regular cash payments and a few free blue movies for their stag nights, relentlessly pursued *OZ*, IT and the publishers of the *Little Red Schoolbook*.

This was a cultural war disguised as an obscenity trial: ordinary porn, which knows its place and reinforces rather than challenges the social order, rarely receives this kind of attention from the authorities. On the other hand, overtly radical work concerned with ideas becomes instantly vulnerable, whenever it touches on matters of sexuality, to mass outbreaks of orchestrated indignation and - in this case - the full weight of the law.

The fact that, between verdict and sentencing, the *OZ* three were subjected to forcible hair-cuts was a valuable clue towards figuring out what their real crimes were. As Jonathon Green wrote in *All Dressed Up*:

> "The Establishment did not like *OZ* or the counter-culture that it represented - when Neville naively, injudiciously, combined 'children' with the usual irritants of drugs and sex and rock, they saw their chance".

In his summing up, Judge Michael Argyle had misrepresented the defendants and their case so thoroughly that the conviction was overruled on appeal. Richard and Jim nevertheless left the country soon afterwards.

Yet the *OZ* three had not, as the prosecution insisted, exploited and corrupted us in order to aim a torrent of filth at helpless infants; they had simply allowed a bunch of bright, discontented kids the opportunity to express themselves. The results were often incoherent, inconsistent or just plain silly, but nevertheless, *OZ* 28 was us.

The crime of *OZ* was to suggest that adolescents found sex both attractive and humorous, and that they were discontented with society and the education system: this was far more disturbing to the powers that be than anything Old Soho could offer its customers.

Similarly, Chris Morris's attack in Brass Eye on orchestrated hysteria and self-aggrandising

celebrities too dozy to listen to what they are reading from an autocue is more upsetting to many than the spectacle of the howling lynch mobs wound up by the *News of the World*.

In the same way, serious movies like *American Psycho*, *Crash* and *Lolita*, adapted from the works of serious writers like Bret Easton Ellis, JG Ballard and Vladimir Nabokov, have far more power to disturb than any straightforward slasher flick or shagfest, simply because they engage the brain.

Depictions of sexuality and violence do not, in themselves, offer any threat. Ideas do, especially when sexuality is involved. From Chatterley to *OZ*, from *Crash* to *Brass Eye*, we have seen those who are threatened by ideas demand censorship in order to win cultural wars when they know, in their heart of hearts, that they have already lost the argument.

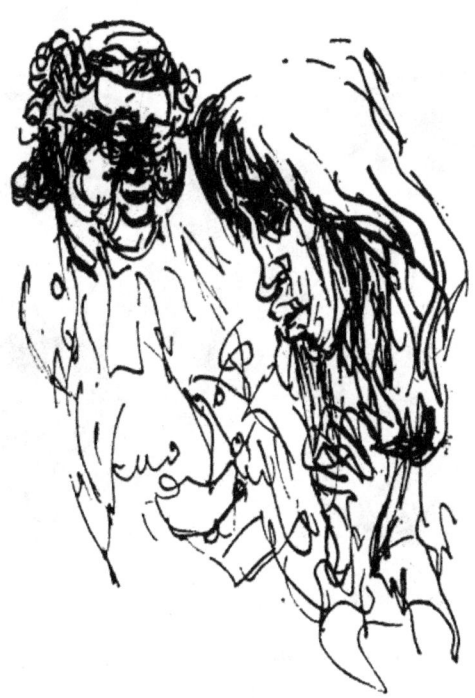

Mr Leary's singular interpretation of the word 'dildo' as 'dill-doll' has finally been vindicated with the discovery of this 18th Century broadsheet ballad

Last Thoughts from Brian Leary QC

In Tony Palmer's book *The Trials of OZ* on page 96 there appears the following passage. "Later, Mr Leary told me he'd grown rather fond of Richard Neville but, like anyone else, he had a job to do."

For the trial at the Central Criminal Court I was instructed to prosecute the case without junior counsel to assist me, and I had nothing to do with the committal proceedings at the Magistrates Court.

Before the jury trial began at the Old Bailey, Richard Neville had approached me in his invariably courteous manner to inform me that he planned to represent himself in the forthcoming trial by jury, and would appreciate my help. Richard Neville explained that he wanted to object to certain of the evidence given by the prosecution at his committal, stating that he proposed to make his objections to the trial judge.

I recall telling Richard Neville that I believed his suggested approach (which he had spelled out for me) would merely annoy and anger the trial judge, and suggested to him an alternative way of expressing his submission. "If," said I, "he were to adopt my suggested form of objection, I would tell the judge that I would immediately concede the argument in his favour and not lead the evidence at the trial.

Thereafter, throughout the trial, I was always ready to help if I could, with any question put to me by the then *student* of the law, Geoffrey Robertson, who is now himself a *famous* Queen's Counsel and who on the cover of his book *The Justice Game* is described as:

> "...giving gripping accounts of defending innocent men against the Government's determination to put them behind bars."

In the book:

> "...there are uproarious accounts of fighting for free speech in the OZ trail, and resisting Mary Whitehouse's crusades against the magazine *Gay News* and Howard Brenton's play at the National Theatre, *The Romans in Britain*".

THE TRIALS OF OZ

The late and sadly missed John Mortimer QC (who represented the other two young men accused in the trial) was, as well as being the most witty and charming of opponents in Court, a great friend of mine. John arranged for me to see the special opening night of *The Romans in Britain*, and when another on another occasion one of his own plays was staged in my wonderful (and wonderfully historic) Inn of Court, the Middle Temple, John arranged for my lady guest and myself, during the interval, to meet his leading lady backstage.

Returning to the trial itself, after the jury's verdicts I was personally horrified by the way in which Judge Argyle treated the three young defendants, and I was delighted *for their sakes* when their appeals were allowed, effectively on the grounds of the trial judge's misdirection of the jury.

Underlining the generosity of the three young men, I remember my surprise occasioned by their extraordinarily kind invitation to myself to attend their celebration party in Soho commemorating their acquittal.

Once I 'took silk' and became Queen's Counsel myself, I have personally enjoyed a wonderful life in appearing both for the Crown and for the defence, at home in England and abroad, and I thank God for my great good fortune and my wonderful wife and stepson.

REFLECTIONS FROM THE DAUGHTERS
by Gabrielle, Caroline & Marie, the daughters of Michael Argyle QC

The OZ trial dominated the media and the public eye for a comparatively short time but had a much longer lasting effect on our family life; it seems quite surreal now.

I was working away from home and my sisters, Marie and Caroline, were at boarding school when it started and we were completely oblivious to the fuss that was about to engulf us.

I called home one evening to have a chat to Mum and a strange man's voice answered. Very confused (it seemed unlikely that a burglar would answer the phone!) I asked to speak to either of my parents and was told they weren't there. I rang off and called the local police station to be told they would 'look in to it' but I shouldn't worry. I spent a very anxious hour wondering what the hell was going on before my mother called to say they were fine; they had been out to dinner and Special Branch were in the house because Dad was about to start 'a high profile case'.

Fast forward a few weeks and Dad is ensconced in the Savoy Hotel as his safety could not be guaranteed at his club. I am not sure but suspect that he was asked where he would prefer to stay and chose the Savoy – there are worse places to be! Marie remembers visiting him in London during the school holidays and running in to the hotel with him after an evening out hotly pursued by members of the press.

Our mother, meanwhile, had two Special Branch officers as a permanent fixture in her kitchen; what isn't known outside of close family and friends is the toll all this eventually took on her health. Mum liked her life in the Nottinghamshire countryside with occasional trips to London to accompany Dad to official dinners or to visit the Kennel Club. She was heavily involved with the dog showing world as a whippet breeder and an international show judge; she became the first woman to be elected to the Kennel Club, previously a male preserve. Above all, she valued her privacy and her own space. To be unable to walk along the banks of the river Trent, which ran at the bottom of our garden, with her dogs or even shop in the village without her 'protection' became oppressive to the extent that she became ill. Eventually, some good friends lent her a cottage in southern Ireland and she retreated for some peace and quiet. I was amused to be standing at a bus stop in Bromley on a day off to read the front page headline in the *Daily Mail*: "Judge's family flees to Ireland". This story

was supplied to the Press by the police to try and take the pressure off things at home where the press were nosing around constantly, neighbours were being asked for stories and quotes and a large quantity of mail arrived on a daily basis – some of it very unpleasant.

Whatever Dad did following *OZ* he would primarily be remembered for that trial which is a pity because he did some other, excellent things during his time both as a Judge and before that as Recorder of Birmingham where he started a campaign against petty crime and vandalism. His statement that "if you come to Birmingham and commit a crime, you can expect to be sent to prison" was very popular with both the police and public and had a positive effect on the crime figures in the City. Behind the scenes he did much to help offenders. He could sometimes glimpse the potential in a person, kept track of their progress in prison and helped get them a job once they were released.

He was, of course, very quotable which meant that he appeared frequently in the papers; this did not always endear him to the Lord Chancellor's office. However, he firmly believed in what he was doing and stuck to his guns. His Anglican faith played an important part in his life; he once told Caroline that he said his prayers three times every day. When he was at home he attended Southwell Minster and was a sidesman there for many years during Sunday services. His deep personal faith helped carry him through some very tough times in his life, for example, he was only sixteen when his beloved mother died at an early age.

Away from the courtroom his great love was watching sport with horse racing and boxing top of his list of interests. He was a great supporter of the Amateur Boxing Association, attending matches in London when he could and fundraising for them at dinners. He believed that it was better for young men to use their energy under controlled conditions in a boxing ring rather than out on the streets and then finish up before him in the dock.

As a father he was a very loyal parent and always ready to defend his children. He took a rather Victorian attitude as far as our boyfriends were concerned; he didn't always approve of our choices and, as Caroline says, we managed to embarrass the heck out of him on more than one occasion but he never stopped loving us. In my case, his objection to the man I later married – and am still married to 36 years later – resulted in him not speaking to me for a while. Malcolm's 'crime' was to be divorced which Dad felt was a bad omen for our future together! However, he came to our wedding at Hampstead Register Office and even signed the certificate. He eventually thawed out, the arrival of grandchildren helping considerably. Dad was a sucker for babies and small children and adored our two girls and Marie's two boys. Once he became a Judge he lived in London during the week returning to the family home on Friday evenings. He relaxed by going for long walks along the river side, watching horse racing on TV and reading. After days spent dealing with complex legal documents he didn't want to tackle anything heavy and I remember the embarrassment as a teenager being sent to the local library to ask for the latest Cowboy and Indian book!

Sunday lunches were a much loved family ritual and Mum was an excellent cook. Dad had a very silly sense of humour which always appealed to young children particularly if it involved being a bit naughty at the same time. If the lunchtime dessert was a sponge pudding, Dad's favourite trick was to stand on his chair holding up a spoon of golden syrup and let it drop on to his plate of sponge from a height. Three small girls would watch hoping it would miss the target and land on the table whilst my mother's expression warned of dreadful consequences if it did. His aim was good and, sadly, he never missed!

When he eventually retired from the judiciary the City of London Police threw a leaving party for him, something which I don't believe they had done before for a Judge. Amongst his leaving presents he was presented with a pair of golden handcuffs, which I now have.

He occupied his time at home in writing articles for the local and national papers, going to race meetings and supporting mum with her judging commitments at dog shows. Sadly, Mum died from cancer in 1994 and life was never quite the same after that. Marie and I visited as often as we could and Caroline came over from the USA every year but he was on his own much of the time. He resolutely refused to contemplate moving to be nearer to any of us because he wanted to maintain the family home we all loved so much. In 1995, when he was in poor health and quite frail, the *OZ* trial reared its head again when an article appeared in *The Spectator* containing some comments from Dad about Felix Dennis. *The Spectator* paid damages to Dennis but Dad was threatened with legal action which made him very agitated and caused us a good deal of concern as he was going to counter sue. Nothing came of it but it seemed an unnecessary turn of events at that stage of his life.

In 1998 Marie and I, with husbands and children in tow, spent Christmas at the house with Dad. It was noisy, chaotic fun but a bit tiring for him I think and we dispersed back to our own homes for New Year. I spoke to him just before New Year's Eve, expressed concern for him and hoped he was getting enough to eat;

> "Darling, over 50 years ago I was crouching in a freezing cold trench being shot at by the Germans, don't worry about me" was the response.

He died on New Year's Eve, sitting in his armchair, glass of whisky in hand and the racing on the television. Not a bad way to go and, as he was fond of saying about contemporaries who had died, "he had a good innings".

Left to right: Gabrielle, Caroline, Michael Argyle & Marie in 1995.

www.ingramcontent.com/pod-product-compliance
Lightning Source LLC
Chambersburg PA
CBHW071709180426
43192CB00052B/2214